Legends

OF THE

Madonna.

LONDON
PRINTED BY SPOTTISWOODE AND CO.
NEW-STREET SQUARE

The Virgin Mary studying the Scriptures in the Temple.

Legends

OF THE

Madonna

AS REPRESENTED IN THE FINE ARTS.

FORMING THE THIRD SERIES OF SACRED AND LEGENDARY ART.

BY MRS. JAMESON.

ILLUSTRATED BY ETCHINGS AND WOODCUTS.

THIRD EDITION.

LONDON:
LONGMAN, GREEN, LONGMAN, ROBERTS, & GREEN.
1864.

CONTENTS.

Page

PREFACE xv

INTRODUCTION.—Origin of the Worship of the Madonna. Earliest artistic Representations. Origin of the Group of the Virgin and Child in the Fifth Century. The First Council at Ephesus. The Iconoclasts. First Appearance of the Effigy of the Virgin on Coins. Period of Charlemagne. Period of the Crusades. Revival of Art in the Thirteenth Century. The Fourteenth Century. Influence of Dante. The Fifteenth Century. The Council of Constance and the Hussite Wars. The Sixteenth Century. The Luxury of Church Pictures. The Influence of Classical Literature on the Representations of the Virgin. The Seventeenth Century. Theological Art. Spanish Art. Influence of Jesuitism on Art. Authorities followed by Painters in the earliest Times. Legend of St. Luke. Character of the Virgin Mary as drawn in the Gospels. Early Descriptions of her Person; how far attended to by the Painters. Poetical Extracts descriptive of the Virgin Mary xvii

SYMBOLS AND ATTRIBUTES OF THE VIRGIN. Proper Costume and Colours . xliv

DEVOTIONAL SUBJECTS AND HISTORICAL SUBJECTS. Altar-pieces. The Life of the Virgin Mary as treated in a Series. The Seven Joys and Seven Sorrows as a Series. Titles of the Virgin as expressed in Pictures and Effigies. Churches dedicated to her. Conclusion lii

SUPPLEMENTARY NOTES lxviii

DEVOTIONAL SUBJECTS.

PART I.

THE VIRGIN WITHOUT THE CHILD.

LA VERGINE GLORIOSA. Earliest Figures. The Mosaics. The Virgin of San Venanzio. The Virgin of Spoleto 3

The Enthroned Virgin without the Child, as type of heavenly Wisdom. Various Examples 7

a 2

Page

L'Incoronata, the Type of the Church triumphant. The Virgin crowned by her Son. Examples from the old Mosaics. Examples of the Coronation of the Virgin from various Painters 13

The Virgin of Mercy, as she is represented in the Last Judgment . . 26

The Virgin, as Dispenser of Mercy on Earth. Various Examples . . 29

The Mater Dolorosa seated and standing, with the Seven Swords . . 35

The *Stabat Mater*, the Ideal Pièta. The Votive Pièta, by Guido . 37, 39

Our Lady of the Immaculate Conception. Origin of the Subject. History of the Theological Dispute. The First Papal Decree touching the Immaculate Conception. The Bull of Paul V. The Popularity of the Subject in Spain. Pictures by Guido, by Roelas, Velasquez, Murillo . . . 42

The Predestination of the Virgin. Curious Picture by Cotignola . . 52

Part II.

THE VIRGIN AND CHILD.

The Virgin and Child enthroned. *Virgo Deipara.* The Virgin in her Maternal Character. Origin of the Group of the Mother and Child. Nestorian Controversy 57

The Enthroned Virgin in the old Mosaics. In early Italian Art. The Virgin standing as *Regina Cœli* 63

La Madre Pia enthroned. *Mater Sapientiæ* with the Book . . . 65

The Virgin and Child enthroned with attendant Figures; with Angels; with Prophets; with Apostles 75

With Saints: John the Baptist; St. Anna; St. Joachim; St. Joseph . . 78

With Martyrs and Patron Saints 82

Various Examples of Arrangement. With the Fathers of the Church; with St. Jerome and St. Catherine; with the Marriage of St. Catherine. The Virgin and Child between St. Catherine and St. Barbara; with Mary Magdalene; with St. Lucia 83, 90

The Virgin and Child between St. George and St. Nicholas; with St. Christopher; with St. Leonard. The Virgin of Charity . . . 90

The Madonnas of Florence; of Siena; of Venice and Lombardy. How attended 91

The Virgin attended by the Monastic Saints. Examples from various Painters . 94

Votive Madonnas. For Mercies accorded: for Victory; for Deliverance from Pestilence; against Flood and Fire 96

Family Votive Madonnas. Examples. The Madonna of the Bentivoglio Family. The Madonna of the Sforza Family. The Madonna of the Meyer Family. The Madonna di Foligno. German Votive Madonna at Rouen. Madonna of Réné, Duke of Anjou; of the Pesaro Family at Venice . . . 101

Page

Half-length Enthroned Madonnas; first introduced by the Venetians. Various
Examples 108

The MATER AMABILIS. The infinite Variety given to this Subject. Early Greek
Examples 114

Virgin and Child with St. John. He takes the Cross 123

The MADRE PIA; the Virgin adores her Son 125

Pastoral Madonnas of the Venetian School 127

Conclusion of the Devotional Subjects 133

HISTORICAL SUBJECTS.

PART I.

THE LIFE OF THE VIRGIN FROM HER BIRTH TO HER MARRIAGE WITH JOSEPH.

THE LEGEND OF JOACHIM AND ANNA 137, 138

Joachim rejected from the Temple. Joachim herding his Sheep on the Moun-
tain. The Altercation between Anna and her Maid Judith. The Meeting
at the Golden Gate 141

THE NATIVITY OF THE VIRGIN. The Importance and Beauty of the Subject.
How treated 146

THE PRESENTATION OF THE VIRGIN. A Subject of great Importance. General
Arrangement and Treatment. Various Examples from celebrated Painters . 150

The Virgin in the Temple 154

THE MARRIAGE OF THE VIRGIN. The Legend as followed by the Painters . 157

Various Examples of the Marriage of the Virgin, as treated by Perugino, Raphael
and others 160

PART II.

THE LIFE OF THE VIRGIN MARY FROM THE ANNUNCIATION TO THE RETURN FROM EGYPT.

THE ANNUNCIATION. Its Beauty as a Subject. Treated as a Mystery and as an
Event. As a Mystery; not earlier than the Eleventh Century. Its proper
Place in architectural Decoration. On Altar-pieces. As an Allegory. The
Annunciation as expressing the Incarnation. Ideally treated with Saints
and Votaries. Examples by Simone Memmi, Fra Bartolomeo, Angelico, and
others 166

Page

The Annunciation as an Event. The appropriate Circumstances. The Time, the Locality, the Accessories. The Descent of the Angel; proper Costume; with the Lily, the Palm, the Olive 175

Proper Attitude and Occupation of Mary; Expression and Deportment. The Dove. Examples from various Painter. Mistakes . . . 181

THE VISITATION. Character of Elizabeth. The Locality and Circumstances. Proper Accessories. Examples from various Painters . . . 186

THE DREAM OF JOSEPH. He entreats Forgiveness of Mary . . . 193

THE NATIVITY. The Prophecy of the Sibyl. *La Madonna del Parto.* The Nativity as a Mystery; with poetical Accessories; with Saints and Votaries 196

The Nativity as an Event. The Time; the Place; the proper Accessories and Circumstances; the angelic Choristers; Signification of the Ox and the Ass 204

THE ADORATION OF THE SHEPHERDS 209

THE ADORATION OF THE MAGI; they are supposed to have been Kings. Prophecy of Balaam. The Appearance of the Star. The Legend of the three Kings of Cologne. Proper Accessories. Examples from various Painters. The Land Surveyers, by Giorgione 210

THE PURIFICATION OF THE VIRGIN. The Prophecy of Simeon. Greek Legend of the *Nunc Dimittis.* Various Examples 223

THE FLIGHT INTO EGYPT. The Massacre of the Innocents. The Preparation for the Journey. The Circumstances. The Legend of the Robbers; of the Palm 228

THE REPOSE OF THE HOLY FAMILY. The Subject often mistaken. Proper Treatment of the Group. The Repose at Matarea. The Ministry of Angels 238

THE LEGEND OF THE GIPSY 243

THE RETURN FROM EGYPT 245

PART III.

THE LIFE OF THE VIRGIN FROM THE SOJOURN IN EGYPT TO THE CRUCIFIXION OF OUR LORD.

THE HOLY FAMILY. Proper Treatment of the Domestic Group as distinguished from the Devotional. The simplest Form that of the Mother and Child. The Child fed from his Mother's Bosom. The Infant sleeps . . 249

Holy Family of three Figures; with the little St. John; with St. Joseph; with St. Anna 256

Holy Family of four Figures; with St. Elizabeth and others . . . 260

The Holy Family of Five and Six Figures 260

The Family of the Virgin grouped together 261

Page

Examples of Holy Family as treated by various Artists 263
The Carpenter's Shop 267
The Infant Christ learning to read 269
THE DISPUTE IN THE TEMPLE. The Virgin seeks her Son . . . 271
THE DEATH OF JOSEPH 274
THE MARRIAGE AT CANA. Proper Treatment of the Virgin in this Subject ; as
 treated by Luini and by Paul Veronese 276
The Virgin attends on the Ministry of Christ. Mystical Treatment by Fra An-
 gelico 279
LO SPASIMO. Christ takes leave of his Mother. Women who are introduced
 into Scenes of the Passion of our Lord. The Five Maries . . . 280
The Procession to Calvary. *Lo Spasimo di Sicilia* 282
THE CRUCIFIXION. Proper Treatment of the Virgin in this Subject. The im-
 propriety of placing her upon the Ground. Her Fortitude. Christ recom-
 mends his Mother to St. John 284
THE DESCENT FROM THE CROSS. Proper Place and Action of the Virgin in this
 Subject 288
THE DEPOSITION. Proper Treatment of this Form of the *Mater Dolorosa.* Per-
 sons introduced. Various Examples 289
THE ENTOMBMENT. Treated as an historical Scene. As one of the Sorrows of
 the Rosary ; attended by Saints 292
The *Mater Dolorosa* attended by St. Peter. Attended by St. John and Mary
 Magdalene 294

PART IV.

THE LIFE OF THE VIRGIN MARY FROM THE RESURRECTION OF OUR LORD TO THE ASSUMPTION.

THE APPARITION OF CHRIST TO HIS MOTHER. Beauty and Sentiment of the old
 Legend ; how represented by the Artists 299
THE ASCENSION OF OUR LORD. The proper Place of the Virgin Mary . . 302
THE DESCENT OF THE HOLY GHOST ; Mary being one of the principal Persons . 303
THE APOSTLES TAKE LEAVE OF THE VIRGIN 303
THE DEATH AND ASSUMPTION OF THE VIRGIN. The old Greek Legend . . 306
The Angel announces to Mary her approaching Death . . . 310
The Death of the Virgin, an ancient and important Subject. As treated in the
 Greek School; in early German Art ; in Italian Art. Various Examples . 312
The Apostles carry the Body of the Virgin to the Tomb . . . 316
The Entombment 317

Page

THE ASSUMPTION. Distinction between the Assumption of the Body and the Assumption of the Soul of the Virgin. The Assumption as a Mystery; as an Event 317

LA MADONNA DELLA CINTOLA. The Legend of the Girdle; as painted in the Cathedral at Prato 320

Examples of the Assumption as represented by various Artists . . . 323

THE CORONATION as distinguished from the *Incoronata*: how treated as an historical Subject. Conclusion 328

LIST OF ILLUSTRATIONS.

𝕼𝖔𝖔𝖉𝖈𝖚𝖙𝖘.

1. The Virgin Mary. *Ancient Greek Bas-relief in Alabaster. S. Maria in Porto Ravenna.*
2. The Virgin. *Ancient Mosaic. San Venanzio, Rome.*
3. The Virgin. *Mosaic. Cathedral, Spoleto.*
4. Ancient Mosaic. *Lateran.*
5. The Virgin enthroned. *Campo Santo, Pisa.*
6. Virgo Sapientissima. *Van Eyck.*
7. Regina Virginum. *Guido.*
8. Regina Cœli. *Holbein.*
9. Santa Maria Vergine. *Guido.*
10. The Virgin as the Winged Woman in the Apocalypse.
11. L'Incoronata. *Mosaic. Santa Maria Maggiore, Rome.*
12. Virgin and Christ enthroned together. *Mosaic. S. Maria in Trastevere, Rome.*
13. L'Incoronata. *Piero Laurati.*
14. L'Incoronata. *Ancient French Carving.*
15. L'Incoronata. *Early German.*
16. The Virgin of Mercy in the Last Judgment. *Campo Santo, Pisa.*
17. Madonna di Misericordia. *Bas-relief. Venice.*
18. Madonna di Misericordia. *Piero della Francesca.*
19. Vision of the Virgin of Mercy. *Moretto.*
20. Mater Dolorosa. *Raphael.*
21. Mater Dolorosa. *Murillo.*
22. Mater Dolorosa, with the Seven Swords.
23. Notre Dame des Sept Douleurs. *Guido.*
24. Mater Dolorosa at the Foot of the Cross. *Champaigne.*
25. Ideal Pietà. *Angelico di Fiesole.*
26. Lamenting Angel. *In an Ancient Greek Pietà.*
27. Our Lady of the Immaculate Conception. *Guido.*
28. La Madonna Purissima. *Guido.*
29. The Predestination of Mary. *Miniature of the Sixteenth Century.*
30. Virgin and Child enthroned. *Mosaic. Cathedral at Capua.*

b

31. Virgo Deipara. *Figure in the Catacombs, Rome.*
32. Virgin and Child enthroned. *Guido da Siena.*
33. Virgin and Child enthroned. *Cimabue.*
34. Virgin and Child standing. *Greek Figure. Orvieto.*
35. Virgin and Child standing. *Early German.*
36. Virgin and Child standing. (*Virgo Lactante.*) *Van Eyck.*
37. La Madre Pia. *Vivarini.*
38. Virgin and Child. (*Mater Sapientiæ* with a Book.)
39. Enthroned Virgin and Child. (*Madonna in Trono.*)
40. Madonna in Trono. *Carlo Crivelli.*
41. Madonna in Gloria. *Raphael.*
42. Virgin and Child attended by the Four Archangels. *Sketch from an early
 Mosaic. Ravenna.*
43. Virgin and Child enthroned with St. Anna. *Early German.*
44. Virgin and Child enthroned. *Raphael.*
45. Votive Madonna. *Siena.*
46. Votive Madonna.
47. Half-length Enthroned Madonna. *Milanese School.*
48. Half-length Enthroned Madonna. *Francesco Francia.*
49. Half-length Enthroned Madonna. *Botticelli.*
50. Half-length Enthroned Madonna. *Titian.*
51. The Virgin and Child, with St. John, St. Joseph, and Zacharias. *Cesare
 di Sesto.*
52. Mater Amabilis. *Luini.*
53. Mater Amabilis. *Greco-Italian. S. Maria in Cosmedino, Rome.*
54. Mater Amabilis. *Greco-Italian. Perugia.*
55. Mater Amabilis. *Greco-Italian. Padua.*
56. Mater Amabilis. (*Vierge à la Pomme.*) *Raphael.*
57. Mater Amabilis. *G. Bellini.*
58. Mater Amabilis. *Squarcione.*
59. Mater Amabilis. *School of Luini.*
60. Mater Amabilis. *Fra Bartolomeo.*
61. Mater Amabilis. *Annibal Caracci.*
62. Mater Amabilis. *Murillo.*
63. Mater Amabilis (in the *Hortus Clausus.*) *Albert Dürer.*
64. Mater Amabilis. *Allori.*
65. Virgin and Child with St. John. *Andrea del Sarto.*
66. Virgin and Child with St. John. *Guido.*
67. Virgin and Child with St. John. *Titian.*
68. Virgin and Child with St. John. *Raphael.*
69. La Madre Pia (in the *Hortus Clausus*). *Filippino Lippi.*
70. La Madre Pia. *Correggio.*
71. La Madre Pia. *Botticelli.*
72. La Madre Pia. *Guido.*

73. Pastoral Madonna and Child. *Palma Vecchio.*

74. Pastoral Madonna with St. Catherine and St. John. *Titian.*

75. Pastoral Madonna, with St. Jerome and St. Dorothea. *Titian.*

76. Virgin and Child, with St. Joseph and St. Catherine. (*Sacra Conversazione*). *Titian.*

77. Sacra Conversazione. *Parmigiano.*

78. Madonna and Child with the Seven Gifts of the Holy Spirit. *Miniature.*

79. The Annunciation to St. Anna. *Luini.*

80. Joachim rejected from the Temple. *Taddeo Gaddi.*

81. Meeting of Joachim and Anna. *Albert Dürer.*

82. Meeting of Joachim and Anna. *Taddeo Gaddi.*

83. Birth of the Virgin. *Ancient Fresco. Florence.*

84. La Vergine Bambina.

85. The Dedication of the Virgin. *Vittore Carpaccio.*

86. The Virgin in the Temple. *Luini.*

87. The Marriage of Joseph and Mary. *Angelico da Fiesole.*

88. Angel. *Vignette.*

89. The Annunciation. *Old Italian.*

90. The Annunciation as a Mystery. *Lorenzo Monaco.*

91. The Annunciation as a Mystery. *Ancient Florentine Master.*

92. The Annunciation as a Mystery. *Simone Memmi.*

93. The Annunciation as a Mystery. *Angelico da Fiesole.*

94. The Annunciation as an Event. *John Van Eyck.*

95. The Annunciation as an Event. *Albert Dürer.*

96. The Annunciation as an Event. *Cimabue.*

97. The Annunciation as an Event. *Andrea del Sarto.*

98. The Annunciation. (*Ecce Ancilla Domini.*) *Flaxman.*

99. The Allegory of the Unicorn. *Old Florentine Engraving.*

100. The Visitation with Angels. *Pinturicchio.*

101. The Visitation. *Lucca della Robbia.*

102. The Visitation. *Cimabue.*

103. The Visitation. *Lucas Van Leyden.*

104. The Sibyl's Prophecy. *Baldassare Peruzzi.*

105. The Nativity as a Mystery. *Albertinelli.*

106. The Nativity as a Mystery. *Lorenzo di Credi.*

107. The Nativity. *Taddeo Gaddi.*

108. The Nativity. *Lorenzo di Credi.*

109. The Adoration of the Shepherds. *Raphael.*

110. An Ideal Nativity. *Perugino.*

111. The Wise Men. The Star appears like a Child. *Taddeo Gaddi.*

112. Adoration of the Magi. *Taddeo Gaddi.*

113. Adoration of the Magi. *Pinturicchio.*

114. Adoration of the Magi. *Albert Dürer.*

115. The Presentation in the Temple. *Fra Bartolomeo.*
116. The Nunc Dimittis. *Byzantine.*
117. Presentation in the Temple. *John Van Eyck.*
118. The Preparation for the Flight into Egypt. *Titian.*
119. The Flight into Egypt. The Massacre of the Innocents in the Background.
 Pinturicchio.
120. The Legend of the Robber. *G. di San Giovanni.*
121. The Flight into Egypt. *Guido.*
122. The Flight into Egypt. *Poussin.*
123. The Riposo. *Jan Schoreel.*
124. The Riposo with dancing Angels. *Vandyck.*
125. Sacra Conversazione. *Milanese School.*
126. Sacra Famiglia. *Ludovico Caracci.*
127. La Vierge à l'Oreiller Verd. *Andrea Solario.*
128. La Madonna della Campanella. *Allori.*
129. St. John caresses the Infant Christ. *Botticelli.*
130. La Madonna del Giglio. *Raphael.*
131. Holy Family. *Raphael.*
132. The Family of the Virgin Mary. *Parmigiano.*
133. Virgin and Child. *Bas-relief.* *M. Angelo.*
134. Christ learning to read. *Schidone.*
135. Mary and Joseph conduct Jesus home. *Rubens.*
136. The Virgin seeks her Son. *Giotto.*
137. Group of the Fainting Virgin at the Foot of the Cross. *Andrea Man-
 tegna.*
138. Descent from the Cross. *Duccio di Siena.*
139. Deposition. *B. de Bruijn.*
140. The Virgin in the Entombment. *Ancient Greek.*
141. The Entombment. *Raphael.*
142. The Ascension. *Giotto.*
143. The Descent of the Holy Ghost. *Hemmelinck.*
144. Assumption of the Virgin. *Titian.*
145. The Angel announces to the Virgin her approaching Death. *A. Orcagna.*
146. The same subject. *Filippo Lippi.*
147. Assumption. Christ takes the Hands of the Virgin. *Von Mekenem.*
148. The Virgin presents her Girdle to St. Thomas. *Palma.*
149. The Coronation of the Virgin. *Filippo Lippi.*
150. The Virgin and Child. *Sculpture.* *Michael Angelo.*
151. Isis nursing Horus.
152. Greek Virgin and Child.
153. An Effect of Light and Shade.
154. Popular Image of the Virgin.
155—164. Plans of Altar-pieces.
165. Head of the Virgin. *After Donatello.*

𝔈𝔱𝔠𝔥𝔦𝔫𝔤𝔰.

Page

I. The Virgin Mary studying the Scriptures in the Temple (v. p. 168). *From the Fresco by Pinturicchio in the Church of S. Maria del Popolo at Rome* *To face the Title.*

II. Ancient Christian Sculpture *Introduction,* p. lxxi.

III. 1. 'Mater Sapientissima.' *After Piero di Cosimo.* 2. La Madonna della Cintola. *After Francesco Granacci* 10

IV. 1. The Coronation of the Virgin, as a Mystery. *After a Cartoon by Raphael, prepared for the High Altar of the Sistine Chapel, and expressing the Three Great Points of Doctrine, viz. The Exaltation of the Virgin as the Symbol of the Church. On the Right, Salvation through Baptism (St. John the Baptist). On the Left, Salvation through Penitence or Penance (St. Jerome).* 2. The Coronation of the Virgin, as an Event. *After Albert Dürer* 24

V. 'Stabat Mater.' 1. *After Angelico da Fiesole.* 2. *After Michael Angelo.* 3. *After Lorenzo di Credi* 37

VI. Ideal Pietà. *After Michael Angelo.* 1. The Composition engraved by Bonasone. 2. The famous Marble Group in St. Peter's at Rome. *(Etched from a Photograph.)* 39

VII. Ideal Pietà. 1. *After Luini.* 2. *After Martin Schoen. Contrasting the Italian and German Treatment* 40

VIII. 1. 'La Divina Pastora.' *After Alonzo M. de Tobar* (v. p. 34). 2. 'Our Lady of the Immaculate Conception.' *After the Picture by Murillo, styled 'La Grande Conception de Seville'* . . . 45

IX. 1. The Virgin and Child enthroned between the two Spose, St. Catherine of Alexandria and St. Catherine of Siena. *After Ambrogio Borgognone.* (*v.* Legendary Art, and the Legends of the Monastic Orders for the details of the subject). 2. The 'Mater Dei,' enthroned, and attended by Angels. *After Nicolo Alunno.* 3. The 'Mater Dei.' Standing figure. *German Sculpture. Nuremberg* . 88

X. The Virgin and Child enthroned. 1. Between two Angels, one of whom offers the Apple. *After Hemling.* 2. Between St. Catherine and St. Barbara. *After Hugo van der Goes. Both in the Florence Gallery* 90

XI. Family Votive Madonna called '*The Madonna of the Meyer Family.*' *After the Picture by Holbein at Dresden.* 2. Votive Madonna of Charity, enthroned between St. Omobuono, giving Alms to a poor Man, and St. Francis with a Taper (*Let your light so shine before men,* &c.). Behind him St. Bernardino da Feltri with a *Mont de Piété,* a small figure of St. Catherine in front. *From a Picture by B. Montagna, in the Berlin Gallery* 102

Page

XII. Half-length Enthroned Madonna, with Saints. 1. Between St. Margaret and St. Dorothea. *After a Picture by Mabuse in the Munich Gallery.* 2. Between St. Catherine and St. Barbara. *After a Picture by Luini in the Belvedere at Vienna* 109

XIII. Ancient Greek Mater Amabilis. 1. ' Virgin Niko-peja ' (i. e. *bringer of Victory*), supposed to be the same which the Empress Eudocia sent to her sister-in-law Pulcheria, now in the Cathedral of St. Mark at Venice. 2. The Virgin of Casopo in Corcyra. 3. The Virgin of the Cathedral at Undine. 4. The Virgin of the Cathedral at Padua. All these effigies are popularly attributed to St. Luke, and are accounted *miracolosissime*. Repetitions in every form abound . . 116

XIV. Mater Amabilis. 1. *After Giorgione, in the Leuchtenberg Gallery at Munich.* 2. *After Hemling, at Bruges. Contrasting the Italian and early Flemish Treatment* 121

XV. The Nativity of the Virgin. *After the Fresco by Ghirlandajo, in S. Maria Novella at Florence* 148

XVI. The Marriage of the Virgin to Joseph (styled a ' Sposalizio '). *After the Fresco by Pinturicchio, in S. Maria del Popolo, at Rome* . 160

XVII. The Annunciation, as a Mystery. 1. *After Raphael.* 2. *After Alvarez Petri (1429), on the Doors of an Altar Piece* . . . 167

XVIII. The Riposo, with Dancing Angèls. *After Lucas Cranach* . 240

XIX. 1. Holy Family, with Saints. *After Giacomo Francia. Berlin Gallery.* 2. Holy Family. *After Michael Angelo. From a Fresco in the Casa Buonarroti, at Florence* 264

XX. Domestic Holy Family. 1. *After Albert Dürer.* 2. *After Giulio Romano (called ' La Madonna del Bacino ')* . . . 266

XXI. The Procession to Calvary. *From the Picture by Raphael, styled ' Lo Spasimo di Sicilia,' now at Madrid* 283

XXII. The Descent from the Cross. Sculpture. *After Nicolà Pisano. Lucca* 289

XXIII. The Deposition. *After a celebrated Drawing by Raphael* . 291

XXIV. 1. The Apparition of Christ to his Mother. *After Albert Dürer.* 2. Mary and St. John returning from the Crucifixion. *After Zurbaran* 301

XXV. 1. The Death of the Virgin Mary. *After Albert Dürer.* 2. Christ bears the Virgin into Heaven. *After Giovanni Pisano* . 313

XXVI. The Assumption of the Virgin. 1. Standing. *After Pinturricchio.* 2. Seated. *After Perugino* 317

XXVII. Death and Assumption of the Virgin, with St. Thomas receiving the Girdle. *After Andrea Orcagna. From the Shrine in Or-san-Michele at Florence. Sculpture in Alabaster* . . . 319

PREFACE

THE FIRST EDITION.

In presenting to my friends and to the public this Third Series of the Sacred and Legendary Art, few preparatory words will be required.

If in the former volumes I felt diffident of my own powers to do any justice to my subject, I have yet been encouraged by the sympathy and approbation of those who have kindly accepted of what has been done, and yet more kindly excused deficiencies, errors, and oversights, which the wide range of subjects rendered almost unavoidable.

With far more of doubt and diffidence, yet not less trust in the benevolence and candour of my critics, do I present this volume to the public. I hope it will be distinctly understood, that the general plan of the work is merely artistic; that it really aims at nothing more than to render the various subjects intelligible. For this reason it has been thought advisable to set aside, in a great measure, individual preferences, and all predilections for particular schools and particular periods of Art—to take, in short, the widest possible range as regards examples—and then to leave the reader, when thus guided to the meaning of what he sees, to select, compare, admire, according to his own discrimination, taste, and requirements. The great difficulty has been to keep within reasonable limits. Though the subject has a unity not found in the other volumes, it is really boundless as regards variety and complexity. I may have been superficial from mere superabun-

dance of materials; sometimes mistaken as to facts and dates; the tastes, the feelings, and the faith of my readers may not always go along with me; but if attention and interest have been excited—if the sphere of enjoyment in works of Art have been enlarged and enlightened, I have done all I ever wished—all I ever hoped, to do.

With regard to a point of infinitely greater importance, I may be allowed to plead—that it has been impossible to treat of the representations of the Blessed Virgin without touching on doctrines such as constitute the principal differences between the creeds of Christendom. I have had to ascend most perilous heights, to dive into terribly obscure depths. Not for worlds would I be guilty of a scoffing allusion to any belief or any object held sacred by sincere and earnest hearts; but neither has it been possible for me to write in a tone of acquiescence, where I altogether differ in feeling and opinion. On this point I shall need, and feel sure that I shall obtain, the generous construction of readers of all persuasions.

The illustrative etchings in this new edition have been executed on steel by a young relative at Rome—they will be found superior to the drawings on stone in the first edition; and in the selection of the subjects some will be found different and more appropriate than the former. Both the woodcuts and the etchings must be considered as mere diagrams to assist the fancy of the observer to the comprehension of the different groups; so that, in looking over pictures and prints, the differences and varieties in point of composition and arrangement may be at once discriminated, not only in those given as examples, but in hundreds of others. In this respect, as it is well known, a few scratches with a pen are better than whole pages of the most elaborate description.

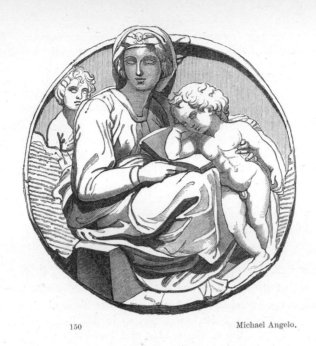

150

Michael Angelo.

Introduction.

I. ORIGIN AND HISTORY OF THE EFFIGIES OF THE MADONNA.

THROUGH all the most beautiful and precious productions of human genius and human skill which the middle ages and the *renaissance* have bequeathed to us, we trace, more or less developed, more or less apparent, present in shape before us, or suggested through inevitable associations, one prevailing idea : it is that of an impersonation in the feminine character of beneficence, purity, and power, standing between an offended Deity and poor, sinning, suffering humanity, and clothed in the visible form of Mary, the Mother of our Lord.

To the Roman Catholics this idea remains an indisputable religious truth of the highest import. Those of a different creed may think fit to dispose of the whole subject of the Madonna either as a form of superstition or a form of Art. But merely as a form of Art, we cannot in these days confine ourselves to empty conventional criticism. We are obliged to look further and deeper ; and in this department of Legendary Art, as in the others, we must take the higher ground, perilous though it be. We must seek to comprehend the

dominant idea lying behind and beyond the mere representation. For, after all, some consideration is due to facts which we must necessarily accept, whether we deal with antiquarian theology or artistic criticism; namely, that the worship of the Madonna did prevail through all the Christian and civilised world for nearly a thousand years; that, in spite of errors, exaggerations, abuses, this worship did comprehend certain great elemental truths interwoven with our human nature, and to be evolved perhaps with our future destinies. Therefore did it work itself into the life and soul of man; therefore has it been worked *out* in the manifestations of his genius; and therefore the multi-form imagery in which it has been clothed, from the rudest imitations of life to the most exquisite creations of mind, may be resolved, as a whole, into one subject, and becomes one great monument in the history of progressive thought and faith, as well as in the history of progressive art.

Of the pictures in our galleries, public or private,—of the architectural adornments of those majestic edifices which sprang up in the middle ages (where they have not been despoiled or desecrated by a zeal as fervent as that which reared them), the largest and most beautiful portion have reference to the Madonna,—her character, her person, her history. It was a theme which never tired her votaries,—whether, as in the hands of great and sin-cere artists, it became one of the noblest and loveliest, or, as in the hands of superficial, unbelieving, time-serving artists, one of the most degraded. All that human genius, inspired by faith, could achieve of best—all that fanaticism, sensualism, atheism, could perpetrate of worst—do we find in the cycle of those representations which have been dedicated to the glory of the Virgin. And indeed the ethics of the Madonna worship, as evolved in art, might be not unaptly likened to the ethics of human love: so long as the object of sense remained in subjection to the moral idea—so long as the appeal was to the best of our faculties and affections—so long was the image grand or refined, and the influences to be ranked with those which have helped to humanise and civilise our race; but so soon as the object became a mere idol, then worship and worshippers, art and artists, were together degraded.

It is not my intention to enter here on that disputed point, the origin of the worship of the Madonna. Our present theme lies within prescribed limits,—wide enough, however, to embrace an immense field of thought; it seeks to trace the progressive influence of that worship on the fine arts for a thousand years or more, and to interpret the forms in which it has been clothed. That the veneration paid to Mary in the early Church was a very natural feeling in those who advocated the divinity of her Son, would be granted, I suppose, by all but the most bigoted reformers; that it led to unwise and wild extremes, confounding the creature with the Creator, would

be admitted, I suppose, by all but the most bigoted Roman Catholics. How it extended from the East over the nations of the West, how it grew and spread, may be read in ecclesiastical histories. Everywhere it seems to have found in the human heart some deep sympathy—deeper far than mere theological doctrine could reach—ready to accept it; and in every land the ground prepared for it in some already dominant idea of a mother-Goddess, chaste, beautiful, and benign. As, in the oldest Hebrew rites and Pagan superstitions, men traced the promise of a coming Messiah,—as the deliverers and kings of the Old Testament, and even the demigods of heathendom, became accepted types of the person of Christ,—so the Eve of the Mosaic history, the Astarte of the Assyrians—

> The mooned Ashtaroth, queen and mother both—

the Isis nursing Horus of the Egyptians, the Demeter and the Aphrodite of the Greeks, the Scythian Freya, have been considered by some writers as types of a divine maternity, foreshadowing the Virgin-mother of Christ. Others will have it that these scattered, dim, mistaken—often gross and perverted—ideas which were afterwards gathered into the pure, dignified, tender image of the Madonna, were but as the voice of a mighty prophecy, sounded through all the generations of men, even from the beginning of time, of the coming moral regeneration, and complete and harmonious development of the whole human race, by the establishment, on a higher basis, of what has been called the 'feminine element' in society. And let me at least speak for myself. In the perpetual iteration of that beautiful image of THE WOMAN highly blessed—*there*, where others saw only pictures or statues, I have seen this great hope standing like a spirit beside the visible form : in the fervent worship once universally given to that gracious presence, I have beheld an acknowledgment of a higher as well as gentler power than that of the strong hand and the might that makes the right,—and in every earnest votary, one who, as he knelt, was in this sense pious beyond the reach of his own thought, and 'devout beyond the meaning of his will.'

It is curious to observe, as the worship of the Virgin-mother expanded and gathered to itself the relics of many an ancient faith, how the new and the old elements, some of them apparently the most heterogeneous, became amalgamated, and were combined into the early forms of art; —how the Madonna, when she assumed the characteristics of the great Diana of Ephesus, at once the type of Fertility, and the Goddess of Chastity, became, as the impersonation of motherhood, all beauty, bounty, and graciousness; and at the same time, by virtue of her perpetual virginity, the patroness of single and ascetic life—the example and the excuse for many of the wildest of the

early monkish theories. With Christianity, new ideas of the moral and religious responsiblity of woman entered the world; and while these ideas were yet struggling with the Hebrew and classical prejudices concerning the whole sex, they seem to have produced some curious perplexity in the minds of the greatest doctors of the faith. Christ, as they assure us, was born of a woman only, and had no earthly father, that neither sex might despair; 'for had he been born a man (which was necessary), yet not born of woman, the women might have despaired of themselves, recollecting the first offence, the first man having been deceived by a woman. Therefore we are to suppose that, for the exaltation of the male sex, Christ appeared on earth as a man; and, for the consolation of womankind, he was born of a woman only; as if it had been said, " From henceforth no creature shall be base before God, unless perverted by depravity." ' [1] Such is the reasoning of St. Augustine, who, I must observe, had an especial veneration for his mother Monica; and it is, perhaps, for her sake that he seems here desirous to prove that through the Virgin Mary all womankind were henceforth elevated in the scale of being. And this was the idea entertained of her subsequently: ' Ennobler of thy nature!' says Dante, apostrophising her, as if her perfections had ennobled not merely her own sex, but the whole human race.[2]

But also with Christianity came the want of a new type of womanly perfection, combining all the attributes of the ancient female divinities with others altogether new. Christ, as the model-man, united the virtues of the two sexes, till the idea that there are essentially masculine and feminine virtues intruded itself on the higher Christian conception, and seems to have necessitated the female type.

The first historical mention of a direct worship paid to the Virgin Mary occurs in a passage in the works of St. Epiphanius, who died in 403. In enumerating the heresies (eighty-four in number) which had sprung up in the early Church, he mentions a sect of women, who had emigrated from Thrace into Arabia, with whom it was customary to offer cakes of meal and honey to the Virgin Mary, as if she had been a divinity, transferring to her, in fact, the worship paid to Ceres. The very first instance which occurs in written history of an invocation to Mary, is in the life of St. Justina, as related by Gregory Nazianzen. Justina calls on the Virgin-mother to protect her against the seducer and sorcerer, Cyprian; and does not call in vain.[3] These passages, however, do not prove that previously to the fourth century there had been no worship or invocation of the Virgin, but rather the contrary.

[1] Augustine, Opera Supt. 238. Serm. 63.
[3] Sacred and Legendary Art, vol. ii. p. 573, 3rd edit.

[2] 'Tu se' colei che l' umana natura Nobilitasti.'

However this may be, it is to the same period—the fourth century—we refer the most ancient representations of the Virgin in art. The earliest figures extant are those on the Christian sarcophagi; but neither in the early sculpture nor in the mosaics of S. Maria Maggiore do we find any figure of the Virgin standing alone; she forms part of a group of the Nativity or the Adoration of the Magi. There is no attempt at individuality or portraiture. St. Augustine says expressly, that there existed in his time no *authentic* portrait of the Virgin; but it is inferred from his account that, authentic or not, such pictures did then exist, since there were already disputes concerning their authenticity. There were at this period received symbols of the person and character of Christ, as the lamb, the vine, the fish, &c., but not, as far as I can learn, any such accepted symbols of the Virgin Mary. Further, it is the opinion of the learned in ecclesiastical antiquities that, previous to the first Council of Ephesus, it was the custom to represent the figure of the Virgin alone without the Child; but that none of these original effigies remain to us, only supposed copies of a later date.[1] And this is all I have been able to discover relative to her in connection with the sacred imagery of the first four centuries of our era.

The condemnation of Nestorius by the Council of Ephesus, in the year 431, forms a most important epoch in the history of religious art. I have given further on a sketch of this celebrated schism, and its immediate and progressive results. It may be thus summed up here. The Nestorians maintained, that in Christ the two natures of God and man remained separate, and that Mary, his human mother, was parent of the man, but not of the God; consequently the title which, during the previous century, had been popularly applied to her, 'Theotokos' (Mother of God), was improper and profane. The party opposed to Nestorius, the Monophysites, maintained that in Christ the divine and human were blended in one incarnate nature, and that consequently Mary was indeed the Mother of God. By the decree of the first Council of Ephesus, Nestorius and his party were condemned as heretics; and henceforth the representation of that beautiful group, since popularly known as the 'Madonna and Child,' became the expression of the orthodox faith. Every one who wished to prove his hatred of the arch-heretic exhibited the image of the maternal Virgin holding in her arms the Infant Godhead, either in his house as a picture, or embroidered on his garments, or on his furniture, on his personal ornaments—in short, wherever it could

[1] *Vide* Memorie dell' Immagine di M. V. dell' Impruneta. Florence, 1714.

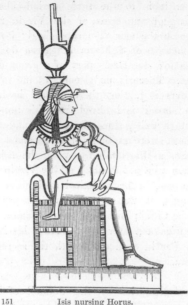

151 Isis nursing Horus.

be introduced. It is worth remarking that Cyril, who was so influential in fixing the orthodox group, had passed the greater part of his life in Egypt, and must have been familiar with the Egyptian type of Isis nursing Horus. Nor, as I conceive, is there any irreverence in supposing that a time-honoured intelligible symbol should be chosen to embody and formalise a creed. For it must be remembered that the group of the Mother and Child was not at first a representation, but merely a theological symbol set up in the orthodox churches, and adopted by the orthodox Christians.

It is just after the Council of Ephesus that history first makes mention of a supposed authentic portrait of the Virgin Mary. The Empress Eudocia, when travelling in the Holy Land, sent home such a picture of the Virgin holding the child to her sister-in-law, Pulcheria, who placed it in a church at Constantinople. It was at that time regarded as of very high antiquity, and supposed to have been painted from the life. It is certain that a picture traditionally said to be the same which Eudocia had sent to Pulcheria, did exist at Constantinople, and was so much venerated by the people as to be regarded as a sort of palladium, and borne in a superb litter or car in the midst of the imperial host, when the Emperor led the army in person. The fate of this

relic is not certainly known. It is said to have been taken by the Turks in 1453, and dragged through the mire; but others deny this as utterly derogatory to the majesty of the Queen of Heaven, who never would have suffered such an indignity to have been put on her sacred image. According to the Venetian legend, it was this identical effigy which was taken by the blind old Dandolo, when he besieged and took Constantinople in 1204, and brought in triumph to Venice, where it has ever since been preserved in the church of St. Mark, and held in *somma venerazione*. No mention is made of St. Luke in the earliest account of this picture, though, like all the antique effigies of uncertain origin, it was in after times attributed to him.

The history of the next three hundred years testifies to the triumph of orthodoxy, the extension and popularity of the worship of the Virgin, and the consequent multiplication of her image, in every form and material, through the whole of Christendom.

Then followed the schism of the Iconoclasts, which distracted the Church for more than one hundred years, under Leo III., the Isaurian, and his immediate successors. Such were the extravagances of superstition to which the image-worship had led the excitable Orientals, that, if Leo had been a wise and temperate reformer, he might have done much good in checking its excesses; but he was himself an ignorant, merciless barbarian. The persecution by which he sought to exterminate the sacred pictures of the Madonna, and the cruelties exercised on her unhappy votaries, produced a general destruction of the most curious and precious remains of antique art. In other respects, the immediate result was naturally enough a reaction which not only reinstated pictures in the veneration of the people, but greatly increased their influence over the imagination; for it is at this time that we first hear of a miraculous picture. Among those who most strongly defended the use of sacred images in the churches, was St. John Damascene, one of the great lights of the Oriental Church. According to the Greek legend, he was condemned to lose his right hand, which was accordingly cut off; but he, full of faith, prostrating himself before a picture of the Virgin, stretched out the bleeding stump, and with it touched her lips, and immediately a new hand sprang forth 'like a branch from a tree.' Hence, among the Greek effigies of the Virgin, there is one, peculiarly commemorative of this miracle, styled 'the Virgin with three hands.'[1] In the west of Europe, where the abuses of the image-worship had never yet reached the wild superstition of the Oriental Christians, the fury of the Iconoclasts excited horror and consternation. The temperate and eloquent apology for sacred pictures,

[1] Didron, Manuel, p. 462.

addressed by Gregory II. to the Emperor Leo, had the effect of mitigating the persecution in Italy, where the work of destruction could not be carried out to the same extent as in the Byzantine provinces. Hence it is in Italy only that any important remains of sacred art anterior to the Iconoclast dynasty have been preserved.[1]

The second Council of Nice, under the Empress Irene in 787, condemned the Iconoclasts, and restored the use of the sacred pictures in the churches. Nevertheless, the controversy still raged till after the death of Theophilus, the last and the most cruel of the Iconoclasts, in 842. His widow Theodora achieved the final triumph of the orthodox party, and restored the Virgin to her throne. We must observe, however, that only pictures were allowed; all sculptured imagery was still prohibited, and has never since been allowed in the Greek Church, except in very low relief. The flatter the surface, the more orthodox.

It is, I think, about 886, that we first find the effigy of the Virgin on the coins of the Greek empire. On a gold coin of Leo VI., the Philosopher, she stands veiled, and draped, with a noble head, no glory, and the arms outspread, just as she appears in the old mosaics. On a coin of Romanus the Younger she crowns the emperor, having herself the nimbus; she is draped and veiled. On a coin of Nicephorus Phocus (who had great pretensions to piety), the Virgin stands, presenting a cross to the emperor, with the inscription 'Theotokos, be propitious.' On a gold coin of John Zimisces, 975, we first find the Virgin and Child,—the symbol merely: she holds against her bosom a circular glory, within which is the head of the Infant Christ. In the successive reigns of the next two centuries, she almost constantly appears as crowning the emperor.

Returning to the West, we find that in the succeeding period, from Charlemagne to the first crusade, the popular devotion to the Virgin, and the multiplication of sacred pictures, continued steadily to increase; yet in the tenth and eleventh centuries art was at its lowest ebb. At this time, the subjects relative to the Virgin were principally the Madonna and Child, represented according to the Greek form; and those scenes from the Gospel in which she is introduced, as the Annunciation, the Nativity, and the Worship of the Magi.

[1] It appears, from one of these letters from Gregory II., that it was the custom at that time (725) to employ religious pictures as a means of instruction in the schools. He says, that if Leo were to enter a school in Italy, and to say that he prohibited pictures, the children would infallibly throw their horn-books (*tavolezze del alfabeto*) at his head.— *v.* Bosio, p. 567.

Towards the end of the tenth century the custom of adding the angelic salutation, the '*Ave Maria*,' to the Lord's prayer, was first introduced ; and by the end of the following century, it had been adopted in the offices of the Church. This was, at first, intended as a perpetual reminder of the mystery of the Incarnation, as announced by the angel. It must have had the effect of keeping the idea of Mary as united with that of her Son, and as the instrument of the Incarnation, continually in the minds of the people.

The pilgrimages to the Holy Land, and the crusades in the eleventh and the twelfth centuries, had a most striking effect on religious art, though this effect was not fully evolved till a century later. More particularly did this returning wave of Oriental influences modify the representations of the Virgin. Fragments of the apocryphal gospels and legends of Palestine and Egypt were now introduced, worked up into ballads, stories, and dramas, and gradually incorporated with the teaching of the Church. A great variety of subjects derived from the Greek artists, and from particular localities and traditions of the East, became naturalised in Western Europe. Among these were the legends of Joachim and Anna ; and the death, the assumption, and the coronation of the Virgin.

Then came the thirteenth century, an era notable in the history of mind, more especially notable in the history of art. The seed scattered hither and thither, during the stormy and warlike period of the crusades, now sprung up and flourished, bearing diverse fruit. A more contemplative enthusiasm, a superstition tinged with a morbid melancholy, fermented into life and form. In that general 'fit of *compunction*,' which we are told seized all Italy at this time, the passionate devotion for the benign Madonna mingled the poetry of pity with that of pain ; and assuredly this state of feeling, with its mental and moral requirements, must have assisted in emancipating art from the rigid formalism of the degenerate Greek school. Men's hearts, throbbing with a more feeling, more pensive life, demanded something more *like* life—and produced it. It is curious to trace in the Madonnas of contemporary, but far distant and unconnected schools of painting, the simultaneous dawning of a sympathetic sentiment—for the first time something in the faces of the divine beings responsive to the feeling of the worshippers. It was this, perhaps, which caused the enthusiasm excited by Cimabue's great Madonna, and made the people shout and dance for joy when it was uncovered before them. Compared with the spectral rigidity, the hard monotony, of the conventional Byzantines, the more animated eyes, the little touch of sweetness in the still, mild face, must have been like a smile out of heaven. As we trace the same softer influence in the earliest Siena and Cologne pictures of

d

about the same period, we may fairly regard it as an impress of the spirit of
the time, rather than that of an individual mind.

In the succeeding century these elements of poetic art, expanded and
animated by an awakened observation of nature, and a sympathy with her
external manifestations, were most especially directed by the increasing
influence of the worship of the Virgin, a worship at once religious and
chivalrous. The title of 'Our Lady'[1] came first into general use in the
days of chivalry, for she was the lady 'of all hearts,' whose colours all were
proud to wear. Never had her votaries so abounded. Hundreds upon
hundreds had enrolled themselves in brotherhoods, vowed to her especial
service;[2] or devoted to acts of charity, to be performed in her name.[3]
Already the great religious communities, which at this time comprehended all
the enthusiasm, learning, and influence of the Church, had placed themselves
solemnly and especially under her protection. The Cistercians wore white in
honour of her purity; the Servi wore black in respect to her sorrows; the
Franciscans had enrolled themselves as champions of the Immaculate Con-
ception; and the Dominicans introduced the rosary. All these richly endowed
communities vied with each other in multiplying churches, chapels, and
pictures, in honour of their patroness, and expressive of her several attributes.
The devout painter, kneeling before his easel, addressed himself to the
task of portraying those heavenly lineaments which had visited him perhaps
in dreams. Many of the professed monks and friars became themselves
accomplished artists.[4]

At this time Jacopo di Voragine compiled the 'Golden Legend,' a
collection of sacred stories, some already current, some new, or in a new
form. This famous book added many themes to those already admitted, and
became the authority and storehouse for the early painters in their groups
and dramatic compositions. The increasing enthusiasm for the Virgin
naturally caused an increasing demand for the subjects taken from her
personal history, and led, consequently, to a more exact study of those natural

[1] *Fr.* Notre Dame. *Ital.* La Madonna. *Ger.* Unser liebe Frau.

[2] As the Serviti, who were called in France, *les esclaves de Marie.*

[3] As the order of 'Our Lady of Mercy,' for the deliverance of captives.—*Vide* Legends of
the Monastic Orders, p. 213.

[4] A very curious and startling example of the theological character of the Virgin in the
thirteenth century is figured in Miss Twining's work, The Symbols of Early Christian Art;
certainly the most complete and useful book of the kind which I know of. Here the Madonna
and Child are seated side by side with the Trinity; the Holy Spirit resting on her crowned
head. —*Vide* pl. xxxiv.

objects and effects which were required as accessories, to greater skill in grouping the figures, and to a higher development of historic art.

But of all the influences on Italian art in that wonderful fourteenth century, Dante was the greatest. He was the intimate friend of Giotto. Through the communion of mind, not less than through his writings, he infused into religious art that mingled theology, poetry, and mysticism, which ruled in the Giottesque school during the following century, and went hand in hand with the development of the power and practice of imitation. Now, the theology of Dante was the theology of his age. His ideas respecting the Virgin Mary were precisely those to which the writings of St. Bernard, St. Bonaventura, and St. Thomas Aquinas had already lent all the persuasive power of eloquence, and the Church all the weight of her authority. Dante rendered these doctrines into poetry, and Giotto and his followers rendered them into form. In the Paradiso of Dante, the glorification of Mary, as the ' Mystic Rose ' (*Rosa mystica*) and Queen of Heaven—with the attendant angels, circle within circle, floating round her in adoration, and singing the Regina Cœli, and saints and patriarchs stretching forth their hands towards her— is all a splendid, but still indefinite vision of dazzling light crossed by shadowy forms. The painters of the fourteenth century, in translating these glories into a definite shape, had to deal with imperfect knowledge and imperfect means; they failed in the power to realise either their own or the poet's conception; and yet—thanks to the divine poet!—that early conception of some of the most beautiful of the Madonna subjects—for instance, the *Coronation* and the *Sposalizio*—has never, as a religious and poetical conception, been surpassed by later artists, in spite of all the appliances of colour, and mastery of light and shade, and marvellous efficiency of hand since attained.

Every reader of Dante will remember the sublime hymn towards the close of the Paradiso :—

Vergine Madre, figlia del tuo figlio !
Umile ed alta più che creatura,
Termine fisso d' eterno consiglio ;
 Tu se' colei che l' umana natura
Nobilitasti sì, che 'l suo fattore
Non disdegnò di farsi sua fattura ;
 Nel ventre tuo si raccese l' amore
Per lo cui caldo nell' eterna pace
Così è germinato questo fiore ;
 Qui se' a noi meridiana face
Di caritate, e giuso intra mortali
Se' di speranza fontana vivace :

> Donna se' tanto grande e tanto vali,
> Che qual vuol grazia e a te non ricorre
> Sua disianza vuol volar senz' ali;
> La tua benignità non pur soccorre
> A chi dimanda, ma molte fiate
> Liberamente al dimandar precorre;
> In te misericordia, in te pietate,
> In te magnificenza, in te s' aduna
> Quantunque in creatura è di bontate!

To render the splendour, the terseness, the harmony, of this magnificent hymn seems impossible. Cary's translation has, however, the merit of fidelity to the sense:—

> O Virgin-Mother, daughter of thy Son!
> Created beings all in lowliness
> Surpassing, as in height above them all;
> Term by the eternal counsel preordained;
> Ennobler of thy nature, so advanc'd
> In thee, that its great Maker did not scorn
> To make himself his own creation;
> For in thy womb, rekindling, shone the love
> Reveal'd, whose genial influence makes now
> This flower to germin in eternal peace:
> Here thou, to us, of charity and love
> Art as the noon-day torch; and art beneath,
> To mortal men, of hope a living spring.
> So mighty art thou, Lady, and so great,
> That he who grace desireth, and comes not
> To thee for aidance, fain would have desire
> Fly without wings. Not only him who asks,
> Thy bounty succours; but doth freely oft
> Forerun the asking. Whatsoe'er may be
> Of excellence in creature, pity mild,
> Relenting mercy, large munificence,
> Are all combin'd in thee!'

It is interesting to turn to the corresponding stanzas in Chaucer. The invocation to the Virgin with which he commences the story of St. Cecilia is rendered almost word for word from Dante:—

> Thou Maid and Mother, daughter of thy Son!
> Thou wel of mercy, sinful soules cure!

The last stanza of the invocation is his own, and as characteristic of the practical Chaucer, as it would have been contrary to the genius of Dante:—

And for that faith is dead withouten workis,
So for to worken give me wit and grace!
That I be quit from thence that most dark is;
O thou that art so fair and full of grace,
Be thou mine advocate in that high place,
There, as withouten end is sung Hozanne,
Thou Christes mother, daughter dear of Anne!

Still more beautiful and more his own is the invocation in the 'Prioress's Tale.' I give the stanzas as modernised by Wordsworth:—

O Mother Maid! O Maid and Mother free!
O bush unburnt, burning in Moses' sight!
That down didst ravish from the Deity,
Through humbleness, the Spirit that did alight
Upon thy heart, whence, through that glory's might,
Conceived was the Father's sapience,
Help me to tell it in thy reverence!

Lady, thy goodness, thy magnificence,
Thy virtue, and thy great humility,
Surpass all science and all utterance;
For sometimes, Lady! ere men pray to thee,
Thou go'st before in thy benignity,
The light to us vouchsafing of thy prayer,
To be our guide unto thy Son so dear.

My knowledge is so weak, O blissful Queen,
To tell abroad thy mighty worthiness,
That I the weight of it may not sustain;
But as a child of twelve months old, or less,
That laboureth his language to express,
Even so fare I; and therefore, I thee pray,
Guide thou my song, which I of thee shall say.

And again, we may turn to Petrarch's hymn to the Virgin, wherein he prays to be delivered from his love and everlasting regrets for Laura:—

Vergine bella, che di sol vestita,
Coronata di stelle, al sommo Sole
Piacesti sì, che 'n te sua luce ascose.

———

Vergine pura, d' ogni parte intera,
Del tuo parto gentil figliuola e madre!

———

Vergine sola al mondo senza esempio,
Che 'l ciel di tue bellezze innamorasti.

The fancy of the theologians of the middle ages played rather dangerously, as it appears to me, for the uninitiated and uninstructed, with the perplexity of these divine relationships. It is impossible not to feel that in their admiration for the divine beauty of Mary, in borrowing the amatory language and luxuriant allegories of the Canticles, which represent her as an object of delight to the supreme Being, theologians, poets, and artists had wrought themselves up to a wild pitch of enthusiasm. In such passages as those I have quoted above, and in the grand old Church hymns, we find the best commentary and interpretation of the sacred pictures of the fourteenth and fifteenth centuries. Yet during the thirteenth century there was a purity in the spirit of the worship which at once inspired and regulated the forms in which it was manifested. The Annunciations and Nativities were still distinguished by a chaste and sacred simplicity. The features of the Madonna herself, even where they were not what we call beautiful, had yet a touch of that divine and contemplative grace which the theologians and the poets had associated with the queenly, maternal, and bridal character of Mary.

Thus the impulses given in the early part of the fourteenth century continued in progressive development through the fifteenth; the spiritual for some time in advance of the material influences; the moral idea emanating as it were *from* the soul, and the influences of external nature flowing *into* it; the comprehensive power of fancy using more and more the apprehensive power of imitation, and both working together till their 'blended might' achieved its full fruition in the works of Raphael.

Early in the fifteenth century, the Council of Constance (A.D. 1414), and the condemnation of Huss, gave a new impulse to the worship of the Virgin. The Hussite wars, and the sacrilegious indignity with which her sacred images had been treated in the north, filled her orthodox votaries of the south of Europe with a consternation and horror like that excited by the Iconoclasts of the eighth century, and were followed by a similar reaction. The Church was called upon to assert more strongly than ever its orthodox veneration for her, and, as a natural consequence, votive pictures multiplied; the works of the excelling artists of the fifteenth century testify to the zeal of the votaries, and the kindred spirit in which the painters worked.

Gerson, a celebrated French priest, and chancellor of the university of Paris, distinguished himself in the Council of Constance by the eloquence with which he pleaded for the Immaculate Conception, and the enthusiasm with which he preached in favour of instituting a festival in honour of this mystery, as well as another in honour of Joseph, the husband of the Virgin.

In both he was unsuccessful during his lifetime; but for both eventually his writings prepared the way. He also composed a Latin poem of three thousand lines in praise of Joseph, which was among the first works published after the invention of printing. Together with St. Joseph, the parents of the Virgin, St. Anna more particularly, became objects of popular veneration, and all were at length exalted to the rank of patron saints, by having festivals instituted in their honour. It is towards the end of the fifteenth century, or rather a little later, that we first meet with that charming domestic group, called the 'Holy Family,' afterwards so popular, so widely diffused, and treated with such an infinite variety.

Towards the end of this century sprung up a new influence—the revival of classical learning, a passionate enthusiasm for the poetry and mythology of the Greeks, and a taste for the remains of antique art. This influence on the representations of the Virgin, as far as it was merely external, was good. An added dignity and grace, a more free and correct drawing, a truer feeling for harmony of proportion and all that constitutes elegance, were gradually infused into the forms and attitudes. But dangerous became the craving for mere beauty—dangerous the study of the classical and heathen literature. This was the commencement of that thoroughly pagan taste which in the following century demoralised Christian art. There was now an attempt at varying the arrangement of the sacred groups which led to irreverence, or at best to a sort of superficial mannered grandeur; and from this period we date the first introduction of the portrait Virgins. An early, and most scandalous example remains to us in one of the frescoes in the Vatican, which represents Giulia Farnese in the character of the Madonna, and Pope Alexander VI. (the infamous Borgia) kneeling at her feet in the character of a votary. Under the influence of the Medici the churches of Florence were filled with pictures of the Virgin, in which the only thing aimed at was an alluring and even meretricious beauty. Savonarola thundered from his pulpit in the garden of San Marco against these impieties. He exclaimed against the profaneness of those who represented the meek mother of Christ in gorgeous apparel, with head unveiled, and under the features of women too well and publicly known. He emphatically declared that if the painters knew as well as he did the influence of such pictures in perverting simple minds, they would hold their own works in horror and detestation. Savonarola yielded to none in orthodox reverence for the Madonna; but he desired that she should be represented in an orthodox manner. He perished at the stake, but not till after he had made a bonfire in the Piazza at Florence of the offensive

effigies; he perished—persecuted to death by the Borgia family. But his
influence on the greatest Florentine artists of his time is apparent in the
Virgins of Botticelli, Lorenzo di Credi, and Fra Bartolomeo, all of whom had
been his friends, admirers, and disciples : and all, differing from each other,
were alike in this, that, whether it be the dignified severity of Botticelli, or
the chaste simplicity of Lorenzo di Credi, or the noble tenderness of Fra
Bartolomeo, we feel that each of them had aimed to portray worthily the
sacred character of the Mother of the Redeemer. And to these, as I think,
we might add Raphael himself, who visited Florence but a short time after
the horrible execution of Savonarola, and must have learned through his
friend Bartolomeo to mourn the fate and revere the memory of that
remarkable man, whom he placed afterwards in the grand fresco of the
'Theologia,' among the doctors and teachers of the Church.[1] Of the
numerous Virgins painted by Raphael in after times, not one is supposed to
have been a portrait : he says himself, in a letter to Count Castiglione, that
he painted from an idea in his own mind, ' mi servo d' una certa idea che mi
viene in mente ; ' while in the contemporary works of Andrea del Sarto, we
have the features of his handsome but vulgar wife in every Madonna he
painted.[2]

In the beginning of the sixteenth century, the constellation of living genius
in every department of art, the riches of the Church, the luxurious habits and
classical studies of the churchmen, the decline of religious conviction, and the
ascendency of religious controversy, had combined to multiply church pic-
tures, particularly those of a large and decorative character. But, instead
of the reign of faith, we had now the reign of taste. There was an absolute
passion for picturesque grouping ; and, as the assembled figures were to be
as varied as possible in action and attitude, the artistic treatment, in order to
prevent the lines of form and the colours of the draperies from interfering
with each other, required great skill and profound study : some of these scenic
groups have become, in the hands of great painters, such as Titian, Paul
Veronese, and Annibal Caracci, so magnificent, that we are inclined to forgive
their splendid errors. The influence of Sanazzaro, and of his famous Latin
poem on the Nativity (' De Partu Virginis '), on the artists of the middle of
the sixteenth century, and on the choice and treatment of the subjects per-

[1] Rome, Vatican.
[2] The tendency to portraiture, in early Florentine and German art, is observable from an
early period. The historical sacred subjects of Masaccio, Ghirlandajo, and Van Eyck, are
crowded with portraits of living personages. Their introduction into devotional subjects, in
the character of sacred persons, is far less excusable.

taining to the Madonna, can hardly be calculated; it was like that of Dante in the fourteenth century, but in its nature and result how different! The grand materialism of Michael Angelo is supposed to have been allied to the genius of Dante; but would Dante have acknowledged the group of the Holy Family in the Florentine Gallery, to my feeling, one of the most profane and offensive of the so-called *religious* pictures, in conception and execution, which ever proceeded from the mind or hand of a great painter? No doubt some of the sculptural Virgins of Michael Angelo are magnificent and stately in attitude and expression, but too austere and mannered as religious conceptions: nor can we wonder if the predilection for the treatment of mere form led his followers and imitators into every species of exaggeration and affectation. In the middle of the sixteenth century, the same artist who painted a Leda, or a Psyche, or a Venus one day, painted for the same patron a Virgin of Mercy, or a 'Mater Purissima' on the morrow. *Here*, the votary told his beads, and recited his Aves, before the blessed Mother of the Redeemer; *there*, she was invoked in the purest Latin by titles which the classical mythology had far otherwise consecrated. I know nothing more disgusting in art than the long-limbed, studied, inflated Madonnas, looking grand with all their might, of this period; luckily they have fallen into such disrepute that we seldom see them. The 'Madonna dell' lungo Collo' of Parmigiano might be cited as a favourable example of this mistaken and wholly artificial grace.[1]

But in the midst of these paganised and degenerate influences, the reform in the discipline of the Roman Catholic Church was preparing a revolution in religious art. The Council of Trent had severely denounced the impropriety of certain pictures admitted into churches: at the same time, in the conflict of creeds which now divided Christendom, the agencies of art could not safely be neglected by that Church which had used them with such signal success. Spiritual art was indeed no more. It was dead: it could never be revived without a return to those modes of thought and belief which had at first inspired it. Instead of religious art, appeared what I must call *theological* art. Among the events of this age, which had great influence on the worship and the representations of the Madonna, I must place the battle of Lepanto, in 1571, in which the combined fleets of Christendom, led by Don Juan of Austria, achieved a memorable victory over the Turks. This victory was attributed by Pope Pius V. to the especial interposition of the Blessed Virgin. A new invocation was now added to her Litany, under the title of

[1] Florence, Pitti Pal.

e

Auxilium Christianorum; a new festival, that of the Rosary, was now added to those already held in her honour; and all the artistic genius which existed in Italy, and all the piety of orthodox Christendom, were now laid under contribution to encase in marble sculpture, to enrich with countless offerings, that miraculous house, which the angels had borne over land and sea, and set down at Loretto; and that miraculous, bejewelled, and brocaded Madonna, enshrined within it.

In the beginning of the seventeenth century, the Caracci school gave a new impetus to religious, or rather, as it had been styled in contradistinction, sacerdotal or theological art. If these great painters had been remarkable merely for the application of new artistic methods, for the success with which they combined the aims of various schools—

> Di Michel Angiol la terribil via
> E'l vero natural di Tiziano,

the study of the antique with the observation of real life—their works undoubtedly would never have taken such a hold on the minds of their contemporaries, nor kept it so long. Everything to live must have an infusion of truth within it, and this ' patch-work ideal,' as it has been well styled, was held together by such a principle. The founders of the Caracci school, and their immediate followers, felt the influences of the time, and worked them out. They were devout believers in their Church, and most sincere worshippers of the Madonna. Guido, in particular, was so distinguished by his passionate enthusiasm for her, that he was supposed to have been favoured by a particular vision, which enabled him more worthily to represent her divine beauty.

It is curious that, hand in hand with this development of taste and feeling in the appreciation of natural sentiment and beauty, and this tendency to realism, we

find the associations of a peculiar and specific sanctity remaining with the old Byzantine type. This arose from the fact, always to be borne in mind, that the most ancient artistic figure of the Madonna was a purely theological

symbol : apparently the moral type was too nearly allied to the human and the real to satisfy faith. It is the ugly, dark-coloured, ancient Greek Madonnas, such as this, which had all along the credit of being miraculous; and 'to this day,' says Kugler, 'the Neapolitan lemonade-seller will allow no other than a formal Greek Madonna, with olive-green complexion and veiled head, to be set up in his booth. It is the same in Russia. Such pictures, in which there is no attempt at representation, real or ideal, and which merely have a sort of imaginary sanctity and power, are not so much idols as they are mere *Fetishes*. The most lovely Madonna by Raphael or Titian would not have the same effect. Guido, who himself painted lovely Virgins, went every Saturday to pray before the little black *Madonna della Guardia*, and, as we are assured, held this old Eastern relic in devout veneration.

In the pictures of the Madonna, produced by the most eminent painters of the seventeenth century, is embodied the theology of the time. The Virgin Mary is not, like the Madonna di San Sisto, 'a single projection of the artist's mind,' but, as far as he could put his studies together, she is 'a compound of every creature's best,' sometimes majestic, sometimes graceful, often full of sentiment, elegance, and refinement, but wanting wholly in the spiritual element. If the Madonna did really sit to Guido in person,[1] we fancy she must have revealed her loveliness, but veiled her divinity.

Without doubt the finest Madonnas of the seventeenth century are those produced by the Spanish school ; not because they more realise our spiritual conception of the Virgin—quite the contrary : for here the expression of life through sensation and emotion prevails over abstract mind, grandeur, and grace—but because the intensely human and sympathetic character given to the Madonna appeals most strongly to our human nature. The appeal is to the faith through the feelings, rather than through the imagination. Morales and Ribera excelled in the Mater Dolorosa ; and who has surpassed Murillo in the tender exultation of maternity?[2] There is a freshness and a depth of feeling in the best Madonnas of the late Spanish school, which puts to shame the mannerism of the Italians, and the naturalism of the Flemish painters of the same period ; and this because the Spaniards were intense and enthusiastic believers, not mere thinkers, in art as in religion.

As in the sixth century, the favourite dogma of the time (the union of the

[1] See Malvasia, 'Felsina Pittrice.'

[2] See in the Handbook to the Private Galleries of Art some remarks on the tendencies of the Spanish School, p. 172.

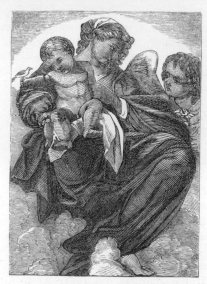

153 An effect of Light and Shade.

divine and human nature in Christ, and the dignity of Mary as parent of both) had been embodied in the group of the Virgin and Child, so now, in the seventeenth, the doctrine of the eternal sanctification and predestination of Mary was, after a long controversy, triumphant, and took form in the 'Immaculate Conception;' that beautiful subject in which Guido and Murillo excelled, and which became the darling theme of the later schools of art. It is worthy of remark, that while in the sixth century, and for a thousand years afterwards, the Virgin, in all devotional subjects, was associated in some visible manner with her divine Son, in this she appears without the Infant in her arms. The maternal character is set aside, and she stands alone, absolute in herself, and complete in her own perfections. This is a very significant characteristic of the prevalent theology of the time.

I forbear to say much of the productions of a school of art which sprung up simultaneously with that of the Caracci, and in the end overpowered its higher aspirations. The *Naturalisti*, as they were called, imitated nature without selection, and produced some charming painters. But their religious pictures are almost all intolerable, and their Madonnas are almost all portraits. Rubens and Albano painted their wives; Allori and Vandyck their mistresses; Domenichino his daughter. Salvator Rosa, in his Satires, exclaims

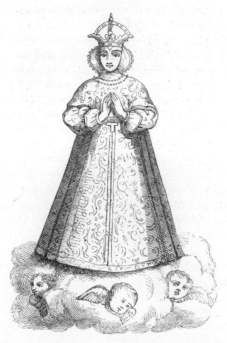

154

against this general profaneness in terms not less strong than those of Sa-
vonarola in his Sermons; but the corruption was by this time beyond the
reach of cure; the sin could neither be preached nor chided away. Striking
effects of light and shade, peculiar attitudes, scenic groups, the perpetual and
dramatic introduction of legendary scenes and personages, of visions and miracles
of the Madonna vouchsafed to her votaries, characterise the productions of
the seventeenth century. As 'they who are whole need not a physician, but
they who are sick,' so in proportion to the decline of faith were the excite-
ments to faith, or rather to credulity : just in proportion as men were less in-
clined to believe were the wonders multiplied which they were called on to
believe.

I have not spoken of the influence of Jesuitism on art. This Order kept
alive that devotion for the Madonna which their great founder Loyola had so
ardently professed when he chose for the 'Lady' of his thoughts, 'no princess,
no duchess, but one far greater, more peerless.' The learning of the Jesuits

supplied some themes not hitherto in use, principally of a fanciful and allegorical kind, and never had the meek Mary been so decked out with earthly ornament as in their church pictures. If the sanctification of simplicity, gentleness, maternal love, and heroic fortitude, were calculated to elevate the popular mind, the sanctification of mere glitter and ornament, embroidered robes, and jewelled crowns, must have tended to degrade it. It is surely an unworthy and a foolish excuse that, in thus desecrating with the vainest and most vulgar finery the beautiful ideal of the Virgin, an appeal was made to the awe and admiration of vulgar and ignorant minds; for this is precisely what, in all religious imagery, should be avoided. As, however, this sacrilegious millinery does not come within the province of the fine arts, I may pass it over here.

Among the Jesuit prints of the seventeenth century, I remember one which represents the Virgin and Child in the centre, and around are the most famous heretics of all ages, lying prostrate, or hanging by the neck. Julian the Apostate; Leo the Isaurian; his son, Constantine Capronymus; Arius; Nestorius; Manicheus; Luther; Calvin—very characteristic of the age of controversy which had succeeded to the age of faith, when, instead of solemn saints and grateful votaries, we have dead or dying heretics surrounding the Mother of Mercy!

After this rapid sketch of the influences which modified in a general way the pictures of the Madonna, we may array before us and learn to compare, the types which distinguished in a more particular manner the separate schools, caught from some more local or individual impulses. Thus we have the stern, awful quietude of the old Mosaics; the hard lifelessness of the degenerate Greek; the pensive sentiment of the Siena, and stately elegance of the Florentine Madonnas; the intellectual Milanese, with their large foreheads and thoughtful eyes; the tender, refined mysticism of the Umbrian; the sumptuous loveliness of the Venetian; the quaint, characteristic simplicity of the early German, so stamped with their nationality, that I never looked round me in a roomful of German girls without thinking of Albert Dürer's Virgins; the intense life-like feeling of the Spanish; the prosaic, portrait-like nature of the Flemish schools; and so on. But here an obvious question suggests itself. In the midst of all this diversity, these ever-changing influences, was there no characteristic type universally accepted, suggested by common religious associations, if not defined by ecclesiastical authority, to which the artist was bound to conform?

How is it that the impersonation of the Virgin fluctuated, not only with the fluctuating tendencies of successive ages, but even with the caprices of the individual artist?

This leads us back to reconsider the sources from which the artist drew his inspiration.

The legend which represents St. Luke the Evangelist as a painter appears to be of Eastern origin, and quite unknown in Western Europe before the first crusade. It crept in then, and was accepted with many other oriental superstitions and traditions. It may have originated in the real existence of a Greek painter named Luca—a saint, too, he may have been; for the Greeks have a whole calendar of canonised artists—painters, poets, and musicians; and this Greek San Luca may have been a painter of those Madonnas imported from the *ateliers* of Mount Athos into the West by merchants and pilgrims; and the West, which knew but of one St. Luke, may have easily confounded the painter and the evangelist.

But we must also remember, that St. Luke the Evangelist was early regarded as the great authority with respect to the few Scripture particulars relating to the character and life of Mary; so that, in the figurative sense, he may be said to have *painted* that portrait of her which has been since received as the perfect type of womanhood:—1. Her noble, trustful humility, when she receives the salutation of the angel;[1] the complete and feminine surrender of her whole being to the higher holier will—' Be it unto me according to thy word.' 2. Then, the decision and prudence of character shown in her visit to Elizabeth, her elder relative; her journey in haste over the hills to consult with her cousin, which journey it is otherwise difficult to accord with the oriental customs of the time, unless Mary, young as she was, had possessed unusual promptitude and energy of disposition.[2] 3. The proof of her intellectual power in the beautiful hymn she has left us, ' *My soul doth magnify the Lord.*'[3] The commentators are not agreed as to whether this effusion was poured forth by immediate inspiration, or composed and written down, because the same words, ' and Mary said,' may be interpreted in either sense; but we can no more doubt her being the authoress, than we can doubt of any other particulars recorded in the same Gospel: it proves that she must have been, for her time and country, most rarely gifted in mind, and deeply read in the Scriptures. 4. She was of a contemplative, reflecting, rather silent disposition. ' She kept all these sayings, and pondered them in her heart.'[4] She made no boast of that wondrous and most blessed destiny to which she was called; she thought upon it in silence.

[1] Luke i. 38. [2] Luke i. 39, 40. [3] Luke i. 46. [4] Luke ii. 51.

It is inferred that as many of these sayings and events could be known to herself alone, St. Luke the Evangelist could have learned them only from her own lips. 5. Next, her truly maternal devotion to her divine Son, whom she attended humbly through his whole ministry; [1] 6, and lastly, the sublime fortitude and faith with which she followed her Son to the death scene, stood beside the cross till all was finished, and then went home, and *lived*; [2] for she was to be to us an example of all that a woman could endure, as well as all that a woman could be and act out in her earthly life.[3] Such was the character of Mary; such the *portrait* really *painted* by St. Luke, and, as it seems to me, these scattered, artless, unintentional notices of conduct and character converge into the most perfect moral type of the intellectual, tender, simple, and heroic woman that ever was placed before us for our edification and example.

But in the Church traditions and enactments, another character was, from the fifth century, assigned to her, out of which grew the theological type, very beautiful and exalted, but absorbing to a great degree the scriptural and moral type, and substituting for the merely human attributes others borrowed from her relation to the great scheme of redemption; for it was contended that, as the mother of *the Divine*, she could not be herself less than divine; consequently above the angels, and first of all created beings. According to the doctrine of the Immaculate Conception, her tender woman's wisdom became supernatural gifts; the beautiful humility was changed into a knowledge of her own pre-destined glory; and, being raised bodily into immortality, and placed beside her Son, in all 'the sacred splendour of beneficence,' she came to be regarded as our intercessor before that divine Son, who could refuse nothing to his mother. The relative position of the Mother and Son being spiritual and indestructible was continued in heaven; and thus step by step the woman was transmuted into the divinity.

But like her Son, Mary had walked in human form upon earth, and in

[1] Milton places in the mouth of our Saviour, an allusion to the influence of his Mother in early life:—

> These growing thoughts my mother soon perceiving
> By words at times cast forth, inly rejoiced,
> And said to me apart, ' High are thy thoughts,
> O Son; but nourish them, and let them soar
> To what height sacred virtue and true worth
> Can raise them, though above example high.'

[2] Luke xxiii. [3] John xix. 25.

form must have resembled her Son ; for, as it is argued, Christ had no earthly father, therefore could only have derived his human lineaments from his mother. All the old legends assume that the resemblance between the Son and the Mother must have been perfect. Dante alludes to this belief:

> Riguarda ormai nella faccia ch' a Christo
> Più s' assomiglia.

> Now raise thy view
> Unto the visage most resembling Christ.

The accepted type of the head of Christ was to be taken as a model in its mild, intellectual majesty, for that of the Virgin-mother, as far as difference of sex would allow.

In the ecclesiastical history of Nicephorus Callixtus, he has inserted a description of the person of Mary, which he declares to have been given by Epiphanius, who lived in the fourth century, and by him derived from a more ancient source. It must be confessed, that the type of person here assigned to the Virgin is more energetic for a woman than that which has been assigned to our Saviour as a man. ' She was of middle stature ; her face oval ; her eyes brilliant, and of an olive tint ; her eyebrows arched and black ; her hair was of a pale brown ; her complexion fair as wheat. She spoke little, but she spoke freely and affably ; she was not troubled in her speech, but grave, courteous, tranquil. Her dress was without ornament, and in her deportment was nothing lax or feeble.' To this ancient description of her person and manners, we are to add the scriptural and popular portrait of her mind ; the gentleness, the purity, the intellect, power, and fortitude ; the gifts of the poetess and prophetess ; the humility in which she exceeded all womankind. Lastly, we are to engraft on these personal and moral qualities, the theological attributes which the Church, from early times, had assigned to her, the supernatural endowments which lifted her above angels and men :—all these were to be combined into one glorious type of perfection. Where shall we seek this highest, holiest impersonation ! Where has it been attained, or even approached ? Not, certainly, in the mere woman, nor yet in the mere idol ; not in those lovely creations which awaken a sympathetic throb of tenderness ; nor in those stern, motionless types, which embody a dogma ; not in the classic features of marble goddesses, borrowed as models ; nor in the painted images which stare upon us from tawdry altars in flaxen wigs and embroidered petticoats. But where ?

Of course we each form to ourselves some notion of what we require ; and these requirements will be as diverse as our natures and our habits of thought.

f

For myself, I have seen my own ideal once, and only once, attained: *there* where Raphael—inspired if ever a painter was inspired—projected on the space before him that wonderful creation which we styled the *Madonna di San Sisto* ;[1] for there she stands—the transfigured woman, at once completely human and completely divine, an abstraction of power, purity, and love, poised on the empurpled air, and requiring no other support; looking out, with her melancholy, loving mouth, her slightly dilated, sibylline eyes, quite through the universe, to the end and consummation of all things;—sad, as if she beheld afar off the visionary sword that was to reach her heart through HIM, now resting as enthroned on that heart; yet already exalted through the homage of the redeemed generations who were to salute her as Blessed. Six times have I visited the city made glorious by the possession of this treasure, and as often, when again at a distance, with recollections disturbed by feeble copies and prints, I have begun to think, 'Is it so indeed? is she indeed so divine? or does not rather the imagination encircle her with a halo of religion and poetry, and lend a grace which is not really there?' and as often, when returned, I have stood before it and confessed that there is more in that form and face than I had ever yet conceived. I cannot here talk the language of critics, and speak of this picture merely as a picture, for to me it was a revelation. In the same gallery is the lovely Madonna of the Meyer family; inexpressibly touching and perfect ·in its way, but conveying only one of the attributes of Mary, her benign pity; while the Madonna di San Sisto is an abstract of *all*.[2]

The poets are ever the best commentators on the painters. I have already given from the great 'singers of high poems' in the fourteenth century *their* exposition of the theological type of the Madonna. Now, in some striking passages of our modern poets, we may find a most beautiful commentary on what I have termed the *moral* type.

The first is from Wordsworth, and may be recited before the Madonna di San Sisto :—

> Mother! whose virgin bosom was uncrost
> With the least shade of thought to sin allied!
> Woman! above all women glorified;
> Our tainted nature's solitary boast;

[1] Dresden Gal.

[2] Expression is the great and characteristic excellence of Raphael, more especially in his Madonnas. It is precisely this which all copies and engravings render at best most imperfectly: and in point of expression the most successful engraving of the Madonna di San Sisto is certainly that of Steinla.

> Purer than foam on central ocean tost;
> Brighter than eastern skies at daybreak strewn
> With fancied roses, than the unblemish'd moon
> Before her wane begins on heaven's blue coast,
> Thy Image falls to earth. Yet some I ween,
> Not unforgiven, the suppliant knee might bend,
> As to a visible Power, in which did blend
> All that was mix'd and reconcil'd in thee,
> Of mother's love with maiden purity,
> Of high with low, celestial with terrene.

The next, from Shelley, reads like a hymn in honour of the Immaculate Conception :—

> Seraph of Heaven! too gentle to be human,
> Veiling beneath that radiant form of woman
> All that is insupportable in thee
> Of light, and love, and immortality!
> Sweet Benediction in the eternal curse!
> Veil'd Glory of this lampless Universe!
> Thou Moon beyond the clouds! Thou living Form
> Among the Dead! Thou Star above the storm!
> Thou Wonder, and thou Beauty, and thou Terror!
> Thou Harmony of Nature's art! Thou Mirror
> In whom, as in the splendour of the Sun,
> All shapes look glorious which thou gazest on!
>
> See where she stands! a mortal shape endued
> With love, and life, and light, and deity;
> The motion which may change but cannot die;
> An image of some bright eternity;
> A shadow of some golden dream; a splendour
> Leaving the third sphere pilotless.

I do not know whether intentionally or not, but we have here assembled some of the favourite symbols of the Virgin—the moon, the star, the ' *terribilis* ut castrorum acies' (Cant. vi. 10), and the mirror.

The third is a passage from Robert Browning, which appears to me to sum up the moral ideal :—

> There is a vision in the heart of each,
> Of justice, mercy, wisdom, tenderness
> To wrong and pain, and knowledge of their cure;
> And these embodied in a woman's form
> That best transmits them pure as first received
> From God above her to mankind below!

f 2

II. Symbols and Attributes of the Virgin.

That which the genius of the greatest of painters only once expressed, we must not look to find in his predecessors, who saw only partial glimpses of the union of the divine and human in the feminine form; still less in his degenerate successors, who never beheld it at all.

The difficulty of fully expressing this complex ideal, and the allegorical spirit of the time, first suggested the expedient of placing round the figure of the glorified Virgin certain accessory symbols, which should assist the artist to express, and the observer to comprehend, what seemed beyond the power of art to portray;—a language of metaphor then understood, and which we also must understand if we would seize the complete theological idea intended to be conveyed.

I shall begin with those symbols which are borrowed from the Litanies of the Virgin, and from certain texts of the Canticles, in all ages of the Church applied to her; symbols which, in the fifteenth and sixteenth centuries, frequently accompany those representations which set forth her Glorification or Predestination; and, in the seventeenth, are introduced into the 'Immaculate Conception.'

1. The Sun and the Moon.—'Electa ut Sol, pulchra ut Luna,' is one of the texts of the Canticles applied to Mary; and also in a passage of the Revelation, '*A woman clothed with the sun, having the moon under her feet, and on her head a crown of twelve stars.*' Hence the radiance of the sun above her head, and the crescent moon beneath her feet. From inevitable association the crescent moon suggests the idea of her perpetual chastity; but in this sense it would be a pagan rather than a Christian attribute.

2. The Star.—This attribute, often embroidered in front of the veil of the Virgin, or on the right shoulder of her blue mantle, has become almost as a badge from which several well-known pictures derive their title, ' La Madonna della Stella.' It is in the first place an attribute alluding to the most beautiful and expressive of her many titles:—' *Stella Maris*,' Star of the Sea,[1] which is one interpretation of her Jewish name, *Miriam* : but she is also ' *Stella Jacobi*,' the Star of Jacob : ' *Stella Matutina*,' the Morning Star ; ' *Stella non Erratica*, the Fixed Star. When, instead of the single star on her veil or mantle, she has the crown of twelve stars, the allusion is to the text of the Apocalypse

[1] Ave Maris Stella
 Dei Mater Alma ! &c.

already quoted, and the number of stars is in allusion to the number of the Apostles.[1]

3. The Lily.—'*I am the rose of Sharon, and the lily of the valleys.*' (Cant. ii. 1, 2.) As the general emblem of purity, the lily is introduced into the Annunciation, where it ought to be without stamens : and in the enthroned Madonnas it is frequently placed in the hands of attendant angels, more particularly in the Florentine Madonnas ; the lily, as the emblem of their patroness, being chosen by the citizens as the *device* of the city. For the same reason it became that of the French monarchy. Thorns are sometimes interlaced with the lily, to express the '*Lilium inter Spinas.*' (Cant. ii. 2.)

4. The Rose.—She is the rose of Sharon, as well as the lily of the valley ; and as an emblem of love and beauty, the rose is especially dedicated to her. The plantation or garden of roses [2] is often introduced ; sometimes it forms the background of the picture. There is a most beautiful example in a Madonna by Cesare di Sesto ; [3] and another, 'the Madonna of the Rose Bush,' by Martin Schoen.[4]

5. The Enclosed Garden (*Hortus conclusus*) is an image borrowed, like many others, from the Song of Solomon. (Cant. iv. 12.) I have seen this enclosed garden very significantly placed in the background of the Annunciation, and in pictures of the Immaculate Conception. Sometimes the enclosure is formed of a treillage or hedge of roses, as in a beautiful Virgin by Francia.[5] Sometimes it is merely formed of stakes or palisades, as in some of the prints by Albert Dürer.

The Well always full; the Fountain for ever sealed; the Tower of David; the Temple of Solomon ; the City of David (*Civitas sancta*), (Cant. iv. 4, 12, 15) ; all these are attributes borrowed from the Canticles, and are introduced into pictures and stained glass.

6. The Porta Clausa, the Closed Gate, is another metaphor, taken from the prophecy of Ezekiel (xliv. 4).

7. The Cedar of Lebanon (*Cedrus exaltata,* ' exalted as a cedar in Lebanon'), because of its height, its incorruptible substance, its perfume, and the healing virtues attributed to it in the East, expresses the greatness, the beauty, the goodness of Mary.

[1] 'In capite, inquit, ejus corona stellarum duodecim ; quidni coronent sidera quam sol vestit ? '—*St. Bernard.*

[2] Quasi plantatio rosæ in Jericho. [3] Milan, Brera. [4] Cathedral, Colmar.

[5] Munich Gal. : another by Antonio da Negroponte in the San Francesco della Vigna at Venice, is also an instance of this significant background.

The victorious PALM, the Plantain 'far spreading,' and the Cypress pointing to heaven, are also emblems of the Virgin.

The OLIVE, as a sign of peace, hope, and abundance, is also a fitting emblem of the graces of Mary.[1]

8. The Stem of Jessie,[2] figured as a green branch entwined with flowers, is also very significant.

9. The MIRROR (*Specula sine maculâ*) is a metaphor borrowed from the Book of Wisdom (vii. 25). We meet with it in some of the late pictures of the Immaculate Conception.

10. The SEALED BOOK is also a symbol often placed in the hands of the Virgin in a mystical Annunciation, and sufficiently significant. The allusion is to the text, 'In that book were all my members written;' and also to the text in Isaiah (xxix. 11, 12), in which he describes the vision of the book that was sealed, and could be read neither by the learned nor the unlearned.

11. 'The Bush which burned and was not consumed,' is introduced, with a mystical significance, into an Annunciation by Titian.

Besides these symbols, which have a mystic and sacred significance, and are applicable to the Virgin only, certain attributes and accessories are introduced into pictures of the Madonna and Child, which are capable of a more general interpretation.

1. The GLOBE, as the emblem of sovereignty, was very early placed in the hand of the divine Child. When the globe is under the feet of the Madonna and encircled by a serpent, as in some later pictures, it figures our Redemption; her triumph over a fallen world—fallen through sin.

2. The SERPENT is the general emblem of Sin or Satan; but under the feet of the Virgin it has a peculiar significance. She has generally her foot on the head of the reptile. 'SHE shall bruise thy head,' as it is interpreted in the Roman Catholic Church.[3]

3. The APPLE, which of all the attributes is the most common, signifies the fall of man, which made Redemption necessary. It is sometimes placed in the hands of the Child; but when in the hand of the Mother, she is then designated as the second Eve.[4]

4. The POMEGRANATE, with the seeds displayed, was the ancient emblem of hope, and more particularly of religious hope. It is often placed in the hands of the Child, who sometimes presents it to his Mother.

[1] Quasi oliva speciosa in campis. [2] Isa. xi. 1.

[3] *Ipsa* conteret caput tu. [4] Mors per Evam : vita per Mariam.

Other fruits and flowers, always beautiful accessories, are frequently introduced acording to the taste of the artist. But fruits in a general sense signified 'the fruits of the Spirit—joy, peace, love;' and flowers were consecrated to the Virgin: hence we yet see them placed before her as offerings.

5. EARS OF WHEAT in the hand of the Infant (as in a lovely little Madonna by Ludovico Caracci) [1] figured the bread in the Eucharist, and GRAPES the wine.

6. The BOOK.—In the hand of the Infant Christ, the book is the Gospel in a general sense, or it is the Book of Wisdom. In the hand of the Madonna, it may have one of two meanings. When open, or when she has her finger between the leaves, or when the Child is turning over the pages, then it is the Book of Wisdom, and is always supposed to be open at the seventh chapter. When the book is clasped or sealed, it is a mystical symbol of the Virgin herself, as I have already explained.

7. The DOVE, as the received emblem of the Holy Spirit, is properly placed above, as hovering over the Virgin. There is an exception to this rule in a very interesting picture in the Louvre, where the Holy Dove (with the *nimbus*) is placed at the feet of the Child. [2] This is so unusual, and so contrary to all the received proprieties of religious art, that I think the *nimbus* may have been added afterwards.

The seven doves round the head of the Virgin signify the seven gifts of the Spirit. These characterise her as personified Wisdom — the Mater Sapientiæ. [3]

Doves placed near Mary when she is reading, or at work in the temple, are expressive of her gentleness and tenderness.

8. BIRDS.—The bird in the Egyptian hieroglyphics signified the soul of man. In the very ancient pictures there can be no doubt, I think, that the bird in the hand of Christ figured the soul, or the spiritual as opposed to the material. But, in the later pictures, the original meaning being lost, birds became mere ornamental accessories, or playthings. Sometimes it is a parrot from the East, sometimes a partridge (the partridge is frequent in the Venetian pictures): sometimes a goldfinch, as in Raphael's Madonna *del Cardellino*. In a Madonna by Guercino, the Mother holds a bird perched on her hand, and the Child, with a most *naïve* infantine expression, shrinks back from it. [4]

[1] Lansdowne Collection. There was another exactly similar in the collection of Mr. Roge

[2] The Virgin has the air of a gipsy. (Louvre, 515.) [3] *v.* p. 134.

[4] It was in the collection of Mr. Rogers.

In a picture by Baroccio, he holds it up before a cat : [1] so completely were the original symbolism and all the religious proprieties of art at this time set aside.

Other animals are occasionally introduced. Extremely offensive are the apes when admitted into devotional pictures. We have associations with the animal as a mockery of the human, which render it a very disagreeable accessory. It appears that, in the sixteenth century, it became the fashion to keep apes as pets, and every reader of Vasari will remember the frequent mention of these animals as pets and favourites of the artists. Thus only can I account for the introduction of the ape, particularly in the Ferrarese pictures. Bassano's dog, Baroccio's cat, are often introduced. In a famous picture by Titian, 'La Vierge au Lapin,' we have the rabbit.[2] The introduction of these and other animals marks the decline of religious art.

Certain women of the Old Testament are regarded as especial types of the Virgin.

EVE. Mary is regarded as the second Eve, because, through her, came the promised Redemption. She bruised the head of the Serpent. The Tree of Life, the Fall, or Eve holding the Apple, are constantly introduced allusively in the Madonna pictures, as ornaments of her throne, or on the predella of an altar-piece representing the Annunciation, the Nativity, or the Coronation.

RACHEL figures as the ideal of contemplative life.

RUTH, as the ancestress of David.

ABISHAG, as 'the Virgin who was brought to the King.' (1 Kings, i. 1.)

BATHSHEBA, because she sat upon a throne on the right hand of her Son.

JUDITH and ESTHER, as having redeemed their people, and brought deliverance to Israel. It is because of their typical character, as emblems of the Virgin, that these Jewish heroines so often figure in the religious pictures.[3]

In his 'Paradiso' (c. xxxii.), Dante represents Eve, Rachel, Sara, Ruth, Judith, as seated at the feet of the Virgin Mary, beneath her throne in heaven; and next to Rachel, by a refinement of spiritual and poetical gallantry, he has placed his Beatrice.

In the beautiful frescoes of the church of St. Apollinaris at Remagen, these Hebrew women stand together in a group below the throne of the Virgin.

[1] Nat. Gal. 29. [2] Louvre.

[3] The artistic treatment of these characters as types of the Virgin, will be found in the fourth series of 'Legendary Art.'

Of the Prophets and the Sibyls who attend on Christ in his character of the Messiah or Redeemer, I shall have much to say when describing the artistic treatment of the history and character of Our Lord. Those of the prophets who are supposed to refer more particularly to the Incarnation, properly attend on the Virgin and Child; but in the ancient altar-pieces, they are not placed within the same frame, nor are they grouped immediately round her throne, but form the outer accessories, or are treated separately as symbolical.

First, MOSES, because he beheld the burning bush, 'which burned and was not consumed.' He is generally in the act of removing his sandals.

AARON, because his rod blossomed miraculously.

GIDEON, on whose fleece descended the dew of heaven, while all was dry around.

DANIEL, who beheld the stone which was cut out without hands, and became a great mountain, filling the earth (ch. ii. 45).

DAVID, as prophet and ancestor. 'Listen O daughter, and incline thine ear.'

ISAIAH. 'Behold a virgin shall conceive and bear a son.'

EZEKIEL. 'This gate shall be shut' (ch. xliv. 2).

Certain of these personages, Moses, Aaron, Gideon, Daniel, Ezekiel, are not merely accessories and attendant figures, but in a manner attributes, as expressing the character of the Virgin. Thus, in many instances, we find the prophetical personages altogether omitted, and we have simply the attribute figuring the prophecy itself, the burning bush, the rod, the dewy fleece, &c.

The Sibyls are sometimes introduced alternately with the Prophets. In general, if there be only two, they are the Tiburtina, who showed the vision to Augustus, and the Cumean Sibyl who foretold the birth of our Saviour. The Sibyls were much the fashion in the classic times of the sixteenth century; Michael Angelo and Raphael have left us consummate examples.

But I must repeat that the full consideration of the Prophets and Sibyls as accessories belongs to another department of sacred art, and they will find their place there.

The Evangelists frequently, and sometimes one or more of the Twelve Apostles, appear as accessories which assist the theological conception. When other figures are introduced, they are generally either the protecting saints of the country or locality, or the saints of the Religious Order to whom the edifice belongs; or, where the picture or window is an *ex-voto*, we find the

g

patron saints of the confraternity, or of the donor or votary who has dedicated it.

Angels seated at the feet of the Madonna and playing on musical instruments, are most lovely and appropriate accessories, for the choral angels are always around her in heaven, and on earth she is the especial patroness of music and minstrelsy.[1] Her delegate Cecilia patronised *sacred* music; but *all* music and musicians, all minstrels, and all who plied the 'gaye science,' were under the protection of Mary. When the angels are singing from their music books, and others are accompanying them with lutes and viols, the song is not always supposed to be the same. In a Nativity they sing the 'Gloria in excelsis Deo;' in a Coronation the 'Regina Cœli;' in an enthroned Madonna with votaries, the 'Salve Regina, Mater Misericordiæ!' in a pastoral Madonna and Child it may be the 'Alma Mater Redemptoris.'

In all the most ancient devotional effigies (those in the catacombs and the old mosaics) the Virgin appears as a majestic woman of mature age. In those subjects taken from her history which precede her return from Egypt, and in the Holy Families, she should appear as a young maiden from fifteen to seventeen years old.

In the subjects taken from her history which follow the baptism of our Lord, she should appear as a matron between forty and fifty, but still of a sweet and gracious aspect. When Michael Angelo was reproached with representing his Mater Dolorosa much too young, he replied that the perfect virtue and serenity of the character of Mary would have preserved her beauty and youthful appearance long beyond the usual period.[2]

Because some of the Greek pictures and carved images had become black through extreme age, it was argued by certain devout writers, that the Virgin herself must have been of a very dark complexion; and in favour of this idea they quoted this text from the Canticles, 'I am black, but comely, O ye daughters of Jerusalem.' But others say that her complexion had become black only during her sojourn in Egypt. At all events, though the blackness of these antique images was supposed to enhance their sanctity, it has never been imitated in the fine arts, and it is quite contrary to the description of Nicephorus, which is the most ancient authority, and that which is followed in the Greek school.

[1] The picture by Lo Spagna, lately added to our National Gallery, is a beautiful example.
[2] The group in St. Peter's, Rome.

The proper dress of the Virgin is a close red tunic, with long sleeves;[1] and over this a blue robe or mantle. In the early pictures, the colours are pale and delicate. Her head ought to be veiled. The fathers of the primeval Church, particularly Tertullian, attach great importance to the decent veil worn by Christian maidens; and in all the early pictures the Virgin is veiled. The enthroned Virgin, unveiled, with long tresses falling down on either side, was an innovation introduced about the end of the fifteenth century; commencing, I think, with the Milanese, and thence adopted in the German schools and those of Northern Italy. The German Madonnas of Albert Durer's time have often magnificent and luxuriant hair, curling in ringlets, or descending to the waist in rich waves, and always fair. Dark-haired Madonnas appear first in the Spanish and later Italian schools.

In the historical pictures, her dress is very simple; but in those devotional figures which represent her as queen of heaven, she wears a splendid crown, sometimes of jewels interwoven with lilies and roses. The crown is often the sovereign crown of the country in which the picture is placed: thus, in the Papal States, she often wears the triple tiara; in Austria, the imperial diadem. Her blue tunic is richly embroidered with gold and gems, or lined with ermine or stuff of various colours, in accordance with a text of Scripture: 'The King's daughter is all glorious within; her clothing is of wrought gold. She shall be brought unto the King in a vesture of needlework.'[2] In the Immaculate Conception, and in the Assumption, her tunic should be plain white, or white spangled with golden stars. In the subjects relating to the Passion, and after the Crucifixion, the dress of the Virgin should be violet or grey. These proprieties, however, are not always attended to.

In the early pictures which represent her as nursing the divine Infant (the subject called the *Vergine Lattante*), the utmost care is taken to veil the bust as much as possible. In the Spanish school the most vigilant censorship was exercised over all sacred pictures, and, with regard to the figures of the Virgin the utmost decorum was required. 'What,' says Pacheco, can be more foreign to the respect which we owe to Our Lady the Virgin, than to paint her sitting down with one of her knees placed over the other, and often

[1] In a famous Pietà by Raphael, engraved by Marc Antonio, the Virgin, standing by the dead form of her Son, has the right arm apparently bare; in the repetition of the subject it is clothed with a full sleeve, the impropriety being corrected. The first is, however, the most perfect and most precious as a work of art.—*Bartsch*, xiv. 34, 35.

[2] Ps. xlv. 13.

with her sacred feet uncovered and naked ? Let thanks be given to the Holy
Inquisition, which commands that this liberty should be corrected.' For
this reason, perhaps, we seldom see the feet of the Virgin in Spanish pictures.
Carducho speaks more particularly on the impropriety of painting the Virgin
unshod : ' since it is manifest that our Lady was in the habit of wearing shoes,
as is proved by the much venerated relic of one of them from her divine feet
at Burgos.'

The Child in her arms is always, in the Greek and early pictures, clothed in a
little tunic, generally white. In the fifteenth century he first appears partly, and
then wholly, undraped. Joseph, as the earthly *sposo*, wears the saffron-coloured
mantle over a grey tunic. In the later schools of art these significant colours are
often varied, and sometimes wholly dispensed with.

III. DEVOTIONAL AND HISTORICAL REPRESENTATIONS.

IN this volume, as in the former ones, I have adhered to the distinction between
the devotional and the historical representations.

I class as devotional, all those which express a dogma merely ; all the enthroned
Madonnas, alone or surrounded by significant accessories or attendant saints ; all
the Mystical Coronations and Immaculate Conceptions; all the Holy Families with
saints, and those completely ideal and votive groups, in which the appeal is made
to the faith and piety of the observer. I shall give the characteristic details, in
particular instances, further on.

The altar-pieces in a Roman Catholic church are always either strictly
devotional subjects, or, it may be, historical subjects (such as the Nativity)
treated in a devotional sense. They are sometimes
in several pieces or compartments. A Diptych is
an altar-piece composed of two divisions or leaves,
which are united by hinges, and close like a book.
Portable altar-pieces of a small size are generally
in this form ; and among the most valuable and
curious remains of early religious art are the Greek
and Byzantine Diptychs, sometimes painted, some-

155

[1] Or in any of the old pictures till the seventeenth century. ' Tandis que Dieu est toujours
montré pieds nus, lui qui est descendu à terre et a pris notre humanité, Marie au contraire
est constamment représentée les pieds perdus dans les plis trainants, nombreux et légers, de sa
robe virginale ; elle qui est elevée au dessus de la terre et rapprochée de Dieu par sa pureté.
Dieu montre par ses pieds nus qu'il a pris le corps de l'homme ; Marie fait comprendre en
les cachant qu'elle participe de la spiritualité de Dieu.'

156

times carved in ivory.[1] A Triptych is an altar-piece in three parts; the two outer divisions or wings often closing as shutters over the central compartment,—in this form.

On the outside of the shutters or doors the Annunciation was generally painted, as the mystery which opened the gates of salvation; occasionally, also, the portraits of the votaries or donors.

Complete examples of devotional representation occur in the complex and elaborate altar-pieces and windows of stained glass, which often comprehend a very significant scheme of theology.[2] I give here plans of two of these old altar-pieces, which will assist the reader in elucidating the meaning of others.

157

The first is the altar-piece in the Rinuccini Chapel in the church of the Santa

[1] Among the 'Casts from Ancient Ivory Carvings,' published by the Arundel Society, will be found some interesting and illustrative examples, particularly Class III. Diptych *b*, Class VII. Diptych *e* and Triptych *f*, Class IX. Triptych *k*.

[2] Still more important examples occur in the porches and exterior decoration of the old Cathedrals, French and English, which have escaped mutilation. These will be found explained at length in the Fourth Series of Sacred and Legendary Art.

Croce of Florence. It is necessary to premise that the chapel was founded in honour of the Virgin and Mary Magdalene; while the church is dedicated to the Holy Cross, and belongs to the Franciscans.

The compartments are separated by wood-work most richly carved and gilt in the Gothic style, with twisted columns, pinnacles, and scrolls. The subjects are thus distributed.

A. The Virgin and Child enthroned. She has the sun on her breast, the moon under her feet, the twelve stars over her head, and is attended by angels bearing the attributes of the cardinal virtues. B. St. John the Baptist. C. St. Francis. D. St. John Evangelist. E. Mary Magdalene. 1. The Crucifixion, with the Virgin and St. John. 2, 3, 4, 5. The four Evangelists with their books: half length. 6, 7. St. Peter and St. Paul: half length. 8, 9, 10, 11. St. Thomas, St. Philip, St. James, and St. Andrew: half length. P P. The Predella. 12. The Nativity and Adoration of Magi. 13. St. Francis receives the Stigmata. 14. Baptism of Christ. 15. The Vision of St. John in Patmos. 16. Mary Magdalene borne up by angels. Between the altar-piece and the predella runs the inscription in Gothic letters, AVE DULCISSIMA VIRGO MARIA, SUCCURRE NOBIS MATER PIA, MCCCLXXVIII.

The second example is sketched from an altar-piece painted for the suppressed convent of Santa Chiara, at Venice. It is six feet high, and eight feet wide,

158

and the ornamental carving in which the subjects are enclosed is particularly splendid and elaborate.

A. The Coronation of the Virgin, treated as a religious mystery, with

choral angels. B. The Nativity of our Lord. C. The Baptism. D. The Last Supper. E. The Betrayal of Christ. F. The Procession to Calvary, in which the Virgin is rudely pushed aside by the soldiers. G. The Crucifixion, as an event: John sustains the Virgin at the foot of the cross. H. The Resurrection and the *Noli me tangere*. I. Ascension. 1. Half-figure of Christ, with the hand extended in benediction: in the other hand the Gospel. 2. David. 3. Isaiah. 4, 5, 6, 7. The four Evangelists standing. 8, 9, 11, 12. Scenes from the Life of St. Francis and St. Clara. 10. The Descent of the Holy Ghost. 13. The Last Judgment.

It is to be regretted that so many of these altar-pieces have been broken up, and the detached parts sold as separate pictures; so that we may find one compartment of an altar in a church at Rome, and another hanging in a drawingroom in London; the upper part at Ghent, the lower half at Paris; one wing at Berlin, another at Florence. But where they exist as a whole, how solemn, significant, and instructive the arrangement! It may be read as we read a poem. Compare these with the groups round the enthroned Virgin in the later altar-pieces, where the saints elbow each other in attitudes, where mortal men sit with unseemly familiarity close to personages recognised as divine. As I have remarked further on, it is one of the most interesting speculations connected with the study of art, to trace this decline from reverence to irreverence, from the most rigid formula to the most fantastic caprice. The gradual disappearance of the personages of the Old Testament, the increasing importance given to the family of the Blessed Virgin, the multiplication of legendary subjects, and all the variety of adventitious, unmeaning, or merely ornamental accessories, strike us just in proportion as a learned theology replaced the unreflecting, undoubting piety of an earlier age.

The historical subjects comprise the events from the Life of the Virgin, when treated in a dramatic form; and all those groups which exhibit her in her merely domestic relations, occupied by cares for her divine Child, and surrounded by her parents and kindred, subjects which assume a pastoral and poetical rather than an historical form.

All these may be divided into Scriptural and Legendary representations. The Scriptural scenes in which the Virgin Mary is a chief or important personage, are the Annunciation, the Visitation, the Nativity, the Purification, the Adoration of the Magi, the Flight into Egypt, the Marriage at Cana, the Procession to Calvary, the Crucifixion (as related by St. John), and the Descent of the Holy Ghost. The Traditional and Legendary scenes are those taken from the apocryphal Scriptures, some of which have existed from the third century. The Legend of Joachim and Anna, the parents of the Virgin,

with the account of her early life, and her Marriage with Joseph, down to the Massacre of the Innocents, are taken from the Gospel of Mary and the Prot-evangelion. The scenes of the Flight into Egypt, the Repose on the Journey, and the Sojourn of the Holy Family at Hieropolis or Matarea, are taken from the Gospel of Infancy. The various scenes attending the Death and Assumption of the Virgin are derived from a Greek legendary poem, once attributed to St. John the Evangelist, but the work, as it is supposed, of a certain Greek, named Meliton, who lived in the ninth century, and who has merely dressed up in a more fanciful form ancient traditions of the Church. Many of these historical scenes have been treated in a devotional style, expressing not the action, but the event, taken in the light of a religious mystery; a distinction which I have fully explained in the following pages, where I have given in detail the legends on which these scenes are founded, and the religious significance conveyed by the treatment.

A complete series of the History of the Virgin begins with the rejection of her father Joachim from the temple, and ends with the assumption and corona-tion, including most of the events in the History of our Lord (as for example, the series painted by Giotto, in the chapel of the Arena, at Padua); but there are many instances in which certain important events relating to the Virgin only, as the principal person, are treated as a devotional series; and such are generally found in the chapels and oratories especially dedicated to her. A beautiful instance is that of the Death of the Virgin, treated in a succession of scenes, as an event apart, and painted by Taddeo Bartolo, in the Chapel of the Palazzo Publico, at Siena. This small chapel was dedicated to the Virgin soon after the terrible plague of 1348 had ceased, as it was believed, by her intercession; so that this municipal chapel was at once an expression of thanksgiving, and a memorial of death, of suffering, of bereavement, and of hope

159

in the resurrection. The frescos cover one wall of the chapel, and are thus arranged in four scenes.

1. Mary is reclining in her last sickness, and around her are the Apostles, who, according to the beautiful legend, were *miraculously* assembled to witness her departure. To express this, one of them is floating in as if borne on the air.[1] St. John kneels at her feet, and she takes, with an expression exquisitely tender and maternal, his two hands in hers. This action is peculiar to the Siena school.[2]

2. She lies extended on her couch, surrounded by the weeping Apostles, and Christ behind receives the parting soul—the usual representation, but treated with the utmost sentiment.

3. She is borne to the grave by the Apostles; in the background, the walls of the city of Jerusalem. Here the Greek legend of St. Michael protecting her remains from the sacrilegious Jew is omitted, and a peculiar sentiment of solemnity pervades the whole scene.

4. The resurrection of the Virgin, when she rises from the tomb sustained by hovering angels, and is received by Christ.[3]

When I first saw these beautiful frescos, in 1847, they were in a very ruined state; they have since been restored in a very good style, and with a reverent attention to the details and expression.

In general, however, the cycle commences either with the legend of Joachim and Anna, or with the Nativity of the Virgin, and ends with the assumption and coronation. A most interesting early example is the series painted in fresco by Taddeo Gaddi, in the Baroncelli Chapel at Florence. The subjects are thus arranged on two walls. The first on the right hand, and the second, opposite to us as we enter.

[1] *v.* p. 307.

[2] On each side of the principal door of the Cathedral at Siena, which is dedicated to 'Beata Vergine Assunta,' and just within the entrance, is a magnificent pilaster, of white marble, completely covered from the base to the capital with the most luxuriant carving, arabesques, foliage, &c., in an admirable and finished style. On the bases of these two pilasters are subjects from the Life of the Virgin, three on each side, and thus arranged, each subject on one side having its pendant on the other.

1. The meeting of Joachim and Anna. 2. The Nativity of Mary. 3. Her sickness and last farewell to the Apostles; bending towards St. John, she takes his hand in hers with the same tender expression as in the fresco by Taddeo Bartola. 4. She lies dead on her couch. 5. The Assumption. 6. The Coronation.

The figures are about a foot in height, delicately carved, full of that sentiment which is especially Sienese, and treated with a truly sculptural simplicity. [3] See p. 323.

h

161

1. Joachim is rejected from the Temple.[1]
2. He is consoled by the Angel.
3. The meeting of Joachim and Anna.[2]
4. The Birth of the Virgin.
5. The Presentation of the Virgin. She is here a child of about five years old; and having ascended five steps (of the fifteen) she turns as if to bid farewell to her parents and companions, who stand below; while on the summit the High Priest, Anna the prophetess, and the maidens of the Temple come forward to receive her.[3]
6. The Marriage to Joseph, and the rage and disappointment of the other suitors.[4]

The second wall is divided by a large window of the richest stained glass, on each side of which the subjects are arranged.

7. The Annunciation. This is peculiar. Mary, not throned or standing, but seated on the ground, with her hands clasped, and an expression beautiful for devotion and humility, looks upwards to the descending angel.
8. The Meeting of Mary and Elizabeth.
9. The Annunciation to the Shepherds.
10. The Nativity (as in the cut at p. 108.)
11. The Wise Men behold the Star in the Form of a Child. (I have given this composition at p. 211.)

[1] v. p. 142, where a small cut is given of this composition.
[2] v. p. 143. [3] v. p. 152. [4] v. p. 159.

12. They approach to Worship (as in the cut at p. 215). Under the window is the altar (†), no longer used as such; and behind it a small but beautiful triptych of the Coronation of the Virgin, by Giotto, containing at least a hundred heads of saints, angels, &c.; and on the wall opposite to No. 1 is the large fresco of the Assumption, by Mainardi, in which St. Thomas receives the girdle, the other Apostles being omitted. This is of much later date, being painted about 1495.

The series of five subjects in the Rinuccini Chapel (in the sacristy of the same church) has been generally attributed to Taddeo Gaddi, but I agree with those who give it to a different painter of the same period.

The subjects are thus arranged:—1. The Rejection of Joachim, which fills

162

the whole arch at the top, and is rather peculiarly treated. On the right of the altar (*a*) advances a company of grave-looking elders, each with his offering. On the left (*b*), a procession of the matrons and widows 'who had been fruitful in Israel,' each with her lamb. In the centre, Joachim, with his lamb in his arms and an affrighted look, is hurrying down the steps. 2. The Lamentation of Joachim on the Mountain, and the Meeting of Joachim and Anna. 3. The Birth of the Virgin. 4. The Presentation in the Temple. 5. The Sposalizio of the Virgin, with which the series concludes; every event referring to her divine Son, even the Annunciation, being omitted. On comparing these frescoes with those in the neighbouring chapel of the Baroncelli, the difference in *feeling* will be immediately felt; but they are very *naïve* and elegant.[1]

About a hundred years later than these two examples we have the celebrated series painted by Ghirlandajo, in the choir of S. Maria Novella at Florence. There are three walls. On the principal wall, facing us as we enter, is the window; and around it the Annunciation (as a mystery), then, the principal saints of the Order to whom the church belongs,— St. Dominic and St. Peter Martyr, and the protecting saints of Florence.

On the left hand (i.e. the right as we face the high altar) is the History of the Virgin; on the opposite side, the History of St. John the Baptist. The various cycles relating to St. John as patron of Florence will be fully treated in the last volume of Legendary Art; at present I shall confine myself to the

[1] At p. 142, at the end of the page, instead of *Rucellai*, read *Baroncelli*. The Rucellai Chapel is in S. Maria Novella.

beautiful set of subjects which relate the history of the Virgin, and which the engravings of Lasinio[1] have rendered well known to the lovers of art. They cover the whole wall, and are thus arranged, beginning from the lowest on the left hand.

1. Joachim is driven from the Temple.[2]

2. The Birth of the Virgin. I have given an etching of this beautiful composition, and the description at p. 148.

3. The Presentation of the Virgin in the Temple.[3]

4. The Marriage of Joseph and Mary.[4]

5. The Adoration of the Magi. (This is very much ruined.)

6. The Massacre of the Innocents. (This also is much ruined.) Vasari says it was the finest of all. It is very unusual to make this terrible and pathetic scene part of the life of the Virgin.

7. In the highest and largest compartment, the Death and Assumption of the Virgin.

163

Nearly contemporary with this fine series is that by Pinturicchio in the Church of S. Maria del Popolo, at Rome (in the third chapel on the right). It is comprised in five lunettes round the ceiling, beginning with the Birth of the Virgin, and is remarkable for its elegance. I have given two subjects from this series, 'the Marriage of the Virgin,' and 'the Virgin studying in the Temple,' which last is rather an uncommon subject.[5]

About forty years after this series was completed the people of Siena, who had always been remarkable for their devotion to the Virgin, dedicated to her honour the beautiful little chapel called the Oratory of San Bernardino,[6] near the church of San Francesco, and belonging to the same Order, the Franciscans. This chapel is an exact parallelogram and the frescos which cover the four walls are thus arranged above the wainscot, which rises about eight feet from the ground.

1. Opposite the door as we enter, the Birth of the Virgin. The usual visitor to St. Anna is here a grand female figure, in voluminous drapery. The delight and exultation of those who minister to the new-born infant are expressed with the most graceful *naïveté*. This beautiful composition should be compared with those of Ghirlandajo and Andrea del Sarto in the Annunziata

[1] See the 'Ancient Florentine Masters.' [2] *v.* p. 142. [3] *v.* p. 152.
[4] *v.* p. 161. [5] *v.* Frontispiece, and p. 155. [6] *v.* Legends of the Monastic Orders.

164

at Florence; [1] it yields to neither as a conception and is wholly different. It is the work of a Sienese painter little known—Girolamo del Pacchio.

2. The Presentation in the Temple, by G. A. Razzi. The principal scene is placed in the background, and the little Madonna, as she ascends the steps, is received by the High Priest and Anna the prophetess. Her father and mother and groups of spectators fill the foreground; here, too, is a very noble female figure on the right; but the whole composition is mannered, and wants repose and religious feeling.

3. The Sposalizio, by Beccafumi. The ceremony takes place after the manner of the Jews, outside the Temple. In a mannered, artificial style.

4, 5. On one side of the altar, the Angel Gabriel floating in—very majestic and angelic; on the other side the Virgin Annunziata, with that attitude and expression so characteristic of the Siena School, as if shrinking from the apparition.[2] These also are by Girolamo del Pacchio, and extremely fine.

6. The enthroned Virgin and Child, by Beccafumi. The Virgin is very fine and majestic; around her throne stand and kneel the guardian saints of Siena and the Franciscan Order : St. Francis, St. Antony of Padua, St. Bernardino, St. Catherine of Siena, St. Ansano, St. John B., St. Louis. (St. Catherine, as patroness of Siena, takes here the place usually given to St. Clara in the Franciscan pictures.)

7. The Visitation. Very fine and rather peculiar; for here Elizabeth bends over Mary as welcoming her, while the other inclines her head as accepting hospitality. By Razzi.

8. The Death of the Virgin. Fourteen figures, among which are four females lamenting, and St. John bearing the palm.[3] The attitude and expression of Mary, composed in death, are very fine; and Christ, instead of standing, as usual, by the couch, with her parting soul in his arms, comes rushing down from above with arms outspread to receive it.

9. The Assumption. Mary, attired all in white, rises majestically. The tomb is seen beneath, out of which grow two tall lilies amid white roses; the

[1] This series, painted by Andrea and his scholars and companions, Franciabigio and Pontormo, is very remarkable as a work of art, but presents nothing new in regard to the choice and treatment of the subjects.

[2] v. p. 172.

[3] See the Legend, p. 306.

Apostles surround it, and St. Thomas receives the girdle.[1] This is one of the finest works of Razzi, and one of the purest in point of sentiment.

10. The Coronation, covering the whole wall which faces the altar, is by Razzi; it is very peculiar and characteristic. The Virgin all in white, and extremely fine, bending gracefully, receives her crown; the other figures have that vulgarity of expression which belonged to the artist, and is often so oddly mingled with the sentiment and grandeur of his school and time. On the right of the principal group stands St. John B.; on the left, Adam and Eve; and behind the Virgin, her mother, St. Anna, which is quite peculiar, and the only instance I can remember.

It appears therefore that the Life of the Virgin may, whether treated as a devotional or historical series, form a kind of pictured drama in successive scenes; sometimes comprising only six or eight of the principal events of her individual life, as her birth, dedication, marriage, death, and assumption : sometimes extending to forty or fifty subjects, and combining her history with that of her divine Son. I may now direct the attention of the reader to a few other instances remarkable for their beauty and celebrity.

Giotto, 1320. In the chapel at Padua styled *la Capella dell' Arena*. One of the finest and most complete examples extant, combining the Life of the Virgin with that of her Son. This series is of the highest value, a number of scenes and situations suggested by the Scriptures being here either expressed for the first time, or in a form unknown in the Greek school.[2]

Angiolo Gaddi, 1380. The series in the cathedral at Prato. These comprise the history of the Holy Girdle.

Andrea Orcagna, 1373. The beautiful series of bas-reliefs on the shrine in Or-San-Michele, at Florence.

Nicolò da Modena, 1450. Perhaps the earliest engraved example : very remarkable for the elegance of the *motifs* and the imperfect execution, engraving on copper being then a new art.

Albert Durer. The beautiful and well-known set of twenty-five woodcuts, published in 1510. A perfect example of the German treatment.

Bernardino Luini, 1515. A series of frescos of the highest beauty, painted for the monastery Della Pace. Unhappily we have only the fragments which are preserved in the Brera.

[1] See the Legend, p. 320.

[2] *Vide* Kugler's Handbook, p. 129. He observes, that 'the introduction of the maid-servant spinning, in the story of St. Anna, oversteps the limits of the higher ecclesiastical style.' For an explanation I must refer to the story as I have given it at p. 139. See, for the distribution of the subjects in this chapel, Lord Lindsay's 'Christian Art,' vol. ii. A set of the subjects has since been published by the Arundel Society.

The series of bas-reliefs on the outer shrine of the Casa di Loretto, by Sansovino, and others of the greatest sculptors of the beginning of the sixteenth century.

The series of bas-reliefs round the choir at Milan : seventeen subjects.

We often find the Seven Joys and the Seven Sorrows of the Virgin treated as a series.

The Seven Joys are, the Annunciation, the Visitation, the Nativity, the Adoration of the Magi, the Presentation in the Temple, Christ found by his Mother, the Assumption and Coronation.

The Seven Sorrows are, the Prophecy of Simeon, the Flight into Egypt, Christ lost by his Mother, the Betrayal of Christ, the Crucifixion (with St. John and the Virgin only present), the Deposition from the Cross, the Ascension when the Virgin is left on earth.

The Seven Joys and Sorrows are frequently found in altar-pieces and religious prints, arranged in separate compartments, round the Madonna in the centre. Or they are combined in various groups into one large composition, as in a famous picture by Hans Hemling, wonderful for the poetry, expression, and finished execution.[1]

Another cycle of subjects consists of the fifteen Mysteries of the Rosary.

The five Joyful Mysteries are, the Annunciation, the Visitation, the Nativity, the Purification, and Christ found in the Temple.

The five Dolorous or Sorrowful Mysteries are, our Lord in the Garden of Olives, the Flagellation, Christ crowned with Thorns, the Procession to Calvary, the Crucifixion.

The five Glorious Mysteries are, the Resurrection, the Ascension, the Descent of the Holy Ghost, the Assumption, the Coronation.

A series of subjects thus arranged cannot be called strictly historical, but partakes of the mystical and devotional character. The purpose being to excite devout meditation, requires a particular sentiment, frequently distinguished from the merely dramatic and historical treatment in being accompanied by saints, votaries, and circumstances purely ideal; as where the Wise Men bring their offerings, while St. Luke sits in a corner painting the portrait of the Virgin, and St. Dominick kneels in adoration of the Mystery ;[2]—and in a hundred other examples.

[1] Altogether, on a careful consideration of this picture, I do not consider the title by which it is generally known as appropriate. It contains many groups which would not enter into the mystic joys or sorrows ; for instance, the Massacre of the Innocents, Christ at Emmaus, the *Noli me tangere*, and others.

[2] Mabuse, Munich Gal.

IV. TITLES OF THE VIRGIN MARY.

OF the various titles given to the Virgin Mary, and thence to certain effigies and pictures of her, some appear to me very touching, as expressive of the wants, the aspirations, the infirmities and sorrows, which are common to poor suffering humanity, or of those divine attributes from which they hoped to find aid and consolation. Thus we have—

Santa Maria ' del buon Consilio.' Our Lady of good Counsel.

S. M. ' del Soccorso.' Our Lady of Succour. Our Lady of the Forsaken.

S. M. ' del buon Core.' Our Lady of good Heart.

S. M. ' della Grazia.' Our Lady of Grace.

S. M. ' di Misericordia.' Our Lady of Mercy.

S. M. ' Auxilium Afflictorum.' Help of the Afflicted.

S. M. ' Refugium Peccatorum.' Refuge of Sinners.

S. M. ' del Pianto,' ' del Dolore.' Our Lady of Lamentation, or Sorrow.

S. M. ' Consolatrice,' ' della Consolazione,' or ' del Conforto.' Our Lady of Consolation.

S. M. ' della Speranza.' Our Lady of Hope.

Under these and similar titles she is invoked by the afflicted, and often represented with her ample robe outspread and upheld by angels, with votaries and suppliants congregated beneath its folds. In Spain, *Nuestra Señora de la Merced* is the patroness of the Order of Mercy ; and in this character she often holds in her hand small tablets bearing the badge of the Order.[1]

S. M. ' della Liberta,' or ' Liberatrice,' Our Lady of Liberty ; and S. M. ' della Catena,' Our Lady of Fetters. In this character she is invoked by prisoners and captives.

S. M. ' del Parto,' Our Lady of Good Delivery, invoked by women in travail.[2]

S. M. ' del Popolo.' Our Lady of the People.

S. M. ' della Vittoria.' Our Lady of Victory.

S. M. ' della Pace.' Our Lady of Peace.

S. M. ' della Sapienza,' Our Lady of Wisdom ; and S. M. ' della Perseveranza,' Our Lady of Perseverance. (Sometimes placed in colleges, with a book in her hand, as patroness of students.)

[1] Legends of the Monastic Orders, 2nd edit.

[2] Dante alludes to her in this character :—

> E per ventura udi ' Dolce Maria !'
> Dinanzi a noi chiamar così nel pianto
> Come fa donna che 'n partorir sia.—*Purg.* c. 20.

S. M. 'della Salute.' Our Lady of Health or Salvation. Under this title pictures and churches have been dedicated after the cessation of a plague, or any other public calamity.[1]

Other titles are derived from particular circumstances and accessories, as —

S. M. 'del Presepio.' Our Lady of the Cradle; generally a Nativity, or when she is adoring her Child.

S. M. ' della Scodella '—with the cup or porringer, where she is taking water from a fountain ; generally a Riposo.

S. M. ' dell' Libro,' where she holds the Book of Wisdom.

S. M. 'della Cintola.' Our Lady of the Girdle; where she is either giving the Girdle to St. Thomas, or where the Child holds it in his hand.

S. M. 'della Lettera.' Our Lady of the Letter. This is the title given to Our Lady as protectress of the city of Messina. According to the Sicilian legend she honoured the people of Messina by writing a letter to them, dated from Jerusalem, ' in the year of her Son, 42.' In the effigies of the ' Madonna della Lettera,' she holds this letter in her hand.

S. M. ' della Rosa.' Our Lady of the Rose. A title given to several pictures in which the rose, which is consecrated to her, is placed either in her hand or in that of the Child.

S. M. ' della Stella.' Our Lady of the Star. She wears the star as one of her attributes embroidered on her mantle.

S. M. ' del Fiore.' Our Lady of the Flower. She has this title especially as protectress of Florence.

S. M. ' della Spina.' She holds in her hand the crown of thorns, and under this title is the protectress of Pisa.

S. M. ' del Rosario.' Our Lady of the Rosary, with the mystic string of beads. I do not remember any instance of the Rosary placed in the hand of the Virgin or the Child till after the battle of Lepanto (1571), and the institution of the Festival of the Rosary, as an act of thanksgiving. After this time pictures of the Madonna ' del Rosario ' abound, and may generally be found in the Dominican churches. There is a famous example by Guido in the Bologna Gallery, and a very beautiful one by Murillo in the Dulwich Gallery.

S. M. ' del Carmine.' Our Lady of Mount Carmel. She is protectress of the Order of the Carmelites, and is often represented holding in her hand small tablets, on which is the effigy of herself with the Child.

[1] There is also somewhere in France a chapel dedicated to *Notre Dame de la Haine.*

S. M. 'de Belem.' Our Lady of Bethlehem. Under this title she is the patroness of the Jeronymites, principally in Spain and Portugal.

S. M. 'della Neve.' Our Lady of the Snow. In Spain, S. Maria la Blanca. To this legend of the snow the magnificent church of S. M. Maggiore at Rome is said to owe its origin. A certain Roman patrician, whose name was John (Giovanni Patricio), being childless, prayed of the Virgin to direct him how best to bestow his worldly wealth. She appeared to him in a dream on the night of the fifth of August, 352, and commanded him to build a church in her honour, on a spot where snow would be found the next morning. The same vision having appeared to his wife and the reigning pope, Liberius, they repaired in procession the next morning to the summit of Mount Esquiline, where, notwithstanding the heat of the weather, a large patch of ground was miraculously covered with snow, and on it Liberius traced out with his crozier the plan of the church. This story has been often represented in art, and is easily recognised; but it is curious that the two most beautiful pictures consecrated to the honour of the Madonna della Neve are Spanish and not Roman, and were painted by Murillo about the time that Philip IV. of Spain sent rich offerings to the church of S. M. Maggiore, thus giving a kind of popularity to the legend. The picture represents the patrician John and his wife asleep, and the vision of the Virgin (one of the loveliest ever painted by Murillo) breaking upon them in splendour through the darkness of the night; while in the dim distance is seen the Esquiline (or what is meant for it) covered with snow. In the second picture, John and his wife are kneeling before the pope, 'a grand old ecclesiastic, like one of Titian's pontiffs.' These pictures, after being carried off by the French from the little Church of S. M. la Blanca at Seville, are now in the Royal Gallery at Madrid.

S. Maria 'di Loretto.' Our Lady of Loretto. The origin of this title is the famous Legend of the Santa Casa, the house at Nazareth, which was the birth-place of the Virgin, and the scene of the Annunciation. During the incursions of the Saracens, the Santa Casa being threatened with profanation, if not destruction, was taken up by the angels and conveyed over land and sea till it was set down on the coast of Dalmatia; but not being safe there, the angels again took it up, and, bearing it over the Adriatic, set it down in a grove near Loretto. But certain wicked brigands having disturbed its sacred quietude by strife and murder, the house again changed its place, and was at length set down on the spot where it now stands. The date of this miracle is placed in 1295.

The Madonna di Loretto is usually represented as seated with the divine Child on the roof of a house, which is sustained at the corners by four angels and thus borne over sea and land. From the celebrity of Loretto as a place

of pilgrimage, this representation became popular, and is often found in chapels dedicated to our Lady of Loretto. Another effigy of our Lady of Loretto is merely a copy of a very old Greek 'Virgin and Child,' which is enshrined in the Santa Casa.

S. M. ' del Pillar,' Our Lady of the Pillar, is protectress of Saragossa. According to the Legend, she descended from heaven standing on an alabaster pillar, and thus appeared to St. James (Santiago) when he was preaching the gospel in Spain. The miraculous pillar is preserved in the cathedral of Saragossa, and the legend appears frequently in Spanish art. Also in a very inferior picture by Nicolo Poussin, now in the Louvre.

Some celebrated pictures are individually distinguished by titles derived from some particular object in the composition, as Raphael's *Madonna del Impannata*, so called from the window in the background being partly shaded with a piece of linen ; [1] Correggio's *Vierge au Panier*, so called from the work-basket which stands beside her ; [2] Murillo's *Virgen de la Servilleta*, the Virgin of the Napkin, in allusion to the dinner napkin on which it was painted.[3] Others are denominated from certain localities, as the *Madonna di Foligno* (now in the Vatican); others from the names of families to whom they have belonged, as *La Madonna della Famiglia Staffa*, at Perugia.

Those visions and miracles with which the Virgin Mary favoured many of the saints, as St. Luke (who was her secretary and painter), St. Catherine, St. Francis, St. Herman, and others, have already been related in the former volumes, and need not be repeated here.

With regard to the churches dedicated to the Virgin, I shall not attempt to enumerate even the most remarkable, as almost every town in Christian Europe contains one or more bearing her name. The most ancient of which tradition speaks, was a chapel beyond the Tiber, at Rome, which is said to have been founded in 217, on the site where S. Maria *in Trastevere* now stands. But there are one or two which carry their pretensions much higher ; for the cathedral at Toledo and the cathedral at Chartres both claim the honour of having been dedicated to the Virgin while she was yet alive.[4]

[1] In the Pitti Pal., Florence. [2] In our Nat. Gal.

[3] There is a beautiful engraving in Stirling's ' Annals of the Artists of Spain.'

[4] In England we have 2120 churches dedicated in her honour ; and one of the largest and most important of the London parishes bears her name—' St. Marie-la-bonne.'

Brief and inadequate as are these introductory notices, they will, I hope, facilitate the comprehension of the critical details into which it has been necessary to enter in the following pages, and lend some new interest to the subjects described. I have heard the artistic treatment of the Madonna styled a monotonous theme ; and to those who see only the perpetual iteration of the same groups on the walls of churches and galleries, varied as they may suppose only by the fancy of the painter, it may seem so. But beyond the visible forms, there lies much that is suggestive to a thinking mind—to the lover of Art a higher significance, a deeper beauty, a more various interest, than could at first be imagined.

In fact, the greatest mistakes in point of *taste* arise in general from not knowing what we ought to demand of the artist, not only in regard to the subject expressed, but with reference to the times in which he lived, and his own individuality. An axiom which I have heard confidently set forth, that a picture is worth nothing unless ' he who runs may read,' has inundated the world with frivolous and pedantic criticism. A picture or any other work of Art, is worth nothing except in so far as it has emanated from mind, and is addressed to mind. It should, indeed, be *read* like a book. Pictures, as it has been well said, are the books of the unlettered, but then we must at least understand the language in which they are written. And further—if, in the old times, it was a species of idolatry to regard these beautiful representations as endued with a specific sanctity and power ; so, in these days, it is a sort of atheism to look upon them reckless of their significance, regardless of the influences through which they were produced, without acknowledgment of the mind which called them into being, without reference to the intention of the artist in his own creation.

SUPPLEMENTARY NOTES TO THE SECOND EDITION.

I

Introduction, p. xxi.—In the first edition of this work, only a passing allusion was made to those female effigies, by some styled, ' *la donna orante*,' (the Praying Woman) and by others supposed to represent Mary the Mother of our Lord, of which so many examples exist in the Catacombs and in the sculptured groups on the ancient Christian sarcophagi. I know it has long been a disputed, or at least an unsettled and doubtful point, as to whether certain female figures existing on the earliest Christian monuments were or

were not intended to represent the Virgin Mary. The Protestants, on the one hand, as if still inspired by that superstition against superstition which led to the violent and vulgar destruction of so many beautiful works of art, and the Catholics on the other, jealous to maintain the authenticity of these figures as a testimony to the ancient worship of the Virgin, both appear to me to have taken an exaggerated and prejudiced view of a subject which ought to be considered dispassionately on purely antiquarian and critical grounds. Having had the opportunity, during a late residence in Italy, of reconsidering and comparing a great number of these antique representations, and having heard the opinions of antiquarians, theologians, and artists, who had given their attention to the subject, and who occasionally differed from each other as to the weight of evidence, I have arrived at the conviction, that some of these effigies represent the Virgin Mary, and others do not. I confess I do not believe in any authentic representation of the Virgin holding the Divine Child older than the sixth century, except when introduced into the groups of the Nativity and the Worship of the Magi. Previous to the Nestorian controversy, these maternal effigies, as objects of devotion, were, I still believe, unknown, but I cannot understand why there should exist among Protestants, so strong a disposition to discredit every representation of Mary the Mother of our Lord to which a high antiquity had been assigned by the Roman Catholics. We know that as early as the second century, not only symbolical figures of our Lord, but figures of certain personages of holy life, as St. Peter and St. Paul, Agnes the Roman, and Euphemia the Greek, martyr, did certainly exist. The critical and historical testimony I have given elsewhere.[1] Why therefore should there not have existed effigies of the Mother of Christ, of the 'Woman highly blessed,' the subject of so many prophecies, and naturally the object of a tender and just veneration among the early Christians? It seems to me that nothing could be more likely, and that such representations ought to have a deep interest for all Christians, no matter of what denomination—for all, in truth, who believe that the Saviour of the world had a good Mother, His only earthly parent, who brought him forth, nurtured and loved Him. That it should be considered a point of faith with Protestants to treat such memorials with incredulity and even derision, appears to me most inconsistent and unaccountable, though I confess that between these simple primitive memorials and the sumptuous tasteless column and image recently erected at Rome there is a very wide margin of disputable ground, of which I shall say no more in this place. But to return to the antique conception of the 'Donna orante' or so-called Virgin Mother, I will mention here only the most remark-

[1] Sacred and Legendary Art, pp. 560, 600.

able examples; for to enter fully into the subject would occupy a volume in itself.

There is a figure often met with in the Catacombs and on the sarcophagi of a majestic woman standing with outspread arms (the ancient attitude of prayer), or holding a book or scroll in her hand. When this figure stands alone and unaccompanied by any attribute, I think the signification doubtful: but in the Catacomb of St. Ciriaco there is a painted figure of a woman, with arms outspread and sustained on each side by figures, evidently St. Peter and St. Paul; on the sarcophagi the same figure frequently occurs; and there are other examples certainly not later than the third and fourth century. That these represent Mary the Mother of Christ I have not the least doubt; I think it has been fully demonstrated that no other Christian woman could have been so represented, considering the manners and habits of the Christian community at that period. Then the attitude and type are precisely similar to those of the ancient Byzantine Madonnas and the Italian mosaics of Eastern workmanship, proving, as I think, that there existed a common traditional original for this figure, the idea of which has been preserved and transmitted in these early copies.

Farther:—there exist in the Roman museums many fragments of ancient glass found in the Christian tombs, on which are rudely pictured in colours figures exactly similar, and having the name MARIA inscribed above them. On one of these fragments I found the same female figure between two male figures, with the names inscribed over them, MARIA. PETRVS. PAVLVS., generally in the rudest and most imperfect style, as if issuing from some coarse manufacture; but showing that they have had a common origin with those far superior figures in the Catacombs and on the sarcophagi, while the inscribed names leave no doubt as to the significance.

On the other hand, there are similar fragments of coarse glass found in the Catacombs—either lamps or small vases, bearing the same female in the attitude of prayer, and superscribed in rude letters, DULCIS ANIMA PIE ZESES VIVAS. (ZESES instead of JESUS.) Such may, possibly, represent, not the Virgin Mary, but the Christian matron or martyr buried in the tomb; at least, I consider them as doubtful.

The Cavaliere Rossi, whose celebrity as an antiquary is not merely Italian, but European, and whose impartiality can hardly be doubted, told me that a Christian sarcophagus had lately been discovered at Saint-Maxime, in the south of France, on which there is the same group of the female figure praying, and over it the name MARIA.

I ought to add, that on one of these sarcophagi, bearing the oft-repeated

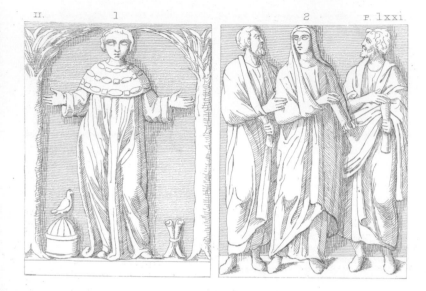

II. 1 2 P. lxxi.

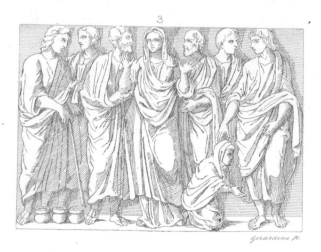

3

Gerardine fc.

Ancient Christian Sculpture.

subject of the good Shepherd feeding His sheep, I found, as the companion group, a female figure in the act of feeding birds which are fluttering to her feet. It is not doubted that the good Shepherd is the symbol of the beneficent Christ ; whether the female figure represent the Virgin-mother, or is to be regarded merely as a general symbol of female beneficence, placed on a par with that of Christ (in His human character), I will not pretend to decide. It is equally touching and beautiful in either significance.

In the annexed etching I have given three examples of these figures.

The first is taken from a Christian sarcophagus of early date, and in a good style of art, probably of the third century—it is a noble figure, in the attitude of prayer, and separated from the other groups by a palm-tree on each side—at her feet is a bird (perhaps a dove, the ancient symbol of the released soul), and scrolls which represent the gospel. I regard this figure as doubtful ; it may possibly be the effigy of a Christian matron, who was interred in the sarcophagus.

The second example is also taken from a sarcophagus. It is a figure holding a scroll of the gospel, and standing between St. Peter and St. Paul : on each side (in the original) there are groups expressing the beneficent miracles of our Lord. This figure, I believe, represents the Virgin Mary.

In the third example, I have shown the manner in which this conspicuous female figure is combined with the series of groups on each side. She stands with hands outspread, in the attitude of prayer, between the two apostles, who seem to sustain her arms. On one side is the miracle of the water changed into wine ; on the other side, Christ healing the woman who touched his garment ; both of perpetual recurrence in these sculptures. Of these groups of the miracles and actions of Christ on the early Christian sarcophagi, I shall give a full account in the ' History of our Lord, as illustrated in the fine arts ; ' at present I confine myself to the female figure which takes this conspicuous place, while other female figures are prostrate, or of a diminutive size, to express their humility or inferiority ; and I have no doubt that thus situated it is intended to represent the woman who was highly honoured as well as highly blessed—the Mother of our Saviour.

I have come therefore to the conclusion, that while many of these figures have a certain significance, others are uncertain. Where the figure is isolated, or placed within a frame or border, like the memorial busts and effigies on the Pagan sarcophagi, I think it may be regarded as probably commemorating the Christian martyr or matron entombed in the sarcophagus ; but when there is no division, where the figure forms part of a continuous series of groups, expressing the character and miracles of Christ, I believe that it represents His mother.

II

P. 45.—The BORGHESE CHAPEL, in the church of St. Maria Maggiore at Rome, was dedicated to the honour of the Virgin Mary by Paul V. (Borghese), in 1611 —the same Pope who in 1615 promulgated the famous Bull relative to the Immaculate Conception.[1] The scheme of decoration in this gorgeous chapel is very remarkable, as testifying to the development which the theological idea of the Virgin, as the Sposa or personified Church, had attained at this period, and because it is not, as in other examples, either historical or devotional, but purely doctrinal.

As we enter, the profusion of ornament, the splendour of colour, marbles, gilding, from the pavement under our feet to the summit of the lofty dome, are really dazzling. First, and elevated above all, we have the 'Madonna della Concezione,' Our Lady of the Immaculate Conception, in a glory of light, sustained and surrounded by angels, having the crescent under her feet, according to the approved treatment.[2] Beneath, round the dome, we read in conspicuous letters the text from the Revelations :—SIGNUM. MAGNUM. APPARAVIT. IN CŒLO. MULIER. AMICTA. SOLE. ET. LUNA. SUB. PEDIBUS. EJUS. ET. IN CAPITE. EJUS. CORONA. STELLARUM. DUODECIM.[3] Lower down is a second inscription, expressing the dedication. MARIÆ. CHRISTI. MATRI. SEMPER. VIRGINI. PAULUS. QUINTUS. P.M. The decorations beneath the cornice consist of eighteen large frescos, and six statues in marble, above life size. Beginning with the frescos, we have the subjects arranged in the following order :—

1. The four great prophets, Isaiah, Jeremiah, Ezekiel, and Daniel, in their usual place in the four pendatives of the dome.[4]

2. Two large frescos. In the first, the Vision of St. Gregory Thaumaturgus,[5] and Heretics bitten by Serpents. In the second, St. John Damascene and St. Ildefonso miraculously rewarded for defending the Majesty of the Virgin.[6]

3. A large fresco, representing the four Doctors of the Church who had especially written in honour of the Virgin : viz. Ireneus and Cyprian, Ignatius and Theophilus, grouped two and two.

4. St. Luke, who painted the Virgin, and whose gospel contains the best account of her.

5. As spiritual conquerors in the name of the Virgin, St. Dominic and St. Francis, each attended by two companions of his Order.

[1] See p. 45. [2] See p. 42. [3] Rev. xii. 1. [4] v. The Introduction, p. xlix.
[5] St. Gregory Thaumaturgus, Bishop of Pontus in the third century, was favoured by a vision of the Trinity, which enabled him to confute and utterly subdue the Sabellian heretics —the Unitarians of his time. [6] Sacred and Legendary Art, p. 324.

6. As military conquerors in the name of the Virgin, the Emperor Heraclius, and Narses, the general against the Arians.

7. A group of three female figures, representing the three famous saintly princesses who in marriage preserved their virginity, Pulcheria, Edeltruda (our famous queen Ethelreda), and Cunegunda.[1]

8. A group of three learned Bishops, who had especially defended the immaculate purity of the Virgin, St. Cyril, St. Anselm, and St. Denis (?).

9. The miserable ends of those who were opposed to the honour of the Virgin. 1. The death of Julian the Apostate, very oddly represented; he lies on an altar, transfixed by an arrow, as a victim; St. Mercurius in the air.[2] 2. The death of Leo IV., who destroyed the effigies of the Virgin. 3. The death of Constantine IV., also a famous iconoclast.

The statues which are placed in niches are—

1, 2. St. Joseph, as the nominal husband, and St. John the Evangelist, as the nominal son of the Virgin; the latter, also, as prophet and poet, with reference to the passage in the Revelation, c. xii. 1.

3, 4. Aaron, as priestly ancestor (because his wand blossomed), and David, as kingly ancestor of the Virgin. (See p. xlix.)

5, 6. St. Dionysius the Areopagite, who was present at the death of the Virgin,[3] and St. Bernard, who composed the famous 'Salve Regina' in her honour.

Such is this grand systematic scheme of decoration, which, to those who regard it cursorily, is merely a sumptuous confusion of colours and forms, or at best, 'a fine example of the Guido school and Bernino.' It is altogether a very complete and magnificent specimen of the prevalent style of art, and a very comprehensive and suggestive expression of the prevalent tendency of thought in the Roman Catholic Church from the beginning of the seventeenth century. In no description of this chapel have I ever seen the names and subjects accurately given: the style of art belongs to the *decadence*, and the taste being worse than questionable, the pervading *doctrinal* idea has been neglected, or never understood.

III

P. 51.—Those pictures which represent the Virgin Mary kneeling before the celestial throne, while the PADRE ETERNO or the MESSIAH extends his

[1] For the legends of Cunegunda and Ethelreda, see Legends of the Monastic Orders.
[2] For this legend see Sacred and Legendary Art, p. 781.
[3] See the Legend, p. 307, and Sacred and Legendary Art, p. 124, 3rd edit.

hand or his sceptre towards her, are generally misunderstood. They do not represent the Assumption, nor yet the reception of Mary in Heaven, as is usually supposed; but the election or predestination of Mary as the immaculate vehicle or tabernacle of human redemption—the earthly parent of the divine Saviour. I have described such a picture by Dosso Dossi at p. 47, and another by Cottignola at p. 53. A third example may be cited in a yet more beautiful and celebrated picture by Francia, now in the Church of San Frediano at Lucca. Above, in the glory of Heaven, the Virgin kneels before the throne of the Creator; she is clad in regal attire of purple and crimson and gold; and she bends her fair crowned head, and folds her hands upon her bosom with an expression of meek yet dignified resignation—'*Behold the handmaid of the Lord!*'—accepting, as woman, that highest glory, as mother, that extremest grief, to which the Divine will, as spoken by the prophets of old, had called her. Below, on the earth and to the right hand, stand David and Solomon, as prophets and kingly ancestors: on the left hand, St. Augustine and St. Anselm in their episcopal robes. (I have mentioned, with regard to the office in honour of the Immaculate Conception, that the idea is said to have originated in England; v. p. 43. I should also have added, that Anselm, Archbishop of Canterbury, was its strenuous advocate.) Each of these personages holds a scroll. On that of David the reference is to the 4th and 5th verses of Psalm xxvii.—'*In the secret of his tabernacle he shall hide me.*' On that of Solomon is the text from his Song, ch. iv. 7. On that of St. Augustine, a quotation, I presume, from his works, but difficult to make out; it seems to be, '*In cœlo qualis est Pater, talis est Filius; qualis est Filius, talis est Mater.*' On that of St. Anselm the same inscription which is on the picture of Cottignola quoted at p. 53, '*non puto verè esse,*' &c., which is, I suppose, taken from his works. In the centre, St. Anthony of Padua kneels beside the sepulchre full of lilies and roses; showing the picture to have been painted for, or under the influence of, the Franciscan Order; and, like other pictures of the same class, 'an attempt to express in a visible form the idea or promise of the redemption of the human race, as existing in the Sovereign Eternal Mind before the beginning of the world.' This altar-piece has no date, but appears to have been painted about the same time as the picture in our National Gallery (No. 179), which came from the same church. As a work of art it is most wonderfully beautiful. The editors of the last excellent edition of Vasari speak of it with just enthusiasm as '*Opera veramente stupenda in ogni parte!*' The predella beneath, painted in chiaroscuro, is also of exquisite beauty; and let us hope that we shall never see it separated from the great subject, like a page or a paragraph torn out of a book, by ignorant and childish collectors.

IV

P. 148.—Although the Nativity of the Virgin Mary is one of the great festivals of the Roman Catholic Church, I have seldom seen it treated as a separate subject and an altar-piece. There is, however, a very remarkable example in the Belle Arti at Siena. It is a triptych inclosed in a framework elaborately carved and gilt, in the Gothic style. In the centre compartment, St. Anna lies on a rich couch covered with crimson drapery; a graceful female presents an embroidered napkin, others enter, bringing refreshments, as usual. In front, three attendants minister to the Infant: one of them is in an attitude of admiration; on the right, Joachim seated, with white hair and beard, receives the congratulations of a young man who seems to envy his paternity. In the compartment on the right stand St. James Major and St. Catherine; on the left, St. Bartholomew and St. Elizabeth of Hungary (?). This picture is in the hard primitive style of the fourteenth century, by an unknown painter, who must have lived before Giovanni di Paolo, but vividly coloured, exquisitely finished, and full of sentiment and dramatic feeling.

V

P. 311.—The woodcut which represents St. Michael holding a taper and announcing to the Virgin her approaching death, is from the centre compartment of a predella now in the Belle Arti at Florence; (in the Catalogue, No. 42.) It is said to be the predella which belongs properly to the great altar-piece by Fra Filippo Lippi, now in the Louvre, and formerly in the S. Spirito at Florence. In the original composition, which I ought to have given entire, we see the miraculous assemblage of the Apostles: Peter is entering at the door, and the others, conducted by angels, are entering the portico behind the Virgin.[1] (In the Catalogue it is called ' The Annunciation,' which is a mistake.) On one side of this subject we have the vision of the Trinity appearing to St. Gregory Thaumaturgus,[2] and on the other, St. Frediano turning the course of the Serchio, both of whom were Augustins, to which Order the Church of the S. Spirito belongs, and these are probably the two saints (called in the French Catalogue ' deux saints évêques ') who are kneeling in front of the grand picture in the Louvre. This is one of many instances in which the separation of the parts of an altar-piece becomes a source of embarrassment to the critic and antiquary. These ' deux saints évêques ' were a great vexation to me, till I found the predella of the altar at Florence.

[1] v. the Legend, p. 307. [2] v. p. lxxii. note.

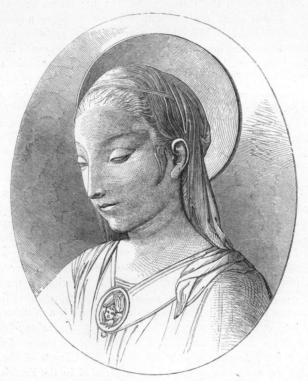

164 Head of the **Virgin Mary** (early Florentine Sculpture).

Devotional Subjects.

PART I.

The Virgin without the Child.

1. LA VERGINE GLORIOSA.
2. L' INCORONATA.
3. LA MADONNA DI MISERICORDIA.
4. LA MADRE DOLOROSA.
5. LA CONCEZIONE.

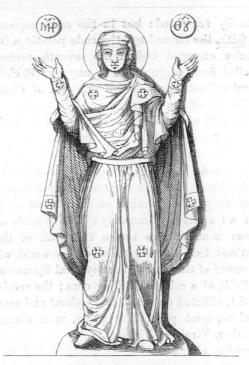

1 The Virgin of Ravenna. (Greek Bas-relief. 6th century.)

The Virgin without the Child.

THE VIRGIN MARY.

Lat. 1. Virgo Gloriosa. 2. Virgo Sponsa Dei. 3. Virgo Potens. 4. Virgo Veneranda. 5. Virgo Prædicanda. 6. Virgo Clemens. 7. Virgo Sapientissima. 8. Sancta Virgo Virginum. *Ital.* La Vergine Gloriosa. La Gran Vergine delle Vergini. *Fr.* La Grande Vierge.

THERE are representations of the Virgin, and among them some of the earliest in existence, which place her before us as an object of religious veneration, but in which the predominant idea is not that of her maternity. No doubt it was as the mother of the Saviour Christ that

she was originally venerated : but in the most ancient monuments of the Christian faith, the sarcophagi, the rude paintings in the catacombs, and the mosaics executed before the seventh century, she appears simply as a veiled female figure, not in any respect characterised. She stands, in a subordinate position, on one side of Christ ; St. Peter or St. John the Baptist on the other.

When the worship of the Virgin came to us from the East, with it came the Greek type — and for ages we had no other — the Greek classical type, with something of the Oriental or Egyptian character. (1) When thus she stands before us without her Son, and the apostles or saints on each side taking the subordinate position, then we are to regard her not only as the mother of Christ, but as the second Eve, the mother of all suffering humanity ; THE WOMAN of the primæval prophecy whose issue was to bruise the head of the Serpent ; the Virgin predestined from the beginning of the world who was to bring forth the Redeemer of the world ; the mystical Spouse of the Canticles ; the glorified Bride of a celestial Bridegroom ; the received Type of the Church of Christ, afflicted on earth, triumphant and crowned in heaven ; the most glorious, most pure, most pious, most clement, most sacred Queen and Mother, Virgin of Virgins.

The form under which we find this grand and mysterious idea of glorified womanhood originally embodied is wonderfully majestic and simple. A female figure of colossal dimensions, far exceeding in proportion all the attendant personages and accessories, stands immediately beneath some figure or emblem representing almighty power : either it is the omnipotent hand stretched out above her, holding the crown of immortality ; or it is the mystic dove which hovers over her ; or it is the half-form of Christ, in the act of benediction.

She stands with arms raised and extended wide, the ancient attitude of prayer (2) ; or with hands merely stretched forth, expressing admiration, humility, and devout love (3). She is attired in an ample tunic of blue or white, with a white veil over her head, thrown a little back, and displaying an oval face with regular features, mild, dignified —sometimes, in the figures of the ruder ages, rather stern and melancholy, from the inability of the artist to express beauty ; but when least beautiful, and most formal and motionless, always retaining some-

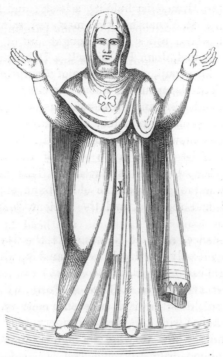

2 Virgin of San Venanzio. (A.D. 642. Mosaic.)

thing of the original conception, and often inexpressibly striking and majestic.

The earliest figure of this character to which I can refer is the mosaic in the oratory of San Venanzio, in the Lateran (2), the work of Greek artists under the popes John IV. and Theodorus, both Greeks by birth, and who presided over the Church from 640 to 649. In the vault of the tribune, over the altar, we have first, at the summit, a figure of Christ half-length, with his hand extended in benediction ; on each side, a worshipping angel ; below, in the centre, the figure of the Virgin according to the ancient type, standing with extended arms, in a violet or rather dark-blue tunic and white veil, with a small cross pendant on her bosom. On her right hand stands St. Paul, on her left St. Peter ; beyond St. Peter and St. Paul, St. John the Baptist holding a cross,

and St. John the Evangelist holding a book ; and beyond these again, St. Domnio and St. Venantius, two martyred saints, who perished in Dalmatia, and whose relics were brought out of that country by the founder of the chapel, John IV., himself a Dalmatian by birth. At the extremities of this group, or rather line of figures, stand the two popes, John IV. and Theodorus, under whom the chapel was founded and dedicated. Although this ancient mosaic has been many times restored, the original composition remains; and I have given the figure of the Virgin from the somewhat coarse engraving in Ciampini.

Similar, but of later date, is the effigy of the Virgin over the altar of the archiepiscopal chapel at Ravenna. This mosaic, with others of Greek work, was brought from the old tribune of the cathedral, when it was altered and repaired, and the ancient decorations removed or destroyed.

Another instance, also, at Ravenna, is the basso-relievo in Greek marble, and evidently of Greek workmanship, which is said to have existed from the earliest ages, in the church of S. Maria-in-Porto-Fuori, and is now preserved in the S. Maria-in-Porto, where I saw it in 1847. It is probably as old as the sixth or seventh century. I give an accurate sketch of the figure with the formal drapery. (1) The features, which I could not render, are very regular and beautiful, quite the Greek type.

In St. Mark's at Venice, in the grand old basilica at Torcello, in San Donato at Murano, at Monreale, near Palermo, and in most of the old churches in the East of Europe, we find similar figures, either Byzantine in origin, or in imitation of the Byzantine style. (3)

But about the middle of the thirteenth century, and contemporary with Cimabue, we find the first indication of a departure, even in the mosaics, from the lifeless, formal type of Byzantine art. The earliest example of a more animated treatment is, perhaps, the figure in the apsis of St. John Lateran.[1] In the centre is an immense cross, emblem of salvation; the four rivers of Paradise (the four Gospels) flow from its base ; and the faithful, figured by the hart and the sheep, drink from these streams. Below the cross is represented, of a small size, the New

[1] Rome.

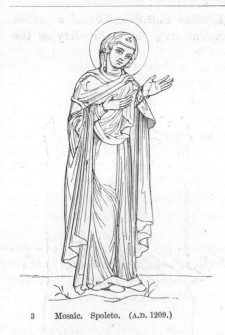

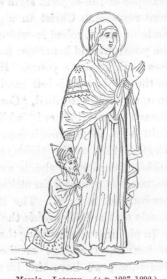

3 Mosaic. Spoleto. (A.D. 1209.) 4 Mosaic. Lateran. (A.D. 1287–1292.)

Jerusalem guarded by an archangel. On the right stands the Virgin, of colossal dimensions. (4) She places one hand on the head of a diminutive kneeling figure, Pope Nicholas IV.,[1] by whom the mosaic was dedicated about 1290; the other hand, stretched forth, seems to recommend the votary to the mercy of Christ.

Full-length effigies of the Virgin seated on a throne, or glorified as queen of heaven, or queen of angels, without her divine Infant in her arms, are exceedingly rare in every age; now and then to be met with in the early pictures and illuminations, but never, that I know of, in the later schools of art. A signal example is the fine enthroned Madonna in the Campo Santo, who receives St. Ranieri when presented by St. Peter and St. Paul. I give a sketch from this majestic figure, because of the beauty and dignity as well as the rarity of the subject. (5)

On the Dalmatica (or Deacon's robe) preserved in the sacristy of

[1] For a minute reduction of the whole composition, see Kugler's Handbook, p. 113.

St. Peter's at Rome (which Lord Lindsay well describes as a perfect example of the highest style of Byzantine art),[1] the embroidery on the front represents Christ in a golden circle or glory, robed in white, with the youthful and beardless face, his eyes looking into yours. He sits on the rainbow; his left hand holds an open book, inscribed, ' Come, ye blessed of my Father! ' while the right is raised in benediction. The Virgin stands on the right entirely *within* the glory; ' she is sweet in feature and graceful in attitude, in her long white robe.' The Baptist stands on the left *outside* the glory.

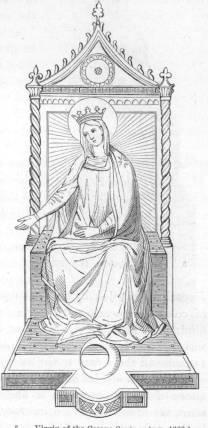

5 Virgin of the Campo Santo. (A.D. 1360.)

In pictures representing the glory of heaven, Paradise, or the Last Judgment, we have this idea constantly repeated—of the Virgin on the right hand of her Son, but not on the same throne with him, unless it be a ' Coronation,' which is a subject apart.

In the great altar-piece of the brothers Van Eyck, the upper part contains three compartments;[2] in the centre is Christ, wearing the triple tiara, and carrying the globe, as King, as Priest, as Judge; on each side, as usual, but in separate compartments, the Virgin and St. John the Baptist. The Virgin, a noble queenly figure, full of serene dignity and grace, is seated on a throne, and wears a superb crown,

[1] Christian Art, i. 136.

[2] It is well known that the different parts of this great work have been dispersed. The three compartments mentioned here are at Berlin.

formed of lilies, roses, and gems, over her long fair hair. She is reading intently in a book—The Book of Wisdom. She is here the *Sponsa Dei*, and the *Virgo Sapientissima*, the most wise Virgin. This is

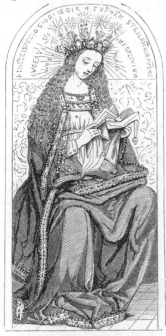

6 Virgo Sapientissima.

the only example I can recollect of the Virgin seated on the right hand of her Son in glory, and *holding a book*. In every other instance she is standing or seated with her hands joined or crossed over her bosom, and her eyes turned towards him.

Among innumerable examples, I will cite only one, perhaps the most celebrated of all, and familiar, it may be presumed, to most of my readers, though perhaps they may not have regarded it with reference to the character and position given to the Virgin. It is one of the four great frescoes of the Camera della Segnatura, in the Vatican, exhibiting the four highest objects of mental culture—Theology, Poetry, Philosophy, and Jurisprudence. In the first of these, commonly, but erroneously, called *La Disputa dell' Sacramento*, Raphael has combined into one great scene the whole system of theology, as set forth by the Catholic Church; it is a sort of concordance between heaven and earth —between the celestial and terrestrial witnesses of the truth. The central group above shows us the Redeemer of the world, seated with extended arms, having on the right the Virgin in her usual place, and on the left, also in his accustomed place, St. John the Baptist; both seated, and nearly on a level with Christ. The Baptist is here in his character of the Precursor 'sent to bear witness to the light, that through him all men might believe.'[1] The Virgin is exhibited, not merely as the Mother, the Sposa, the Church, but as HEAVENLY WISDOM, for in this character the Catholic Church has applied to her

[1] John i. 7.

C

the magnificent passage in Proverbs: 'The Lord possessed me in the beginning of His way, before His works of old. I was set up from everlasting, from the beginning, or ever the earth was.' 'Then I was by Him as one brought up with Him, and I was daily His delight, rejoicing alway before Him.'[1]

Nothing can be more beautiful than the serene grace and the mingled majesty and humility in the figure of the Virgin, and in her countenance, as she looks up adoring to the Fountain of *all* light, *all* wisdom, and *all* goodness. Above the principal group, is the emblematical image of the FATHER; below is the holy Dove, in the act of descending to the earth. The rest of this wonderful and suggestive composition I omit here, as foreign to my subject.[2]

The Virgin alone, separate from her Son, standing or enthroned before us, simply as the *Vergine Dea*, or *Regina Cœli*, is rarely met with in modern art, either in sculpture or painting. I will give, however, one single example.

7 Regina Virginum.

In an altar-piece painted by Cosimo Rosselli, for the Serviti at Florence, she stands alone, and in a majestic attitude, on a raised pedestal. She holds a book, and looks upward to the holy Dove, hovering over her head; she is here again the *Virgo Sapientiæ*.[3] On one side are St. John the Evangelist and St. Antonino of Florence;[4] on the other, St. Peter and St. Philip Benozzi; in front kneel St. Margaret and St. Catherine: all appear to contemplate with rapturous devotion the vision of the Madonna. The

[1] Prov. viii. 12–36, and Eccles. xxiv. 15, 16.

[2] For a detailed description of this fresco, see Passavant's Raphael, i. 140, and Kugler's Handbook, 2nd edit., where a minute and beautiful reduction of the whole composition will give an idea of the general design.

[3] Fl. Gal. [4] See Legends of the Monastic Orders, p. 397.

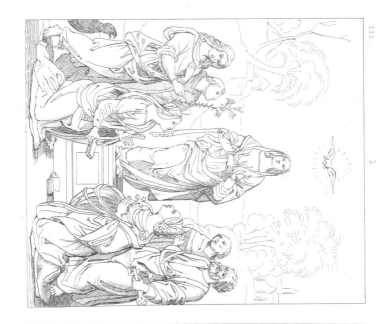

Madonna di Sapienza.

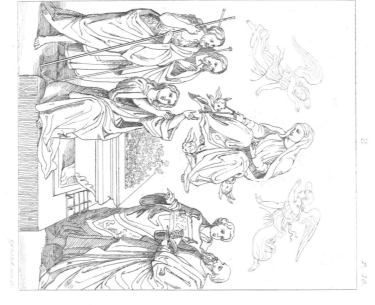

Madonna della Giritola.

heads and attitudes in this picture have that character of elegance which distinguished the Florentine school at this period, without any

8 Regina Cœli.

of those extravagancies and peculiarities into which Piero often fell; for the man had evidently a touch of madness, and was as eccentric in his works as in his life and conversation. The order of the Serviti, for whom he painted this picture, was instituted in honour of the Virgin, and for her particular service, which will account for the unusual treatment.[1]

The numerous—often most beautiful—heads and half-length figures which represent the Virgin alone, looking up with a devout or tender expression, or with the head declined, and the hands joined in prayer, or crossed over the bosom with virginal humility and modesty, belong to this class of representations. In the

9 Santa Maria Vergine. (Guido.)

ancient heads, most of which are imitations of the old Greek effigies

[1] Monastic Orders, p. 213.

c 2

ascribed to St. Luke, there is often great simplicity and beauty. When she wears the crown over her veil, or bears a sceptre in her hand, she figures as the queen of heaven (*Regina Cœli*). When such effigies are attended by adoring angels, she is the queen of angels (*Regina Angelorum*). When she is weeping or holding the crown of thorns, she is Our Lady of Sorrow, the *Mater Dolorosa*. When she is merely veiled, with folded hands, and in her features all the beauty, maiden purity, and sweetness which the artist could render, she is simply the Blessed Virgin, the Madonna, the *Santa Maria Vergine*. Such heads are very rare in the earlier schools of art, which seldom represented the Virgin without her Child, but became favourite studies of the later painters, and were multiplied and varied to infinitude from the beginning of the seventeenth century. From these every trace of the mystical and solemn conception of antiquity gradually disappeared; till, for the majestic ideal of womanhood, we have merely inane prettiness, or rustic, or even meretricious grace, the borrowed charms of some earthly model.

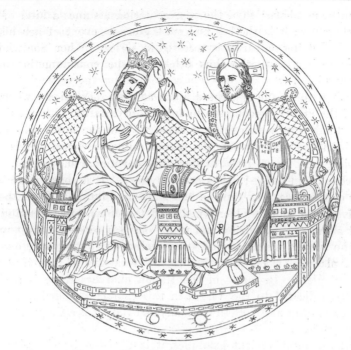

11 Coronation. (Mosaic, 1290.)

L' Incoronata.

The Coronation of the Virgin. *Lat.* Coronatio Beatæ Mariæ Virginis. *Ital.* Maria coronata
 dal divin suo Figlio. *Fr.* Le Couronnement de la Sainte Vierge. *Ger.* Die Krönung
 Mariä.

The usual type of the Church triumphant is the Coronation of the
Virgin properly so called, Christ in the act of crowning his Mother;
one of the most popular, significant, and beautiful subjects in the whole
range of mediæval art.

When in a series of subjects from the life of the Virgin, so often met
with in religious prints and in the Roman Catholic churches, we find
her death and her assumption followed by her coronation; when the
bier or sarcophagus and the twelve apostles appear below, while heaven

opens upon us above; then the representation assumes a kind of dramatic character: it is the last and most glorious event of her history. The Mother, dying on earth, is received into glory by her Son who had gone before her, and who thus celebrates the consummation of his victory and hers.

But when the scene is treated apart as a single subject; when, instead of the apostles gazing up to heaven, or looking with amazement into the tomb from which she had risen, we find the lower part of the composition occupied by votaries, patron saints, or choral angels; then the subject must be regarded as absolutely devotional and typical. It is not a scene or an action; it is a great mystery. It is consecrated to the honour of the Virgin as type of the spiritual Church. The Espoused is received into glory and crowned with the crown of everlasting life, exalted above angels, spirits, and men. In this sense we must understand the subject when we find it in ecclesiastical sculpture, over the doors of places of worship, in the decorative carving of church utensils, in stained glass. In many of the Italian churches there is a chapel especially dedicated to the Virgin in this character, called *la Capella dell' Incoronata*; and both in Germany and Italy it is a frequent subject as an altar-piece.

In all the most ancient examples, it is Christ only who places the crown on the head of his Mother, seated on the same throne and placed at his right hand. Sometimes we have the two figures only; sometimes the *Padre Eterno* looks down, and the Holy Spirit in the form of the dove hovers above or between them. In some later examples the Virgin is seated between the Father and the Son, both in human form: they place the crown on her head, each holding it with one hand, the Holy Spirit hovering above. In other representations the Virgin *kneels* at the feet of Christ, and he places the crown on her head, while two or more rejoicing and adoring angels make heavenly music, or all Paradise opens to the view; and there are examples where not only the choir of attendant angels, but a vast assembly of patriarchs, saints, martyrs, fathers of the Church — the whole company of the blessed spirits — assist at this great ceremony.

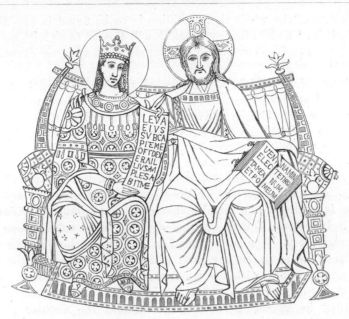

12 Virgin and Christ enthroned. (Mosaic. A.D. 1130–1143.)

I will now give some celebrated examples of the various styles of treatment, which will be better than pages of general description.

There is a group in mosaic, which I believe to be singular in its kind, where the Virgin is enthroned with Christ. (12) She is seated at his right hand, at the same elevation, and altogether as his equal. His right arm embraces her, and his hand rests on her shoulder. She wears a gorgeous crown, which her Son has placed on her brow. Christ has only the cruciform nimbus; in his left hand is an open book, on which is inscribed, ' *Veni, Electa mea,*' &c. 'Come, my chosen one, and I will place thee upon my throne.' The Virgin holds a tablet, on which are the words 'His right hand should be under my head, and his left hand should embrace me.'[1] The omnipotent hand is stretched forth in benediction above. Here the Virgin is the type of the Church triumphant and glorified, having overcome the world; and the solemn

[1] Cant. viii. 3.

significance of the whole representation is to be found in the Book of Revelations: ' To him that overcometh will I grant *to sit with me in my throne*, even as I also overcame and am set down with my Father in his throne.' [1]

This mosaic, in which, be it observed, the Virgin is enthroned with Christ, and *embraced*, not crowned, by him, is, I believe, unique either as a picture or a church decoration. It is not older than the twelfth century, is very ill executed, but is curious from the peculiarity of the treatment. [2]

In the mosaic in the tribune of S. Maria-Maggiore at Rome, perhaps the earliest example extant of the Coronation, properly so called, the subject is treated with a grand and solemn simplicity. (11) Christ and the Virgin, colossal figures, are seated on the same regal throne within a circular glory. The back-ground is blue studded with golden stars. He places the crown on her head with his right hand; in the left he holds an open book, with the usual text, ' *Veni, Electa mea, et ponam te in thronum meum*,' &c. She bends slightly forward, and her hands are lifted in adoration. Above and around the circular glory the emblematical vine twines in arabesque form: among the branches and leaves sit peacocks and other birds; the peacock being the old emblem of immortality, as birds in general are emblems of spirituality. On each side of the glory are nine adoring angels, representing the nine choirs of the heavenly hierarchy; beyond these on the right stand St. Peter, St. Paul, St. Francis; on the left, St. John the Baptist, St. John the Evangelist, and St. Antony of Padua; all these figures being very small in proportion to those of Christ and the Virgin. Smaller still, and quite diminutive in comparison, are the kneeling figures of Pope Nicholas IV. and Cardinal Giacomo Colonna, under whose auspices the mosaic was executed by Jacopo della Turrita, a Franciscan friar, about 1288. In front flows the river Jordan, symbol of baptism and regeneration; on its shore stands the hart, the emblem of religious aspiration. Underneath the central group is the inscription,—

> MARIA VIRGO ASSUMPTA AD ETHERIUM THALAMUM
> IN QUO REX REGUM STELLATO SEDET SOLIO.

[1] Rev. iii. 21. [2] Rome. S. Maria in Trastevere.

The whole of this vast and poetical composition is admirably executed, and it is the more curious as being, perhaps, one of the earliest examples of the glorification of St. Francis and St. Antony of Padua,[1] who were canonised about thirty or forty years before.[2]

The mosaic, by Gaddo Gaddi,[3] over the great door in the cathedral at Florence, is somewhat different. Christ, while placing the crown on the head of his Mother with his *left* hand, blesses her with his right hand, and he appears to have laid aside his own crown, which lies near him. The attitude of the Virgin is also peculiar.[4]

In a small altar-piece by Giotto,[5] Christ and the Virgin are seated together on a throne. He places the jewelled crown on her head with *both* hands, while she bends forward with her hands crossed in her lap, and the softest expression in her beautiful face, as if she as meekly resigned herself to this honour, as heretofore to the angelic salutation which pronounced her ' Blessed : ' angels kneel before the throne with censers and offerings. In another, by Giotto,[6] Christ wearing a coronet of gems is seated on a throne : the Virgin *kneels* before him with hands joined : twenty angels with musical instruments attend around. In this ' Coronation,' by Piero Laurati, the figures of Christ and the Virgin, seated together, resemble in sentiment and expression those of Giotto. The angels are arranged in a glory around, and the treatment is wholly typical. (13)

One of the most beautiful and celebrated of the pictures of Angelico da Fiesole is the ' Coronation ' now in the Louvre; formerly it stood over the high altar of the Church of St. Dominick at Fiesole, where Angelico had been nurtured, and made his profession as monk. The composition is conceived as a grand regal ceremony, but the beings who

[1] Monastic Orders, 2nd edit. 238–278.

[2] I have given the central group only, because in the last edition of Kugler's Handbook, vol. i., may be found a beautiful and elaborate reduction of the whole composition, by Mr. George Scharf. The same volume contains the Mosaic of the Lateran mentioned at p. 7, and an exquisite reduction of the ' Coronation,' by Angelico da Fiesole, to which I must refer the reader. [3] Florence, A.D. 1330.

[4] In the same cathedral (which is dedicated to the Virgin Mary) the circular window of the choir opposite to the Mosaic exhibits the Coronation. The design, by Donatello, is eminently fine and classical. [5] Florence, S. Croce.

[6] D'Agincourt, Peinture, pl. cxiv.

D

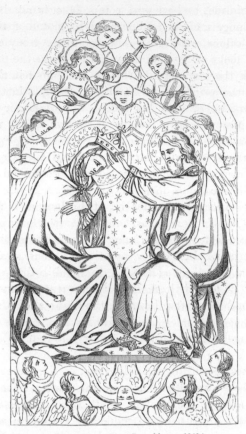

13 Coronation. (Piero Laurati, A.D. 1340.)

figure in it are touched with a truly celestial grace. The Redeemer, crowned himself, and wearing the ermine mantle of an earthly monarch, is seated on a magnificent throne, under a Gothic canopy, to which there is an ascent of nine steps. He holds the crown, which he is in the act of placing, with both hands, on the head of the Virgin, who kneels before him, with features of the softest and most delicate beauty, and an expression of divine humility. Her face, seen in profile, is partly shaded by a long transparent veil, flowing over her ample robe

of a delicate crimson, beneath which is a blue tunic. On each side a choir of lovely angels, clothed from head to foot in spangled tunics of azure and rose-colour, with shining wings, make celestial music, while they gaze with looks of joy and adoration towards the principal group. Lower down on the right of the throne are eighteen, and on the left twenty-two, of the principal patriarchs, apostles, saints, and martyrs; among whom the worthies of Angelico's own community, St. Dominick and St. Peter Martyr, are of course conspicuous. At the foot of the throne kneel on one side St. Augustine, St. Benedict, St. Charlemagne, the royal saint; St. Nicholas; and St. Thomas Aquinas holding a pen (the great literary saint of the Dominican order, and author of the Office of the Virgin); on the left we have a group of virgins, St. Agnes, St. Catherine with her wheel, St. Catherine of Siena, her habit spangled with stars; St. Cecilia crowned with her roses, and Mary Magdalene, with her long golden hair.[1] Beneath this great composition runs a border or predella, in seven compartments, containing in the centre a Pietà, and on each side three small subjects from the history of St. Dominick, to whom the church, whence it was taken, is dedicated. The spiritual beauty of the heads, the delicate tints of the colouring, an ineffable charm of mingled brightness and repose shed over the whole, give to this lovely picture an effect like that of a church hymn, sung at some high festival by voices tuned in harmony—'blest voices, uttering joy!'

In strong contrast with this graceful Italian conception, is the German 'Coronation,' now in the Wallerstein collection.[2] It is supposed to have been painted for Philip the Good, Duke of Burgundy, either by Hans Hemling, or a painter not inferior to him. Here the Virgin is crowned by the Trinity. She kneels, with an air of majestic humility, and hands meekly folded on her bosom, attired in simple blue drapery, before a semicircular throne, on which are seated the Father and the Son, between them, with outspread wings touching their mouths, the Holy Dove. The Father, a venerable figure, wears the triple tiara, and holds the sceptre: Christ, with an expression of suffering,

[1] See Legends of the Monastic Orders, and Sacred and Legendary Art, for an account of all these personages. [2] Kensington Pal.

holds in his left hand a crystal cross; and they sustain between them a crown which they are about to place on the head of the Virgin. Their golden throne is adorned with gems, and over it is a glory of seraphim, with hair, faces, and plumage, all of a glowing red. The lower part of this picture and the compartments on each side are filled with a vast assemblage of saints, and martyrs, and holy confessors; conspicuous among them we find the saints most popular in Flanders and Burgundy — St. Adrian, St. George, St. Sebastian, St. Maurice, clad in coats of mail and crowned with laurel, with other kingly and warlike personages; St. Philip, the patron of Philip the Good; St. Andrew, in whose honour he instituted the order of the Golden Fleece: and a figure in a blue mantle with a ducal crown, one of the three kings of Cologne, is supposed to represent Duke Philip himself. It is impossible by any description to do justice to this wonderful picture, as remarkable for its elaborate workmanship, the mysticism of the conception, the quaint elegance of the details, and portrait-like reality of the faces, as that of Angelico for its spiritual, tender, imaginative grace.

There is a 'Coronation' by Vivarini,[1] which may be said to comprise in itself a whole system of theology. It is one vast composition, not divided by compartments. In the centre is a magnificent carved throne sustained by six pillars, which stand on a lofty richly ornamented pedestal. On the throne are seated Christ and the Virgin; he is crowned, and places with both hands a crown on her head. Between them hovers the celestial Dove, and above them is seen the Heavenly Father in likeness of 'the Ancient of Days,' who paternally lays a hand on the shoulder of each. Around his head and over the throne, are the nine choirs of angels, in separate groups. First and nearest, hover the glowing seraphim and cherubim, winged, but otherwise formless. Above these, the Thrones, holding the globe of sovereignty; to the right, the Dominations, Virtues, and Powers; to the left, the Princedoms, Archangels, and Angels. Below these, on each side of the throne, the prophets and patriarchs of the Old Testament, holding each a scroll. Below these the apostles on twelve thrones, six on each side, each holding the Gospel. Below these, on each side, the saints and martyrs. Below these, again, the virgins and holy

[1] Acad. Venice.

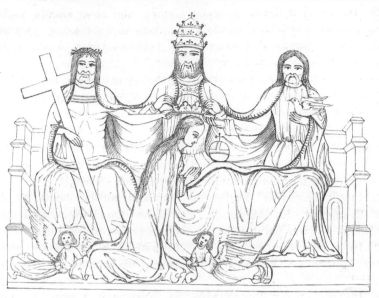

14 Coronation. (Ancient French Carving.)

women. Under the throne, in the space formed by the pillars, is seen a group of beautiful children (not angels), representing, I think, the martyred Innocents. They bear the instruments of Christ's passion— the cross, nails, spear, crown of thorns, &c. On the step below the pedestal, and immediately in front, are seated the Evangelists and doctors of the Church; on the right St. Matthew and St. Luke, and behind them St. Ambrose and St. Augustine; on the left St. Mark and St. John, and behind them St. Jerome and St. Gregory.[1] Every part of this curious picture is painted with the utmost care and delicacy: the children are exquisite, and the heads, of which there are at least seventy without counting the angels, are finished like miniatures.

This simple, and altogether typical representation of the Virgin crowned by the Trinity in human form, is from a French carving of the fifteenth century, and though ill drawn, there is considerable naïveté in the treatment. The Eternal Father wears, as is usual, the

[1] See Sacred and Legendary Art, 3rd edit. p. 141, for the artistic treatment of these personages when combined.

triple tiara, the Son has the cross and the crown of thorns, and the Holy Ghost is distinguished by the dove on his hand. All three sustain the crown over the head of the kneeling Virgin, whose train is supported by two angels. (14)

In a bas-relief over a door of the cathedral at Treves, the subject is very simply treated; both Christ and the Virgin are standing, which is unusual, and behind each is an angel, also standing and holding a crown.

Where not more than five or six saints are introduced as attendants and accessories, they are usually the patron saints of the locality or community, which may be readily distinguished. Thus,

1. In a 'Coronation' by Sandro Botticelli, we find below, St. John the Evangelist, St. Augustine, St. John Gualberto, St. Bernardo Cardinale. It was painted for the Vallombrosian monks.[1]

2. In a very fine example by Ghirlandajo, St. Dominick and St. Peter Martyr are conspicuous: painted, of course, for the Dominicans.[2]

3. In another, by Pinturicchio, St. Francis is a principal figure, with St. Bonaventura and St. Louis of Toulouse : painted for the Franciscans, or at least for a Franciscan pope, Sixtus IV.[3]

4. In another, by Guido, the treatment differs from the early style. The coronation above is small and seen as a vision ; the saints below, St. Bernard and St. Catherine, are life-size. It was painted for a community of Bernardines, the monks of Monte Oliveto.[4]

5. In a beautiful little altar-piece by Lorenzo di Credi,[5] the Virgin is kneeling above, while Christ, seated, places the crown on her head. A glory of red seraphim surround the two figures. Below are the famous patron saints of Central Italy, St. Nicholas of Bari and St. Julian of Rimini, St. Barbara and St. Christina. The St. Francis and St. Antony, in the predella, show it to have been painted for a Franciscan church or chapel, probably for the same church at Cestello for which Lorenzo painted the St. Julian and St. Nicholas now in the Louvre.

[1] Fl. Gal. [2] Paris, Louvre. [3] Rome, Vatican. [4] Bologna, Gal.
[5] Once in the collection of Mr. Rogers : v. Sacred and Legendary Art.

The 'Coronation of the Virgin' by Annibale Carracci is in a spirit altogether different, magnificently studied.[1] On high, upon a lofty throne which extends across the whole picture from side to side, the Virgin, a noble majestic creature, in the true Carracci style, is seated in the midst as the principal figure, her hands folded on her bosom. On the right hand sits the Father, on the left the Son; they hold a heavenly crown surmounted by stars above her head. The locality is the Empyreum. The audience consists of angels only, who, circle within circle, filling the whole space, and melting into an abyss of light, chant hymns of rejoicing and touch celestial instruments of music. This picture shows how deeply Annibale Carracci had studied Correggio, in the magical chiaro-scuro, and the lofty but somewhat mannered grace of the figures.

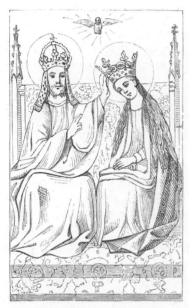

15 Coronation. (Early German. 14th century. Boisserée Gal.)

This rather homely and formal 'Coronation' is from the early Cologne school. (15)

One of the latest examples I can point to is also one of the most simple and grand in conception.[2] It is that by Velasquez, the finest perhaps of the very few devotional subjects painted by him. We have here the three figures only, as large as life, filling the region of glory, without angels, witnesses, or accessories of any kind, except the small cherubim beneath; and the symmetrical treatment gives to the whole a sort of sublime effect. But the heads have the air of portraits: Christ has a dark, earnest, altogether Spanish physiognomy; the Virgin has dark hair; and the *Padre Eterno*, with a long beard, has a bald head—a gross fault in taste and propriety;

[1] This was also in the collection of Mr. Rogers. [2] Madrid Gal.

because, though the loose beard and flowing white hair may serve to typify the 'Ancient of Days,' baldness expresses not merely age, but the infirmity of age.

Rubens, also, painted a 'Coronation,' with all his own lavish magnificence of style, for the Jesuits at Brussels. After the time of Velasquez and Rubens, the 'Immaculate Conception' superseded the 'Coronation.'

To enter further into the endless variations of this charming and complex subject would lead us through all the schools of art from Giotto to Guido. I have said enough to render it intelligible and interesting, and must content myself with one or two closing *memoranda*.

1. The dress of the Virgin in a 'Coronation' is generally splendid, too like the coronation robes of an earthly queen—it is a 'raiment of needlework'—'a vesture of gold wrought about with divers colours'—generally blue, crimson, and white, adorned with gold, gems, and even ermine. In the 'Coronation' by Filippo Lippi, at Spoleto, she wears a white robe embroidered with golden suns. In a beautiful little 'Coronation' in the Wallerstein collection[1] she wears a white robe embroidered with suns and moons, the former red with golden rays, the latter blue with coloured rays—perhaps in allusion to the text so often applied in reference to her, 'a woman clothed with the *sun*,' &c.[2]

2. In the set of cartoons for the tapestries of the Sistine Chapel,[3] as originally prepared by Raphael, we have the foundation, the heaven-bestowed powers, the trials and sufferings of the early Church, exhibited in the calling of St. Peter, the conversion of St. Paul, the acts and miracles of the apostles, the martyrdom of St. Stephen; and the series closed with the Coronation of the Virgin, placed over the altar, as typical of the final triumph of the Church, the completion and fulfilment of all the promises made to man, set forth in the exaltation and union of the mortal with the immortal, when the human Mother and her divine Son are reunited and seated on the same throne.

[1] Kensington Pal. [2] Rev. xii. 1, or Cant. vi. 10. [3] Kugler's Handbook, ii. 394.

1

2

The Coronation of the Virgin

Raphael placed on one side of the celestial group, St. John the Baptist, representing sanctification through the rite of baptism; and on the other, St. Jerome, the general symbol of sanctification through faith and repentance. The cartoon of this grand symbolical composition, in which all the figures were colossal, is unhappily lost; the tapestry is missing from the Vatican collection; two old engravings, however, exist, from which some idea may be formed of the original group.[1]

3. It will be interesting to remember that the earliest existing impression taken from an engraved metal plate, is a 'Coronation of the Virgin.' Maso Finiguerra, a skilful goldsmith and worker in niello, living at Florence in 1434, was employed to execute a pix (the small casket in which the consecrated wafer of the sacrament is deposited), and he decorated it with a representation of the Coronation in presence of saints and angels, in all about thirty figures, minutely and exquisitely engraved on the silver face. Whether Finiguerra was the first worker in niello to whom it occurred to fill up the lines cut in the silver with a black fluid, and then, by laying on it a piece of damp paper and forcibly rubbing it, take off the facsimile of his design and try its effect before the final process—this we cannot ascertain; we only know that the impression of his 'Coronation' is the earliest specimen known to exist, and gave rise to the practice of cutting designs on plates of copper (instead of silver), for the purpose of multiplying impressions of them. The pix, finished by Maso in 1452, is now in the Florence Gallery in the 'Salle des Bronzes.' The invaluable print, first of its species, exists in the National Library at Paris. There is a very exact facsimile of it in Otley's 'History of Engraving.' Christ and the Virgin are here seated together on a lofty architectural throne: her hands are crossed on her bosom, and she bends her meek veiled head to receive the crown, which her Son, who wears a triple tiara, places on her brow. The saints most conspicuous are St. John the Baptist, patron of Florence and of the church for which the pix was executed, and a female saint, I believe St. Reparata, both standing; kneeling in front

[1] Passavant's Rafael, ii. 258.

E

are St. Cosmo and St. Damian, the patrons of the Medici family, then paramount at Florence.[1]

4. In an illuminated 'Office of the Virgin,' I found a version of this subject which must be rare, and probably confined to miniatures. Christ is seated on a throne, and the Virgin kneels before him; he bends forwards, and tenderly takes her clasped hands in both his own. An empty throne is at the right hand of Christ, over which hovers an angel bearing a crown. This is the moment which *precedes* the Coronation, as the group already described in the S. Maria-in-Trastevere exhibits the moment which *follows* the Coronation. (12)

5. Finally, we must bear in mind that those effigies in which the Madonna is holding her Child, while angels place a crown upon her head, do not represent THE CORONATION properly so called, but merely the Virgin honoured as Mother of Christ and Queen of Heaven (*Mater Christi, Regina Cœli*); and that those representations of the Coronation which conclude a series of the life of the Virgin, and surmount her deathbed or her tomb, are historical and dramatic rather than devotional and typical. Of this historical treatment there are beautiful examples from Cimabue down to Raphael, which will be noticed hereafter in their proper place.

THE VIRGIN OF MERCY.

Our Lady of Succour.
Ital. La Madonna di Misericordia. *Fr.* Notre Dame de Miséricorde.
Ger. Maria Mutter des Erbarmens. *Sp.* Nuestra Señora de Grazia.

WHEN once the Virgin had been exalted and glorified in the celestial paradise, the next and the most natural result was, that she should be regarded as being in heaven the most powerful of intercessors, and on earth a most benign and ever-present protectress. In the mediæval idea of Christ, there was often something stern; the Lamb of God

[1] Sacred and Legendary Art, 3rd edit. p. 433.

who died for the sins of the world, is also the inexorable Judge of the quick and the dead. When he shows his wounds, it is as if a vindictive feeling was supposed to exist; as if he were called upon to remember in judgment the agonies and the degradation to which he had been exposed below for the sake of wicked ungrateful men. In a Greek 'Day of Judgment,' cited by Didron, Moses holds up a scroll, on which is written, 'Behold Him whom ye crucified,' while the Jews are dragged into everlasting fire. Everywhere is the sentiment of vengeance; Christ himself is less a judge than an avenger. Not so the Virgin; she is represented as all mercy, sympathy, and benignity. In some of the old pictures of the Day of Judgment, she is seated by the side of Christ, on an equality with him, and often in an attitude of deprecation, as if adjuring him to relent; or her eyes are turned on the redeemed souls, and she looks away from the condemned as if unable to endure the sight of their doom. In other pictures she is lower than Christ, but always on his right hand, and generally seated; while St. John the Baptist, who is usually placed opposite to her on the left of Christ, invariably stands or kneels. Instead of the Baptist, it is sometimes, but rarely, John the Evangelist, who is the pendant of the Virgin.

In the Greek representations of the Last Judgment, a river of fire flows from under the throne of Christ to devour and burn up the wicked.[1] In Western art the idea is less formidable—Christ is not at once judge and executioner; but the sentiment is always sufficiently terrible; 'the angels and all the powers of heaven tremble before him.' In the midst of these terrors, the Virgin, whether kneeling, or seated, or standing, always appears as a gentle mediator, a supplicant for mercy. In the 'Day of Judgment,' as represented in the 'Hortus Deliciarum,'[2] we read inscribed under her figure the words '*Maria Filio suo pro Ecclesia supplicat.*' In a very fine picture by Martin Schoen,[3] it is the Father, who, with a sword and three javelins in his hand, sits as the

[1] Didron, Iconographie Chrétienne ; and in the mosaic of the Last Judgment, executed by Byzantine artists, in the cathedral at Torcello.

[2] A celebrated illuminated MS. (date about 1159 to 1175), preserved in the Library at Strasburg. [3] Schleissheim Gal.

16

avenging judge; near him Christ; while the Virgin stands in the fore-
ground, looking up to her Son with an expression of tender suppli-
cation, and interceding, as it appears, for the sinners kneeling round
her, and whose imploring looks are directed to *her*. In the well-known
fresco by Andrea Orcagna,[1] Christ and the Virgin sit throned above,
each in a separate aureole, but equally glorified. (16) Christ, pointing
with one hand to the wound in his side, raises the other in a threatening
attitude, and his attention is directed to the wicked, whom he hurls into
perdition. The Virgin, with one hand pressed to her bosom, looks to
him with an air of supplication. Both figures are regally attired, and
wear radiant crowns; and the twelve apostles attend them, seated on
each side.

In the centre group of Michael Angelo's 'Last Judgment,' we have

[1] Pisa, Campo Santo.

the same leading *motif*, but treated in a very different feeling. Christ stands before us in figure and mien like a half-naked athlete; his left hand rejects, his right hand threatens, and his whole attitude is as utterly devoid of dignity as of grace. I have often wondered, as I have looked at this grand and celebrated work, what could be Michael Angelo's idea of Christ. He who was so good, so religious, so pure-minded, and so high-minded, was deficient in humility and sympathy; if his morals escaped, his imagination was corrupted by the profane and pagan influences of his time. His conception of Christ is here most unchristian, and his conception of the Virgin is not much better. She is grand in form, but the expression is too passive. She looks down and seems to shrink; but the significance of the attitude—the hand pressed to the maternal bosom—given to her by the old painters, is lost.

In a 'Last Judgment' by Rubens, painted for the Jesuits of Brussels,[1] the Virgin extends her robe over the world, as if to shield mankind from the wrath of her Son; pointing, at the same time, significantly to her bosom, whence he derived his earthly life. The daring bad taste, and the dramatic power of this representation, are characteristic alike of the painter, the time, and the community for which the picture was painted.

More beautiful and more acceptable to our feelings are those graceful representations of the Virgin as dispenser of mercy on earth; as protectress and patroness either of all Christendom, or of some particular locality, country, or community. In such pictures she stands with outstretched arms, crowned with a diadem, or in some instances simply veiled; her ample robe, extended on each side, is held up by angels, while under its protecting folds are gathered worshippers and votaries of all ranks and ages—men, women, children—kings, nobles, eccle-

[1] Brussels; Musée.

17 La Madonna di Misericordia. (Bas-relief, Venice.)

siastics—the poor, the lame, the sick. Or if the picture be less universal
in its significance, dedicated perhaps by some religious order or chari-
table brotherhood, we see beneath her robe an assemblage of monks
and nuns, or a troop of young orphans or redeemed prisoners. Such a
representation is styled a *Misericordia*.

 1. In a picture by Fra Filippo Lippi,[1] the Madonna of Mercy extends
her protecting mantle over thirty-five kneeling figures, the faces like
portraits, none elevated or beautiful, but the whole picture as an
example of the subject most striking.

 2. This majestic figure is from a bas-relief at Venice, placed over
the entrance of the Scuola (or brotherhood) of Charity. The members

[1] Berlin Gal.

18 La Madonna di Misericordia. (Piero della Francesca.)

of the community are here gathered under the robe of their patroness. (17)

3. This singular figure, which looks like that of an Indian goddess, is from a 'Misericordia' painted by Piero della Francesca for the hospital of Borgo San Sepolcro, in the Apennines. (18)

4. A very beautiful and singular representation of the Virgin of Mercy without the Child, I found in the collection of Herr v. Quandt, of Dresden. She stands with hands folded over her bosom, and wrapped in ample white drapery, without ornament of any kind; over her head, a veil of transparent gauze of a brown colour, such as, from various portraits of the time, appears to have been then a fashion. The expression of the face is tender and contemplative, almost sad; and the whole figure, which is life-size, is inexpressibly refined and dignified.

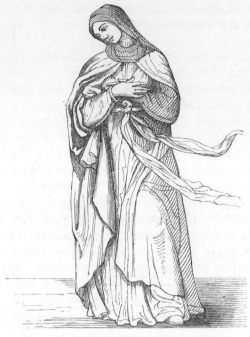

19 B. Maria Vergine.

The following inscription is on the dark background to the right of the
Virgin :—

<div align="center">

IMAGO
BEATÆ MARIÆ VIRGINIS
QUÆ
MENS. AUGUST. MIƆXXXIII.
APPARUIT
MIRACULOR. OPERATIONE
CONCURSU POP.
CELEBERRIM.

</div>

This beautiful picture was brought from Brescia to Vienna by a
picture-dealer, and purchased by Herr v. Quandt. It was painted by
Moretto of Brescia, of whom Lanzi truly says that his sacred subjects
express *la compunzione, la pietà, la carità istessa* ; and this picture is an

instance. But by whom dedicated, for what especial mercy, or in what church, I could not ascertain.[1]

It is seldom that the Madonna di Misericordia appears without the Child in her arms; her maternity is supposed to be one element in her sympathy with suffering humanity. I will add, however, to the examples already given, one very celebrated instance.

The picture entitled the 'Misericordia di Lucca' is famous in the history of art.[2] It is the most important work of Fra Bartolomeo, and is dated 1515, two years before his death. The Virgin, a grand and beautiful figure, stands alone on a raised platform, with her arms extended, and looking up to heaven. The ample folds of her robe are held open by two angels. Beneath and round her feet are various groups in attitudes of supplication, who look up to her, as she looks up to heaven. On one side the donor of the picture is presented by St. Dominick. Above, in a glory, is the figure of Christ surrounded by angels, and seeming to bend towards his Mother. The expression in the heads, the dignified beneficence of the Virgin, the dramatic feeling in the groups, particularly the women and children, justify the fame of this picture as one of the greatest of the productions of mind.[3]

There is yet another version of this subject, which deserves notice from the fantastic grace of the conception. As, in early Christian Art, our Saviour was frequently portrayed as the Good Shepherd, so, among the later Spanish fancies, we find his Mother represented as the Divine Shepherdess. In a picture painted by Alonzo Miguel de Tobar,[4] about the beginning of the eighteenth century, we find the Virgin Mary

[1] I possess a charming drawing of the head by Fraulein Louise Seidler of Weimar, whose feeling for early religious art is shown in her own works, as well as in the beautiful copies she has made of others.

[2] Lucca. S. Romano.

[3] According to the account in Murray's Handbook, this picture was dedicated by the noble family of Montecanini, and represents the Virgin interceding for the Lucchesi during the wars with Florence. But I confess I am doubtful of this interpretation, and rather think it refers to the pestilence, which, about 1512, desolated the whole of the north of Italy. Wilkie, who saw this picture in 1825, speaks of the workmanship with the enthusiasm of a workman.

[4] Madrid Gal. 226.

seated under a tree, in guise of an Arcadian pastorella, wearing a broad-brimmed hat, encircled by a glory, a crook in her hand, while she feeds her flock with the mystical roses. The beauty of expression in the head of the Virgin is such as almost to redeem the quaintness of the religious conceit; the whole picture is described as worthy of Murillo. It was painted for a Franciscan church at Madrid, and the idea became so popular, that we find it multiplied and varied in French and German prints of the last century; the original picture remains unequalled for its pensive poetical grace; but it must be allowed that the idea, which at first view strikes from its singularity, is worse than questionable in point of taste, and will hardly bear repetition.

There are some ex-voto pictures of the Madonna of Mercy, which record individual acts of gratitude. One, for instance, by Nicolò Alunno,[1] in which the Virgin, a benign and dignified creature, stretches forth her sceptre from above, and rebukes the ugly fiend of Sin, about to seize a boy. The mother kneels on one side, with eyes uplifted, in faith and trembling supplication. The same idea I have seen repeated in a picture by Lanfranco.

The innumerable votive pictures which represent the Madonna di Misericordia with the Child in her arms, I shall notice hereafter. They are in Catholic countries the usual ornaments of charitable institutions and convents of the Order of Mercy; and have, as I cannot but think, a very touching significance.

[1] Rome, Pal. Colonna.

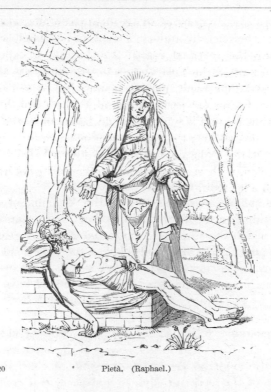

20 • Pietà. (Raphael.)

The Mater Dolorosa.

Ital. La Madre di Dolore. L'Addolorata. *Fr.* Notre Dame de Pitié. La Vierge de Douleur. *Sp.* Nuestra Señora de Dolores. *Ger.* Die schmerzhafte Mutter.

ONE of the most important of these devotional subjects proper to the Madonna is the 'Mourning Mother,' the *Mater Dolorosa*, in which her character is that of the mother of the crucified Redeemer; the mother of the atoning Sacrifice; the queen of martyrs; the woman whose bosom was pierced with a sharp sword; through whose sorrow the world was saved, whose anguish was our joy, and to whom the Roman Catholic Christians address their prayers as consoler of the afflicted, because she had herself tasted of the bitterest of all earthly sorrow, the pang of the agonised mother for the loss of her child.

F 2

In this character we have three distinct representations of the Madonna.

MATER DOLOROSA. In the first she appears alone, a seated or standing figure, often the head or half-length only; the hands clasped, the head bowed in sorrow, tears streaming from the heavy eyes, and the whole expression intensely mournful. The features are properly those of a woman in middle age; but in later times the sentiment of beauty predominated over that of the mother's agony; and I have seen the sublime Mater Dolorosa transformed into a merely beautiful and youthful maiden, with such an air of sentimental grief as might serve for the loss of a sparrow.

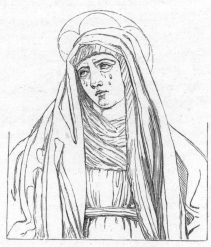

21 Mater Dolorosa. (Murillo.)

Not so with the older heads; even those of the Carracci and the Spanish school have often a wonderful depth of feeling.

It is common in such representations to represent the Virgin with a sword in her bosom, and even with *seven* swords, in allusion to the *seven* sorrows. (22) This very material and palpable version of the allegorical prophecy [1] has been found extremely effective as an appeal to the popular feelings, so that there are few Roman Catholic churches

[1] Luke ii. 35.

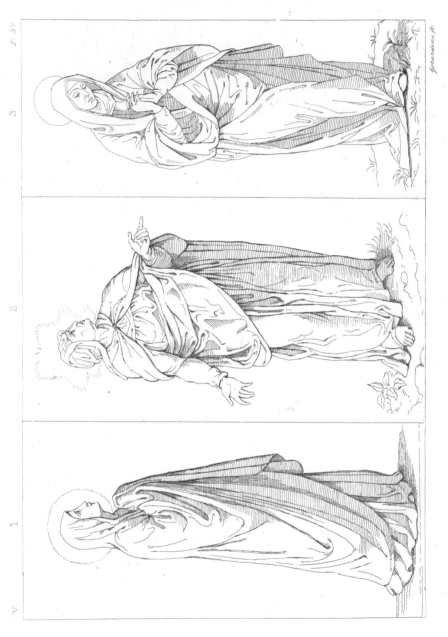

P. 37.

V. 1 2 3

Generation fc

"Stabat Mater."

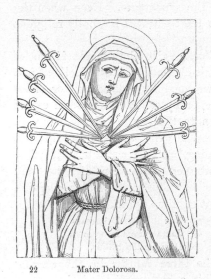

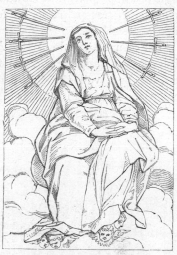

22 Mater Dolorosa. 23 Notre Dame des Sept Douleurs.

without such a painful and literal interpretation of the text. It occurs perpetually in prints, and there is a fine example after Vandyck; sometimes the swords are placed round her head (23);—but there is no instance of such a figure from the best period of religious art, and it must be considered as anything but artistic: in this case, the more materialised and the more matter-of-fact, the more *unreal*.

STABAT MATER. A second representation of the *Madre di Dolore* is that figure of the Virgin which, from the very earliest times, was placed on the right of the Crucifix, St. John the Evangelist being invariably on the left. I am speaking here of the *crucifix* as a wholly ideal and mystical emblem of our faith in a crucified Saviour; not of the *crucifixion* as an event, in which the Virgin is an actor and spectator, and is usually fainting in the arms of her attendants. In the ideal subject she is merely an ideal figure, at once the mother of Christ, and the personified Church. This, I think, is evident from those very ancient carvings, and examples in stained glass, in which the Virgin, as the Church, stands on one side of the cross, trampling on a female

figure which personifies Judaism or the synagogue. Even when the allegory is less palpable, we feel that the treatment is wholly religious and poetical.

The usual attitude of the *Mater Dolorosa* by the crucifix is that of intense but resigned sorrow; the hands clasped, the head declined and shaded by a veil, the figure closely wrapped in a dark blue or violet mantle. In some instances a more generally religious and ideal cast is given to the figure; she stands with outspread arms, and looking up; not weeping, but in her still beautiful face a mingled expression of faith and anguish. This is the true conception of the sublime hymn,

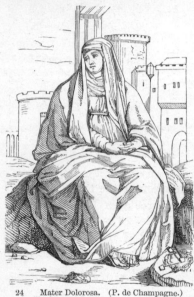

24 Mater Dolorosa. (P. de Champagne.)

> Stabat Mater Dolorosa
> Juxta crucem lachrymosa
> Dum pendebat filius.

The three figures in the etching exhibit a characteristic difference of treatment: the first is by Angelico; the second by Michael Angelo; the third by Guido. In this sketch, after Philippe de Champagne, she is not standing, but seated at the foot of the cross. (24) The original picture deserves its celebrity; it is very fine and solemn.

LA PIETÀ. The third, and it is the most important and most beautiful of all as far as the Virgin is concerned, is the group called the PIETÀ, which, when strictly devotional, consists only of the Virgin with her dead Son in her arms, or on her lap, or lying at her feet; in some instances with lamenting angels, but no other personages. This group has been varied in a thousand ways; no doubt the two most perfect conceptions are those of Michael Angelo and Raphael; the first excelling in sublimity, the latter in pathos. The celebrated marble group by Michael Angelo stands in the Vatican in a chapel to the right as we enter. The Virgin is seated; the dead Saviour lies across the knees of

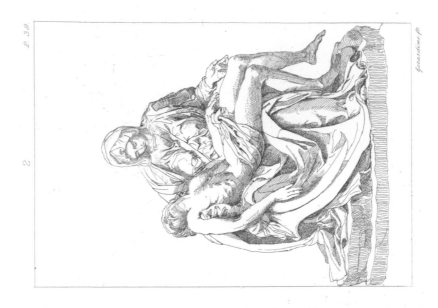

P. 39

2

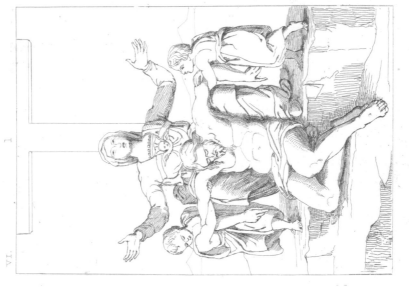

VI.

1

"La Pietà"

his mother; she looks down on him in mingled sorrow and resignation, but the majestic resignation predominates. The composition of Raphael exists only as a print; but the flimsy paper, consecrated through its unspeakable beauty, is likely to be as lasting as the marble. It represents the Virgin standing with outstretched arms, and looking up with an appealing agonised expression towards heaven; before her, on the earth, lies extended the form of the Saviour. (20) In tenderness, dignity, simplicity, and tragic pathos, nothing can exceed this production; the head of the Virgin in particular is regarded as a masterpiece, so far exceeding in delicacy of execution every other work of Marc Antonio, that some have thought that Raphael himself took the burin from his hand, and touched himself that face of quiet woe.

Another example of wonderful beauty is the Pietà by Francia, in our National Gallery. The form of Christ lies extended before his mother; a lamenting angel sustains the head, another is at the feet; the Virgin, with eyes red and heavy with weeping, looks out of the picture. There needs no visible sword in her bosom to tell what anguish has pierced that maternal heart.

There is another Pietà, by Michael Angelo, quite a different conception. The Virgin sits at the foot of the cross; before her, and half sustained by her knees, lies the form of the dead Saviour, seen in front; his arms are held up by two angels (unwinged, as is usual with Michael Angelo). The Virgin looks up to heaven with an appealing expression; and in one engraving of this composition the cross is inscribed with the words, 'Tu non pensi quanto sangue costa.' There is no painting by Michael Angelo himself, but many copies and engravings of the drawing. A beautiful small copy, by Marcello Venusti, is in the Queen's Gallery.

There is yet another version of the Pietà, quite mystical and devotional in its significance—but, to my feeling, more painful and material than poetical. It is variously treated; for example:—1. The dead Redeemer is seen half-length within the tomb; his hands are extended to show his wounds; his eyes are closed, his head declined, his bleeding brow encircled by thorns. On one side is the Virgin, on the other St. John the Evangelist, in attitudes of profound grief and commiseration. 2. The dead form, half emerging from the tomb, is

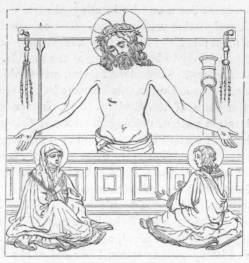

25 Pietà. (B. Angelico. Centre of a Predella.)

sustained in the arms of the Mater Dolorosa. St. John the Evangelist
on the other side. There are sometimes angels.

The Pietà thus conceived as a purely religious and ideal impersona-
tion of the atoning Sacrifice is commonly placed over the altar of the
sacrament; and in many altar-pieces it forms the centre of the predella,
just in front where the mass is celebrated (25), or on the door of the
tabernacle where the Host is deposited.

When, with the Mater Dolorosa and St. John, Mary Magdalene is
introduced with her dishevelled hair, the group ceases to be properly a
Pietà, and becomes a representation rather than a symbol.

There are also examples of a yet more complex but still perfectly ideal
and devotional treatment, in which the Mourning Mother is attended
by saints.

A most celebrated instance of this treatment is the Pietà by Guido.[1]
In the upper part of the composition, the figure of the dead Redeemer
lies extended on a white shroud; behind him stands the Virgin mother,

[1] Bologna Gal.

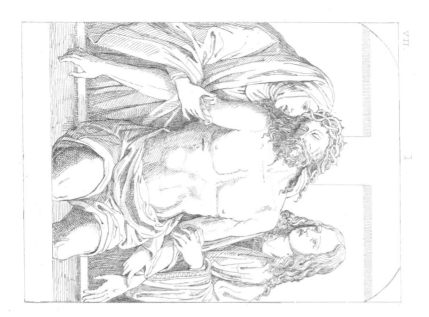

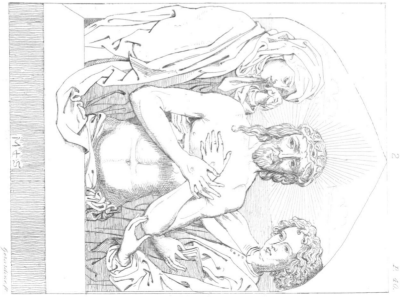

with her eyes raised to heaven, and sad appealing face, touched with so
divine a sorrow—so much of dignity in the midst of infinite anguish,
that I know nothing finer in its way. Her hands are resignedly folded
in each other, not raised, not clasped, but languidly drooping. An
angel stands at the feet of Christ looking on with a tender adoring com-
miseration; another, at his head, turns away weeping. A kind of
curtain divides this group from the lower part of the picture, where,
assembled on a platform, stand or kneel the guardian saints of Bologna :
in the centre, the benevolent St. Charles Borromeo, who just about that
time had been canonised and added to the list of the patrons of Bologna
by a decree of the senate; on the right, St. Dominick and St.
Petronius; on the left, St. Proculus and St. Francis.[1] These sainted
personages look up as if adjuring the Virgin, even by her own deep
anguish, to intercede for the city; she is here at once our Lady of
Pity, of Succour, and of Sorrow. This wonderful picture was dedi-
cated, as an act of penance and piety, by the magistrates of Bologna, in
1616, and placed in their chapel in the church of the 'Mendicanti,'
otherwise S. Maria-della-Pietà. It hung there for two centuries, for
the consolation of the afflicted; it is now placed in the Academy of
Bologna for the admiration of connoisseurs.

[1] *v.* Legends of the Monastic Orders, 2nd edit. p. 158 ; and Sacred and Legendary Art,
3rd edit. p. 709.

26 Lamenting Angel, from an ancient Greek Pietà.

G

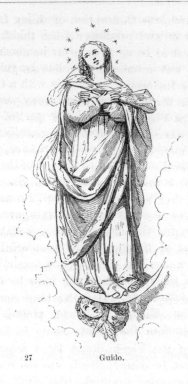

27 Guido.

OUR LADY OF THE IMMACULATE CONCEPTION.

Ital. La Madonna Purissima. *Lat.* Regina sine labe originali concepta. *Spa.* Nuestra Señora sin peccado concepida. La Concepcion. *Fr.* La Conception de la Vierge Marie. *Ger.* Das Geheimniss der unbefleckten Empfängniss Mariä. Dec. 8.

THE last and the latest subject in which the Virgin appears alone without the Child, is that entitled the 'Immaculate Conception of the Blessed Virgin;' and sometimes merely 'THE CONCEPTION.' There is no instance of its treatment in the earlier schools of art; but as one of the most popular subjects of the Italian and Spanish painters of the seventeenth century, and one very frequently misunderstood, it is necessary to go into the history of its orgin.

In the early ages of Christianity, it was usual to celebrate, as

festivals of the Church, the Conception of Jesus Christ, and the Conception of his kinsman and precursor John the Baptist; the latter as miraculous, the former as being at once divine and miraculous. In the eleventh century it was proposed to celebrate the Conception of the Virgin Mother of the Redeemer.

From the time that the heresy of Nestorius had been condemned, and that the dignity of the Virgin as Mother of the *Divinity* had become a point of doctrine, it was not enough to advocate her excelling virtue and stainless purity as a mere human being. It was contended, that having been predestined from the beginning as the Woman through whom the divine nature was made manifest on earth, she must be presumed to be exempt from all sin, even from that original taint inherited from Adam. Through the first Eve, we had all died; through the second Eve, we had all been 'made alive.' It was argued that God had never suffered his earthly temple to be profaned; had even promulgated in person severe ordinances to preserve its sanctuary inviolate. How much more to him was that temple, that *tabernacle* built by no human hands, in which he had condescended to dwell! Nothing was impossible to God; it lay, therefore, in his power to cause his Mother to come absolutely pure and immaculate into the world: being in his power, could any earnest worshipper of the Virgin doubt for a moment that for one so favoured it would not be done? Such was the reasoning of our forefathers; and, the premises granted, who shall call it illogical or irreverent?

For three or four centuries, from the seventh to the eleventh, these ideas had been gaining ground. St. Ildefonso of Seville distinguished himself by his writings on this subject; and how the Virgin recompensed his zeal, Murillo has shown us, and I have related in the life of that saint.[1] But the first mention of a festival, or solemn celebration of the Mystery of the Immaculate Conception, may be traced to an English monk of the eleventh century, whose name is not recorded.[2] When, however, it was proposed to give the papal sanction to this doctrine as an article of belief, and to institute a church office for the purpose of celebrating the Conception of Mary, there arose strong opposition.

[1] Legends of the Monastic Orders, 2nd edit. p. 24.　　[2] *v.* Baillet, vol. xii.

What is singular, St. Bernard, so celebrated for his enthusiastic devotion o the Virgin, was most strenuous and eloquent in his disapprobation. He pronounced no judgment against those who received the doctrine of the Immaculate Conception, he rather leaned towards it; but he opposed the institution of the festival as an innovation not countenanced by the early fathers of the Church. After the death of St. Bernard, for about a hundred years the dispute slept; but the doctrine gained ground. The thirteenth century, so remarkable for the manifestation of religious enthusiasm in all its forms, beheld the revival of this celebrated controversy. A certain Franciscan friar, Duns Scotus (John Scott of Dunse), entered the lists as champion for the Virgin. He was opposed by the Dominicans and their celebrated polemic Thomas Aquinas, who, like St. Bernard, was known for his enthusiastic reverence for the Virgin; but, like him, and on the same grounds, objected to the introduction of new forms. Thus the theological schools were divided.

During the next two hundred years the belief became more and more general, the doctrine more and more popular; still the Church, while it tolerated both, refused to ratify either. All this time we find no particular representation of the favourite dogma in art, for until ratified by the authority of the Church, it could not properly enter into ecclesiastical decoration. We find, however, that the growing belief in the pure Conception and miraculous sanctification of the Virgin multiplied the representations of her coronation and glorification, as the only permitted expression of the popular enthusiasm on this point. For the powerful Order of the Franciscans, who were at this time and for a century afterwards the most ardent champions of the Immaculate Conception, were painted most of the pictures of the Coronation produced during the fourteenth century.

The first papal decree touching the 'Immaculate Conception' as an article of faith, was promulgated in the reign of Sixtus IV., who had been a Franciscan friar, and he took the earliest opportunity of giving the solemn sanction of the Church to what had ever been the favourite dogma of his Order; but the celebration of the festival, never actually forbidden, had by this time become so usual, that the papal ordinance merely sanctioned without however rendering it obligatory. An office

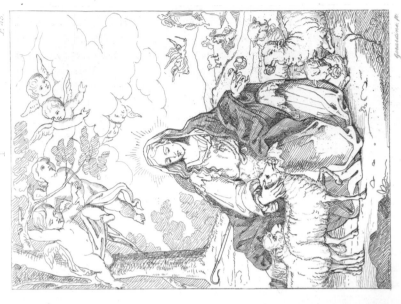

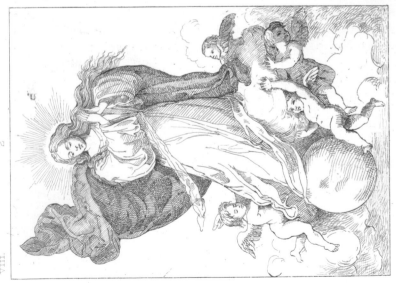

1

2

VIII

La Divina Pastora.

The Immaculate Conception.

was composed for the festival, and in 1496 the Sorbonne declared in favour of it. Still it remained a point of dispute; still there were dissentient voices, principally among the Dominican theologians; and from 1500 to 1600 we find this controversy occupying the pens of the ecclesiastics, and exciting the interest and the imagination of the people. In Spain the 'Immaculate Conception of the Virgin,' owing perhaps to the popularity and power of the Franciscans in that country, had long been 'the darling dogma of the Spanish Church.' Villegas, in the 'Flos Sanctorum,' while admitting the modern origin of the opinion, and the silence of the Church, contended that, had this great fact been made manifest earlier and in less enlightened times, it might possibly have led to the error of worshipping the Virgin as an actual goddess.[1] To those who are conversant with Spanish theology and art, it may seem that the distinction drawn in theory is not very definite or perceptible in practice.

At length, in July 1615, Paul V. formally instituted the office commemorating the Immaculate Conception, and in 1617 issued a bull forbidding any one to teach or preach a contrary opinion. 'On the publication of this bull, Seville flew into a frenzy of religious joy.' The archbishop performed a solemn service in the cathedral. Cannon roared, and bull-fights, tournaments, and banquets celebrated this triumph of the votaries of the Virgin. Spain and its dependencies were solemnly placed under the protection of the 'Immaculate Conception,' thus personifying an abstract idea; and to this day, a Spaniard salutes his neighbour with the angelic 'Ave Maria purissima!' and he responds 'Sin peccado concepida!'[2]

I cannot find the date of the earliest picture of the Immaculate Conception; but the first writer on the art who makes allusion to the subject, and lays down specific rules from ecclesiastical authority for its proper treatment, is the Spaniard Pacheco, who must have been about forty years of age when the bull was published at Seville in 1618. It

[1] Stirling's Artists of Spain, p. 905.

[2] In our own days we have seen this curious controversy revived. One of the latest, if not the last, writer on the subject was Cardinal Lambruschini; and the last papal ordinance was promulgated by Pio Nono, and dated from Gaeta, 1849.

is soon after this time that we first hear of pictures of the Immaculate Conception. Pacheco subsequently became a familiar of the Inquisition, and wielded the authority of the holy office as inspector of sacred pictures; and in his 'Arte de la Pintura,' published in 1649, he laid down those rules for the representation which had been generally, though not always, exactly followed.

It is evident that the idea is taken from the woman in the Apocalypse, 'clothed with the sun, having the moon under her feet, and on her head a crown of twelve stars.' The Virgin is to be portrayed in the first spring and bloom of youth as a maiden of about twelve or thirteen years of age; with 'grave sweet eyes;' her hair golden; her features 'with all the beauty painting can express;' her hands are to be folded on her bosom or joined in prayer. The sun is to be expressed by a flood of light around her. The moon under her feet is to have the horns pointing downwards, because illuminated from above, and the twelve stars are to form a crown over her head. The robe must be of spotless white; the mantle or scarf blue. Round her are to hover cherubim bearing roses, palms, and lilies; the head of the bruised and vanquished dragon is to be under her feet. She ought to have the cord of St. Francis as a girdle, because in this guise she appeared to Beatriz de Silva, a noble Franciscan nun, who was favoured by a celestial vision of the Madonna in her beatitude. Perhaps the good services of the Franciscans as champions of the Immaculate Conception procured them the honour of being thus commemorated.

All these accessories are not absolutely and rigidly required; and Murillo, who is entitled *par excellence* the painter of the Conception, sometimes departed from the letter of the law without being considered as less orthodox. With him the crescent moon is sometimes the full moon, or, when a crescent, the horns point upwards instead of downwards. He usually omits the starry crown, and, in spite of his predilection for the Capuchin Order, the cord of St. Francis is in most instances dispensed with. He is exact with regard to the colours of the drapery, but not always in the colour of the hair. On the other hand, the beauty and expression of the face and attitude, the mingled loveliness, dignity, and purity, are given with exquisite feeling; and we are never, as in his other representations of the Madonna, reminded of

common-place, homely, often peasant, portraiture; here all is spotless grace, ethereal delicacy, benignity, refinement, repose — the very apotheosis of womanhood.

I must go back to observe, that previous to the promulgation of the famous bull of Pope Paul V., the popular ideas concerning the Immaculate Conception had left their impress on art. Before the subject had taken an express and authorised form, we find pictures which, if they do not represent it, relate to it. I remember two which cannot be otherwise interpreted, and there are probably others.

The first is a curious picture of the early Florentine School.[1] In the centre is original sin, represented by Eve and the Serpent; on the right stand St. Ambrose, St. Hilarius, St. Anselm, and St. Bernard; on the left, St. Cyril, Origen, St. Augustine, and St. Cyprian; and below are inscribed passages from the writings of these fathers, relating to the Immaculate Conception of the Virgin : all of them had given to her in their works the title of Immaculate, most pure ; but they differed as to the period of her sanctification, as to whether it was in the moment of conception or at the moment of birth.

The other picture is in the Dresden Gallery, and one of the finest productions of that extraordinary Ferrarese painter, Dosso Dossi. In the lower part of the picture are the four Latin Fathers, turning over their great books, or in deep meditation; behind them, the Franciscan Bernardino of Siena.[2] Above, in a glory of light, the Virgin, clothed, not in spotless white, but a richly embroidered regal mantle, 'wrought about with divers colours,' kneels at the feet of the Almighty, who extends his hand in benediction. I find no account in the catalogue whence this picture was taken, but it was evidently painted for the Franciscans.

In 1617, when the bull of Paul V. was formally expedited, Guido was attached to the papal court in quality of painter and an especial favourite with his Holiness. Among the earliest accredited pictures of the Immaculate Conception, are four of his finest works.

1. The cupola of the private chapel of the Quirinal represents the

[1] Berlin Gal. [2] Mon. Orders, 2nd edit. p. 291.

Almighty meditating the great miracle of the Immaculate Conception, and near him, within the same glory of light, is the Virgin in her white tunic, and in an attitude of adoration. This was painted about 1610 or 1611, when Pope Paul V. was meditating the promulgation of his famous ordinance.

2. The great picture, also painted for Paul V., represents the doctors of the Church arguing and consulting their great books for the authorities on the subject of the Conception.[1] Above, the Virgin is seated in glory, arrayed in spotless white, her hands crossed over her bosom, and her eyes turned towards the celestial fountain of light. Below are six doctors, consulting their books; they are not well characterised, being merely so many ideal heads in a mannered style; but I believe they represent the four Latin Fathers, with St. John Damascene and St. Ildefonso, who were especial defenders of the doctrine.

3. The next in point of date was painted for the Infanta of Spain, which I believe to be the same now in the possession of Lord Ellesmere. The figure of the Virgin, crowned with the twelve stars, and relieved from a background of golden light, is standing on a crescent sustained by three cherubs beneath: she seems to float between heaven and earth; on either side is a seraph, with hands folded and looks upraised in adoration. The whole painted in his silvery tone, with such an extreme delicacy and transparency of effect, that it might be styled 'a vision of the Immaculate Conception.'

4. The fourth was painted for the chapel of the Immaculate Conception, in the church of San Biagio at Forlì, and is there still.

Just as the Italian schools of painting were on the decline, the Spanish school of art arose in all its glory, and the 'Conception' became, from the popularity of the dogma, not merely an ecclesiastical, but a popular subject. Not only every church, but almost every private house, contained the effigy, either painted or carved, or both, of our Lady '*sin peccado concepida*;' and when the academy of painting was founded at Seville, in 1660, every candidate for admission had to declare his orthodox belief in *the most pure Conception of our Lady*.

[1] Petersburg Imp. Gal. There is a fine engraving.

The finest Spanish 'Conception' before the time of Murillo, is by Roelas, who died in 1625; it is in the academy at Seville, and is mentioned by Mr. Ford as 'equal to Guido.'[1]

One of the most beautiful and characteristic, as well as earliest, examples of this subject I have seen, is a picture in the Esterhazy Gallery at Vienna. The Virgin is in the first bloom of girlhood; she looks not more than nine or ten years old, with dark hair, Spanish features, and a charming expression of childlike simplicity and devotion. She stands amid clouds, with her hands joined, and the proper white and blue drapery: there are no accessories. This picture is attributed to an obscure painter, Lazaro Tavarone, of whom I can learn nothing more than that he was employed in the Escurial about 1590.

The beautiful small 'Conception' by Velasquez, in the possession of Mr. Frere, is a departure from the rules laid down by Pacheco in regard to costume; therefore, as I presume, painted before he entered the studio of the artist-inquisitor, whose son-in-law he became before he was three and twenty. Here the Virgin is arrayed in a pale violet robe, with a dark blue mantle. Her hands are joined, and she looks down. The solemnity and depth of expression in the sweet girlish face is very striking; the more so, that it is not a beautiful face, and has the air of a portrait. Her long hair flows over her shoulders. The figure is relieved against a bright sun, with fleecy clouds around; and the twelve stars are over her head. She stands on the round moon, of which the upper half is illumined. Below, on earth, and through the deep shadow, are seen several of the emblems of the Virgin—the fountain, the temple, the olive, the cypress, and the garden enclosed in a treillage of roses.[2] This picture is very remarkable; it is in the earliest manner of Velasquez, painted in the bold free style of his first master, Herrara, whose school he quitted when he was about seventeen or eighteen, just at the period when the Pope's ordinance was proclaimed at Seville.

Of twenty-five pictures of this subject, painted by Murillo, there are

[1] Handbook of Spain. A very fine picture of this subject, by Roelas, was sold out of the Soult Collection. [2] v. Introduction: The Symbols and Attributes of the Virgin.

H

not two exactly alike; and they are of all sizes, from the colossal figure called the 'Great Conception of Seville,' to the exquisite miniature representation in the possession of Lord Overston, not more than fifteen inches in height. Lord Lansdowne has also a beautiful small 'Conception,' very simply treated. In those which have dark hair, Murillo is said to have taken his daughter, Francisca, as a model. The number of attendant angels varies from one or two to thirty. They bear the palm, the olive, the rose, the lily, the mirror; sometimes a sceptre and crown. I remember but few instances in which he has introduced the dragon-fiend, an omission which Pacheco is willing to forgive; 'for,' as he observes, 'no man ever painted the devil with good will.'

In the Louvre picture,[1] the Virgin is adored by three ecclesiastics. In another example, quoted by Mr. Stirling,[2] a friar is seen writing at her feet: this figure probably represents her champion, the friar Duns Scotus. There is at Hampton Court a picture, by Spagnoletto, of this same Duns Scotus writing his defence of the Immaculate Conception. Spagnoletto was painting at Naples, when, in 1618, 'the Viceroy solemnly swore, in presence of the assembled multitude, to defend with his life the doctrine of the Immaculate Conception;' and this picture, curious and striking in its way, was painted about the same time.

In Italy, the decline of Art in the seventeenth century is nowhere more apparent, or more offensive, than in this subject. A finished example of the most execrable taste is the mosaic in St. Peter's, after Pietro Bianchi. There exists, somewhere, a picture of the Conception, by Le Brun, in which the Virgin has no other drapery than a thin transparent gauze, and has the air of a Venus Meretrix. In some old French prints, the Virgin is surrounded by a number of angels, defending her with shield and buckler against demons who are taking aim at her with fiery arrows. Such, and even worse, vagaries and perversities, are to be found in the innumerable pictures of this favourite subject, which inundated the churches between 1640 and 1720. Of these I shall say no more. The pictures of Guido and Murillo, and the carved figures of Alonzo Cano, Montanez, and Hernandez, may be regarded as authorised effigies of 'Our Lady of the most pure Conception;' in

[1] No. 1124. [2] Artists of Spain, p. 839.

other words, as embodying, in the most attractive, decorous, and intelligible form, an abstract theological dogma, which is in itself one of the most curious, and, in its results, one of the most important of the religious phenomena connected with the artistic representations of the Virgin.[1]

We must be careful to discriminate between the Conception, so styled by ecclesiastical authority, and that singular and mystical representation which is sometimes called the 'Predestination of Mary,' and sometimes the 'Litanies of the Virgin.' Collectors and writers on art must bear in mind, that the former, as a subject, dates only from the beginning of the seventeenth century, the latter from the beginning of the sixteenth. Although, as representations, so very similar, yet the intention and meaning are different. In the Conception it is the sinless Virgin, in her personal character, who is held up to reverence, as the purest, wisest, holiest, of created beings. The earlier theme involves a yet more recondite signification. It is undoubtedly to be regarded as an attempt on the part of the artist to express, in a visible form, the idea or promise of the redemption of the human race, as existing in the Sovereign Mind before the beginning of things. They do not personify this idea under the image of Christ—for they conceived that, as the second person of the Trinity, he could not be his own instrument—but by the image of Mary surrounded by those attributes which were afterwards introduced into the pictures of the Conception; or setting her foot, as second Eve, on the head of the prostrate serpent. Not seldom, in a series of subjects from the Old Testament, the *pendant* to Eve holding the apple is Mary crushing the head of the fiend; and thus the 'bane and antidote are both before us.' This is the proper interpretation of those effigies, so prevalent in every form of art during the sixteenth century, and which are often, but erroneously, styled the Immaculate Conception.

[1] We often find on pictures and prints of the Immaculate Conception, certain scriptural texts which the theologians of the Roman Church have applied to the Blessed Virgin; for instance, from Ps. xliv., ' *Omnis gloria ejus filiæ regis ab intus*—'The king's daughter is all glorious within;' or from the Canticles, iv. 7, *Tota pulchra es amica mea, et macula non est in te*—'Thou art all fair, my love, there is no spot in thee.' I have also seen the texts, Ps. xxii. 10, and Prov. viii. 22, 23, xxxi. 29, thus applied, as well as other passages from the very poetical office of the Virgin *In Festo Immaculatæ Conceptionis.*

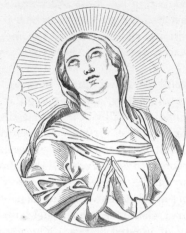

28 La Madonna Purissima.

The numerous heads of the Virgin which proceeded from the later schools of Italy and Spain, wherein she appears neither veiled nor crowned, but very young, and with flowing hair and white vesture, are intended to embody the popular idea of the *Madonna purissima*, of 'the Virgin most pure, conceived without sin,' in an abridged form. There is one by Murillo, in the collection of Mr. Holford; and here is another by Guido, which will give an idea of the treatment. (28)

Before quitting the subject of the Immaculate Conception, I must refer to a very curious picture[1] called an Assumption, but certainly painted at least one hundred years before the Immaculate Conception was authorised as a Church subject.

From the year 1496, when Sixtus IV. promulgated his Bull, and the Sorbonne put forth their famous decree—at a time when there was less of faith and religious feeling in Italy than ever before—this abstract dogma became a sort of watchword with theological disputants; not ecclesiastics only, the literati and the reigning powers took an interest in the controversy, and were arrayed on one side or the other. The Borgias, for instance, were opposed to it. Just at this period, the

[1] Once in the collection of Mr. Solly, and now in the possession of Mr. Bromley, of Wootten.

singular picture I allude to was painted by Girolamo da Cotignola. It is mentioned by Lanzi, but his account of it is not quite correct.

Above, in glory, is seen the *Padre Eterno,* surrounded by cherubim bearing a scroll, on which is inscribed, ' *Non enim pro te sed pro omnibus hœc lex constitutura est.*' [1] Lower down, the Virgin stands on clouds, with hands joined, and attired in a white tunic embroidered with gold, a blue mantle lined with red, and, which is quite singular and unorthodox, *black shoes.* Below, on the earth, and to the right, stands a bishop without a glory, holding a scroll, on which is inscribed, ' *Non puto verè esse amatorem Virginis qui respuit celebrare Festum suæ Conceptionis;*' on the left is St Jerome. In the centre are three kneeling figures : on one side St. Catherine (or perhaps Caterina Sforza in the character of St. Catherine, for the head looks like a portrait); on the other an elderly woman, Ginevra Tiepolo, widow of Giovanni Sforza, last prince of Pesaro ; [2] between them the little Costanzo Sforza, looking up with a charming devout expression.[3] Underneath is inscribed, ' JUNIPERA SFORTIA PATRIA A MARITO RECEPTA. EXVOTO MCCCCCXII.' Giovanni Sforza had been dispossessed of his dominions by the Borgias, after his divorce from Lucrezia, and died in 1501. The Borgias ceased to reign in 1512 ; and Ginevra, apparently restored to her country, dedicated this picture, at once a memorial of her gratitude and of her faith. It remained over the high-altar of the Church of the Serviti, at Pesaro, till acquired by Mr. Solly, from whom it was purchased by Mr. Bromley.[4]

[1] From the Office of the Blessed Virgin.

[2] This Giovanni was the first husband of Lucrezia Borgia.

[3] Lanzi calls this child Costanzo II., prince of Pezaro. Very interesting memoirs of all the personages here referred to may be found in Mr. Dennistoun's Dukes of Urbino.

[4] Girolamo Marchesi da Cotignola was a painter of the Francia school, whose works date from about 1506 to 1550. Those of his pictures which I have seen are of very unequal merit, and, with much feeling and expression in the heads, are often mannered and fantastic as compositions. This agrees with what Vasari says, that his excellence lay in portraiture, for which reason he was summoned, after the battle of Ravenna, to paint the portrait of Gaston de Foix, as he lay dead. (See Vasari, *Vita di Bagnacavallo* ; and in the English trans., vol. iii. 331.) The picture above described, which has a sort of historical interest, is perhaps the same mentioned in Murray's Handbook (Central Italy, p. 110) as an *enthroned* Madonna, dated 1513, and as being in 1843 in its original place over the altar in the Serviti at Pesaro ; if so, it is there no longer.

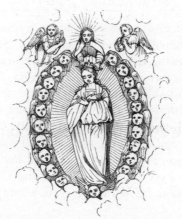

29 The Predestination. (Miniature of the 16th century.)

Devotional Subjects.

PART II.

The Virgin and Child.

1. LA VERGINE MADRE DI DIO.
2. LA MADRE AMABILE.

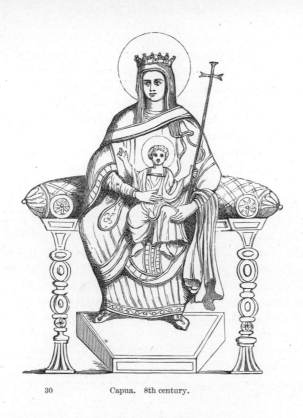

30 Capua. 8th century.

The Virgin and Child enthroned.

Lat. Sancta Dei Genitrix. Virgo Deipara. *Ital.* La Santissima Vergine, Madre di Dio.
Fr. La Sainte Vierge, Mère de Dieu. *Ger.* Die heilige Mutter Gottes.

The Virgin in her maternal character opens upon us so wide a field of
illustration, that I scarce know where to begin or how to find my way,
amid the crowd of associations which press upon me. A mother hold-
ing her child in her arms is no very complex subject; but like a very
simple air constructed on a few expressive notes, which, when har-
monised, is susceptible of a thousand modulations, and variations, and
accompaniments, while the original *motif* never loses its power to
speak to the heart; so it is with the Madonna and Child;—a subject

I

so consecrated by its antiquity, so hallowed by its profound significance, so endeared by its associations with the softest and deepest of our human sympathies, that the mind has never wearied of its repetition, nor the eye become satiated with its beauty. Those who refuse to give it the honour due to a religious representation, yet regard it with a tender half-unwilling homage; and when the glorified type of what is purest, loftiest, holiest in womanhood, stands before us, arrayed in all the majesty and beauty that accomplished Art, inspired by faith and love, could lend her, and bearing her divine Son, rather enthroned than sustained on her maternal bosom, 'we look, and the heart is in heaven!' and it is difficult, very difficult, to refrain from an *Ora pro Nobis*. But before we attempt to classify these lovely and popular effigies, in all their infinite variety, from the enthroned grandeur of the Queen of Heaven, the SANCTA DEI GENITRIX, down to the peasant mother swaddling or suckling her infant, or to interpret the innumerable shades of significance conveyed by the attendant accessories, we must endeavour to trace the representation itself to its origin.

This is difficult. There exists no proof, I believe, that the effigies of the Virgin with the infant Christ in her arms, which existed before the end of the fifth century, were placed before Christian worshippers as objects of veneration. They appear to have been merely groups representing a particular incident of the New Testament, namely, the adoration of the Magi; for I find no other in which the mother is seated with the infant Christ, and this is an historical subject of which we shall have to speak hereafter. From the beginning of the fourth century, that is, from the time of Constantine and the condemnation of Arius, the popular reverence for the Virgin, the Mother of Christ, had been gaining ground, and at the same time the introduction of images and pictures into the places of worship and into the houses of Christians, as ornaments on glass vessels and even embroidered on garments and curtains, became more and more diffused.[1]

The earliest effigies of the Virgin and Child may be traced to Alexandria, and to Egyptian influences; and it is as easily conceivable that the time-consecrated Egyptian myth of Isis and Horus may have sug-

[1] *v.* Neander's Church History.

gested the original type, the outward form and the arrangement of the maternal group, as that the classical Greek types of the Orpheus and Apollo should have furnished the early symbols of the Redeemer as the Good Shepherd; a fact which does not rest upon supposition, but of which the proofs remain to us in the antique Christian sculptures and the paintings in the catacombs.

The most ancient Greek figures of the Virgin and Child have perished; but, as far as I can learn, there is no evidence that these effigies were recognised by the Church as sacred before the beginning of the sixth century. It was the Nestorian schism which first gave to the group of the Mother bearing her divine Son that religious importance and significance which it has ever since retained in Catholic countries.

The divinity of Christ and his miraculous conception, once established as articles of belief, naturally imparted to Mary, his mother, a dignity beyond that of other mothers: her Son was God; therefore the title of MOTHER OF GOD was assigned to her. When or by whom first brought into use, does not appear; but about the year 400 it became a popular designation.

Nestorius, patriarch of Constantinople in 428, had begun by persecuting the Arians; but while he insisted that in Jesus were combined two persons and two natures, he insisted that the Virgin Mary was the mother of Christ considered as *man*, but not the mother of Christ considered as *God*; and that, consequently, all those who gave her the title of *Dei Genitrix, Deipara*,[1] were in error. There were many who adopted these opinions, but by a large portion of the Church they were repudiated with horror, as utterly subverting the doctrine of the mystery of the Incarnation. Cyril of Alexandria opposed Nestorius and his followers, and defended with zealous enthusiasm the claims of the Virgin to all the reverence and worship due to her; for, as he argued, the two natures being one and indivisible from the moment of the miraculous conception, it followed that Mary did indeed bring forth God, —was, in fact, the mother of God; and all who took away from her this dignity and title were in error, and to be condemned as heretics.

[1] The inscription on the Greek and Byzantine pictures is usually MHP ΘY (Μήτηρ Θεοῦ).

I hope I shall not be considered irreverent in thus plainly and simply stating the grounds of this celebrated schism, with reference to its influence on Art; an influence incalculable, not only at the time, but ever since that time; of which the manifold results, traced from century to century down to the present hour, would remain quite unintelligible, unless we clearly understood the origin and the issue of the controversy.

Cyril, who was as enthusiastic and indomitable as Nestorius, and had the advantage of taking the positive against the negative side of the question, anathematised the doctrines of his opponent, in a synod held at Alexandria in 430, to which Pope Celestine II. gave the sanction of his authority. The emperor Theodosius II. then called a general council at Ephesus in 431, before which Nestorius refused to appear, and was deposed from his dignity of patriarch by the suffrages of 200 bishops. But this did not put an end to the controversy; the streets of Ephesus were disturbed by the brawls, and the pavement of the cathedral was literally stained with the blood of the contending parties.

Theodosius arrested both the patriarchs; but after the lapse of only a few days, Cyril triumphed over his adversary: with him triumphed the cause of the Virgin. Nestorius was deposed and exiled; his writings condemned to the flames; but still the opinions he had advocated were adopted by numbers, who were regarded as heretics by those who called themselves 'the Catholic Church.'

The long continuance of this controversy, the obstinacy of the Nestorians, the passionate zeal of those who held the opposite doctrines, and their ultimate triumph when the Western Churches of Rome and Carthage declared in their favour, all tended to multiply and disseminate far and wide throughout Christendom those images of the Virgin which exhibited her as Mother of the Godhead. At length the ecclesiastical authorities, headed by Pope Gregory the Great, stamped them as orthodox: and as the cross had been the primeval symbol which distinguished the Christian from the Pagan, so the image of the Virgin Mother with her Child now became the symbol which distinguished the Catholic Christian from the Nestorian Dissenter.

Thus it appears that if the first religious representations of the Virgin and Child were not a consequence of the Nestorian schism, yet the consecration of such effigies as the visible form of a theological dogma

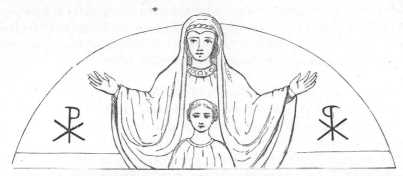

31 Virgo Deipara. (From a Painting in the Catacombs. 7th century.)

to the purposes of worship and ecclesiastical decoration must date from the Council of Ephesus in 431; and their popularity and general diffusion throughout the Western Churches, from the pontificate of Gregory in the beginning of the seventh century.

In the most ancient of these effigies which remain, we have clearly only a symbol; a half-figure, veiled, with hands outspread, and the half-figure of a child placed against her bosom, without any sentiment, without even the action of sustaining him. Such was the formal but quite intelligible sign; but it soon became more, it became a representation. As it was in the East that the cause of the Virgin first triumphed, we might naturally expect to find the earliest examples in the old Greek churches; but these must have perished in the furious onslaught made by the Iconoclasts on all the sacred images. The controversy between the image-worshippers and the image-breakers, which distracted the East for more than a century,[1] did not, however, extend to the west of Europe. We find the primeval Byzantine type, or at least the exact reproduction of it, in the most ancient western churches, and preserved to us in the mosaics of Rome, Ravenna, and Capua. These remains are nearly all of the same date, much later than the single figures of Christ as Redeemer, and belonging unfortunately to a lower period and style of art. The true significance of the representation is not, however, left doubtful; for all the earliest traditions and inscriptions are in this

[1] That is, from 726 to 840.

agreed, that such effigies were intended as a confession of faith; an acknowledgment of the dignity of the Virgin Mary, as the 'SANCTA DEI GENITRIX;' as a visible refutation of 'the infamous, iniquitous, and sacrilegious doctrines of Nestorius the Heresiarch.' [1]

As these ancient mosaic figures of the Virgin, enthroned with her infant Son, were the precursors and models of all that was afterwards conceived and executed in art, we must examine them in detail before proceeding further.

The mosaic of the cathedral of Capua represents in the highest place the half-figure of Christ in the act of benediction. In one of the spandrils, to the right, is the prophet Isaiah, bearing a scroll, on which is inscribed, *Ecce Dominus in fortitudine veniet, et brachium ejus dominabitur,*—'The Lord God will come with strong hand, and his arm shall rule for him.' [2] On the left stands Jeremiah, also with a scroll, and the words, *Fortissime, magne, et potens Dominus exercituum nomen tibi,*—'The great, the mighty God, the Lord of hosts is his name.' [3] In the centre of the vault beneath, the Virgin is seated on a rich throne, a footstool under her feet; she wears a crown over her veil. Christ, seated on her knee, and clothed, holds a cross in his left hand; the right is raised in benediction. On one side of the throne stand St. Peter and St. Stephen; on the other, St. Paul and St. Agatha, to whom the church is dedicated. The Greek monogram of the Virgin is inscribed below the throne.

The next in date which remains visible, is the group in the apsis of S. Maria-della-Navicella,[4] executed about 820, in the time of Paschal I., a pontiff who was very remarkable for the zeal with which he rebuilt and adorned the then half-ruined churches of Rome. The Virgin, of colossal size, is seated on a throne; her robe and veil are blue; the infant Christ, in a gold-coloured vest, is seated in her lap, and raises his hand to bless the worshippers. On each side of the Virgin is a group of adoring angels; at her feet kneels the diminutive figure of Pope Paschal.

[1] *Monstrando quod ipsa Deipara esset contra impiam Nestorii hæresim quam talem esse iste nefandus Hæresiarcha negabat.* Vide Ciampini, and Munter's Sinnbilder.

[2] Isaiah xl. 10. [3] Jeremiah xxxii. 18. [4] Rome.

In the Santa Maria-Nova,[1] the Virgin is seated on a throne, wearing a rich crown, as queen of heaven. The infant Christ stands upon her knee; she has one hand on her bosom and sustains him with the other.

On the façade of the portico of the S. Maria-in-Trastevere at Rome, the Virgin is enthroned, and crowned, and giving her breast to the Child. This mosaic is of later date than that in the apsis, but is one of the oldest examples of a representation which was evidently directed against the heretical doubts of the Nestorians: 'How,' said they, pleading before the council of Ephesus, 'can we call him God who is only two or three months old; or suppose the Logos to have been *suckled* and to increase in wisdom?' The Virgin in the act of suckling her Child, is a *motif* often since repeated when the original significance was forgotten.

In the chapel of San Zeno,[2] the Virgin is enthroned; the Child is seated on her knee. He holds a scroll, on which are the words *Ego sum lux mundi*, 'I am the light of the world;' the right hand is raised in benediction. Above is the monogram **M-P ΘY**, MARIA MATER DEI.

In the mosaics, from the eighth to the eleventh century, we find Art at a very low ebb. The background is flat gold, not a blue heaven with its golden stars, as in the early mosaics of the fifth and sixth centuries. The figures are ill-proportioned; the faces consist of lines without any attempt at form or expression. The draperies, however, have a certain amplitude; 'and the character of a few accessories, for example, the crown on the Virgin's head, instead of the invariable Byzantine veil, betrays,' says Kugler, 'a northern and probably a Frankish influence.' The attendant saints, generally St. Peter and St. Paul, stand stiff and upright on each side.

But with all their faults, these grand, formal, significant groups— or rather not groups, for there was as yet no attempt either at grouping or variety of action, for that would have been considered irreverent— but these rows of figures, were the models of the early Italian painters and mosaic-workers in their large architectural mosaics and altar-pieces set up in the churches during the revival of Art, from the period of

[1] Called also 'Santa Francesca,' Rome. [2] Rome.

Cimabue and Andrea Tafi down to the latter half of the thirteenth century: all partook of this lifeless, motionless character, and were, at the same time, touched with the same solemn religious feeling. And long afterwards, when the arrangement became less formal and conventional, their influence may still be traced in those noble enthroned Madonnas, which represent the Virgin as queen of heaven and of angels, either alone, or with attendant saints, and martyrs, and venerable confessors waiting round her state.

The general disposition of the two figures varies but little in the earliest examples which exist for us in painting, and which are, in fact, very much alike. The Madonna seated on a throne, wearing a red tunic and a blue mantle, part of which is drawn as a veil over her head, holds the infant Christ, clothed in a red or blue tunic. She looks straight out of the picture with her head a little declined to one side. Christ has the right hand raised in benediction, and the other extended. Such were the simple, majestic, and decorous effigies, the legitimate successors of the old architectural mosaics, and usually placed over the high altar of a church or chapel. The earliest examples which have been preserved are for that reason celebrated in the history of Art.

The first is the enthroned Virgin of Guido da Siena, who preceded Cimabue by twenty or thirty years. In this picture (32), the Byzantine conception and style of execution are adhered to, yet with a softened sentiment, a touch of more natural, lifelike feeling, particularly in the head of the Child. The expression in the face of the Virgin struck me as very gentle and attractive; but it has been, I am afraid, retouched, so that we cannot be quite sure that we have the original features. Fortunately Guido has placed a date on his work, MCCXXI., and also inscribed on it a distich, which shows that he felt, with some consciousness and self-complacency, his superiority to his Byzantine models :—

> Me Guido de Senis diebus depinxit amœnis,
> Quem Christus lenis nullis velit angere pœnis.[1]

Next we may refer to the two colossal Madonnas by Cimabue, preserved at Florence. The first, which was painted for the Vallombrosian

[1] The meaning, for it is not easy to translate literally, is ‘ *Me hath painted, in pleasant days, Guido of Siena, Upon whose soul may Christ deign to have mercy!* ’

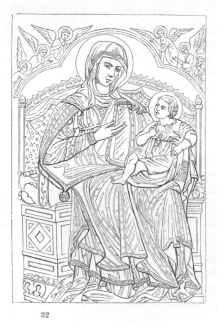

32

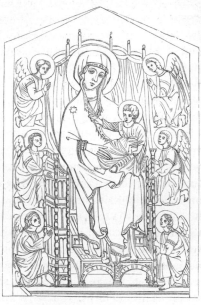

33

monks of the S. Trinità, is now in the gallery of the academy. It has all the stiffness and coldness of the Byzantine manner. There are three adoring angels on each side, disposed one above another, and four prophets are placed below in separate niches, half-figures, holding in their hands their prophetic scrolls, as in the old mosaic at Capua, already described. The second is preserved in the Ruccellai chapel, in the S. Maria-Novella, in its original place. (33) In spite of its colossal size, and formal attitude, and severe style, the face of this Madonna is very striking, and has been well described as 'sweet and unearthly, reminding you of a sibyl.' The infant Christ is also very fine. There are three angels on each side, who seem to sustain the carved chair or throne on which the Madonna is seated; and the prophets, instead of being below, are painted in small circular medallions down each side of the frame. The throne and the background are covered with gold. Vasari gives a very graphic and animated account of the estimation in which this

picture was held when first executed. Its colossal dimensions, though familiar in the great mosaics, were hitherto unknown in painting; and not less astonishing appeared the deviation, though slight, from ugliness and lifelessness into grace and nature. 'And thus,' he says, 'it happened that this work was an object of so much admiration to the people of that day, they having then never seen anything better, that it was carried in solemn procession, with the sound of trumpets and other festal demonstrations, from the house of Cimabue to the church, he himself being highly rewarded and honoured for it. It is further reported, and may be read in certain records of old painters, that, whilst Cimabue was painting this picture, in a garden near the gate of San Pietro, King Charles the Elder, of Anjou, passed through Florence, and the authorities of the city, among other marks of respect, conducted him to see the picture of Cimabue. When this work was thus shown to the King, it had not before been seen by any one; wherefore all the men and women of Florence hastened in crowds to admire it, making all possible demonstrations of delight. The inhabitants of the neighbourhood, rejoicing in this occurrence, ever afterwards called that place *Borgo Allegri*; and this name it has ever since retained, although in process of time it became enclosed within the walls of the city.'

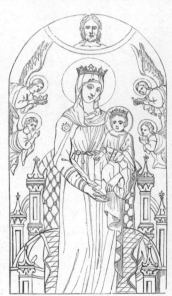

34 La Madonna di San Brizio.

In the strictly devotional representations of the Virgin and Child, she is invariably seated, till the end of the thirteenth century; and for the next hundred years the innovation of a standing figure was confined to sculpture. An early example is the beautiful statue by Niccolò Pisano, in the Capella della Spina at Pisa; and others will be found in Cicognara's work.[1] The Gothic cathedrals, of the thirteenth century,

[1] Storia della Scultura Moderna.

also exhibit some most graceful examples of the Madonna in sculpture, standing on a pedestal, crowned or veiled, sustaining on her left arm the divine Child, while in her right she holds a sceptre or

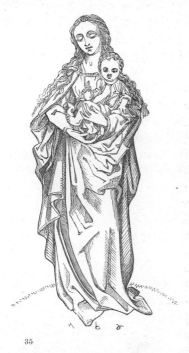

perhaps a flower. Such crowned or sceptred effigies of the Virgin were placed on the central pillar which usually divided the great door of a church into two equal parts; in reference to the text, 'I am the DOOR; by me if any man enter in, he shall be saved.' In Roman Catholic countries we find such effigies set up at the corners of streets, over the doors of houses, and the gates of gardens, sometimes rude and coarse, sometimes exceedingly graceful, according to the period of art and skill of the local artist. Here the Virgin appears in her character of Protectress—our Lady of Grace, or our Lady of Succour.

35

In pictures, we rarely find the Virgin standing, before the end of the fourteenth century. An almost singular example is to be found in an old Greek Madonna, venerated as miraculous, in the cathedral of Orvieto, under the title of *La Madonna di San Brizio,* and to which is attributed a fabulous antiquity. (34) I may be mistaken, but my impression, on seeing it, was, that it could not be older than the end of the thirteenth century. The crowns worn by the Virgin and Christ are even more modern, and out of character with the rest of the painting, of which I give a sketch. In Italy the pupils of Giotto first began to represent the Virgin standing on a raised dais. There is an example by Puccio Capanna, engraved in D'Agincourt's work;[1] but such figures

[1] Pl. 117.

K 2

are very uncommon. In the fifteenth and sixteenth centuries they occur more frequently in the northern than in the Italian schools. This little sketch, after Martin Schön, is an example. (35)

In the simple enthroned Madonna, variations of attitude and sentiment were gradually introduced. The Virgin, instead of supporting her Son with both hands, embraces him with one hand, and with the other points to him; or raises her right hand to bless the worshipper. Then the Child caresses his mother — 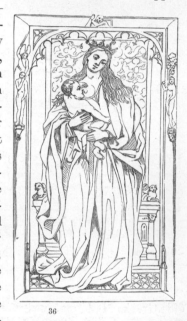 a charming and natural idea, but a deviation from the solemnity of the purely religious significance; better imagined, however, to convey the relation between the mother and child, than the Virgin suckling her infant, to which I have already alluded in its early religious, or rather controversial, meaning. It is not often that the enthroned Virgin is thus occupied. Mr. Rogers had in his collection an exquisite example where the Virgin, seated in state on a magnificent throne under a Gothic canopy and crowned as queen of heaven, offers her breast to the divine Infant. This sketch, from a beautiful little 'Virgin' in the Vienna Gallery, attributed to the same master, John v. Eyck, exhibits the same action. (36) The Virgin is here stand-

36

ing, as if she had just risen from her throne, under a Gothic canopy, on which is sculptured the Fall; Adam on one side, and Eve on the other.

Then the Mother adores her child. This is properly the *Madre Pia*, afterwards so beautifully varied. He lies extended on her knee, and she looks down upon him with hands folded in prayer; or she places her hand under his foot, an attitude which originally implied her acknowledgment of his sovereignty and superiority, but was continued as a natural *motif* when the figurative and religious meaning was no longer

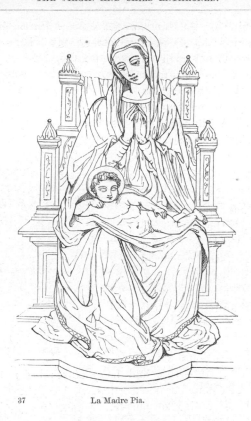

37 La Madre Pia.

considered. Sometimes the Child looks up in his mother's face, with his finger on his lip, expressing the *Verbum sum,* 'I am the Word.' Sometimes the Child, bending forwards from his mother's knee, looks down benignly on the worshippers, who are *supposed* to be kneeling at the foot of the altar. Sometimes, but very rarely, he sleeps; never in the earliest examples; for to exhibit the young Redeemer asleep, where he is an object of worship, was then a species of solecism.

When the enthroned Virgin is represented holding a book, or reading, while the infant Christ, perhaps, lays his hand upon it—a variation in the first simple treatment not earlier than the end of the fourteenth century, and very significant—she is then the *Virgo Sapientissima,* the

most Wise Virgin; or the Mother of Wisdom, *Mater Sapientiæ*; and the book she holds is the Book of Wisdom.[1] This is the proper inter-

pretation, where the Virgin is seated on her throne. In a most beautiful picture by Granacci,[2] she is thus enthroned, and reading intently; while John the Baptist and St. Michael stand on each side.

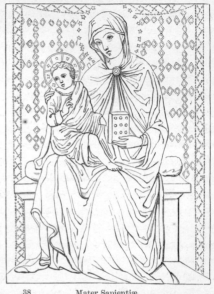

38 Mater Sapientiæ.

With regard to costume, the colours in which the enthroned Virgin-Mother was arrayed scarcely ever varied from the established rule : her tunic was to be red, her mantle blue; red, the colour of love and religious aspiration; blue, the colour of constancy and heavenly purity. In the pictures of the thirteenth and fourteenth centuries, and down to the early part of the fifteenth, these colours are of a soft and delicate tint—rose and pale azure; but afterwards, when powerful effects of colour became a study, we have the intense crimson, and the dark blue verging on purple. Sometimes the blue mantle is brought over her head, sometimes she wears a white veil, in other instances the queenly crown. Sometimes (but very rarely when she is throned as the *Regina Cœli*) she has no covering or ornament on her head; and her fair hair, parted on her brow, flows down on either side in long luxuriant tresses.

In the Venetian and German pictures she is often most gorgeously arrayed; her crown studded with jewels, her robe covered with embroidery, or bordered with gold and pearls. The ornamental parts of her dress and throne were sometimes, to increase the magnificence of

[1] L'Abbé Crosnier, Iconographie Chrétienne ; but the book as an attribute had another meaning, for which, see the Introduction. [2] Berlin Gal.

the effect, raised in relief and gilt. To the early German painters we might too often apply the sarcasm of Apelles, who said of his rival, that, 'not being able to make Venus *beautiful*, he had made her *fine*;' but some of the Venetian Madonnas are lovely as well as splendid. Gold was often used, and in great profusion, in some of the Lombard pictures even of a late date; for instance, by Carlo Crivelli: before the middle of the sixteenth century, this was considered barbaric. The best Italian painters gave the Virgin ample, well-disposed drapery, but dispensed with ornament. The star embroidered on her shoulder, so often retained when all other ornament was banished, expresses her title 'Stella Maris.' I have seen some old pictures in which she wears a ring on the third finger. This expresses her dignity as the *Sposa* as well as the Mother.

With regard to the divine Infant, he is, in the early pictures, invariably draped, and it is not till the beginning of the fifteenth century that we find him first partially and then wholly undraped. In the old representations, he wears a long tunic with full sleeves, fastened with a girdle. It is sometimes of gold stuff embroidered, sometimes white, crimson, or blue. This almost regal robe was afterwards exchanged for a little semi-transparent shirt without sleeves. In pictures of the throned Madonna painted expressly for nunneries, the Child is, I believe, always clothed, or the Mother partly enfolds him in her own drapery. In the Umbrian pictures of the fifteenth century, the Infant often wears a coral necklace, then and now worn by children in that district, as a charm against the evil eye. In the Venetian pictures he has sometimes a coronal of pearls. In the carved and painted images set up in churches, he wears, like his mother, a rich crown over a curled wig, and is hung round with jewels; but such images must be considered as out of the pale of legitimate art.

Of the various objects placed in the hand of the Child as emblems I have already spoken, and of their sacred significance as such—the globe, the book, the bird, the flower, &c. In the works of the ignorant secular artists of later times, these symbols of power, or divinity, or wisdom, became mere playthings; and when they had become familiar, and required by custom, and the old sacred associations utterly for-

gotten, we find them most profanely applied and misused. To give one example:—the bird was originally placed in the hand of Christ as the emblem of the soul, or of the spiritual as opposed to the earthly nature; in a picture by Baroccio, he holds it up before a cat, to be frightened and tormented.[1] But to proceed.

The throne on which the Virgin is seated, is, in very early pictures, merely an embroidered cushion on a sort of stool, or a carved Gothic chair, such as we see in the thrones and stalls of cathedrals. It is afterwards converted into a rich architectural throne, most elaborately adorned, according to the taste and skill of the artist. Sometimes, as in the early Venetian pictures, it is hung with garlands of fruits and flowers, most fancifully disposed. Sometimes the arabesque ornaments are raised in relief and gilt. Sometimes the throne is curiously painted to imitate various marbles, and adorned with medallions and bas-reliefs from those subjects of the Old Testament which have a reference to the character of the Virgin and the mission of her divine Child; the commonest of all being the Fall, which rendered a Redeemer necessary. Moses striking the rock (the waters of life), the elevation of the brazen serpent, the gathering of the manna, or Moses holding the broken tablets of the old law—all types of redemption—are often thus introduced as ornaments. In the sixteenth century, when the purely religious sentiment had declined, and a classical and profane taste had infected every department of art and literature, we find the throne of the Virgin adorned with classical ornaments and bas-reliefs from the antique remains; as, for instance, the hunt of Theseus and Hippolyta. We must then suppose her throned on the ruins of paganism, an idea suggested by the old legends, which represent the temples and statues of the heathen gods as falling into ruin on the approach of the Virgin and her Child; and a more picturesque application of this idea afterwards became common in other subjects. In this sketch, after Garofalo (39), the throne is adorned with sphinxes—*à l'antique.* Andrea del Sarto has placed harpies at the corner of the pedestal of the throne, in his famous Madonna di San Francesco,[2]—a gross fault in that otherwise

[1] In the History of our Lord, as illustrated in the Fine Arts, the devotional and characteristic effigies of the Infant Christ, and the accompanying attributes, will be treated at length. [2] Florence Gal.

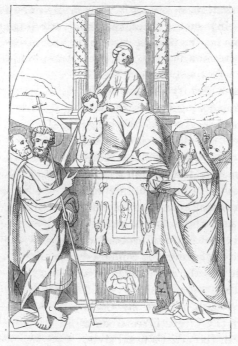

39 La Madonna *in Trono*. (Garofalo.)

grand and faultless picture; one of those desecrations of a religious theme which Andrea, as devoid of religious feeling as he was weak and dishonest, was in the habit of committing.

But whatever the material or style of the throne, whether simple or gorgeous, it is supposed to be a heavenly throne. It is not of the earth, nor on the earth; and at first it was alone and unapproachable. The Virgin mother, thus seated in her majesty, apart from all human beings, and in communion only with the Infant Godhead on her knee, or the living worshippers who come to lay down their cares and sorrows at the foot of her throne and breathe a devout 'Salve Regina!'—is, through its very simplicity and concentrated interest, a sublime conception. The effect of these figures, in their divine quietude and loveliness, can never be appreciated when hung in a gallery or room, with other

L

pictures, for admiration, or criticism, or comparison. I remember well suddenly discovering such a Madonna, in a retired chapel in S. Francesco della Vigna at Venice—a picture I had never heard of, by a painter then quite unknown to me, Fra Antonio da Negroponte, a Franciscan friar who lived in the fifteenth century. The calm dignity of the attitude, the sweetness, the adoring love in the face of the queenly mother, as with folded hands she looked down on the divine Infant reclining on her knee, so struck upon my heart, that I remained for minutes quite motionless. In this picture, nothing can exceed the gorgeous splendour of the Virgin's throne and apparel: she wears a jewelled crown; the Child a coronal of pearls; while the background is composed entirely of the mystical roses twined in a sort of *treillage.*

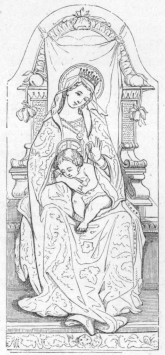

40 La Madonna *in Trono.* (Carlo Crivelli.)

I remember, too, a picture by Carlo Crivelli, in which the Virgin is seated on a throne, adorned, in the artist's usual style, with rich festoons of fruit and flowers. She is most sumptuously crowned and apparelled; and the beautiful Child on her knee, grasping her hand as if to support himself, with the most *naïve* and graceful action bends forward and looks down benignly on the worshippers *supposed* to be kneeling below. (40)

When human personages were admitted within the same compartment, the throne was generally raised by several steps, or placed on a lofty pedestal, and till the middle of the fifteenth century it was always in the centre of the composition fronting the spectator. It was a Venetian innovation to place the throne at one side of the picture, and show the Virgin in profile or in the act of turning round. This more scenic disposition became afterwards, in the passion for variety and effect, too palpably artificial, and at length forced and theatrical.

The Italians distinguish between the *Madonna in Trono* and the *Madonna in Gloria.* When human beings, however sainted and exalted, were admitted within the margin of the picture, the divine dignity of the Virgin as *Madre di Dio* was often expressed by elevating her wholly above the earth, and placing her 'in regions mild of calm and serene air,' with the crescent or the rainbow under her feet. This is styled a 'Madonna in Gloria.' It is, in fact, a return to the antique conception of the enthroned Redeemer, seated on a rainbow, sustained by the 'curled clouds,' and encircled by a glory of cherubim. The aureole of light, within which the glorified Madonna and her Child when in a standing position are often placed, is of an oblong form,

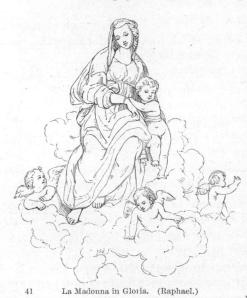

41 La Madonna in Gloria. (Raphael.)

called from its shape the *mandorla,* 'the almond;'[1] but in general she is seated above in a sort of ethereal exaltation, while the attendant saints stand on the earth below. This beautiful arrangement, though often very sublimely treated, has not the simple austere dignity of the throne of state; and when the Virgin and Child, as in the works of the late Spanish and Flemish painters, are formed out of earth's most coarse and common-place materials, the aerial throne of floating fantastic clouds suggests a disagreeable discord, a fear lest the occupants of heaven should fall on the heads of their worshippers below. Not so the Virgins of the old Italians; for they look so divinely ethereal that they seem uplifted by their own spirituality: not even the air-borne clouds are needed to sustain them. (41)

[1] Or the 'Vesica Piscis,' by Lord Lindsay and others. See Cut 16.

They have no touch of earth or earth's material beyond the human form; their proper place is the seventh heaven; and there they repose, a presence and a power—a personification of infinite mercy sublimated by innocence and purity; and thence they look down on their worshippers and attendants, while these gaze upwards 'with looks commercing with the skies.'

And now of these angelic and sainted accessories, however placed, we must speak at length; for much of the sentiment and majesty of the Madonna effigies depend on the proper treatment of the attendant figures, and on the meaning they convey to the observer.

The Virgin is entitled, by authority of the Church, queen of angels, of prophets, of apostles, of martyrs, of virgins, and of confessors; and from among these her attendants are selected.

ANGELS were first admitted, waiting immediately round her chair of state. A signal instance is the group of the enthroned Madonna, attended by the four archangels, as we find it in the very ancient mosaic in Sant-Apollinare-Novo, at Ravenna. (42) As the belief in the superior power and sanctity of the Blessed Virgin grew and spread, the angels no longer attended her as princes of the heavenly host, guardians, or councillors; they became, in the early pictures, adoring angels, sustaining her throne on each side, or holding up the embroidered curtain which forms the background. In the Madonna by Cimabue, which, if it be not the earliest after the revival of art, was one of the first in which the Byzantine manner was softened and Italianised, we have six grand, solemn-looking angels, three on each side of the throne, arranged perpendicularly one above another.[1] The Virgin herself is of colossal proportions, far exceeding them in size, and looking out of her frame, 'large as a goddess of the antique world.' In the other Madonna in the gallery of the academy, we have the same arrangement of the angels. Giotto diversified this arrangement. He placed the angels kneeling at the foot of the throne, making music, and waiting on their divine Mistress as her celestial choristers,—a service the more

[1] Florence, S. Maria Novella: v. p. 65.

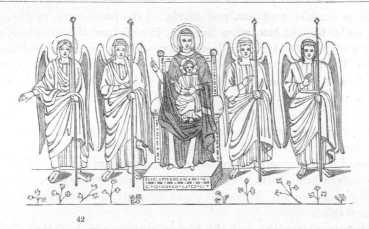

42

fitting because she was not only queen of angels, but patroness of music and minstrelsy, in which character she has St. Cecilia as her deputy and delegate. This accompaniment of the choral angels was one of the earliest of the accessories, and continued down to the latest times. They are most particularly lovely in the pictures of the fifteenth century. They kneel and strike their golden lutes, or stand and sound their silver clarions, or sit like beautiful winged children on the steps of the throne, and pipe and sing as if their spirits were overflowing with harmony as well as love and adoration.[1] In a curious picture of the enthroned Madonna and Child,[2] by Gentil Fabriano, a tree rises on each side of the throne, on which little red seraphim are perched like birds, singing and playing on musical instruments. In later times, they play and sing for the solace of the divine Infant, not merely adoring, but ministering: but these angels ministrant belong to another class of pictures. Adoration, not service, was required by the divine Child and his mother, when they were represented simply in their divine character, and placed far beyond earthly wants and earthly associations.

There are examples where the angels in attendance bear, not harps or lutes, but the attributes of the Cardinal Virtues, as in an altar-piece by Taddeo Gaddi at Florence.[3]

[1] As in the picture by Lo Spagna in our National Gallery. No. 282. [2] Berlin Gal.
[3] Santa Croce, Rinuccini Chapel.

The patriarchs, prophets, and sibyls, all the personages, in fact, who lived under the old law, when forming, in a picture or altar-piece, part of the *cortége* of the throned Virgin, as types, or prophets, or harbingers of the Incarnation, are on the *outside* of that sacred compartment wherein she is seated with her Child. This was the case with *all* the human personages down to the end of the thirteenth century; and after that time, I find the characters of the Old Testament still excluded from the groups immediately round her throne. Their place was elsewhere allotted, at a more respectful distance. The only exceptions I can remember, are King David and the patriarch Job; and these only in late pictures where David does not appear as prophet, but as the ancestor of the Redeemer; and Job, only at Venice, where he is a patron saint.

The four evangelists and the twelve apostles are, in their collective character in relation to the Virgin, treated like the prophets, and placed around the altar-piece. Where we find one or more of the evangelists introduced into the group of attendant 'Sanctities' on each side of her throne, it is not in their character of evangelists, but rather as patron saints. Thus St. Mark appears constantly in the Venetian pictures; but it is as the patron and protector of Venice. St. John the Evangelist, a favourite attendant on the Virgin, is near her in virtue of his peculiar relation to her and to Christ; and he is also a popular patron saint. St. Luke and St. Matthew, unless they be patrons of the particular locality, or of the votary who presents the picture, never appear. It is the same with the apostles in their collective character as such; we find them constantly, as statues, ranged on each side of the Virgin, or as separate figures. Thus they stand over the screen of St. Mark's, at Venice, and also on the carved frames of the altar-pieces; but either from their number, or some other cause, they are seldom grouped round the enthroned Virgin.

It is St. John the Baptist who, next to the angels, seems to have been the first admitted to a propinquity with the divine persons. In Greek art, he is himself an angel, a messenger, and often represented with wings. He was especially venerated in the Greek Church in his character of precursor of the Redeemer, and, as such, almost indispen-

sable in every sacred group; and it is, perhaps, to the early influence of Greek art on the selection and arrangement of the accessory person- ages, that we owe the preeminence of John the Baptist. One of the most graceful, and appropriate, and familiar of all the accessory figures grouped with the Virgin and Child, is that of the young St. John (called in Italian *San Giovannino*, and in Spanish *San Juanito*). When first introduced, we find him taking the place of the singing or piping angels in front of the throne. He generally stands, 'clad in his raiment of camel's hair, having a girdle round his loins,' and in his hand a reed cross, round which is bound a scroll with the words ' *Ecce Agnus Dei* ' ('Behold the Lamb of God '), while with his finger he points up to the enthroned group above him, expressing the text from St. Luke (c. ii.), 'And thou, CHILD, shalt be called the Prophet of the Highest,' as in Francia's picture in our National Gallery. Sometimes he bears a lamb in his arms, the *Ecce Agnus Dei* in form instead of words.

The introduction of the young St. John becomes more and more usual from the beginning of the sixteenth century. In later pictures, a touch of the dramatic is thrown into the arrangement : instead of being at the foot of the throne, he is placed beside it; as where the Virgin is throned on a lofty pedestal, and she lays one hand on the head of the little St. John, while with the other she strains her Child to her bosom; or where the infant Christ and St. John, standing at her knee, embrace each other—a graceful incident in a Holy Family, but in the enthroned Madonna it impairs the religious conception; it places St. John too much on a level with the Saviour, who is here in that divine character to which St. John bore witness, but which he did not share. It is very unusual to see John the Baptist in his childish character glorified in heaven among the celestial beings : I remember but one instance, in a beautiful picture by Bonifazio.[1] The Virgin is seated in glory, with her Infant on her knee, and encircled by cheru- bim; on one side an angel approaches with a basket of flowers on his head, and she is in act to take these flowers and scatter them on the saints below,—a new and graceful *motif* : on the other side sits John

[1] Acad. Venice.

the Baptist as a boy about twelve years of age. The attendant saints below are St. Peter, St. Andrew, St. Thomas holding the girdle,[1] St. Francis, and St. Clara, all looking up with ecstatic devotion, except St. Clara, who looks down with a charming modesty.

In early pictures, St. Anna, the mother of the Virgin, is very seldom introduced, because in such sublime and mystical representations of the *Vergine Dea,* whatever connected her with realities, or with her earthly genealogy, is suppressed. But from the middle of the fifteenth century, St. Anna became, from the current legends of the history of the Virgin, an important saint, and when introduced into the devotional groups, which, however, is seldom, it seems to have embarrassed the painters how to dispose of her. She could not well be placed below her daughter; she could not be placed above her. It is a curious proof of the predominance of the feminine element throughout these representations, that while St. Joachim the father, and St. Joseph the husband, of the Virgin, are either omitted altogether, or are admitted only in a subordinate and inferior position, St. Anna, when she does appear, is on an equality with her daughter. There is a beautiful example, and apt for illustration, in the picture by Francia, in our National Gallery, where St. Anna and the Virgin are seated together on the same throne, and the former presents the apple to her divine Grandson. I remember, too, a most graceful instance where St. Anna stands behind and a little above the throne, with her hands placed affectionately on the shoulders of the Virgin, and raises her eyes to heaven as if in thanksgiving to God, who through her had brought salvation into the world. Where the Virgin is seated on the knees of St. Anna, it is a still later innovation. There is such a group in a picture in the Louvre, after a famous cartoon by Leonardo da Vinci, which, in spite of its celebrity, has always appeared to me very fantastic and irreverent in treatment. There is also a fine print by Carraglio, in which the Virgin and Child are sustained on the knees of St. Anna: under her feet lies the dragon. St. Roch and St. Sebastian on each side, and the dead dragon, show that this is a votive subject, an expres-

[1] St. Thomas is called in the catalogue, James, king of Arragon.

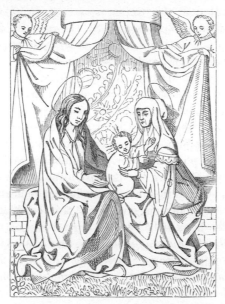

43 The Virgin and Child enthroned with St. Anna.

sion of thanksgiving after the cessation of a plague. The Germans, who were fond of this group, imparted even to the most religious treatment a domestic sentiment, as in the above sketch.

The earliest instance I can point to, of the enthroned Virgin attended by both her parents, is by Vivarini:[1] St. Anna is on the right of the throne; St. Joachim, in the act of reverently removing his cap, stands on the left; more in front is a group of Franciscan saints.

The introduction of St. Anna into a Holy Family, as part of the domestic group, is very appropriate and graceful; but this of course admits, and indeed requires, a wholly different sentiment. The same remark applies to St. Joseph, who, in the earlier representations of the enthroned Virgin, is carefully excluded; he appears, I think, first in the Venetian pictures. There is an example in a splendid composition by Paul Veronese.[2] The Virgin, on a lofty throne, holds the Child; both look down on the worshippers; St. Joseph is partly seen behind leaning

[1] Acad. Venice. [2] Acad. Venice.

M

on his crutch. Round the throne stand St. John the Baptist, St. Justina, as patroness of Venice, and St. George; St. Jerome is on the other side in deep meditation. A magnificent picture, quite sumptuous in colour and arrangement, and yet so solemn and so calm! [1]

The composition by Michael Angelo styled a 'Holy Family,' is, though singular in treatment, certainly devotional in character, and an enthroned Virgin. She is seated in the centre, on a raised architectural seat, holding a book; the infant Christ slumbers—books can teach him nothing, and to make him reading is unorthodox. In the background on one side, St. Joseph leans over a balustrade, as if in devout contemplation; a young St. John the Baptist leans on the other side. The grand, mannered, symmetrical treatment is very remarkable and characteristic. There are many engravings of this celebrated composition. In one of them, the book held by the Virgin bears on one side the text in Latin, ' *Blessed art thou among women, and blessed is the fruit of thy womb.*' On the opposite page, ' *Blessed be God, who has regarded the low estate of his hand-maiden. For, behold, from henceforth all generations shall call me blessed.*'

While the young St. John is admitted into such close companionship with the enthroned Madonna, his mother Elizabeth, so commonly and beautifully introduced into the Holy Families, is almost uniformly excluded.

Next in order, as accessory figures, appear some one or two or more of the martyrs, confessors, and virgin patronesses, with their respective attributes, either placed in separate niches and compartments on each side, or, when admitted within the sacred precincts where sit the queenly Virgin Mother and her divine Son, standing, in the manner of councillors and officers of state on solemn occasions, round an earthly sovereign, all reverently calm and still; till gradually this solemn formality, this isolation of the principal characters, gave way to some sentiment which placed them in nearer relation to each other, and to the divine personages. Occasional variations of attitude and action were

[1] There is another example by Paul Veronese, similar in character and treatment, in which St. John and St. Joseph are on the throne with the Virgin and Child, and St. Catherine and St. Antony below.

introduced—at first, a rare innovation; ere long, a custom, a fashion. For instance;—the doctors turn over the leaves of their great books as if seeking for the written testimonies to the truth of the mysterious Incarnation made visible in the persons of the Mother and Child; the confessors contemplate the radiant group with rapture, and seem ready to burst forth in hymns of praise; the martyrs kneel in adoration; the virgins gracefully offer their victorious palms: and thus the painters of the best periods of art contrived to animate their sacred groups without rendering them too dramatic and too secular.

Such, then, was the general arrangement of that religious subject which is technically styled 'The Madonna enthroned and attended by Saints.' The selection and the relative position of these angelic and saintly accessories were not, as I have already observed, matters of mere taste or caprice; and an attentive observation of the choice and disposition of the attendant figures will often throw light on the original significance of such pictures, and the circumstances under which they were painted.

Shall I attempt a rapid classification and interpretation of these infinitely varied groups? It is a theme which might well occupy volumes rather than pages, and which requires far more antiquarian learning and historical research than I can pretend to; still, by giving the result of my own observations in some few instances, it may be possible so to excite the attention and fancy of the reader, as to lead him further on the same path than I have myself been able to venture.

We can trace, in a large class of these pictures, a general religious significance, common to all periods, all localities, all circumstances; while in another class, the interest is not only particular and local, but sometimes even personal.

To the first class belongs the antique and beautiful group of the Virgin and Child, enthroned between the two great archangels, St. Michael and St. Gabriel. It is probably the most ancient of these combinations: we find it in the earliest Greek art, in the carved ivory diptychs of the eighth and ninth centuries, in the old Greco-Italian pictures, in the ecclesiastical sculpture and stained glass of from the

twelfth to the fifteenth century. In the most ancient examples, the two angels are seen standing on each side of the Madonna, not worshipping, but with their sceptres and attributes, as princes of the heavenly host, attending on her who is queen of angels; St. Gabriel as the angel of birth and life, St. Michael as the angel of Death, that is, in the Christian sense, of deliverance and immortality. There is an instance of this antique treatment in a small Greek picture in the Wallerstein collection.[1]

In later pictures, St. Gabriel seldom appears except as the *Angelo Annunziatore*; but St. Michael very frequently. Sometimes, as conqueror over sin and representative of the Church militant, he stands with his foot on the dragon with a triumphant air; or, kneeling, he presents to the infant Christ the scales of eternal justice, as in a famous picture by Leonardo da Vinci. It is not only because of his popularity as a patron saint, and of the number of churches dedicated to him, that he is so frequently introduced into the Madonna pictures; according to the legend, he was by divine appointment the guardian of the Virgin and her Son while they sojourned on earth. The angel Raphael leading Tobias always expresses protection, and especially protection to the young. Tobias with his fish was an early type of baptism. There are many beautiful examples. In Raphael's 'Madonna dell' Pesce'[2] he is introduced as the patron saint of the painter, but not without a reference to a more sacred meaning, that of the guardian spirit of all humanity. (44) The warlike figure of St. Michael, and the benign St. Raphael, are thus represented as celestial guardians in the beautiful picture by Perugino now in our National Gallery.[3]

There are instances of the three archangels all standing together below the glorified Virgin: St. Michael in the centre with his foot on the prostrate fiend; St. Gabriel on the right presents his lily; and, on the left, the protecting angel presents his human charge, and points up to the source of salvation.[4]

The Virgin between St. Peter and St. Paul is also an extremely ancient and significant group. It appears in the old mosaics. As

[1] Now at Kensington Palace.
[2] Madrid Gal.
[3] No. 288.
[4] In an engraving after Giulio Romano.

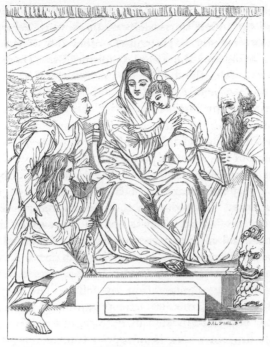

44 La Madonna dell' Pesce.

chiefs of the apostles and joint founders of the Church, St. Peter and
St. Paul are prominent figures in many groups and combinations, par-
ticularly in the altar-pieces of the Roman churches, and those painted
for the Benedictine communities.

The Virgin, when supported on each side by St. Peter and St. Paul,
must be understood to represent the personified Church between her
two great founders and defenders; and this relation is expressed in a
very poetical manner, when St. Peter, kneeling, receives the allegorical
keys from the hand of the infant Saviour. There are some curious and
beautiful instances of this combination of a significant action with the
utmost solemnity of treatment; for example, in that very extraordinary
Franciscan altar-piece, by Carlo Crivelli, lately purchased by Lord
Ward, where St. Peter, having deposited his papal tiara at the foot of
the throne, kneeling receives the great symbolical keys. And again,

in a fine picture by Andrea Meldula, where the Virgin and Child are
enthroned, and the infant Christ delivers the keys to Peter, who stands,
but with a most reverential air; on the other side of the throne is St.
Paul with his book and the sword held upright. There are also two
attendant angels. On the border of the mantle of the Virgin is in-
scribed '*Ave Maria, gratia plena.*' [1]

I do not recollect any instance in which the four evangelists as such,
or the twelve apostles in their collective character, wait round the
throne of the Virgin and Child, though one or more of the evangelists
and one or more of the apostles perpetually occur.

The Virgin between St. John the Baptist and St. John the Evan-
gelist, is also a very significant and beautiful combination, and one very
frequently met with. Though both these saints were, as children, con-
temporary with the Child Christ, and so represented in the Holy
Families, in these solemn ideal groups they are always men. The first
St. John expresses regeneration by the rite of baptism : the second St.
John, distinguished as *Theologus*, 'the Divine,' stands with his sacra-
mental cup, expressing regeneration by faith. The former was the
precursor of the Saviour, the first who proclaimed him to the world as
such ; the latter beheld the vision in Patmos, of the Woman in travail
pursued by the dragon, which is interpreted in reference to the Virgin
and her Child. The group thus brought into relation is full of meaning,
and, from the variety and contrast of character, full of poetical and
artistic capabilities. St. John the Baptist is usually a man about thirty,
with wild shaggy hair and meagre form, so draped that his vest of
camel's hair is always visible; he holds his reed cross. St. John the
Evangelist is generally the young and graceful disciple; but in some
instances he is the venerable seer of Patmos,

<div style="text-align:center">Whose beard descending sweeps his aged breast.</div>

There is an example in one of the finest pictures by Perugino. The
Virgin is throned above, and surrounded by a glory of seraphim, with
many-coloured wings. The Child stands on her knee. In the land-

[1] In the collection of Mr. Bromley, of Wootton. This picture is otherwise remarkable as
the only authenticated work of a very rare painter. It bears his signature, and the style in-
dicates the end of the fifteenth century as the probable date.

scape below are St. Michael, St. Catherine, St. Apollonia, and St. John the Evangelist as the aged prophet with white flowing beard.[1]

The Fathers of the Church, as interpreters and defenders of the mystery of the Incarnation, are very significantly placed near the throne of the Virgin and Child. In Western art, the Latin doctors, St. Jerome, St. Ambrose, St. Augustine, and St. Gregory, have of course the preeminence.[2]

The effect produced by these aged, venerable, bearded dignitaries, with their gorgeous robes and mitres and flowing beards, in contrast with the soft simplicity of the divine Mother and her Infant, is, in the hands of really great artists, wonderfully fine. There is a splendid example, by Vivarini;[3] the old doctors stand two on each side of the throne, where, under a canopy upborne by angels, sits the Virgin, sumptuously crowned and attired, and looking most serene and goddess-like; while the divine Child, standing on her knee, extends his little hand in the act of benediction. Of this picture I have already given a very detailed description.[4] Another example, a grand picture by Moretto, now in the Museum at Frankfort, I have also described. There is here a touch of the dramatic sentiment;—the Virgin is tenderly caressing her Child, while two of the old doctors, St. Ambrose and St. Augustine, stand reverently on each side of her lofty throne; St. Gregory sits on the step below, reading, and St. Jerome bends over and points to a page in his book. The Virgin is not sufficiently dignified; she has too much the air of a portrait; and the action of the Child is also, though tender, rather unsuited to the significance of the rest of the group; but the picture is, on the whole, magnificent. There is another fine example of the four doctors attending on the Virgin, in the Milan Gallery.[5]

Sometimes not four, but two only of these Fathers, appear in combination with other figures, and the choice would depend on the locality and other circumstances. But, on the whole, we rarely find a group of personages assembled round the throne of the Virgin which does not

[1] Bologna Acad. [2] *v.* Sacred and Legend. Art, 3rd edit. p. 281.
[3] Venice Acad. [4] Sacred and Legend. Art, 3rd edit. p. 283.
[5] In a votive picture of the Milanese School, dedicated by Ludovico Sforza *Il Moro.*

include one or more of these venerable pillars of the Church. St. Ambrose appears most frequently in the Milanese pictures: St. Augustine and St. Jerome, as patriarchs of monastic orders, are very popular: St. Gregory, I think, is more seldom met with than the others.

The Virgin, with St. Jerome and St. Catherine, the patron saints of theological learning, is a frequent group in all monasteries, but particularly in the churches and houses of the Jeronimites. A beautiful example is the Madonna by Francia.[1] St. Jerome, with Mary Magdalene, also a frequent combination, expresses theological learning in union with religious penitence and humility. Correggio's famous picture is an example, where St. Jerome on one side presents his works in defence of the Church, and his translation of the Scriptures; while, on the other, Mary Magdalene, bending down devoutly, kisses the feet of the infant Christ.[2]

Of all the attendants on the Virgin and Child, the most popular is, perhaps, St. Catherine; and the 'Marriage of St. Catherine,' as a religious mystery, is made to combine with the most solemn and formal arrangement of the other attendant figures. The enthroned Virgin presides over the mystical rite. This was, for intelligible reasons, a favourite subject in nunneries.[3]

In a picture by Garofalo, the Child, bending from his mother's knee, places a golden crown on the head of St. Catherine as *Sposa*; on each side stand St. Agnes and St. Jerome.

In a picture by Carlo Maratti, the nuptials take place in heaven, the Virgin and Child being throned in clouds.

If the kneeling *Sposa* be St. Catherine of Siena, the nun, and not St. Catherine of Alexandria, or if the two are introduced, then we may be sure that the picture was painted for a nunnery of the Dominican order.[4]

The great Madonna *in Trono* by the Dominican Fra Bartolomeo,

[1] Borghese Palace, Rome. [2] Parma.

[3] For a detailed account of the legendary marriage of St. Catherine and examples of treatment, see Sacred and Legendary Art, 3rd edit. p. 483.

[4] See Legends of the Monastic Orders, 2nd edit. p. 395. A fine example of this group, 'the Spozalizio of St. Catherine of Siena,' has lately been added to our National Gallery (Lorenzo di San Severino, No. 249).

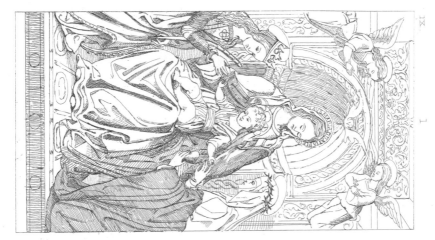

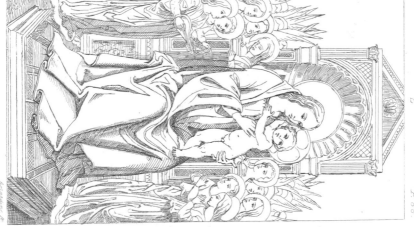

Enthroned Madonna and Child.

wherein the queenly St. Catherine of Alexandria witnesses the mystical marriage of her sister saint, the nun of Siena, will occur to every one who has been at Florence;[1] and there is a smaller picture by the same painter in the Louvre;—a different version of the same subject.

I must content myself with merely referring to these well-known pictures which have been often engraved, and dwell more in detail on another, not so well known, and, to my feeling, as preeminently beautiful and poetical, but in the early Flemish, not the Italian style —a poem in a language less smooth and sonorous, but still a *poem*.

This is the altar-piece painted by Hemmelinck for the charitable sisterhood of St. John's Hospital at Bruges. The Virgin is seated under a porch, and her throne decorated with rich tapestry; two graceful angels hold a crown over her head. On the right, St. Catherine, superbly arrayed as a princess, kneels at her side, and the beautiful infant Christ bends forward and places the bridal ring on her finger. Behind her a charming angel, playing on the organ, celebrates the espousals with hymns of joy; beyond him stands St. John the Baptist with his lamb. On the left of the Virgin kneels St. Barbara, reading intently; behind her an angel with a book; beyond him stands St. John the Evangelist, youthful, mild, and pensive. Through the arcades of the porch is seen a landscape background, with incidents picturesquely treated from the lives of the Baptist and the Evangelist. Such is the central composition. The two wings represent—on one side, the beheading of St. John the Baptist; on the other, St. John the Evangelist in Patmos, and the vision of the Apocalypse. In this great work there is a unity and harmony of design which blends the whole into an impressive poem. The object was to do honour to the patrons of the hospital, the two St. Johns, and, at the same time, to express the piety of the Charitable Sisters, who, like St. Catherine (the type of contemplative studious piety), were consecrated and espoused to Christ, and, like St. Barbara (the type of active piety), were dedicated to good works. It is a tradition, that Hemmelinck painted this altar-piece as a votive offering in gratitude to the good Sisters, who had taken him in and nursed him when dangerously wounded: and surely, if this tradition be true, never was charity more magnificently recompensed.

[1] Florence Gal., Monastic Orders, 2nd edit. p. 381.

N

In a very beautiful picture by Ambrogio Borgognone[1] the Virgin is seated on a splendid throne; on the right kneels St. Catherine of Alexandria, on the left St. Catherine of Siena: the Virgin holds a hand of each, which she presents to the divine Child seated on her knee, and to each she presents a ring.

The Virgin and Child between St. Catherine and St. Barbara is one of the most popular, as well as one of the most beautiful and expressive, of these combinations; signifying active and contemplative life, or the two powers between which the social state was divided in the middle ages, namely, the ecclesiastical and the military, learning and arms;[2] St. Catherine being the patron of the first, and St. Barbara of the last. When the original significance had ceased to be understood or appreciated, the group continued to be a favourite one, particularly in Germany; and examples are infinite.

The Virgin between St. Mary Magdalene and St. Barbara, the former as the type of penance, humility, and meditative piety, the latter as the type of fortitude and courage, is also very common. When between St. Mary Magdalene and St. Catherine, the idea suggested is learning, with penitence and humility; this is a most popular group. So is St. Lucia with one of these or both: St. Lucia with her *lamp* or her *eyes*, is always expressive of *light*, the light of divine wisdom.

The Virgin between St. Nicholas and St. George is a very expressive group; the former as the patron saint of merchants, tradesmen, and seamen, the popular saint of the bourgeoisie; the latter as the patron of soldiers, the chosen saint of the aristocracy. These two saints with St. Catherine are preeminent in the Venetian pictures; for all three, in addition to their poetical significance, were venerated as especial protectors of Venice.

St. George and St. Christopher both stand by the throne of the Virgin of Succour as protectors and deliverers in danger. The attribute of St. Christopher is the little Christ on his shoulder; and there

[1] Dresden, collection of M. Grahl. [2] Sacred and Legend. Art, 3rd edit. p. 496.

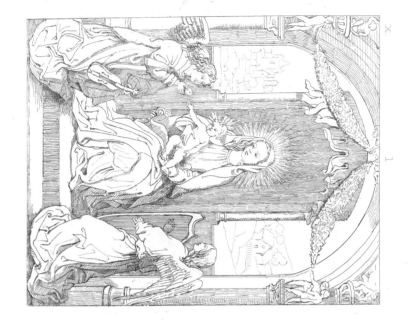

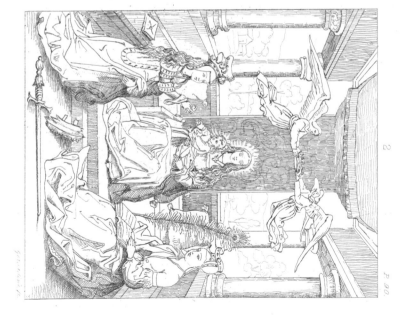

Madonna and Child enthroned with Angels and Saints.

are instances in which Christ appears on the lap of his mother, and also on the shoulder of the attendant St. Christopher. This blunder, if it may be so called, has been avoided, very cleverly I should think in his own opinion, by a painter who makes St. Christopher kneel, while the Virgin places the little Christ on his shoulders; a *concetto* quite inadmissible in a really religious group.

In pictures dedicated by charitable communities, we often find St. Nicholas and St. Leonard as the patron saints of prisoners and captives. Wherever St. Leonard appears he expresses deliverance from captivity. St. Omobuono, St. Martin, St. Elizabeth of Hungary, St. Roch, or other beneficent saints, waiting round the Virgin with kneeling beggars, or the blind, the lame, the sick, at their feet, always expressed the Virgin as the mother of mercy, the *Consolatrix afflictorum*. Such pictures were commonly found in hospitals, and the chapels and churches of the Order of Mercy, and other charitable institutions. The examples are numerous. I remember one, a striking picture, by Bartolomeo Montagna, where the Virgin and Child are enthroned in the centre as usual. On her right, the good St. Omobuono, dressed as a burgher, in a red gown and fur cap, gives alms to a poor beggar; on the left, St. Francis presents a celebrated friar of his Order, Bernardino da Feltri, the first founder of a *mont-de-piété*, who kneels, holding the emblem of his institution, a little green mountain with a cross at the top. I give a sketch from this curious picture, which has never been engraved.

Besides these saints, who have a *general* religious character and significance, we have the national and local saints, whose presence very often marks the country or school of art which produced the picture.

A genuine Florentine Madonna is distinguished by a certain elegance and stateliness, and well becomes her throne. As patroness of Florence, in her own right, the Virgin bears the title of Santa Maria del Fiore, and in this character she holds a flower, generally a rose, or is in the act of presenting it to the Child. She is often attended by St. John the Baptist, as patron of Florence; but he is everywhere a saint of such power and importance as an attendant on the divine personages, that

his appearance in a picture does not stamp it as Florentine. St. Cosmo and St. Damian are Florentine, as the protectors of the Medici family; but as patrons of the healing art, they have a significance which renders them common in the Venetian and other pictures. It may, however, be determined, that if St. John the Baptist, St. Cosmo and St. Damian, with St. Laurence (the patron of Lorenzo the Magnificent), appear together in attendance on the Virgin, that picture is of the Florentine school. The presence of St. Zenobio, or of St. Antonino, the patron archbishops of Florence, will set the matter at rest, for these are exclusively Florentine. In a picture by Giotto, angels attend on the Virgin bearing vases of lilies in their hands. (Lilies are at once the emblem of the Virgin and the *device* of Florence.) On each side kneel St. John the Baptist and St. Zenobio.[1]

A Siena Madonna would naturally be attended by St. Bernardino and St. Catherine of Siena; if they seldom appear together, it is because they belong to different religious orders.

In the Venetian pictures we find a crowd of guardian saints; first among them, St. Mark, then St. Catherine, St. George, St. Nicholas, and St. Justina: wherever these appear together, that picture is surely from the Venetian school.

All through Lombardy and Piedmont, St. Ambrose of Milan and St. Maurice of Savoy are favourite attendants on the Virgin.

In Spanish and Flemish art, the usual attendants on the queenly Madonna are monks and nuns, which brings us to the consideration of a large and interesting class of pictures, those dedicated by the various religious orders. When we remember that the institution of some of the most influential of these communities was coeval with the revival of art; that, for three or four centuries, art in all its forms had no more powerful or more munificent patrons; that they counted among their various brotherhoods some of the greatest artists the world has seen; we can easily imagine how the beatified members of these orders have become so conspicuous as attendants on the celestial personages.

[1] We now possess in our National Gallery a very interesting example of a Florentine enthroned Madonna, attended by St. John the Baptist and St. Zenobio as patrons of Florence (Benozzo Gozzoli, 283).

To those who are accustomed to read the significance of works of art, a single glance is often sufficient to decide for what order it has been executed.

St. Paul is a favourite saint of the Benedictine communities; and there are few great pictures painted for them in which he does not appear. When in companionship with St. Benedict, either in the original black habit or the white habit of the reformed orders, with St. Scholastica bearing her dove, with St. Bernard, St. Romualdo, or other worthies of this venerable community, the interpretation is easy.

Here are some examples by Domenico Puligo. The Virgin not seated, but standing on a lofty pedestal, looks down on her worshippers; the Child in her arms extends the right hand in benediction; with his left he points to himself, 'I am the Resurrection and the Life.' Around are six saints, St. Peter, St. Paul, St. John the Baptist as protector of Florence, St. Matthew, St. Catherine; and St. Bernard, in his ample white habit, with his keen intellectual face, is about to write in a great book, and looking up to the Virgin for inspiration. The picture was originally painted for the Cistercians.[1]

The Virgin and Child enthroned between St. Augustine and his mother St. Monica, as in a fine picture by Florigerio,[2] would show the picture to be painted for one of the numerous branches of the Augustine Order. St. Antony the abbot is a favourite saint in pictures painted for the Augustine hermits.

In the 'Madonna del Baldachino' of Raphael, the beardless saint who stands in a white habit on one side of the throne is usually styled St. Bruno; an evident mistake. It is not a Carthusian, but a Cistercian monk, and I think St. Bernard, the general patron of monastic learning. The other attendant saints are St. Peter, St. James, and St. Augustine. The picture was originally painted for the church of San Spirito at Florence, belonging to the Augustines.

But St. Augustine is also the patriarch of the Franciscans and Dominicans, and frequently takes an influential place in their pictures, as

[1] It is now in the S. Maria Maddalena de' Pazzi at Florence. Engraved in the 'Etruria Pittrice,' xxxv. [2] Venice Acad.

the companion either of St. Francis or of St. Dominick, as in a picture by Fra Angelico.[1]

Among the votive Madonnas of the Mendicant orders, I will mention a few conspicuous for beauty and interest, which will serve as a key to others.

1. The Virgin and Child enthroned between St. Antony of Padua and St. Clara of Assisi, as in a small elegant picture by Pellegrino, must have been dedicated in a church of the Franciscans.[2]

2. The Virgin blesses St. Francis, who looks up adoring: behind him St. Antony of Padua; on the other side, St. John the Baptist as a man, and St. Catherine. A celebrated but not an agreeable picture, painted by Correggio for the Franciscan church at Parma.[3]

3. The Virgin is seated in glory; on one side St. Francis, on the other St. Antony of Padua, both placed in heaven, and almost on an equality with the celestial personages. Around are seven female figures, representing the seven cardinal virtues, bearing their respective attributes. Below are seen the worthies of the Franciscan Order; to the right of the Virgin, St. Elizabeth of Hungary, St. Louis of France, St. Bonaventura; to the left, St. Ives of Bretagne, St. Eleazar, and St. Louis of Toulouse.[4] Painted for the Franciscans by Morone and Paolo Cavazzolo of Verona. This is a picture of wonderful beauty, and quite poetical in the sentiment and arrangement, and the mingling of the celestial, the allegorical, and the real personages, with a certain solemnity and gracefulness quite indescribable. The virtues, for instance, are not so much allegorical persons as spiritual appearances, and the whole of the upper part of the picture is like a vision.

4. The Virgin, standing on the tree of life, holds the Infant: rays of glory proceed from them on every side. St. Francis, kneeling at the foot of the tree, looks up in an ecstasy of devotion, while a snake with a wounded and bleeding head is crawling away. This strange picture, painted for the Franciscans, by Carducho, about 1625, is a representation of an abstract dogma (redemption from original sin), in the most real, most animated form—all over life, earthly breathing life—and

[1] Florence Gal.　　　　[2] Sutherland Gal.　　　　[3] Dresden Gal.
[4] For these Franciscan saints, v. Legends of the Monastic Orders.

made me start back : in the mingling of mysticism and materialism, it is quite Spanish.[1]

The Virgin and Child enthroned. On the right of the Virgin, St. John the Baptist and St. Zenobio, the two protectors of Florence. The latter wears his episcopal cope richly embroidered with figures. On the left stand St. Peter and St. Dominick, protectors of the company for whom the picture was painted. In front kneel St. Jerome and St. Francis. This picture was originally placed in San Marco, a church belonging to the Dominicans.[2]

6. When the Virgin or the Child holds the rosary, it is then a *Madonna del Rosario,* and painted for the Dominicans. The Madonna by Murillo, in the Dulwich Gallery, is an example. There is an instance in which the Madonna and Child enthroned are distributing rosaries to the worshippers, and attended by St. Dominick and St. Peter Martyr, the two great saints of the Order.[3]

7. Very important in pictures is the Madonna as more particularly the patroness of the Carmelites, under her well-known title of ' Our Lady of Mount Carmel,' or *La Madonna del Carmine.* The members of this Order received from Pope Honorius III. the privilege of styling themselves the ' Family of the Blessed Virgin,' and their churches are all dedicated to her under the title of *S. Maria del Carmine.* She is generally represented holding the infant Christ, with her robe outspread, and beneath its folds the Carmelite brethren and their chief saints.[4] There is an example in a picture by Pordenone which once belonged to Canova.[5] The Madonna del Carmine is also portrayed

[1] Esterhazy Gal., Vienna. Mr. Stirling tells us that the Franciscan friars of Valladolid possessed two pictures of the Virgin by Mateo de Cerezo ' in one of which she was represented sitting in a cherry-tree and adored by St. Francis. This unusual throne may perhaps have been introduced by Cerezo as a symbol of his own devout feelings, his patronymic being the Castilian word for cherry-tree.'—*Stirling's Artists of Spain,* p. 1033. There are, however, many prints and pictures of the Virgin and Child seated in a tree. It was one of the fantastic conceptions of an unhealthy period of religion and art.

[2] I saw and admired this fine and valuable picture in the Rinuccini Palace at Florence in 1847 ; it was purchased for our National Gallery in 1855.

[3] Caravaggio, Belvedere Gal., Vienna.

[4] *v.* Legends of the Monastic Orders, ' The Carmelites,' 2nd edit. p. 411.

[5] Acad. Venice.

as distributing to her votaries small tablets on which is a picture of herself.

8. The Virgin, as patroness of the Order of Mercy, also distributes tablets, but they bear the badge of the Order; and this distinguishes 'Our Lady of Mercy,' so popular in Spanish art, from 'Our Lady of Mount Carmel.'[1]

A large class of these Madonna pictures are votive offerings for public or private mercies. They present some most interesting varieties of character and arrangement.

A votive Mater Misericordiæ, with the Child in her arms, is often standing with her wide ample robe extended, and held up on each side by angels. Kneeling at her feet are the votaries who have consecrated the picture, generally some community or brotherhood instituted for charitable purposes, who, as they kneel, present the objects of their charity — widows, orphans, prisoners, or the sick and infirm. The Child, in her arms, bends forward with the hand raised in benediction. I have already spoken of the Mater Misericordiæ *without* the Child. The sentiment is yet more beautiful and complete where the Mother of Mercy holds the infant Redeemer, the representative and pledge of God's infinite mercy, in her arms.

There is a 'Virgin of Mercy,' by Salvator Rosa, which is singular and rather poetical in the conception. She is seated in heavenly glory; the infant Christ, on her knee, bends benignly forward. Tutelary angels are represented as pleading for mercy, with eager outstretched arms; other angels, lower down, are liberating the souls of repentant sinners from torment. The expression in some of the heads, the contrast between the angelic pitying spirits and the anxious haggard features of the '*Anime del Purgatorio*,' are very fine and animated. Here the Virgin is the 'Refuge of Sinners,' *Refugium Peccatorum*. Such pictures are commonly met with in chapels dedicated to services for the dead.

Another class of votive pictures are especial acts of thanksgiving:—
1st. For victory, as *La Madonna della Vittoria, Notre Dame des Victoires*. The Virgin, on her throne, is then attended by one or more of

[1] *v.* Monastic Orders, p. 233.

the warrior saints, together with the patron or patroness of the victors. She is then our Lady of Victory. A very perfect example of these victorious Madonnas exists in a celebrated picture by Andrea Mantegna. The Virgin is seated on a lofty throne, embowered by garlands of fruit, leaves, and flowers, and branches of coral, fancifully disposed as a sort of canopy over her head. The Child stands on her knee, and raises his hand in the act of benediction. On the right of the Virgin appear the warlike saints, St. Michael and St. Maurice; they recommend to her protection the Marquis of Mantua, Giovan Francesco Gonzaga, who kneels in complete armour.[1] On the left stand St. Andrew and St. Longinus, the guardian saints of Mantua; on the step of the throne, the young St. John the Baptist, patron of the Marquis; and more in front, a female figure, seen half-length, which some have supposed to be St. Elizabeth, the mother of the Baptist, and others, with more reason, the wife of the Marquis, the accomplished Isabella d'Este.[2] This picture was dedicated in celebration of the victory gained by Gonzaga over the French, near Fornone, in 1495.[3] There is something exceedingly grand, and, at the same time, exceedingly fantastic and poetical, in the whole arrangement; and besides its beauty and historical importance, it is the most important work of Andrea Mantegna. Gonzaga, who is the hero of the picture, was a poet as well as a soldier. Isabella d'Este shines conspicuously, both for virtue and talent, in the history of the revival of art during the fifteenth century. She was one of the first who collected gems, antiques, pictures, and made them available for the study and improvement of the learned. Altogether, the picture is most interesting in every point of view. It was carried off by the French from Milan in 1797; and considering the occasion on which it was painted, they must have had a special pleasure in placing it in their Louvre, where it still remains.

[1] 'Qui rend grâces du *prétendu* succès obtenu sur Charles VIII à la bataille de Fornone,' as the French catalogue expresses it.

[2] Both, however, may be right; for St. Elizabeth was the patron saint of the Marchesana: the head has quite the air of a portrait, and may be Isabella in likeness of a saint.

[3] 'Si les soldats avaient mieux secondé la bravoure de leur chef, l'armée de Charles VIII était perdue sans ressource.—Ils se dispersèrent pour piller et laissèrent aux Français le temps de continuer leur route.'

There is a very curious and much more ancient Madonna of this class preserved at Siena, and styled the 'Madonna del Voto.' The Sienese being at war with Florence, placed their city under the protection of the Virgin, and made a solemn vow that, if victorious, they would make over their whole territory to her as a perpetual possession, and

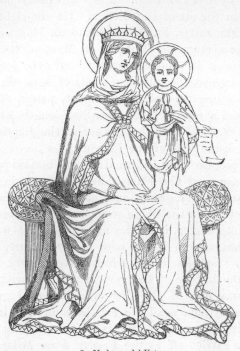

45 La Madonna del Voto.

hold it from her as her loyal vassals. After the victory of Arbia, which placed Florence itself for a time in such imminent danger, a picture was dedicated by Siena to the Virgin *della Vittoria.* She is enthroned and crowned, and the infant Christ, standing on her knee, holds in his hand the deed of gift.

2ndly. For deliverance from plague and pestilence, those scourges of the middle ages. In such pictures the Virgin is generally attended

by St. Sebastian, with St. Roch or St. George; sometimes, also, by St. Cosmo and St. Damian, all of them protectors and healers in time of sickness and calamity. These intercessors are often accompanied by the patrons of the church or locality.

There is a remarkable picture of this class by Matteo di Giovanni,[1] in which the Virgin and Child are throned between St. Sebastian and St. George, while St. Cosmo and St. Damian, dressed as physicians, and holding their palms, kneel before the throne.

In a very famous picture by Titian,[2] the Virgin and Child are seated in heavenly glory. She has a smiling and gracious expression, and the Child holds a garland, while angels scatter flowers. Below stand St. Sebastian, St. *Nicholas*, St. Catherine, St. Peter, and St. *Francis*. The picture was an offering to the Virgin, after the cessation of a pestilence at Venice, and consecrated in a church of the *Franciscans* dedicated to St. *Nicholas*.[3]

Another celebrated votive picture against pestilence is Correggio's 'Madonna di San Sebastiano.'[4] She is seated in heavenly glory, with little angels, not so much adoring as sporting and hovering round her; below are St. Sebastian and St. Roch, the latter asleep. (There would be an impropriety in exhibiting St. Roch sleeping but for the reference to the legend, that, while he slept, an angel healed him, which lends the circumstance a kind of poetical beauty). St. Sebastian, bound, looks up on the other side. The introduction of St. Geminiano, the patron of Modena, shows the picture to have been painted for that city, which had been desolated by pestilence in 1512. The date of the picture is 1515.

We may then take it for granted, that wherever the Virgin and Child appear attended by St. Sebastian and St. Roch, the picture has been a votive offering against the plague; and there is something touching in the number of such memorials which exist in the Italian churches.[5]

The brotherhoods instituted in most of the towns of Italy and Germany, for attending the sick and plague-stricken in times of public calamity,

[1] Siena Acad. [2] Rome, Vatican.
[3] San Nicolo de' Frari, since destroyed, and the picture has been transferred to the Vatican. [4] Dresden Gal.
[5] *v.* Sacred and Legendary Art, 3rd edit. p. 432.

were placed under the protection of the Virgin of Mercy, St. Sebastian, and St. Roch; and many of these pictures were dedicated by such communities, or by the municipal authorities of the city or locality. There is a memorable example in a picture by Guido, painted, by command of the Senate of Bologna, after the cessation of the plague which desolated the city in 1630.[1] The benign Virgin, with her Child, is seated in the skies; the rainbow, symbol of peace and reconciliation, is under her feet. The infant Christ, lovely and gracious, raises his right hand in the act of blessing; in the other he holds a branch of olive: angels scatter flowers around. Below stand the guardian saints, the 'Santi Protettori' of Bologna;—St. Petronius, St. Francis, St. Dominick; the warrior-martyrs, St. Proculus and St. Florian, in complete armour; with St. Ignatius and St. Francis Xavier. Below these is seen, as if through a dark cloud and diminished, the city of Bologna, where the dead are borne away in carts and on biers. The upper part of this famous picture is most charming for the gracious beauty of the expression, the freshness and delicacy of the colour. The lower part is less happy, though the head of St. Francis, which is the portrait of Guido's intimate friend and executor, Saulo Guidotti, can hardly be exceeded for intense and life-like truth. The other figures are deficient in expression, and the execution hurried, so that on the whole it is inferior to the votive Pietà already described.[2] Guido, it is said, had no time to prepare a canvas or cartoons, and painted the whole on a piece of white silk. It was carried in grand procession, and solemnly dedicated by the Senate, whence it obtained the title by which it is celebrated in the history of art, 'Il Pallione del Voto.'

3rdly. Against inundations, flood, and fire, St. George is the great protector. This saint and St. Barbara, who is patroness against thunder and tempest, express deliverance from such calamities, when in companionship.

The 'Madonna di San Giorgio' of Correggio[3] is a votive altar-piece dedicated on the occasion of a great inundation of the river Secchia. She is seated on her throne, and the Child looks down on the worshippers and votaries. St. George stands in front victorious, his foot

[1] Acad. Bologna. [2] v. p. 40. [3] Dresden Gal.

on the head of the dragon. The introduction of St. Geminiano tells us that the picture was painted for the city of Modena; the presence of St. John the Baptist and St. Peter Martyr shows that it was dedicated by the Dominicans, in their church of St. John.[1]

Not less interesting are those votive Madonnas dedicated by the piety of families and individuals. In the family altar-pieces, the votary is often presented on one side by his patron saint, and his wife by her patron on the other. Not seldom a troop of hopeful sons attend the father, and a train of gentle, demure-looking daughters kneel behind the mother. Such memorials of domestic affection and grateful piety are often very charming; they are pieces of family biography:[2] we have celebrated examples both in German and Italian art.

1. The 'Madonna della Famiglia Bentivoglio' was painted by Lorenzo Costa, for Giovanni II., lord or tyrant of Bologna from 1462 to 1506. The history of this Giovanni is mixed up in an interesting manner with the revival of art and letters; he was a great patron of both, and among the painters in his service were Francesco Francia and Lorenzo Costa. The latter painted for him his family chapel in the church of San Giacomo at Bologna; and, while the Bentivogli have long since been chased from their native territory, their family altar still remains untouched, unviolated. The Virgin, as usual, is seated on a lofty throne bearing her divine Child; she is veiled, no hair seen, and simply draped; she bends forward with mild benignity. To the right of the throne kneels Giovanni with his four sons; on the left his wife, attended by six daughters: all are portraits, admirable studies for character and costume. Behind the daughters, the head of an old woman is just visible—according to tradition the old nurse of the family.

2. Another most interesting family Madonna is that of Ludovico Sforza il Moro, painted for the church of Sant' Ambrogio at Milan.[3] The Virgin sits enthroned, richly dressed, with long fair hair hanging

[1] See Legends of the Monastic Orders, 2nd edit. p. 371.

[2] Several are engraved, as illustrations, in Litta's great History of the Italian Families.

[3] By an unknown painter of the school of Lionardo, and now in the gallery of the Brera.

down, and no veil or ornament; two angels hold a crown over her
head. The Child lies extended on her knee. Round her throne are
the four fathers, St. Ambrose, St. Gregory, St. Jerome, and St. Au-
gustine. In front of the throne kneels Ludovico il Moro, Duke of
Milan, in a rich dress and unarmed; Ambrose, as protector of Milan,
lays his hand upon his shoulder. At his side kneels a boy about five
years old. Opposite to him is the duchess, Beatrice d'Este, also kneel-
ing; and near her a little baby in swaddling clothes, holding up its
tiny hands in supplication, kneels on a cushion. The age of the
children shows the picture to have been painted about 1496. The fate
of Ludovico il Moro is well known: perhaps the blessed Virgin deemed
a traitor and an assassin unworthy of her protection. He died in the
frightful prison of Loches after twelve years of captivity; and both his
sons, Maximilian and Francesco, were unfortunate. With them the
family of Sforza and the independence of Milan were extinguished
together in 1535.

3. Another celebrated and most precious picture of this class is the
Virgin of the Meyer family, painted by Holbein for the burgomaster
Jacob Meyer of Basle.[1] According to a family tradition, the youngest
son of the burgomaster was sick even to death, and, through the
merciful intercession of the Virgin, was restored to his parents, who, in
gratitude, dedicated this offering. She stands on a pedestal in a richly
ornamented niche; over her long fair hair, which falls down her
shoulders to her waist, she wears a superb crown; and her robe of a
dark greenish blue is confined by a crimson girdle. In purity, dignity,
humility, and intellectual grace, this exquisite Madonna has never been
surpassed, not even by Raphael; the face, once seen, haunts the
memory. The Child in her arms is generally supposed to be the infant
Christ. I have fancied, as I look on the picture, that it may be the
poor sick child recommended to her mercy, for the face is very pathetic,
the limbs not merely delicate but attenuated, while, on comparing it
with the robust child who stands below, the resemblance and the con-
trast are both striking. To the right of the Virgin kneels the burgo-
master Meyer with two of his sons, one of whom holds the little brother

[1] Dresden Gal. The engraving by Steinle is justly celebrated.

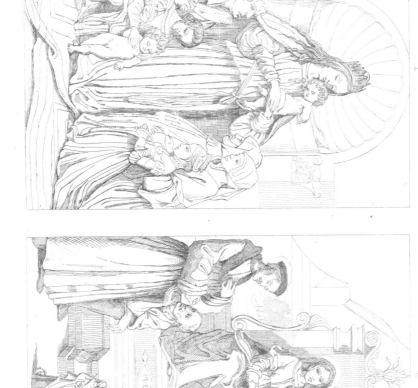

Family Votive Madonna

Madonna of Charity.

1

2

who is restored to health, and seems to present him to the people. On the left kneel four females—the mother, the grandmother, and two daughters. All these are portraits, touched with that homely, vigorous truth, and finished with that consummate delicacy, which characterised Holbein in his happiest efforts; and, with their earnest but rather ugly and earthly faces, contrasting with the divinely compassionate and refined being who looks down on them with an air so human, so maternal, and yet so unearthly.

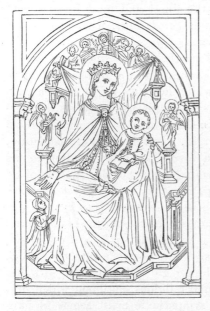

46 Votive Madonna.

Sometimes it is a single votary who kneels before the Madonna. In the old times he expressed his humility by placing himself in a corner and making himself so diminutive as to be scarce visible (46); afterwards, the head of the votary or donor is seen life-size, with hands joined in prayer, just above the margin at the foot of the throne; care being taken to remove him from all juxtaposition with the attendant saints. But, as the religious feeling in art declined, the living votaries are mingled with the spiritual patrons—the 'human mortals' with the 'human immortals,'—with a disregard to time and place, which, if it be not so lowly in spirit, can be rendered by a great artist strikingly poetical and significant.

1. The renowned 'Madonna di Foligno,' one of Raphael's masterpieces, is a votive picture of this class. It was dedicated by Sigismund Conti of Foligno, private secretary to Pope Julius II., and a distinguished man in other respects, a writer and a patron of learning. It appears that Sigismund having been in great danger from a meteor or thunderbolt, vowed an offering to the blessed Virgin, to whom he attributed his safety, and in fulfilment of his vow consecrated this pre-

cious picture. In the upper part of the composition sits the Virgin in heavenly glory; by her side the infant Christ, partly sustained by his mother's veil, which is drawn round his body : both look down benignly on the votary Sigismund Conti, who, kneeling below, gazes up with an expression of the most intense gratitude and devotion. It is a portrait from the life, and certainly one of the finest and most life-like that exist in painting. Behind him stands St. Jerome, who, placing his hand upon the head of the votary, seems to present him to his celestial protectress. On the opposite side John the Baptist, the meagre wild-looking prophet of the desert, points upward to the Redeemer. More in front kneels St. Francis, who, while he looks up to heaven with trusting and imploring love, extends his right hand towards the worshippers supposed to be assembled in the church, recommending them also to the protecting grace of the Virgin. In the centre of the picture, dividing these two groups, stands a lovely angel-boy holding in his hand a tablet, one of the most charming figures of this kind Raphael ever painted; the head, looking up, has that sublime, yet perfectly childish grace, which strikes us in those awful angel-boys in the 'Madonna di San Sisto.' The background is a landscape in which appears the city of Foligno at a distance; it is overshadowed by a storm-cloud, and a meteor is seen falling; but above these bends a rainbow, pledge of peace and safety. The whole picture glows throughout with life and beauty, hallowed by that profound religious sentiment which suggested the offering, and which the sympathetic artist seems to have caught from the grateful donor. It was dedicated in the church of the Ara-Celi at Rome, which belongs to the Franciscans; hence St. Francis is one of the principal figures. When I was asked, at Rome, why St. Jerome had been introduced into the picture, I thought it might be thus accounted for :—The patron saint of the donor, St. Sigismund, was a king and a warrior, and Conti might possibly think that it did not accord with his profession, as an humble ecclesiastic, to introduce him here. The most celebrated convent of the Jeronimites in Italy is that of St. Sigismund near Cremona, placed under the special protection of St. Jerome, who is also in a general sense the patron of all ecclesiastics; hence, perhaps, he figures here as the protector of Sigismund Conti. The picture was painted, and placed over the high altar of the

Ara-Celi in 1511, when Raphael was in his twenty-eighth year. Conti died in 1512, and in 1565 his grandniece, Suora Anna Conti, obtained permission to remove it to her convent at Foligno, whence it was carried off by the French in 1792. Since the restoration of the works of art in Italy, in 1815, it has been placed among the treasures of the Vatican.

2. Another perfect specimen of a votive picture of this kind, in a very different style, I saw in the museum at Rouen, attributed there to Van Eyck. It is, probably, a fine work by a later master of the school, perhaps Hemmelinck. In the centre, the Virgin is enthroned; the Child, seated on her knee, holds a bunch of grapes, symbol of the eucharist. On the right of the Virgin is St. Apollonia; then two lovely angels in white raiment, with lutes in their hands; and then a female head, seen looking from behind, evidently a family portrait. More in front, St. Agnes, splendidly dressed in green and sable, her lamb at her feet, turns with a questioning air to St. Catherine, who, in queenly garb of crimson and ermine, seems to consult her book. Behind her another member of the family, a man with a very fine face; and more in front St. Dorothea, with a charming expression of modesty, looks down on her basket of roses. On the left of the Virgin is St. Agatha; then two angels in white with viols; then St. Cecilia; and near her a female head, another family portrait; next St. Barbara wearing a beautiful head-dress, in front of which is worked her tower, framed like an ornamental jewel in gold and pearls;[1] she has a missal in her lap. St. Lucia next appears; then another female portrait. All the heads are about one-fourth of the size of life. I stood in admiration before this picture—such miraculous finish in all the details, such life, such spirit, such delicacy in the heads and hands, such brilliant colour in the draperies! Of its history I could learn nothing, nor what family had thus introduced themselves into celestial companionship. The portraits seemed to me to represent a father, a mother, and two daughters.

[1] This head is engraved in Sacred and Legendary Art, 3rd edit. p. 500.

P

I must mention some other instances of votive Madonnas, interesting either from their beauty or their singularity.

3. René, Duke of Anjou, and King of Sicily and Jerusalem, the father of our Amazonian queen, Margaret of Anjou, dedicated, in the church of the Carmelites, at Aix, the capital of his dominions, a votive picture, which is still to be seen there. It is not only a monument of his piety, but of his skill; for, according to the tradition of the country, he painted it himself. The good King René was no contemptible artist; but though he may have suggested the subject, the hand of a practised and accomplished painter is too apparent for us to suppose it his own work.

This altar-piece is a triptychon, and when the doors are closed it measures twelve feet in height, and seven feet in width. On the outside of the doors is the Annunciation: to the left, the angel standing on a pedestal, under a Gothic canopy; to the right, the Virgin standing with her book, under a similar canopy: both graceful figures. On opening the doors, the central compartment exhibits the Virgin and her Child enthroned in a burning bush; the bush which burned with fire, and was not consumed, being a favourite type of the immaculate purity of the Virgin. Lower down, in front, Moses appears surrounded by his flocks, and at the command of an angel is about to take off his sandals. The angel is most richly dressed, and on the clasp of his mantle is painted in miniature Adam and Eve tempted by the serpent. Underneath this compartment is the inscription, ' *Rubum quem viderat Moyses, incombustum, conservatam agnovimus tuam laudabilem Virginitatem, Sancta Dei Genitrix.*' [1] On the door to the right of the Virgin kneels King René himself before an altar, on which lie an open book and his kingly crown. He is dressed in a robe trimmed with ermine, and wears a black velvet cap. Behind him, Mary Magdalene (the patroness of Provence), St. Antony, and St. Maurice. On the other door, Jeanne de Laval, the second wife of René, kneels before an open book; she is young and beautiful, and richly attired; and behind her stand St. John (her patron saint), St. Catherine (very noble and elegant), and St. Nicholas. I saw this curious and interesting picture in 1846. It

[1] For the relation of Moses to the Virgin (as attribute) *v.* the Introduction.

is very well preserved, and painted with great finish and delicacy in the manner of the early Flemish school.

4. In a beautiful little picture by Van Eyck,[1] the Virgin is seated on a throne, holding in her arms the infant Christ, who has a globe in his left hand, and extends the right in the act of benediction. The Virgin is attired as a queen, in a magnificent robe falling in ample folds around her, and trimmed with jewels; an angel, hovering with outspread wings, holds a crown over her head. On the left of the picture, a votary, in the dress of a Flemish burgomaster, kneels before a priedieu, on which is an open book, and with clasped hands adores the Mother and her Child. The locality represents a gallery or portico paved with marble, and sustained by pillars in a fantastic Moorish style. The whole picture is quite exquisite for the delicacy of colour and execution. In the catalogue of the Louvre, this picture is entitled 'St. Joseph adoring the Infant Christ'—an obvious mistake, if we consider the style of the treatment and the customs of the time.

5. All who have visited the church of the Frari at Venice will remember—for once seen, they never can forget—the ex-voto altarpiece which adorns the chapel of the Pesaro family. The beautiful Virgin is seated on a lofty throne to the right of the picture, and presses to her bosom the *Dio Bambinetto*, who turns from her to bless the votary presented by St. Peter. The saint stands on the steps of the throne, one hand on a book; and behind him kneels one of the Pesaro family, who was at once bishop of Paphos and commander of the Pope's galleys: he approaches to consecrate to the Madonna the standards taken from the Turks, which are borne by St. George, as patron of Venice. On the other side appear St. Francis and St. Antony of Padua, as patrons of the church in which the picture is dedicated. Lower down, kneeling on one side of the throne, is a group of various members of the Pesaro family, three of whom are habited in crimson robes, as *Cavalieri di San Marco*; the other, a youth about fifteen, looks out of the picture, astonishingly *alive*, and yet sufficiently idealised to harmonise with the rest. This picture is very remarkable for several reasons. It is a piece of family history, curiously illustrative of

[1] Louvre, No. 162. Ecole Allemande.

the manners of the time. The Pesaro here commemorated was an ecclesiastic, but appointed by Alexander VI. to command the galleys with which he joined the Venetian forces against the Turks in 1503. It is for this reason that St. Peter—as representative here of the Roman pontiff—introduces him to the Madonna, while St. George, as patron of Venice, attends him. The picture is a monument of the victory gained by Pesaro, and the gratitude and pride of his family. It is also one of the finest works of Titian; one of the earliest instances in which a really grand religious composition assumes almost a dramatic and scenic form, yet retains a certain dignity and symmetry worthy of its solemn destination.[1]

6. I will give one more instance. There is in our National Gallery a Venetian picture which is striking from its peculiar and characteristic treatment. On one side, the Virgin with her Infant is seated on a throne; a cavalier, wearing armour and a turban, who looks as if he had just returned from the eastern wars, prostrates himself before her: in the background, a page (said to be the portrait of the painter) holds the horse of the votary. The figures are life-size, or nearly so, as well as I can remember, and the sentimental dramatic treatment is quite Venetian. It is supposed to represent a certain Duccio Constanzo of Treviso, and was once attributed to Giorgione: it is certainly of the school of Bellini.[2]

As these enthroned and votive Virgins multiplied, as it became more and more a fashion to dedicate them as offerings in churches, want of space, and perhaps, also, regard to expense, suggested the idea of representing the figures half-length. The Venetians, from early time the best face-painters in the world, appear to have been the first to cut off the lower part of the figure, leaving the arrangement otherwise

[1] We find in the catalogue of pictures which belonged to our Charles I. one which represented 'a pope preferring a general of his navy to St. Peter.' It is Pope Alexander VI. presenting this very Pesaro to St. Peter; that is, in plain unpictorial prose, giving him the appointment of admiral of the galleys of the Roman states. This interesting picture, after many vicissitudes, is now in the museum at Antwerp. (See the Handbook to the Royal Galleries, p. 201.) [2] Nat. Gal. Catalogue, 234.

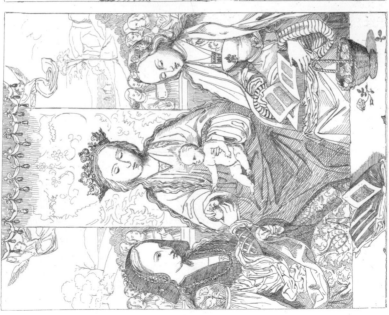

2

XII.

1

Geronimo p.

Half-length enthroned. Madonna with Saints.

much the same. The Virgin is still a queenly and majestic creature, sitting there to be adored. A curtain or part of a carved chair represents her throne. The attendant saints are placed to the right and to the left; or sometimes the throne occupies one side of the picture, and the saints are ranged on the other. From the shape and diminished size of these votive pictures, the personages, seen half-length, are necessarily placed very near to each other, and the heads nearly on a level with that of the Virgin, who is generally seen to the knees, while the Child is always full-length. In such compositions we miss the grandeur of the entire forms, and the consequent diversity of character and attitude; but sometimes the beauty and individuality of the heads atone for all other deficiencies.

In the earlier Venetian examples, those of Gian Bellini particularly, there is a solemn quiet elevation which renders them little inferior, in religious sentiment, to the most majestic of the enthroned and enskied Madonnas.

There is a sacred group by Bellini, in the possession of Sir Charles Eastlake, which has always appeared to me a very perfect specimen of this class of pictures. It is also the earliest I know of. The Virgin, pensive, sedate, and sweet, like all Bellini's Virgins, is seated in the centre, and seen in front. The Child, on her knee, blesses with his right hand, and the Virgin places hers on the head of a votary, who just appears above the edge of the picture, with hands joined in prayer; he is a fine young man with an elevated and elegant profile. On the right are St. John the Baptist pointing to the Saviour, and St. Catherine; on the left, St. George with his banner, and St. Peter holding his book. A similar picture, with Mary Magdalene and St. Jerome on the right, St. Peter and St. Martha on the left, is in the Leuchtenberg Gallery at Munich. Another of exquisite beauty is in the Venice Academy, in which the lovely St. Catherine wears a crown of myrtle. Once introduced, these half-length enthroned Madonnas became very common, spreading from the Venetian states through the north of Italy; and we find innumerable examples from the best schools of art in Italy and Germany, from the middle of the fifteenth to the middle of the

sixteenth century. I shall particularise a few of these, which will be
sufficient to guide the attention of the observer; and we must carefully
discriminate between the sentiment proper to these half-length en-
throned Madonnas, and the pastoral or domestic sacred groups and Holy
Families, of which I shall have to treat hereafter.

Raphael's well-known Madonna *della Seggiola* and Madonna *della
Candelabra*, are both enthroned Virgins in the grand style, though seen
half-length. In fact, the air of the head ought, in the higher schools of
art, at once to distinguish a Madonna *in trono*, even where only the
head is visible.

In this-sketch (47), from a Milanese picture, the Virgin and Child
appear between St. Laurence and
St. John. The mannered and some-
what affected treatment should be
contrasted with the quiet, solemn
simplicity of the next group, after
Francia (48), where the Virgin
and Child appear as objects of wor-
ship between St. Dominick and St.
Barbara.

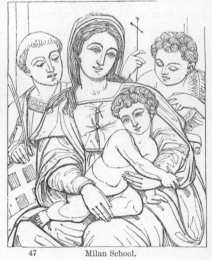

47 Milan School.

The Child, standing or seated on
a table or balustrade in front, en-
abled the painter to vary the atti-
tude, to take the infant Christ out
of the arms of the Mother, and to
render his figure more prominent.
It was a favourite arrangement with
the Venetians; and there is an in-
stance in a pretty picture in our National Gallery, attributed to
Perugino.

Sometimes, even where the throne and the attendant saints and
angels show the group to be wholly devotional and exalted, we find the
sentiment varied by a touch of the dramatic—by the introduction of an
action; but it must be one of a wholly religious significance, suggestive

48 Francesco Francia.

of a religious feeling, or the subject ceases to be properly *devotional* in character.

Here is a sketch from a picture by Botticelli, before which, in walking up the corridor of the Florence Gallery, I used, day after day, to make an involuntary pause of admiration. The Virgin, seated in a chair of state, but seen only to the knees, sustains her divine Son with one arm; four angels are in attendance, one of whom presents an ink-horn, another holds before her an open book, and she is in the act of

¹ In this group, which is a copy of the engraving, St. Barbara holds an arrow—a mistake of the copyist or engraver: it ought to be a palm; the arrow is the attribute of St. Ursula.

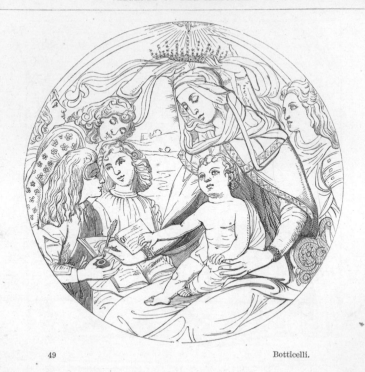

49 Botticelli.

writing the Magnificat, 'My soul doth magnify the Lord!' The head of the figure behind the Virgin is the portrait of Lorenzo de' Medici when a boy. (49) In the original picture by Botticelli, there is absolutely no beauty of feature, either in the Madonna, or the Child, or the angels, yet every face is full of dignity and character.

In a beautiful picture by Titian,[1] the Virgin is enthroned on the left, and on the right appear St. George and St. Laurence as listening, while St. Jerome reads from his great book. A small copy of this picture is at Windsor.

A family group is sometimes treated in this grand style, but the symmetry of the arrangement and the sentiment show the picture to be devotional; as in this sketch (51), where the Virgin is seated on a

[1] Bel. Gal., Vienna. Louvre, No. 458.

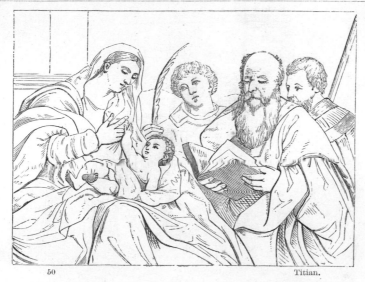

50 Titian.

throne, with St. Joseph and St. Zacharias on each side, and the little
St. John adores the infant Christ. (51)

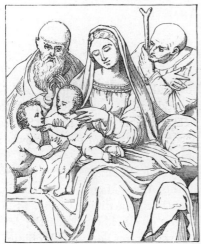

51 The Virgin and Child, the little St. John, with
St. Joseph and Zacharias. (Cesare da Sesto.)

The old German and Flemish
painters, in treating the enthroned
Madonna, sometimes introduced ac-
cessories which no painter of the
early Italian school would have
descended to; and which tinge with
a homely sentiment their most ex-
alted conceptions. Thus, I have
seen a German Madonna, seated on
a superb throne, and most elaborately
and gorgeously arrayed, pressing
her Child to her bosom with a truly
maternal air; while beside her, on a
table, are a honeycomb, some butter,
a dish of fruit, and a glass of water.[1]
It is possible that in this case, as
in the Virgin suckling her Child, there may be a religious allusion:—
'*Butter and honey shall he eat,*' &c.

[1] Bel. Gal., Vienna.

Q

52

The Mater Amabilis.

Ital. La Madonna col Bambino. La Madonna col celeste suo Figlio. *Fr.* La Vierge et
l'Enfant Jésus. *Ger.* Maria mit dem Kind.

THERE is yet another treatment of the Madonna and Child, in which
the Virgin no longer retains the lofty goddess-like exaltation given to
her in the old time. She is brought nearer to our sympathies. She is
not seated in a chair of state with the accompaniments of earthly power;
she is not enthroned on clouds, nor glorified and star-crowned in
heaven; she is no longer so exclusively the VERGINE DEA, nor the
VIRGO DEI GENITRIX; but she is still the ALMA MATER REDEMPTORIS,
the young, and lovely, and most pure mother of a divine Christ. She
is not sustained in mid-air by angels; she dwells lowly on earth; but
the angels leave their celestial home to wait upon her. Such effigies,
when conceived in a strictly ideal and devotional sense, I shall designate
as the MATER AMABILIS.

The first and simplest form of this beautiful and familiar subject, we find in those innumerable half-length figures of the Madonna holding her Child in her arms, painted chiefly for oratories, private or wayside chapels, and for the studies, libraries, and retired chambers of the devout, as an excitement to religious feeling, and a memorial of the mystery of the Incarnation, where large or grander subjects, or more expensive pictures, would be misplaced. Though unimportant in comparison with the comprehensive and magnificent church altar-pieces already described, there is no class of pictures so popular and so attractive, none on which the character of the time and the painter is stamped more clearly and intelligibly, than on these simple representations.

The Virgin is not here the dispenser of mercy; she is simply the mother of the Redeemer. She is occupied only by her divine Son. She caresses him, or she gazes on him fondly. She presents him to the worshipper. She holds him forth with a pensive joy as the predestined offering. (52) If the profound religious sentiment of the early masters was afterwards obliterated by the unbelief and conventionalism of later art, still this favourite subject could not be so wholly profaned by degrading sentiments and associations, as the mere portrait heads of the Virgin alone. No matter what the model for the Madonna might have been—a wife, a mistress, a *contadina* of Frascati, a Venetian *Zitella*, a *Mädchen* of Nuremberg, a buxom Flemish *Frow*—for the Child was there; the baby innocence in her arms consecrated her into that 'holiest thing alive,' a mother. The theme, however inadequately treated as regarded its religious significance, was sanctified in itself beyond the reach of a profane thought. Miserable beyond the reach of hope, dark below despair, that moral atmosphere which the presence of sinless unconscious infancy cannot for a moment purify or hallow!

Among the most ancient and most venerable of the effigies of the Madonna, we find the old Greek pictures of the *Mater Amabilis*, if that epithet can be properly applied to the dark-coloured, sad-visaged Madonnas generally attributed to St. Luke, or transcripts of those said to be painted by him, which exist in so many churches, and are, or were, supposed by the people to possess a peculiar sanctity. These are almost all of oriental origin, or painted to imitate the pictures brought

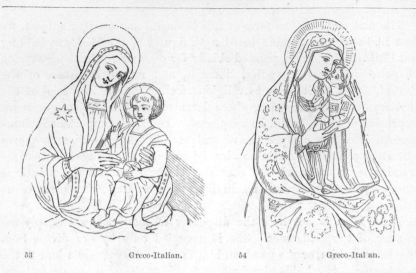

53 Greco-Italian. 54 Greco-Ital an.

from the East in the tenth or twelfth century. There are a few striking and genuine examples of these ancient Greek Madonnas in the Florentine Gallery, and, nearer at hand, in the Wallerstein collection at Kensington Palace. They much resemble each other in the general treatment.

I give a series of four drawings from genuine and renowned Greek pictures, all of which have the credit of performing stupendous miracles and claim a fabulous antiquity. Yet of the many miracle-working Madonnas in Italy, popularly attributed to St. Luke, few are either of Greek workmanship or very ancient. Thus the Virgin of the Ara-Celi is undoubtedly as Greek, and old, and black, and ugly, as sanctity could desire; while the rival Madonna in Santa Maria-in-Cosmedino (53), dark as it is in colour, is yet most lovely; both Mother and Child are full of grace and refined expression: but though an undoubted 'original St. Luke,' like many original Raphaels and Titians, it is not even a softened copy of a Greek model; the sentiment is altogether Italian, as may be seen in the above sketch. The sketch 54 is from an ancient fresco at Perugia. The next (55) is a very peculiar imitation of the Greek, from the early Paduan school.

The infinite variety which painters have given to this most simple

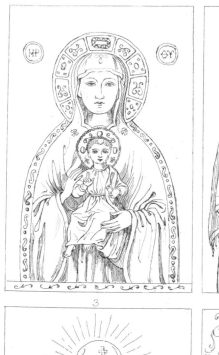

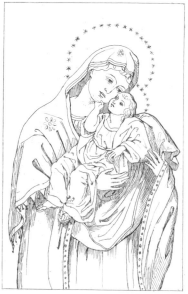

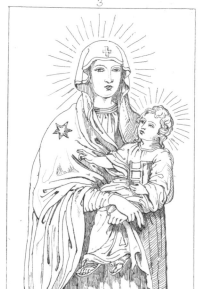

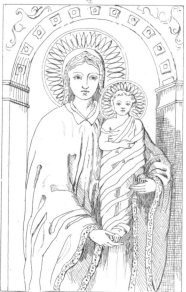

Greek Mater Amabilis.

motif, the Mother and the Child only, without accessories or accom-
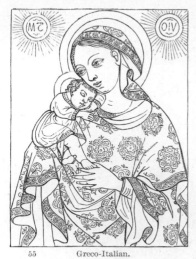
paniments of any kind, exceeds all
possibility of classification, either as to
attitude or sentiment. Here Raphael
shone supreme : the simplicity, the
tenderness, the halo of purity and vir-
ginal dignity, which he threw round
the *Mater Amabilis*, have never been
surpassed—in his best pictures, never
equalled. The 'Madonna del Gran-
Duca,' where the Virgin holds the
Child seated on her arm; the 'Ma-
donna Tempi,' where she so fondly
presses her cheek to his—are perhaps
the most remarkable for simplicity. The
Madonna of the Bridgewater Gallery,
where the infant lies on her knees, and
the Mother and Son look into each

55 Greco-Italian.

other's eyes; the little 'Madonna Conestabile,' where she holds the
book, and the infant Christ, with a serious yet perfectly childish grace,
bends to turn over the leaf—are the most remarkable for sentiment.
In this sketch, from a picture not so well known, the Mater Amabilis
holds the apple as second Eve. (56)

Other Madonnas by Raphael, containing three or more figures, do
not belong to this class of pictures. They are not strictly devotional,
but are properly Holy Families, groups and scenes from the domestic
life of the Virgin.

With regard to other painters before or since his time, the examples
of the *Mater Amabilis* so abound in public and private galleries, and
have been so multiplied in prints, that comparison is within the reach of
every observer. I will content myself with noticing a few of the most
remarkable for beauty or characteristic treatment. Two painters, who
eminently excelled in simplicity and purity of sentiment, are Gian
Bellini of Venice, and Bernardino Luini of Milan. Squarcione, though
often fantastic, has painted one or two of these Madonnas, remarkable
for simplicity and dignity, as also his pupil Mantegna; though in both

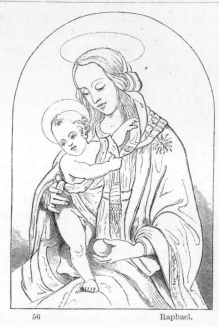

56 Raphael.

the style of execution is somewhat hard and cold. In this, by Fra
Bartolomeo (60), there is such a depth of maternal tenderness in the

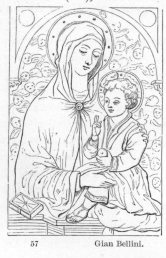

57 Gian Bellini.

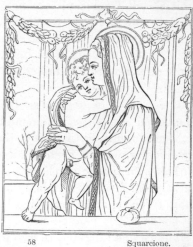

58 Squarcione.

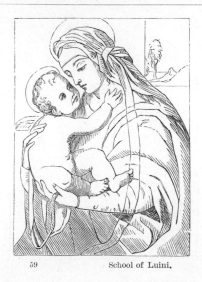

School of Luini.

expression and attitude, we wonder where the good monk found his
model. In his own heart ? in his dreams ? A *Mater Amabilis* by one

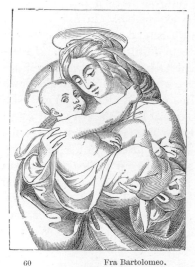

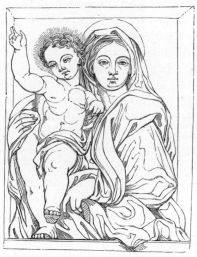

60 Fra Bartolomeo. 61 Annibal Caracci.

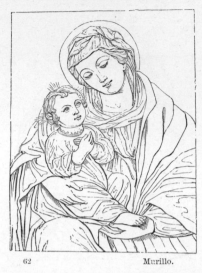

62 Murillo.

of the Caracci or by Vandyck is generally more elegant and dignified
than tender. This Madonna, for instance, by Annibal, has something of
the majestic sentiment of an enthroned Madonna. (61) Murillo excelled
in this subject; although most of his Virgins have a portrait air of
common life, they are redeemed by the expression. In one of these,
the Child, looking out of the picture with extended arms and eyes full
of divinity, seems about to spring forth to fulfil his mission. In an-
other (62) he folds his little hands, and looks up to heaven, as if de-
voting himself to his appointed suffering, while the Mother looks down
upon him with a tender resignation.[1] In a noble Madonna by Vandyck,[2]
it is she herself who devotes him to do his Father's will; and I still
remember a picture of this class, by Carlo Cignani,[3] which made me
start, with the intense expression: the Mother presses to her the Child,
who holds a cross in his baby hand; she looks up to heaven with an
appealing look of love and anguish—almost of reproach. Guido did
not excel so much in children, as in the Virgin alone. Poussin, Carlo
Dolce, Sasso Ferrato, and, in general, all the painters of the seven-
teenth century, give us pretty women and pretty children. We may
pass them over.

 [1] Leuchtenberg Gal. [2] Bridgewater Gal. [3] Belvedere Gal., Vienna.

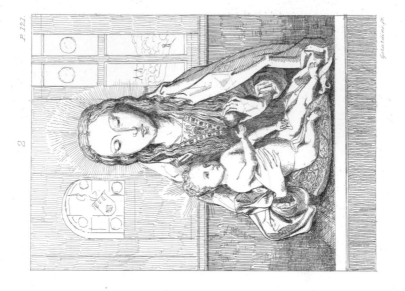

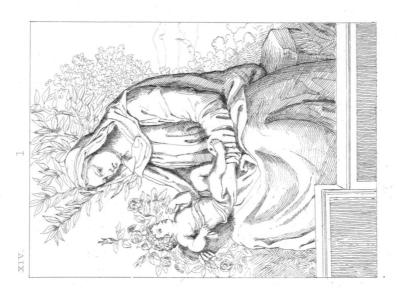

Mater Amabilis

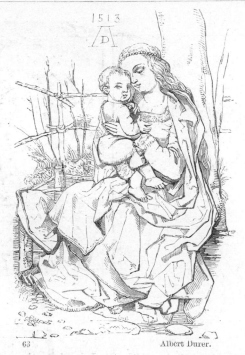

1513

63 Albert Durer.

A second version of the Mater Amabilis, representing the Virgin and Child full-length, but without accessories, has been also very beautifully treated. She is usually seated in a landscape, and frequently within the mystical enclosure (*Hortus clausus*), which is sometimes in the German pictures a mere palisade of stakes or boughs, as in this example after Albert Durer. (63)

Andrea Mantegna, though a fantastic painter, had generally some meaning in his fancies. There is a fine picture of his in which the Virgin and Child are seated in a landscape, and in the background is a stone quarry, where a number of figures are seen busily at work ; perhaps hewing the stone to build the new temple of which our Saviour was the corner-stone.[1] In a group by Cristofano Allori (64), the Child places a wreath of flowers on the brow of his Mother, holding in his other hand his own crown of thorns : one of the *fancies* of the later schools of art.

[1] Florence Gal.

B

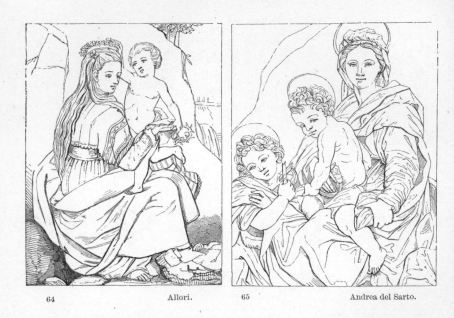

64 Allori. 65 Andrea del Sarto.

The introduction of the little St. John into the group of the Virgin and Child lends it a charming significance and variety, and is very popular; we must, however, discriminate between the familiarity of the domestic subject and the purely religious treatment. When the Giovannino adores with folded hands, as acknowledging in Christ a superior power (65), or kisses his feet humbly (66), or points to him exulting, then it is evident that we have the two Children in their spiritual character, the Child, Priest and King, and the Child, Prophet.

In a picture by Lionardo da Vinci,[1] the Madonna, serious and beautiful, without either crown or veil, and adorned only by her long fair hair, is seated on a rock. On one side, the little Christ, supported in the arms of an angel, raises his hand in benediction; on the other side, the young St. John, presented by the Virgin, kneels in adoration.

[1] Coll. of the Earl of Suffolk.

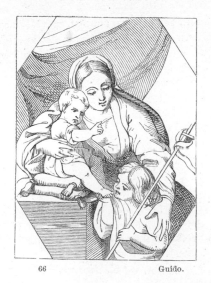 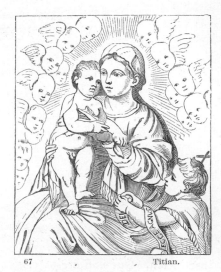

66 Guido. 67 . Titian.

Where the Children are merely embracing each other, or sporting at
the feet of the Virgin, or playing with the cross, or with a bird, or with
the lamb, or with flowers, we might call the treatment domestic or
poetical; but where St. John is taking the cross from the hand of
Christ, it is clear, from the perpetual repetition of the theme, that it is
intended to express a religious allegory. It is the mission of St. John
as Baptist and Prophet. He receives the symbol of faith ere he goes
forth to preach and to convert; or, as it has been interpreted, he, in the
sense used by our Lord, 'takes up the cross of our Lord.' The first is,
I think, the meaning when the cross is enwreathed with the *Ecce Agnus
Dei*; the latter, when it is a simple cross.

In Raphael's 'Madonna della Famiglia Alva,'[1] and in his Madonna
of the Vienna Gallery, Christ gives the cross to St. John. In a picture
of the Lionardo school in the Louvre we have the same action; and
again in a graceful group by Guido, which, in the engraving, bears this

[1] Now in the Imp. Gal., St. Petersburg.

R 2

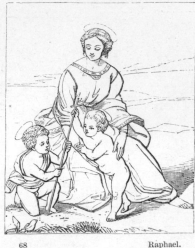

68 Raphael.

inscription, ' *Qui non accipit crucem suam non est me dignus.*' [1] This, of course, fixes the signification.

Another, and, as I think, a wholly fanciful interpretation, has been given to this favourite group by Tieck and by Monckton Milnes. The Children contend for the cross. The little St. John begs to have it.

> Give me the cross, I pray you, dearest Jesus!
> O if you knew how much I wish to have it,
> You would not hold it in your hand so tightly.
> Something has told me, something in my breast here,
> Which I am sure is true, that if you keep it,
> If you will let no other take it from you,
> Terrible things I cannot bear to think of
> Must fall upon you. Show me that you love me:
> Am I not here to be your little servant,
> Follow your steps, and wait upon your wishes?

But Christ refuses to yield the terrible plaything, and claims his privilege to be the elder ' in the heritage of pain.'

In a picture by Carlo Maratti, I think this action is evident—Christ takes the cross, and St. John yields it with reluctance.

[1] Matt. x. 38.

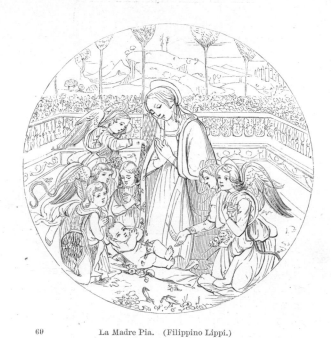

69 La Madre Pia. (Filippino Lippi.)

A beautiful version of the Mater Amabilis is the MADRE PIA, where the Virgin in her divine Infant acknowledges and adores the Godhead. We must be careful to distinguish this subject from the Nativity, for it is common, in the scene of the birth of the Saviour at Bethlehem, to represent the Virgin adoring her new-born Child. The presence of Joseph—the ruined shed or manger—the ox and ass—these express the *event*. But in the MADRE PIA properly so called, the locality, and the accessories, if any, are purely ideal and poetical, and have no reference to time or place. The early Florentines, particularly Lorenzo di Credi, excelled in this charming subject.

I give an example, which appears to me eminently beautiful and poetical. (69) Here the mystical garden is formed of a balustrade, beyond which is seen a hedge all in a blush with roses. The Virgin kneels in the midst, and adores her Infant, who has (in the original) his

70 Correggio.

finger on his lip *(Verbum sum!)*; an angel scatters rose-leaves over
him, while the little St. John also kneels, and four angels, in attitudes
of adoration, complete the group.

But a more perfect example is the Madonna by Francia in the
Munich Gallery, where the divine Infant lies on the flowery turf; and
the Mother, standing before him and looking down on him, seems on the
point of sinking on her knees in a transport of tenderness and devotion.
This, to my feeling, is one of the most perfect pictures in the world; it
leaves nothing to be desired. With all the simplicity of the treatment
it is strictly devotional. The Mother and her Child are placed within
the mystical garden enclosed in a treillage of roses, alone with each
other, and apart from all earthly associations, all earthly communion.
The accompanying sketch, unworthy as it is of the original, will give some
idea of the attitude and treatment.

The beautiful altar-piece by Perugino in our National Gallery (288)
is properly a Madre Pia; the Child seated on a cushion is sustained by
an angel; the mother kneels before him.

The famous Correggio in the Florentine Gallery is also a Madre
Pia. (70) It is very tender, sweet, and maternal. The Child lying on
part of his mother's blue mantle, so arranged that while she kneels and

bends over him, she cannot change her attitude without disturbing him,

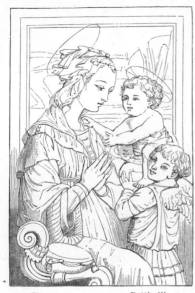

71 Botticelli.

is a *concetto* admired by critics in sentiment and Art; but it appears to me very inferior and common-place in comparison to the Francia at Munich.

In this group (71), angels sustain the Infant, while the Mother, seated, with folded hands, adores him; and in this favourite composition by Guido (72) he sleeps.

And, lastly, we have the Mater Amabilis in a more complex and picturesque, though still devotional, form. The Virgin, seen at full length, reclines on a verdant bank, or is seated under a tree. She is not alone with her Child. Holy personages, admitted to a communion with her, attend around her, rather sympathising than adoring. The love of varied nature, the love of life under all its aspects, became mingled with the religious conception. Instead of carefully avoiding whatever may remind us of her earthly relationship, the members of her family always form a part of her *cortège*. This pastoral and dramatic treatment began with the Venetian and Paduan schools, and extended to the early German schools, which were allied to them in feeling, though contrasted with them in form and execution.

The perpetual introduction of St. Joseph, St. Elizabeth, and other relatives of the Virgin (always avoided in a Madonna del Trono), would compose what is called a Holy Family, but that the presence of sainted personages whose existence and history belong to a wholly different era — St. Catherine, St. George, St. Francis, or St. Dominick — takes the composition out of the merely domestic and historical, and lifts it at once into the ideal and devotional line of art. Such a group cannot well be styled a *Sacra Familia*; it is a *Sacra Conversazione* treated in the pastoral and lyrical rather than the lofty epic style.

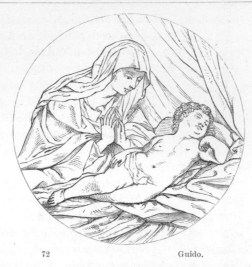

72 Guido.

In this subject the Venetians, who first introduced it, excel all other painters. There is no example by Raphael. The German and Flemish

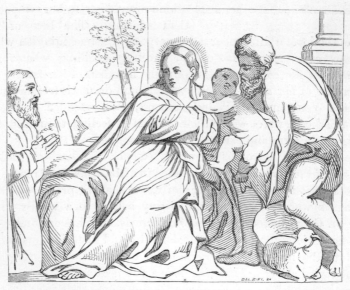

73 Pastoral Madonna. (Palma.)

painters who adopted this treatment were often coarse and familiar; the later Italians became flippant and fantastic. The Venetians alone knew how to combine the truest feeling for nature with a sort of Elysian grace.

I shall give a few examples.

1. In a picture by Titian,[1] the Virgin is seated on a green bank enamelled with flowers. She is simply dressed like a *contadina*, in a crimson tunic, and a white veil half shading her fair hair. She holds in her arms her lovely Infant, who raises his little hand in benediction. St. Catherine kneels before him on one side; on the other, St. Barbara. St. John the Baptist, not as a child, and the contemporary of our Saviour, but in likeness of an Arcadian shepherd, kneels with his cross and his lamb—the *Ecce Agnus Dei*, expressed, not in words, but in form. St. George stands by as a guardian warrior. And St. Joseph, leaning on his stick behind, contemplates the group with an air of dignified complacency.

2. Here is another instance also from Titian. In a most luxuriant landscape thick with imbowering trees, and the mountains of Cadore in the background, the Virgin is seated on a verdant bank; St. Catherine has thrown herself on her knees, and stretches out her arms to the divine Child in an ecstasy of adoration, in which there is nothing unseemly or familiar. At a distance St. John the Baptist approaches with his lamb.

3. In another very similar group the action of St. Catherine is rather too familiar—it is that of an elder sister or a nurse: the young St. John kneels in worship. (74)

4. Wonderfully fine is a picture of this class by Palma, now in the Dresden Gallery. The noble, serious, sumptuous loveliness of the Virgin; the exquisite Child, so thoughtful, yet so infantine; the manly beauty of the St. John; the charming humility of the St. Catherine as she presents her palm, form one of the most perfect groups in the world. Childhood, motherhood, maidenhood, manhood, were never, I think, combined in so sweet a spirit of humanity.[2]

[1] Dresden Gal.

[2] When I was at Dresden, in 1850, I found Steinle, so celebrated for his engravings of the Madonna di San Sisto and the Holbein Madonna, employed on this picture; and, as far as his art could go, transferring to his copper all the fervour and the *morbidezza* of the original.

S

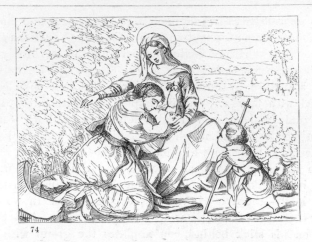

74

5. In another picture by Palma, in the same gallery, we have the same picturesque arrangement of the Virgin and Child, while the *little* St. John adores with folded hands, and St. Catherine sits by in tender contemplation.

This Arcadian sentiment is carried as far as could well be allowed in a picture by Titian,[1] known as the *Vierge au Lapin.* The Virgin holds a white rabbit, towards which the infant Christ, in the arms of St. Catherine, eagerly stretches his hand. In a picture by Paris Bordone it is carried, I think, too far. The Virgin reclines under a tree with a book in her hand; opposite to her sits St. Joseph holding an apple; between them, St. John the Baptist, as a bearded man, holds in his arms the infant Christ, who caressingly puts one arm round his neck, and with the other clings to the rough hairy raiment of his friend.

It will be observed, that in these Venetian examples St. Catherine, the beloved protectress of Venice, is seldom omitted. She is not here the learned princess who confounded tyrants and converted philosophers, but a bright-haired, full-formed Venetian maiden, glowing with love and life, yet touched with a serious grace, inexpressibly charming.

St. Dorothea is also a favourite saint in these sacred pastorals. Here is an instance in which she is seated by the Virgin with her basket of

[1] Louvre, 459.

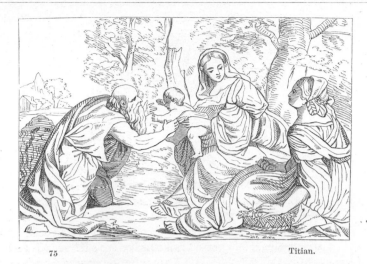

75 Titian.

fruits and flowers; and St. Jerome, no longer beating his breast in penance, but in likeness of a fond old grandfather, stretches out his arms to the Child. Much finer is a picture now in the possession of Sir Charles Eastlake. The lovely Virgin is seated under a tree: on one side appears the angel Raphael, presenting Tobit; on the other, St. Dorothea, kneeling, holds up her basket of celestial fruit, gathered for her in Paradise.[1]

When St. Ursula, with her standard, appears in these Venetian patorals, we may suppose the picture to have been painted for the famous brotherhood (*Scuola di Sant' Orsola*) which bears her name. Thus, in a charming picture by Palma, she appears before the Virgin, accompanied by St. Mark as protector of Venice.[2]

Ex-voto pictures in this style are very interesting, and the votary, without any striking impropriety, makes one of the Arcadian group. Very appropriate, too, is the marriage of St. Catherine, often treated in this poetical style. In a picture by Titian, the family of the Virgin attend the mystical rite, and St. Anna places the hand of St. Catherine in that of the Child.

In this group by Signorelli (76), Christ appears as if teaching

[1] See Sacred and Legendary Art for the beautiful legend of St. Dorothea, 3rd edit. p. 568.
[2] Vienna, Belvedere Gal.

s 2

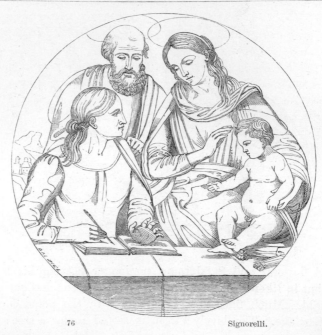

76 Signorelli.

St. Catherine; he dictates, and she, the patroness of 'divine philosophy,' writes down his words.

When the later painters in their great altar-pieces imitated this .idyllic treatment, the graceful Venetian conception became in their hands heavy, mannered, tasteless—and sometimes worse. The monastic saints or mitred dignitaries, introduced into familiar and irreverent communion with the sacred and ideal personages, in spite of the grand scenery, strike us as at once prosaic and fantastic: 'we marvel how they got there.' Parmigiano, when he fled from the sack of Rome in 1527, painted at Bologna, for the nuns of Santa Margherita, an altar-piece which has been greatly celebrated. The Madonna, holding her Child, is seated in a landscape under a tree, and turns her head to the Bishop St. Petronius, protector of Bologna. St. Margaret, kneeling and attended by her great dragon, places one hand, with a free and easy air, on the knee of the Virgin, and with the other seems to be about to chuck the infant Christ under the chin. In a large picture by Giacomo Francia, the Virgin, walking in a flowery meadow with the infant

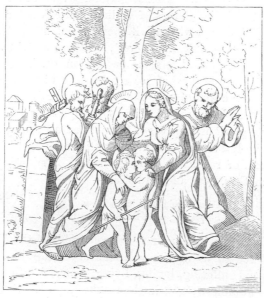

77 Parmigiano.

Christ and St. John, and attended by St. Agnes and Mary Magdalene, meets St. Francis and St. Dominick, also, apparently, taking a walk.[1] And again — the Madonna and St. Elizabeth meet with their children in a landscape, while St. Peter, St. Paul, and St. Benedict stand behind in attitudes of attention and admiration. (77) Now, such pictures may be excellently well painted, greatly praised by connoisseurs, and held in ‘ *somma venerazione*,’ but they are offensive as regards the religious feeling, and are, in point of taste, mannered, fantastic, and secular.

Here we must end our discourse concerning the Virgin and Child as a devotional subject. Very easily and delightfully to the writer, perhaps not painfully to the reader, might we have gone on to the end of the volume; but my object was not to exhaust the subject, to point out every interesting variety of treatment, but to lead the lover

[1] Berlin Gal., No. 281.

of art, wandering through a church or gallery, to new sources of pleasure; to show him what infinite shades of feeling and character may still be traced in a subject which, with all its beauty and attractiveness, might seem to have lost its significant interest, and become trite from endless repetition; to lead the mind to some perception of the intention of the artist in his work—under what aspect he had himself contemplated and placed before the worshipper the image of the Mother of Christ—whether crowned and enthroned as the sovereign lady of Christendom; or exalted as the glorious empress of heaven and all the spiritual world; or bending benignly over us, the impersonation of sympathising womanhood, the emblem of relenting love, the solace of suffering humanity, the maid and mother, dear and undefiled—

> Created beings all in lowliness
> Surpassing, as in height above them all.

It is time to change the scene—to contemplate the Virgin, as she has been exhibited to us in the relations of earthly life, as the mere woman, acting and suffering, loving, living, dying, fulfilling the highest destinies in the humblest state, in the meekest spirit. So we begin her history as the ancient artists have placed it before us, with that mingled *naïveté* and reverence, that vivid dramatic power, which only faith, and love, and genius united, could impart.

78 The Madonna and Child surrounded by the Seven Gifts of the Holy Spirit.

Historical Subjects.

———◆———

PART I.

The Life of the Virgin Mary from her Birth to her Marriage with Joseph.

1. THE LEGEND OF JOACHIM AND ANNA.
2. THE NATIVITY OF THE BLESSED VIRGIN.
3. THE DEDICATION IN THE TEMPLE.
4. THE MARRIAGE WITH JOSEPH.

79 The Annunciation to St. Anna. (Luini.)

The Legend of Joachim and Anna.

Ital. La Leggenda di Sant' Anna Madre della Gloriosa Vergine Maria, e di San Gioacchino.

Of the sources whence are derived the popular legends of the life of the Virgin Mary, which, mixed up with the few notices in Scripture, formed one continuous narrative, authorised by the priesthood, and accepted and believed in by the people, I have spoken at length in the Introduction. We have now to consider more particularly the scenes and characters associated with her history; to show how the artists of the Middle Ages, under the guidance and by the authority of the Church, treated in detail these favourite themes in ecclesiastical decoration.

In early art, that is, up to the end of the fifteenth century, Joachim

T

and Anna, the parents of the Virgin, never appear except in the series of subjects from her life. In the devotional groups and altar-pieces, they are omitted. St. Bernard, the great theological authority of those times, objects to the invocation of any saints who had lived before the birth of Christ, consequently to their introduction into ecclesiastical edifices in any other light than as historical personages. Hence, perhaps, there were scruples relative to the representations of St. Anna, which, from the thirteenth to the fifteenth century, placed the artists under certain restrictions.

Under the name of Anna, the Church has honoured, from remote times, the memory of the mother of the Virgin. The Hebrew name, signifying *Grace*, or *the Gracious*, and all the traditions concerning her, came to us from the East, where she was so early venerated as a saint, that a church was dedicated to her by the Emperor Justinian, in 550. Several other churches were subsequently dedicated to her in Constantinople during the sixth and seventh centuries, and her remains are said to have been deposited there in 710. In the West, she first became known in the reign of Charlemagne; and the Greek apocryphal gospels, or at least stories and extracts from them, began to be circulated about the same period. From these are derived the historic scenes and legendary subjects relating to Joachim and Anna which appear in early art. It was about 1500, in the beginning of the sixteenth century, that the increasing veneration for the Virgin Mary gave to her parents, more especially to St. Anna, increased celebrity as patron saints; and they became, thenceforward, more frequent characters in the sacred groups. The feast of St. Anna was already general and popular throughout Europe long before it was rendered obligatory in 1584.[1] The growing enthusiasm for the doctrine of the Immaculate Conception gave, of course, additional splendour and importance to her character. Still, it is only in later times that we find the effigy of St. Anna separated from that of the Virgin. There is a curious picture by Cesi,[2] in which St. Anna kneels before a vision of her daughter before she is born---the Virgin of the Immaculate Conception. A fine model of a

[1] In England we have twenty-eight churches dedicated in the name of St. Anna.
[2] Bologna Gal.

bearded man was now sometimes converted into a St. Joachim reading or meditating, instead of a St. Peter or a St. Jerome, as heretofore. In the Munich Gallery are two fine ancient-looking figures of St. Joachim the father, and St. Joseph the husband, of the Virgin, standing together; but all these, as separate representations, are very uncommon; and of those which exhibit St. Anna devotionally, as enthroned with the Virgin and Child, I have already spoken. Like St. Elizabeth, she should be an elderly, but not a *very* old woman. Joachim, in such pictures, never appears but as an attendant saint, and then very rarely; always very old, and sometimes in the dress of a priest, which, however, is a mistake on the part of the artist.

A complete series of the history of the Blessed Virgin, as imaged forth by the early artists, always begins with the legend of Joachim and Anna, which is thus related.

'There was a man of Nazareth, whose name was Joachim, and he had for his wife a woman of Bethlehem, whose name was Anna, and both were of the royal race of David. Their lives were pure and righteous, and they served the Lord with singleness of heart. And, being rich, they divided their substance into three portions, one for the service of the temple, one for the poor and the strangers, and the third for their household. On a certain feast-day, Joachim brought double offerings to the Lord according to his custom, for he said, " Out of my superfluity will I give for the whole people, that I may find favour in the sight of the Lord, and forgiveness for my sins." And when the children of Israel brought their gifts, Joachim also brought his; but the high priest Issachar stood over against him and opposed him, saying, " It is not lawful for thee to bring thine offering, seeing that thou hast not begot issue in Israel." And Joachim was exceeding sorrowful, and went down to his house; and he searched through all the registers of the twelve tribes to discover if he alone had been childless in Israel. And he found that all the righteous men, and the patriarchs who had lived before him, had been the fathers of sons and daughters. And he

called to mind his father Abraham, to whom in his old age had been granted a son, even Isaac.

'And Joachim was more and more sorrowful; and he would not be seen by his wife, but avoided her, and went away into the pastures where were the shepherds and the sheep-cotes. And he built himself a hut, and fasted forty days and forty nights; for he said, " Until the Lord God look upon me mercifully, prayer shall be my meat and my drink."

'But his wife Anna remained lonely in her house, and mourned with a twofold sorrow, for her widowhood and for her barrenness.

'Then drew near the last day of the feast of the Lord; and Judith her handmaid said to Anna, "How long wilt thou thus afflict thy soul? Behold, the feast of the Lord is come, and it is not lawful for thee thus to mourn. Take this silken fillet, which was bestowed on me by one of high degree whom I formerly served, and bind it round thy head, for it is not fit that I who am thy handmaid should wear it, but it is fitting for thee, whose brow is as the brow of a crowned queen." And Anna replied, "Begone! such things are not for me, for the Lord hath humbled me. As for this fillet, some wicked person hath given it to thee; and art thou come to make me a partaker in thy sin?" And Judith her maid answered, " What evil shall I wish thee since thou wilt not hearken to my voice? for worse I cannot wish thee than that with which the Lord hath afflicted thee, seeing that he hath shut up thy womb, that thou shouldst not be a mother in Israel."

'And Anna, hearing these words, was sorely troubled. And she laid aside her mourning garments, and she adorned her head, and put on her bridal attire; and at the ninth hour she went forth into her garden, and sat down under a laurel-tree and prayed earnestly. And looking up to heaven she saw within the laurel bush a sparrow's nest; and mourning within herself she said, " Alas! and woe is me! who hath begotten me? who hath brought me forth? that I should be accursed in the sight of Israel and scorned and shamed before my people, and cast out of the temple of the Lord! Woe is me! to what shall I be likened? I cannot be likened to the fowls of heaven, for the fowls of heaven are fruitful in thy sight, O Lord! Woe is me! to what shall I be likened? Not to the unreasoning beasts of the earth, for they are fruitful in thy sight,

O Lord! Woe is me! to what shall I be likened? Not to these waters, for they are fruitful in thy sight, O Lord! Woe is me! to what shall I be likened? Not unto the earth, for the earth bringeth forth her fruit in due season, and praiseth thee, O Lord!"

'And behold, an angel of the Lord stood by her and said, "Anna, thy prayer is heard; thou shalt bring forth, and thy child shall be blessed throughout the whole world." And Anna said, "As the Lord liveth, whatever I shall bring forth, be it a man-child or a maid, I will present it an offering to the Lord." And behold, another angel came and said to her, "See, thy husband Joachim is coming with his shepherds;" for an angel had spoken to him also, and had comforted him with promises. And Anna went forth to meet her husband, and Joachim came from the pasture with his herds, and they met at the golden gate; and Anna ran and embraced her husband, and hung upon his neck, saying, "Now know I that the Lord hath blessed me. I who was a widow am no longer a widow; I who was barren shall become a joyful mother."

'And they returned home together.

'And when her time was come, Anna brought forth a daughter; and she said, "This day my soul magnifieth the Lord." And she laid herself down in her bed; and she called the name of her child Mary, which in the Hebrew is Miriam.'

With the scenes of this beautiful pastoral begins the life of the Virgin.

1. We have first Joachim rejected from the temple. He stands on the steps before the altar holding a lamb; and the high priest opposite to him, with arm upraised, appears to refuse his offering. Such is the usual *motif*; but the incident has been variously treated—in the earlier and ruder examples, with a ludicrous want of dignity; for Joachim is almost tumbling down the steps of the temple to avoid the box on the ear which Issachar the priest is in the act of bestowing in a most energetic fashion. On the other hand, the group by Taddeo Gaddi,[1] though so early in date, has not since been excelled either in the grace or the dramatic significance of the treatment. Joachim turns away, with his lamb in his arms, repulsed, but gently, by the priest. To the right are

[1] Florence, Baroncelli Chapel, S. Croce.

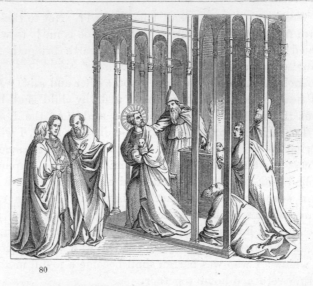

80

three personages who bring offerings, one of whom, prostrate on his
knees, yet looks up at Joachim with a sneering expression—a fine re-
presentation of the pharisaical piety of one of the elect, rejoicing in the
humiliation of a brother. On the other side are three persons who
appear to be commenting on the scene. In the more elaborate com-
position by Ghirlandajo,[1] there is a grand view into the interior of the
temple, with arches richly sculptured. Joachim is thrust forth by one
of the attendants, while in the background the high priest accepts the
offering of a more favoured votary. On each side are groups looking
on, who express the contempt and hatred they feel for one who, not
having children, presumes to approach the altar. All these, according
to the custom of Ghirlandajo, are portraits of distinguished persons.
The first figure on the right represents the painter Baldovinetti; next
to him, with his hand on his side, Ghirlandajo himself; the third, with
long black hair, is Bastiano Mainardi, who painted the Assumption in
the Ruccellai Chapel, in the Santa Croce; and the fourth, turning his
back, is David Ghirlandajo. These real personages are so managed,

[1] Florence, S. Maria Novella.

that, while they are not themselves actors, they do not interfere with the main action, but rather embellish and illustrate it, like the chorus in a Greek tragedy. Every single figure in this fine fresco is a study for manly character, dignified attitude, and easy grand drapery.

In the same scene by Albert Durer,[1] the high priest, standing behind a table, rejects the offering of the lamb, and his attendant pushes away the doves. Joachim makes a gesture of despair, and several persons who bring offerings look at him with disdain or with sympathy.

The same scene by Luini[2] is conceived with much pathetic as well as dramatic effect. But as I have said enough to render the subject easily recognised, we proceed.

2. ' Joachim herding his sheep on the mountain, and surrounded by his shepherds, receives the message of the angel.' This subject may so nearly resemble the Annunciation to the Shepherds in St. Luke's Gospel, that we must be careful to distinguish them, as, indeed, the best of the old painters have done with great taste and feeling.

In the fresco by Taddeo Gaddi (in the Baroncelli Chapel), Joachim is seated on a rocky mountain, at the base of which his sheep are feeding, and turns round to listen to the voice of the angel. In the fresco by Giotto in the Arena at Padua, the treatment is nearly the same.[3] In the series by Luini, a stream runs down the centre of the picture : on one side is Joachim listening to the angel ; on the other, Anna is walking in her garden. This incident is omitted by Ghirlandajo. In Albert Durer's composition, Joachim is seen in the foreground kneeling, and looking up at an angel, who holds out in both hands a sort of parchment roll looking like a diploma with seals appended, and which we may suppose to contain the message from on high (if it be not rather the emblem of the *sealed book*, so often introduced, particularly by the German masters). A companion of Joachim also looks up with amazement, and further in the distance are sheep and shepherds.

The Annunciation to St. Anna may be easily mistaken for the Annunciation to the Virgin Mary—we must therefore be careful to discriminate, by an attention to the accessories. Didron observes that

[1] In the set of woodcuts of the Life of the Virgin. [2] Milan, Brera.
[3] The subject will be found in the set of woodcuts published by the Arundel Society.

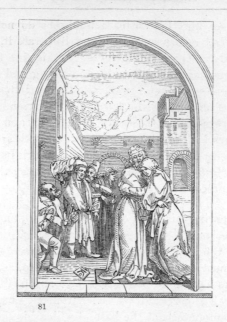

81

in Western art the annunciation to St. Anna usually takes place in a chamber. In the East it takes place in a garden, because there ' *on vit peu dans les maisons et beaucoup en plein air* ; ' but, according to the legend, the locality ought to be a garden, and under a laurel-tree, which is not always attended to. (79)

3. The altercation between St. Anna and her maid Judith I have never met with but once, in the series by Luini, where the disconsolate figure and expression of St. Anna are given with infinite grace and sentiment.[1]

4. 'The meeting of Joachim and Anna before the golden gate.' This is one of the most important subjects. It has been treated by the very early artists with much *naïveté*, and in the later examples with infinite beauty and sentiment; and, which is curious, it has been

[1] Milan, Brera.

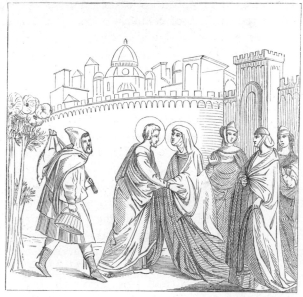

82 Taddeo Gaddi.

idealised into a devotional subject, and treated apart. The action is in
itself extremely simple. The husband and wife affectionately and
joyfully embrace each other. In the background is seen a gate, richly
ornamented. Groups of spectators and attendants are sometimes, not
always, introduced.

In the composition of Albert Durer (81) nothing can be more
homely, hearty, and conjugal. A burly fat man, who looks on with a
sort of wondering amusement in his face, appears to be a true and
animated transcript from nature, as true as Ghirlandajo's attendant
figures—but how different! what a contrast between the Florentine
citizen and the German burgher! In the simpler composition by
Taddeo Gaddi (82), St. Anna is attended by three women, among whom
the maid Judith is conspicuous, and behind Joachim is one of his
shepherds.[1]

[1] In two compartments of a small altar-piece (which probably represented in the centre the
Nativity of the Virgin), I found on one side the story of St. Joachim, on the other the story
of St. Anna.—*Collection of Lord Northwick, No. 513 in his Catalogue.*

U

The Franciscans, those enthusiastic defenders of the Immaculate Conception, were the authors of a fantastic idea, that the birth of the Virgin was not only *immaculate,* but altogether *miraculous,* and that she owed her being to the joyful kiss which Joachim gave his wife when they met at the gate. Of course the Church gave no countenance to this strange poetical fiction, but it certainly modified some of the representations: for example, there is a picture by Vittore Carpaccio, wherein St. Joachim and Anna tenderly embrace. On one side stands St. Louis of Toulouse as bishop; on the other St. Ursula with her standard, whose presence turns the incident into a religious mystery. In another picture, painted by Ridolfo Ghirlandajo, we have a still more singular and altogether mystical treatment. In the centre St. Joachim and St. Anna embrace; behind St. Joachim stands St. Joseph with his lily wand and a book; behind St. Anna, the Virgin Mary (thus represented as existing before she was born[1]), and beyond her St. Laurence; in the corner is seen the head of the votary, a Servite monk; above all, the Padre Eterno holds an open book with the *Alpha* and *Omega.* This singular picture was dedicated and placed over the high altar of the Conception in the Church of the Servi, who, under the title of *Serviti di Maria,* were dedicated to the especial service of the Virgin Mary.[2]

THE NATIVITY OF THE BLESSED VIRGIN.

Ital. La Nascità della B. Vergine. *Fr.* La Naissance de la S. Vierge.
Ger. Die Geburt Maria.

THIS is, of course, a very important subject. It is sometimes treated apart as a separate scene; and a series of pictures dedicated to the honour of the Virgin, and comprising only a few of the most eventful scenes in her history, generally begins with her Nativity. The primitive treatment is Greek, and, though varied in the details and the sentiment, it has never deviated much from the original *motif.*

St. Anna reclines on a couch covered with drapery, and a pillow under

[1] Prov. viii. 22, 23. These texts are applied to the Madonna.
[2] *v.* Legends of the Monastic Orders, 2nd edit. p. 213.

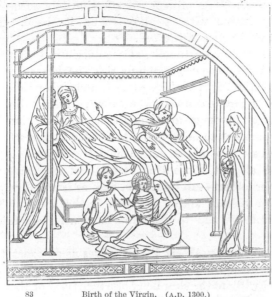

83 Birth of the Virgin. (A.D. 1300.)

her head; two handmaids sustain her; a third fans her, or presents re-
freshments; more in front a group of women are busied about the new-
born child. It has been the custom, I know not on what authority, to
introduce neighbours and friends, who come to congratulate the parents.
The whole scene thus treated is sure to come home to the bosom of the
observer. The most important event in the life of a woman, her most
common and yet most awful experience, is here so treated as to be at
once ennobled by its significance, and endeared by its thoroughly do-
mestic character.

I will give some examples. 1. The first (83) is after an unknown
master of the Greco-Italian school, and referred by D'Agincourt to the
thirteenth century, but it is evidently later, and quite in the style of
the Gaddi.

2. There is both dignity and simplicity in the fresco by Taddeo
Gaddi.[1] St. Anna is sitting up in bed; an attendant pours water over

[1] Florence, Baroncelli Chapel.

her hands. In front, two women are affectionately occupied with the
child, a lovely infant with a glory round its head. Three other
attendants are at the foot of the bed.

3. We have next in date, the elegant composition by Ghirlandajo. As
Joachim and Anna were 'exceedingly rich,' he has surrounded them
with all the luxuries of life. The scene is a chamber richly decorated;
a frieze of angelic boys ornaments the alcove; St. Anna lies on a couch.
Vasari says 'certain women are ministering to her;' but in Lasinio's
engraving they are not to be found. In front a female attendant pours
water into a vase; two others seated hold the infant. A noble lady,
habited in the elegant Florentine costume of the fifteenth century,
enters with four others—all portraits, and, as is usual with Ghirlan-
dajo, looking on without taking any part in the action. The lady in
front is traditionally said to be Ginevra Benci, celebrated for her
beauty.

4. The composition by Albert Durer [1] gives us an exact transcript of
antique German life, quite wonderful for the homely truth of the delinea-
tion, but equally without the simplicity of a scriptural or the dignity of an
historical scene. In an old-fashioned German chamber lies St. Anna in
an old-fashioned canopied bedstead. Two women bring her a soup and
something to drink, while the midwife, tired with her exertions, leans
her head on the bedside, and has sunk to sleep. A crowd of women fill
up the foreground, one of whom attends to the new-born child; others,
who appear to have watched through the night, as we may suppose from
the nearly extinguished candles, are intent on good cheer; they congra-
tulate each other; they eat, drink, and repose themselves. It would be
merely a scene of German *commérage*, full of nature and reality, if an
angel hovering above and swinging a censer did not remind us of the
sacred importance of the incident represented.

5. In the strongest possible contrast to the homely but animated con-
ception of Albert Durer, is the grand fresco by Andrea del Sarto, in the
church of the Nunziata at Florence. The incidents are nearly the
same : we have St. Anna reclining in her bed and attended by her
women; the nurses waiting on the lovely new-born child; the visitors

[1] In the set of woodcuts of the 'Life of the Virgin Mary.'

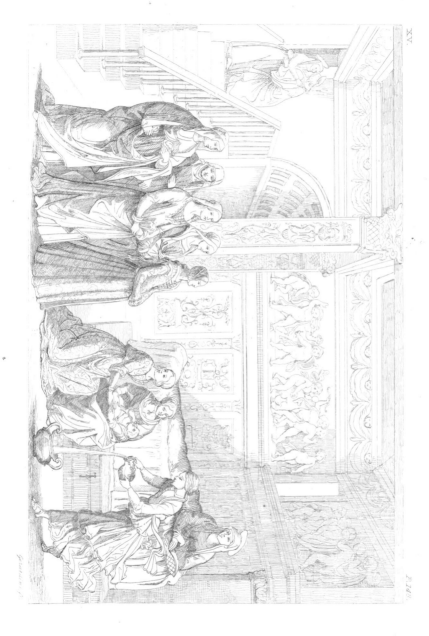

The Nativity of the Virgin Mary.

who enter to congratulate; but all, down to the handmaidens who
bring refreshments, are noble and dignified, and draped in that magni-
ficent taste which distinguished Andrea. Angels scatter flowers from
above, and, which is very uncommon, Joachim is seen, after the anxious
night, reposing on a couch. Nothing in fresco can exceed the harmony
and brilliancy of the colouring, and the softness of the execution. It
appeared to me a masterpiece as a picture. Like Ghirlandajo, Andrea
has introduced portraits; and in the Florentine lady who stands in the
foreground we recognise the features of his worthless wife Lucrezia, the
original model of so many of his female figures that the ignoble beauty
of her face has become quite familiar.

84 ' *Vera Effigie della Santissima Vergine Bambina che si venera nella*
Chiesa di Civitanova.'

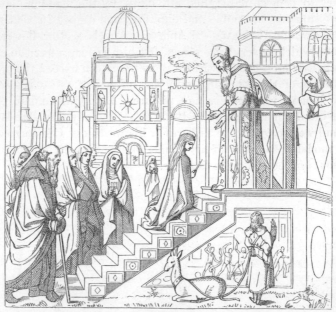

85 Presentation of the Virgin in the Temple. (V. Carpaccio.)

The Presentation of the Virgin.

Ital. La Presentazione, ove nostra Signora piccioletta sale i gradi del Tempio.
Ger. Joachim und Anna weihen ihre Tochter Maria im Tempel.
Die Vorstellung der Jungfrau im Tempel. Nov. 21.

In the interval between the birth of Mary and her consecration in the temple, there is no incident which I can remember as being important or popular as a subject of art.

It is recorded with what tenderness her mother Anna watched over her, 'how she made of her bedchamber a holy place, allowing nothing that was common or unclean to enter in;' and called to her 'certain daughters of Israel, pure and gentle,' whom she appointed to attend

on her. In some of the early miniature illustrations of the Offices of the Virgin, St. Anna thus ministers to her child; for instance, in a beautiful Greek MS. in the Vatican, she is tenderly putting her into a little bed or cradle, and covering her up.[1]

It is not said anywhere that St. Anna instructed her daughter. It has even been regarded as unorthodox to suppose that the Virgin, enriched from her birth, and before her birth, with all the gifts of the Holy Spirit, required instruction from any one. Nevertheless, the subject of the 'Education of the Virgin' has been often represented in later times. There is a beautiful example by Murillo; while Anna teaches her child to read, angels hover over them with wreaths of roses.[2] Another by Rubens, in which, as it is said, he represented his young wife, Helena Forman.[3] There is also a picture in which St. Anna ministers to her daughter, and is intent on braiding and adorning her long golden hair, while the angels look on with devout admiration.[4] In all these examples Mary is represented as a girl of ten or twelve years old. Now, as the legend expressly relates that she was three years old when she became an inmate of the temple, such representations must be considered as incorrect.

The narrative thus proceeds:—

'And when the child was *three years old*, Joachim said, " Let us invite the daughters of Israel, and they shall take each a taper or a lamp, and attend on her, that the child may not turn back from the temple of the Lord. And being come to the temple, they placed her on the first step, and she ascended alone all the steps to the altar : and the high priest received her there, kissed her, and blessed her, saying, ' Mary, the Lord hath magnified thy name to all generations, and in thee shall be made known the redemption of the children of Israel." And being placed before the altar, she danced with her feet, so that all the house of Israel rejoiced with her, and loved her. Then her parents returned home, blessing God because the maiden had not turned back from the temple.'

Such is the incident, which, in artistic representation, is sometimes

[1] It is engraved in D'Agincourt.
[2] Madrid Gal.
[3] Musée, Antwerp.
[4] Vienna, Lichtenstein Gal.

styled the 'Dedication,' but more generally 'THE PRESENTATION OF THE VIRGIN.'

It is a subject of great importance, not only as a principal incident in a series of the Life of the Virgin, but because this consecration of Mary to the service of the temple being taken in a general sense, it has often been given in a separate form, particularly for the nunneries. Hence it has happened that we find 'The Presentation of the Virgin' among some of the most precious examples of ancient and modern art.

The *motif* does not vary. The child Mary, sometimes in a blue, but oftener in a white vesture, with long golden hair, ascends the steps which lead to the porch of the temple, which steps are always fifteen in number. · She ought to be an infant of three years of age; but in many pictures she is represented older, veiled, and with a taper in her hand instead of a lamp, like a young nun; but this is a fault. The 'fifteen steps' rest on a passage in Josephus, who says, 'between the wall which separated the men from the women, and the great porch of the temple, were fifteen steps;' and these are the steps which Mary is supposed to ascend.

1. It is sometimes treated with great simplicity; for instance, in the bas-relief by Andrea Orcagna, there are only three principal figures— the Virgin in the centre (too old, however), and Joachim and Anna stand on each side.[1]

2. In the fresco by Taddeo Gaddi we have the same artless grace, the same dramatic grouping, and the same faults of drawing and perspective as in the other compartments of the series.[2]

3. The scene is represented by Ghirlandajo with his usual luxury of accessories and accompaniments.[3] The locality is the court of the temple; on the right a magnificent porch; the Virgin, a young girl of about nine or ten years old, is seen ascending the steps with a book in her hand; the priest stretches out his arms to receive her; behind him is another priest; and 'the young virgins who were to be her companions' are advancing joyously to receive her.[4] At the foot of the

[1] Florence, Or San Michele. [2] Florence, Baroncelli Chapel.
[3] Florence, S. Maria Novella. [4] Adducentur Regi Virgines post eam. Ps. xlv.

steps are St. Anna and St. Joachim, and further off a group of women and spectators, who watch the event in attitudes of thanksgiving and joyful sympathy. Two venerable, grand-looking Jews, and two beautiful boys, fill the foreground; and the figure of the pilgrim resting on the steps is memorable in art as one of the earliest examples of an undraped figure, accurately and gracefully drawn. The whole composition is full of life and character, and that sort of *elegance* peculiar to Ghirlandajo.

4. In the composition of Albert Durer we see the entrance of the temple on the left, and the child Mary with flowing hair ascending the steps; behind her stand her parents and other personages, and in front are vendors of provisions, doves, &c., which are brought as offerings.

5. The scene, as given by Carpaccio, appears to me exceedingly graceful. (85) The perfectly childish figure of Mary with her light flowing tresses, the grace with which she kneels on the steps, and the disposition of the attendant figures, are all beautifully conceived. Conspicuous in front is a page holding a unicorn, the ancient emblem of chastity, and often introduced significantly into pictures of the Virgin.[1]

6. But the most celebrated example is the Presentation by Titian, in the academy at Venice, originally painted for the church of the brotherhood of charity (*Scuola della Carità*), and still to be seen there — the Carità being now the academy of art. This famous picture is so well known through the numerous engravings, that I have not thought it necessary to reproduce it here. In the general arrangement, Titian seems to have been indebted to Carpaccio; but all that is simple and poetical in the latter becomes in Titian's version sumptuous and dramatic. Here Mary does not kneel, but, holding up her light blue drapery, ascends the steps with childish grace and alacrity. The number of portrait-heads adds to the value and interest of the picture. Titian himself is looking up, and near him stands his friend, Andrea de' Franceschi, grandchancellor of Venice,[2] robed as a *Cavaliero di San Marco.* In the fine

[1] Venice Academy.

[2] '*Amorevolissimo del Pittore,*' says Ridolfi. It is the same person whom Titian introduced, with himself, in the fine picture at Windsor; there, by a truly unpardonable mistake, called 'Titian and Aretino.'

X

bearded head of the priest, who stands behind the high priest, we may recognise, I think, the likeness of Cardinal Bembo. In the foreground, instead of the poetical symbol of the unicorn, we have an old woman selling eggs and fowls, as in Albert Durer's print, which must have been well known to Titian. Albert Durer published his Life of the Virgin in 1520, and Titian painted his picture about 1550.[1]

From the life of the Virgin in the Temple, we have several beautiful pictures. As she was to be placed before women as an example of every virtue, so she was skilled in all feminine accomplishments; she was as studious, as learned, as wise, as she was industrious, chaste, and temperate.

She is seen surrounded by her young companions, the maidens who were brought up in the temple with her, in a picture by Agnolo Gaddi.[2] She is instructing her companions, in a charming picture by Luini: here she appears as a girl of seven or eight years old, seated on a sort of throne, dressed in a simple light-blue tunic, with long golden hair; while the children around her look up and listen with devout faces.[3]

Some other scenes of her early life, which, in the Protevangelion, are placed after her marriage with Joseph, in pictures usually precede it. Thus, she is chosen by lot to spin the fine purple for the temple, to weave and embroider it. Didron mentions a fine antique tapestry at Rheims, in which Mary is seated at her embroidery, while two unicorns crouching on each side look up in her face.

I remember a fine drawing, in which the Virgin is seated at a large tapestry frame. Behind her are two maidens, one of whom is reading; the other, holding a distaff, lays her hand on the shoulder of the Virgin, as if about to speak. The scene represents the interior of the temple with rich architecture.[4]

In a small but very pretty picture by Guido, the Virgin, as a young girl, sits embroidering a *yellow* robe.[5] She is attended by four angels, one of whom draws aside a curtain.

[1] Venice Academy. [2] Florence, Carmine. [3] Milan, Brera.
[4] Vienna, Col. of Archduke Charles. [5] Lord Ellesmere's Gal.

It is also related, that among the companions of Mary in the temple was Anna the prophetess; and that this aged and holy woman, knowing by inspiration of the Holy Spirit the peculiar grace vouchsafed to Mary, and her high destiny, beheld her with equal love and veneration; and, notwithstanding the disparity of age, they became true and dear friends.

In an old illumination, the Virgin is seated spinning, with an angel by her side.[1]

It is recorded that the angels daily ministered to her and fed her with celestial food. Hence in some early specimens of art an angel brings her a loaf of bread and a pitcher of water—the *bread of life* and the *water of life* from Paradise. In this subject, as we find it carved on the stalls of the cathedral of Amiens, Mary holds a book, and several books are ranged on a shelf in the background: there is, besides, a clock, such as was in use in the fifteenth century, to indicate the studious and regular life led by Mary in the temple.

St. Evode, patriarch of Antioch, and St. Germanus assert, as an indubitable tradition of the Greek Church, that Mary had the privilege —never granted to one of her sex before or since—of entering the Holy of Holies, and praying before the ark of the covenant. Hence, in some of the scenes from her early life, the ark is placed in the background. We must also bear in mind that the ark was one of the received types of her who bore the Logos within her bosom.

In her fourteenth year, Mary was informed by the high priest that it was proper that she should be married; but she modestly replied that her parents had dedicated her to the service of the Lord, and that, therefore, she could not comply. But the high priest, who had received a revelation from an angel concerning the destiny of Mary, informed her thereof, and she with all humility submitted herself to the divine will. The scene between Mary and the high priest has

[1] Office of the Virgin, 1408. Oxford, Bodleian.

x 2

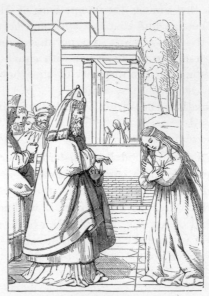

86 The Virgin in the Temple. (Luini.)

been painted by Luini (86), and it is the only example with which I am acquainted.

Pictures of the Virgin in her girlhood, reading intently the Book of Wisdom, while angels watch over her, are often of great beauty.

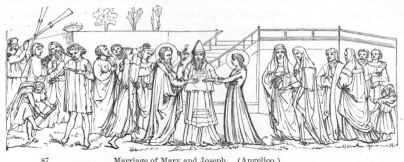

87 Marriage of Mary and Joseph. (Angelico.)

The Marriage of the Virgin.

Ital. Il Sposalizio. *Fr.* Le Marriage de la Vierge. *Ger.* Die Trauung Mariä. Jan. 23.

THIS, as an artistic subject, is cf great consequence, from the beauty
and celebrity of some of the representations, which, however, are unin-
telligible without the accompanying legends. And it is worth remark-
ing, that while the incident is avoided in early Greek art, it became
very popular with the Italian and German painters from the fourteenth
century.

In the East, the prevalence of the monastic spirit, from the fourth
century, had brought marriage into disrepute; by many of the ascetic
writers of the West it was considered almost in the light of a necessary
evil. This idea, that the primal and most sacred ordinance of God and
nature was incompatible with the sanctity and purity acceptable to God,
was the origin of the singular legends of the Marriage of the Virgin.
One sees very clearly that, if possible, it would have been denied that
Mary had ever been married at all; but, as the testimony of the Gospel
was too direct and absolute to be set aside, it became necessary, in the
narrative, to give to this distasteful marriage the most recondite motives,
and, in art, to surround it with the most poetical and even miraculous
accessories.

But before we enter on the treatment of the subject, it is necessary

to say a few words on the character of Joseph, wonderfully selected to be the husband and guardian of the consecrated mother of Christ, and foster-father of the Redeemer; and so often introduced into all the pictures which refer to the childhood of our Lord.

From the Gospels we learn nothing of him but that he was of the tribe of Judah and the lineage of David; that he was a *just* man; that he followed the trade of a carpenter, and dwelt in the little city of Nazareth. We infer from his conduct towards Mary that he was a mild, and tender, and pure-hearted, as well as an upright man. Of his age and personal appearance nothing is said. These are the points on which the Church has not decided, and on which artists, left to their own devices, and led by various opinions, have differed considerably.

The very early painters deemed it right to represent Joseph as very old, almost decrepit with age, and supported by a crutch. According to some of the monkish authorities, he was a widower, and eighty-four years old when he was espoused to Mary. On the other hand, it was argued, that such a marriage would have been quite contrary to the custom of the Jews; and that to defend Mary, and to provide for her celestial offspring, it was necessary that her husband should be a man of mature age, but still strong and robust and able to work at his trade; and thus, with more propriety and better taste, the later painters have represented him. In the best Italian and Spanish pictures of the Holy Family, he is a man of about forty or fifty, with a mild, benevolent countenance, brown hair, and a short, curled beard: the crutch, or stick, however, is seldom omitted; it became a conventional attribute.

In the German pictures Joseph is not only old, but appears almost in a state of dotage, like a lean, wrinkled mendicant, with a bald head, a white beard, a feeble frame, and a sleepy or stupid countenance. Then, again, the later Italian painters have erred as much on the other side; for I have seen pictures in which St. Joseph is not only a young man not more than thirty, but bears a strong resemblance to the received heads of our Saviour.

It is in the sixteenth century that we first find Joseph advanced to the dignity of a saint in his own right; and in the seventeenth he became very popular, especially in Spain, where St. Theresa had chosen him for her patron saint, and had placed her powerful order of the

reformed Carmelites under his protection. Hence the number of pictures of that time, which represent Joseph, as the foster-father of Christ, carrying the Infant on his arm and caressing him, while in the other hand he bears a lily, to express the sanctity and purity of his relations with the Virgin.

The legend of 'the Marriage of Joseph and Mary' is thus given in the Protevangelion and the History of Joseph the Carpenter :—

'When Mary was fourteen years old, the priest Zacharias[1] inquired of the Lord concerning her, what was right to be done; and an angel came to him and said, "Go forth, and call together all the widowers among the people, and let each bring his rod (or wand) in his hand, and he to whom the Lord shall show a sign, let him be the husband of Mary." And Zacharias did as the angel commanded, and made proclamation accordingly. And Joseph the carpenter, a righteous man, throwing down his axe, and taking his staff in his hand, ran out with the rest. When he appeared before the priest, and presented his rod, lo! a dove issued out of it—a dove dazzling white as the snow—and after settling on his head flew towards heaven. Then the high priest said to him, "Thou art the person chosen to take the Virgin of the Lord, and to keep her for him." And Joseph was at first afraid, and drew back, but afterwards he took her home to his house, and said to her, "Behold, I have taken thee from the temple of the Lord, and now I will leave thee in my house, for I must go and follow my trade of building. I will return to thee, and meanwhile the Lord be with thee and watch over thee." So Joseph left her, and Mary remained in her house.'

There is nothing said of any marriage ceremony; some have even affirmed that Mary was only betrothed to Joseph, but for conclusive reasons it remains an article of faith that she was married to him.

I must mention here an old tradition cited by St. Jerome, and which has been used as a text by the painters. The various suitors who

[1] Or Abiathar, as he is elsewhere called.

aspired to the honour of marrying the consecrated 'Virgin of the Lord,' among whom was the son of the high priest, deposited their wands in the temple over night,[1] and next morning the rod of Joseph was found, like the rod of Aaron, to have budded forth into leaves and flowers. The other suitors thereupon broke their wands in rage and despair; and one among them, a youth of noble lineage, whose name was Agabus, fled to Mount Carmel, and became an anchorite, that is to say, a Carmelite friar.

According to the Abbé Orsini, who gives a long description of the espousals of Mary and Joseph, they returned after the marriage ceremony to Nazareth, and dwelt in the house of St. Anna.

Now, with regard to the representations, we find that many of the early painters, and particularly the Italians, have carefully attended to the fact, that, among the Jews, marriage was a civil contract, not a religious rite. The ceremony takes place in the open air, in a garden, or in a landscape, or in front of the temple. Mary, as a meek and beautiful maiden of about fifteen, attended by a train of virgins, stands on the right; Joseph, behind whom are seen the disappointed suitors, is on the left. The priest joins their hands, or Joseph is in the act of placing the ring on the finger of the bride. This is the traditional arrangement from Giotto down to Raphael. In the series by Giotto, in the Arena at Padua, we have three scenes from the marriage legend. 1. St. Joseph and the other suitors present their wands to the high priest. 2. They kneel before the altar, on which their wands are deposited, waiting for the promised miracle. 3. The marriage ceremony. It takes place before an altar in the *interior* of the temple. The Virgin, a most graceful figure, but rather too old, stands attended by her maidens; St. Joseph holds his wand with the flower and the holy Dove resting on it: one of the disappointed suitors is about to strike him; another breaks his wand against his knee. Taddeo Gaddi, Angelico, Ghirlandajo, Perugino, all followed this traditional conception of the subject, except that they omit the altar, and place the locality in the open air, or under a portico. Among the relics venerated in the

[1] The suitors kneeling with their wands before the altar in the temple, is one of the series by Giotto in the Arena at Padua.

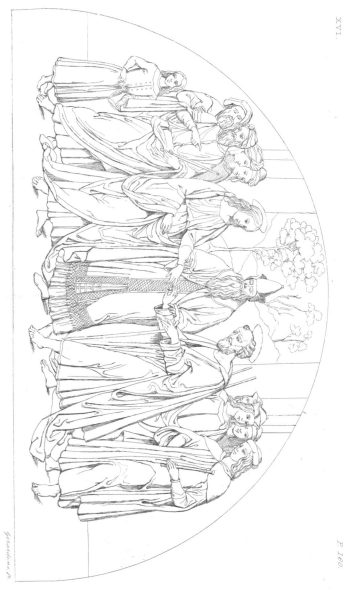

XVI.

"La Spurabien."

P. 160

Gavarni in.

Cathedral of Perugia, is the nuptial ring of the blessed Virgin; and for the altar of the sacrament there, Perugino painted the appropriate subject of the Marriage of the Virgin.[1] Here the ceremony takes place under the portico of the temple, and Joseph of course puts the ring on her finger. It is a beautiful composition, which has been imitated more or less by the painters of the Perugino school, and often repeated in the general arrangement.

But in this subject, Raphael, while yet a youth, excelled his master and all who had gone before him. Every one knows the famous 'SPOSALIZIO of the Brera.'[2] It was painted by Raphael in his twenty-first year, for the church of S. Francesco, in Città di Castello; and though he has closely followed the conception of his master, it is modified by that ethereal grace which even then distinguished him. Here Mary and Joseph stand in front of the temple, the high priest joins their hands, and Joseph places the ring on the finger of the bride: he is a man of about thirty, and holds his wand, which has blossomed into a lily, but there is no Dove upon it. Behind Mary is a group of the virgins of the temple; behind Joseph the group of disappointed suitors; one of whom, in the act of breaking his wand against his knee, a singularly graceful figure, seen more in front and richly dressed, is perhaps the despairing youth mentioned in the legend.[3] With something of the formality of the elder schools, the figures are noble and dignified; the countenances of the principal personages have a characteristic refinement and beauty, and a soft, tender, enthusiastic melancholy, which lends a peculiar and appropriate charm to the subject. In fact, the whole scene is here idealised; it is like a lyric poem.[4]

In Ghirlandajo's composition,[5] Joseph is an old man with a bald head; the architecture is splendid; the accessory figures, as is usual with Ghirlandajo, are numerous and full of grace. In the background are musicians playing on the pipe and tabor, an incident which I do not recollect to have seen in other pictures.

[1] It was carried off from the church by the French, sold in France, and is now to be seen in the Musée at Caen.
[2] At Milan. The fine engraving by Longhi is well known.
[3] In the series by Giotto at Padua, we have the youth breaking his wand across his knee.
[4] Kugler's Handbook, 2nd edit. [5] Florence, S. Maria Novella.

Y

The Sposalizio by Girolamo da Cotignola,[1] painted for the church of St. Joseph, is treated quite in a mystical style. Mary and Joseph stand before an altar, on the steps of which are seated, on one side a prophet, on the other a sibyl.

By the German painters the scene is represented with a characteristic homely neglect of all historic propriety. The temple is a Gothic church; the altar has a Gothic altar-piece; Joseph looks like an old burgher, arrayed in furs and an embroidered gown; and the Virgin is richly dressed in the costume of the fifteenth century. The suitors are often knights and cavaliers with spurs and tight hose.

It is not said anywhere that St. Anna and St. Joachim were present at the marriage of their daughter; hence they are supposed to have been dead before it took place. This has not prevented some of the old German artists from introducing them, because, according to their ideas of domestic propriety, they *ought* to have been present.

I observe that the later painters who treated the subject, Rubens and Poussin for instance, omit the disappointed suitors.

After the marriage, or betrothal, Joseph conducts his wife to his house. The group of the returning procession has been beautifully treated in Giotto's series at Padua;[2] still more beautifully by Luini in the fragment of fresco now in the Brera at Milan. Here Joseph and Mary walk together hand in hand. He looks at her, just touching her fingers with an air of tender veneration; she looks down, serenely modest. Thus they return together to their humble home; and with this scene closes the first part of the life of the Virgin Mary.

[1] Bologna Gal. [2] Cappella dell' Arena, engraved for the Arundel Society.

Historical Subjects.

PART II.

The Life of the Virgin Mary from the Annunciation to the Return from Egypt.

1. THE ANNUNCIATION.

2. THE SALUTATION OF ELIZABETH.

3. THE JOURNEY TO BETHLEHEM.

4. THE NATIVITY.

5. THE ADORATION OF THE SHEPHERDS.

6. THE ADORATION OF THE MAGI.

7. THE PRESENTATION IN THE TEMPLE.

8. THE FLIGHT INTO EGYPT.

9. THE RIPOSO.

10. THE RETURN FROM EGYPT.

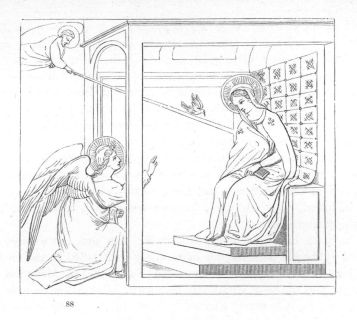

88

The Annunciation.

Ital. L' Annunciazione. La B. Vergine Annunziata. *Fr.* L' Annonciation. La Salutation Angélique. *Ger.* Die Verkündigung. Der englische Gruss. March 25.

THE second part of the life of the Virgin Mary begins with the Annunciation and ends with the Crucifixion, comprising all those scriptural incidents which connect her history with that of her divine Son.

But to the scenes narrated in the Gospels the painters did not confine themselves. Not only were the simple Scripture histories coloured throughout by the predominant and enthusiastic veneration paid to the Virgin—till the life of Christ was absolutely merged in that of His mother, and its various incidents became 'the seven joys and the seven sorrows of Mary'—but we find the artistic representations of her life curiously embroidered and variegated by the introduction of traditional and apocryphal circumstances, in most cases sanctioned by the Church authorities of the time. However doubtful or repulsive some of these scenes and incidents, we cannot call them absolutely unmeaning or

absurd; on the contrary, what was *supposed* grew up very naturally, in the vivid and excited imaginations of the people, out of what was *recorded*; nor did they distinguish accurately between what they were allowed and what they were commanded to believe. Neither can it be denied that the traditional incidents—those at least which we find artistically treated—are often singularly beautiful, poetical, and instructive. In the hands of the great religious artists, who worked in their vocation with faith and simplicity, objects and scenes the most familiar and commonplace became sanctified and glorified by association with what we deem most holy and most venerable. In the hands of the later painters the result was just the reverse—what was most spiritual, most hallowed, most elevated, became secularised, materialised, and shockingly degraded.

No subject has been more profoundly felt and more beautifully handled by the old painters, nor more vilely mishandled by the moderns, than the ANNUNCIATION, of all the scenes in the life of Mary the most important and the most commonly met with. Considered merely as an artistic subject, it is surely eminently beautiful: it places before us the two most graceful forms which the hand of man was ever called on to delineate;—the winged spirit fresh from paradise; the woman not less pure, and even more highly blessed — the chosen vessel of redemption, and the personification of all female loveliness, all female excellence, all wisdom, and all purity.

We find the Annunciation, like many other scriptural incidents, treated in two ways—as a mystery, and as an event. Taken in the former sense, it became the expressive symbol of a momentous article of faith, *The Incarnation of the Deity.* Taken in the latter sense, it represented the announcement of salvation to mankind, through the direct interposition of miraculous power. In one sense or the other, it enters into every scheme of ecclesiastical decoration; but chiefly it is set before us as a great and awful mystery, of which the two figures of Gabriel, the angel-messenger, and Mary the 'highly favoured,' placed in relation to each other, became the universally accepted symbol, rather than the representation.

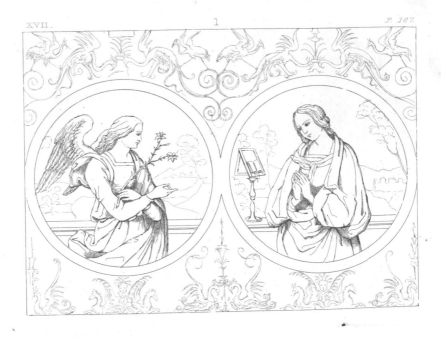

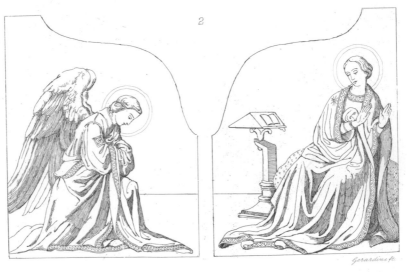

The Annunciation as a Mystery.

THE ANNUNCIATION AS A MYSTERY.

Considering the importance given to the Annunciation in its mystical sense, it is strange that we do not find it among the very ancient symbolical subjects adopted in the first ages of Christian art. It does not appear on the sarcophagi, nor in the early Greek carvings and diptychs, nor in the early mosaics—except once, and then as a part of the history of Christ, not as a symbol; nor can we trace the mystical treatment of this subject higher than the eleventh century, when it first appears in the Gothic sculpture and stained glass. In the thirteenth, and thenceforward, the Annunciation appears before us, as the expression in form of a theological dogma, everywhere conspicuous. It became a primal element in every combination of sacred representations—the corner-stone, as it were, of every architectural system of religious decoration. It formed a part of every altar-piece, either in sculpture or painting. Sometimes the Virgin stands on one side of the altar, the angel on the other, carved in marble or alabaster, or of wood richly painted and gilt; or even, as I have seen in some instances, of solid silver. Not seldom, we find the two figures placed in niches against the pillars, or on pedestals at the entrance of the choir. It was not necessary, when thus symbolically treated, to place the two figures in proximity to signify their relation to each other: they are often divided by the whole breadth of the chancel.

Whatever the subject of the altar-piece—whether the Nativity, or the Enthroned Madonna, or the Coronation, or the Crucifixion, or the Last Supper—the Annunciation almost invariably formed part of the decoration, inserted either into the spandrils of the arches above, or in the predella below; or, which is very common, painted or carved on the doors of a tabernacle or triptychon.

If the figures are full-length, a certain symmetry being required, they are either both standing or both kneeling; it is only in later times that the Virgin sits and the angel kneels. When disposed in circles or semicircles, they are often merely busts, or half-length figures, separated perhaps by a framework of tracery, or set on each side of the principal

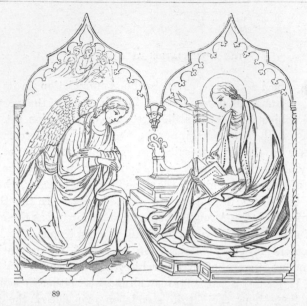

89

subject, whatever that may be. Hence it is that we so often find, in galleries and collections, pictures of the Annunciation in two separate parts, the angel in one frame, the Virgin in another; and perhaps the two pictures, thus disunited, may have found their way into different countries and different collections—the Virgin being in Italy, and the angel in England.

Sometimes the Annunciation—still as a mystical subject—forms an altar-piece of itself. In many Roman Catholic churches there is a chapel or an altar dedicated expressly to the mystery of the Annunciation, the subject forming of course the principal decoration. At Florence there is a church—one of the most splendid and interesting of its many beautiful edifices—dedicated to the Annunciation, or rather to the Virgin in her especial character and dignity as the Instrument of the Incarnation, and thence styled the church *della Santissima Nunziata*. The fine mosaic of the Annunciation by Ghirlandajo is placed over the principal entrance. Of this church, and of the order of the Servi, to whom it belongs, I have already spoken at length. Here, in the first chapel on the left, as we enter, is to be found the miraculous

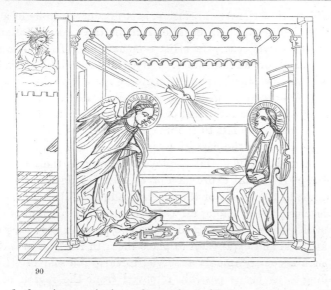

90

picture of the Annunciation, formerly held in such veneration, not merely by all Florence, but all Christendom:—found, but not seen—for it is still concealed from profane eyes, and exhibited to the devout only on great occasions. The name of the painter is disputed; but, according to tradition, it is the work of a certain Bartolomeo; who, while he sat meditating on the various excellences and perfections of our Lady, and most especially on her divine beauty, and thinking, with humility, how inadequate were his own powers to represent her worthily, fell asleep; and on awaking, found the head of the Virgin had been wondrously completed, either by the hand of an angel, or by that of St. Luke, who had descended from heaven on purpose. Though this curious relic has been frequently restored, no one has presumed to touch the features of the Virgin, which are, I am told—for I have never been blessed with a sight of the original picture—marvellously sweet and beautiful. It is concealed by a veil, on which is painted a fine head of the Redeemer, by Andrea del Sarto; and forty-two lamps of silver burn continually round it. There is a copy in the Pitti Palace, by Carlo Dolce, from which I give a little sketch, showing the disposition of the figures. (90)

z

It is evident that the Annunciation, as a mystery, admits of a style of treatment which would not be allowable in the representation of an event. In the former case, the artist is emancipated from all considerations of locality or circumstance. Whether the background be of gold, or of blue, or star-bespangled sky—a mere curtain, or a temple of gorgeous architecture; whether the accessories be the most simple or the most elaborate, the most real or the most ideal; all this is of little moment, and might be left to the imagination of the artist, or might be modified according to the conditions imposed by the purpose of the representation and the material employed, so long as the chief object is fulfilled—the significant expression of an abstract dogma, appealing to the faith, not to the senses or the understanding, of the observer.

To this class, then, belong all those church images and pictures of the Annunciation, either confined to the two personages, with just sufficient of attitude and expression to place them in relation to each other, or with such accompaniments as served to carry out the mystical idea, still keeping it as far as possible removed from the region of earthly possibilities.

In the fifteenth century—that age of mysticism—we find the Annunciation not merely treated as an abstract religious emblem, but as a sort of divine allegory or poem, which in old French and Flemish art is clothed in the quaintest, the most curious forms. I recollect going into a church at Breslau, and finding over one of the altars a most elaborate carving in wood of the Annunciation. Mary is seated within a Gothic porch of open tracery work; a unicorn takes refuge in her bosom; outside, a kneeling angel winds a hunting horn; three or four dogs are crouching near him. I looked and wondered. At first I could make nothing of this singular allegory; but afterwards found the explanation in a learned French work on the 'Stalles d'Amiens.' I give the original passage, for it will assist the reader to the comprehension of many curious works of art; but I do not venture to translate it.

'On sait qu'au xvie siècle, le mystère de l'Incarnation étoit souvent représenté par une allégorie ainsi conçue : Une licorne se réfugiant au sein d'une vierge pure, quatre lévriers la pressant d'une course rapide, un veneur ailé sonnant de la trompette. La science de la zoologie

mystique du temps aide à en trouver l'explication ; le fabuleux animal
dont l'unique corne ne blessait que pour purger de tout venin l'endroit du
corps qu'elle avoit touché, figuroit Jésus-Christ, médecin et sauveur des
âmes ; on donnait aux lévriers agiles les noms de Misericordia, Veritas,
Justitia, Pax, les quatre raisons qui ont pressé le Verbe éternel de sortir
de son repos ; mais comme c'étoit par la Vierge Marie qu'il avoit voulu
descendre parmi les hommes et se mettre en leur puissance, on croyoit
ne pouvoir mieux faire que de choisir dans la fable le fait d'une pucelle
pouvant seule servir de piége à la licorne, en l'attirant par le charme et
le parfum de son sein virginal qu'elle lui présentoit ; enfin l'ange Gabriel
concourant au mystère étoit bien reconnoissable sous les traits du veneur
ailé lançant les lévriers et embouchant la trompette.'

It appears that this was an accepted religious allegory, as familiar in
the sixteenth century as those of Spenser's 'Fairy Queen' or the
'Pilgrim's Progress' are to us. I have since found it frequently re-
produced in the old French and German prints : there is a specimen in
the British Museum ; and there is a picture similarly treated in the
Musée at Amiens. I have never seen it in an Italian picture or print ;
unless a print after Guido, wherein a beautiful maiden is seated under a
tree, and a unicorn has sought refuge in her lap, be intended to convey
the same far-fetched allegory.

Very common, however, in Italian art, is a less fantastic, but still
wholly poetical version of the Annunciation, representing, in fact, not
the Annunciation, but the Incarnation. Thus, in a picture by Giovanni
Sanzio [1] (the father of Raphael), Mary stands under a splendid portico ;
she appears as if just risen from her seat ; her hands are meekly folded
over her bosom ; her head declined. The angel kneels outside the por-
tico, holding forth his lily ; while above, in the heavens, the Padre
Eterno sends forth the Redeemer, who, in form of the infant Christ
bearing his cross, floats downwards towards the earth, preceded by the
mystic Dove. This manner of representing the Incarnation is strongly
disapproved of by the Abbé Méry,[2] as not only an error, but a heresy ;
yet it was frequently repeated in the sixteenth century.

[1] Brera Milan. [2] *v.* Théologie des Peintres.

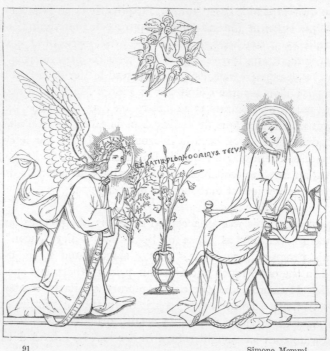

91 Simone Memmi.

The Annunciation is also a mystery when certain emblems are intro-
duced conveying a certain signification; as when Mary is seated on a
throne, wearing a radiant crown of mingled gems and flowers, and re-
ceives the message of the angel with all the majesty that could be ex-
pressed by the painter; or is seated in a garden enclosed by a hedge of
roses (the *Hortus clausus* or *conclusus* of the Canticles):[1] or where
the angel holds in his hands the sealed book, as in the famous altar-piece
at Cologne.

In a picture by Simone Memmi (91), the Virgin seated on a Gothic
throne receives, as the higher and superior being, yet with a shrinking
timidity, the salutation of the angel, who comes as the messenger of peace,
olive-crowned, and bearing a branch of olive in his hand.[2] This poetical

[1] See the Introduction. [2] Florence Gal.

version is very characteristic of the early Siena school, in which we often find a certain fanciful and original way of treating well-known subjects. Taddeo Bartoli, another Sienese, and Martin Schoen, the most poetical of the early Germans, also adopted the olive-symbol; and we find it also in the tabernacle of King René, already described.

The treatment is clearly devotional and ideal where attendant saints and votaries stand or kneel around, contemplating with devout gratitude or ecstatic wonder the divine mystery. Thus, in a remarkable and most beautiful picture by Fra Bartolomeo, the Virgin is seated on her throne; the angel descends from on high bearing his lily; around the throne attend St. John the Baptist and St. Francis, St. Jerome, St. Paul, and St. Margaret.[1] Again, in a very beautiful picture by Francia, Mary stands in the midst of an open landscape; her hands, folded over each other, press to her bosom a book closed and clasped: St. Jerome stands on the right, John the Baptist on the left; both look up with a devout expression to the angel descending from above. In both these examples Mary is very nobly and expressively represented as the chosen and predestined vehicle of human redemption. It is not here the Annunciation, but the '*Sacratissima Annunziata*,' we see before us. In a curious picture by Francesco da Cotignola, Mary stands on a sculptured pedestal, in the midst of an architectural decoration of many-coloured marbles, most elaborately painted: through an opening is seen a distant landscape, and the blue sky; on her right stands St. John the Baptist, pointing upwards; on her left St. Francis, adoring; the votary kneels in front.[2] Votive pictures of the Annunciation were frequently expressive offerings from those who desired, or those who had received, the blessing of an heir; and this I take to be an instance.

In the following example the picture is votive in another sense, and altogether poetical. The Virgin Mary receives the message of the angel, as usual; but before her, at a little distance, kneels the Cardinal Torrecremata, who presents three young girls, also kneeling, to one of whom the Virgin gives a purse of money. This curious and beautiful picture becomes intelligible, when we find that it was painted for a charitable community, instituted by Torrecremata, for educating and

[1] Bologna Gal. [2] Berlin Gal.

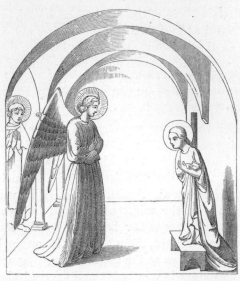

Angelico da Fiesole.

endowing poor orphan girls, and styled the ' *Confraternità dell' An-nunziata*.' [1]

In this charming Annunciation by Angelico, the scene is in the cloister of his own convent of St. Mark. A Dominican (St. Peter Martyr) stands in the background with hands folded in prayer. I might add many beautiful examples from Fra Bartolomeo, and in sculpture from Benedetto Maiano, Luca della Robbia, and others, but have said enough to enable the observer to judge of the intention of the artist. The Annunciation by Sansovino, among the bas-reliefs which cover the chapel at Loretto, is of great elegance.

I must, however, notice one more picture. Of six Annunciations painted by Rubens, five represent the event; the sixth is one of his magnificent and most palpable allegories, all glowing with life and reality. Here Mary kneels on the summit of a flight of steps; a dove, encompassed by cherubim, hovers over her head. Before her kneels the celestial messenger; behind him Moses and Aaron, with David and

[1] Benozzo Gozzoli, in S. Maria sopra Minerva, Rome.

other patriarchal ancestors of Christ. In the clouds above is seen the heavenly Father; on his right are two female figures, Peace and Reconciliation; on his left, angels bear the ark of the covenant. In the lower part of the picture, stand Isaiah and Jeremiah, with four sibyls:—thus connecting the prophecies of the Old Testament, and the promises made to the Gentile nations through the sibyls, with the fulfilment of both in the message from on high.

THE ANNUNCIATION AS AN EVENT.

Had the Annunciation to Mary been merely mentioned as an awful and incomprehensible vision, it would have been better to have adhered to the mystical style of treatment, or left it alone altogether; but the Scripture history, by giving the whole narration as a simple fact, a real event, left it free for representation as such; and, as such, the fancy of the artist was to be controlled and limited only by the words of Scripture, as commonly understood and interpreted, and by those proprieties of time, place, and circumstance, which would be required in the representation of any other historical incident or action.

When all the accompaniments show that nothing more was in the mind of the artist than the aim to exhibit an incident in the life of the Virgin, or an introduction to that of our Lord, the representation is no longer mystical and devotional, but historical. The story was to be told with all the fidelity, or at least all the likelihood, that was possible; and it is clear that, in this case, the subject admitted, and even required, a more dramatic treatment, with such accessories and accompaniments as might bring the scene within the sphere of the actual. In this sense it is not to be mistaken. Although the action is of itself so very simple, and the actors confined to two persons, it is astonishing to note the infinite variations of which this favourite theme has been found susceptible. Whether all these be equally appropriate and laudable, is quite another question; and in how far the painters have truly interpreted the Scriptural narration, is now to be considered.

And first with regard to the time, which is not especially mentioned.

It was presumed by the Fathers and early commentators on Scripture, that the Annunciation must have taken place in early spring-time, at eventide, soon after sunset, the hour since consecrated as the 'Ave Maria,' as the bell which announces it is called the 'Angelus;'[1] but other authorities say that it was rather at midnight, because the nativity of our Lord took place at the corresponding hour in the following December. This we find exactly attended to by many of the old painters, and indicated either by the moon and stars in the sky, or by a taper or a lamp burning near.

With regard to the locality, we are told by St. Luke that the angel Gabriel was sent from God, and that 'he came *in* to Mary' (Luke i. 28), which seems to express that she was *within* her house.

In describing the actual scene of the interview between the angel and Mary, the legendary story of the Virgin adheres very closely to the Scriptural text. But it also relates, that Mary went forth at evening to draw water from the fountain; that she heard a voice which said, 'Hail, thou that art full of grace!' and thereupon being troubled, she looked to the right and to the left, and, seeing no one, returned to her *house*, and sat down to her work.[2] Had any exact attention been paid to oriental customs, Mary might have been working or reading or meditating on the roof of her house; but this has not suggested itself in any instance that I can remember. We have, as the scene of the interview, an interior which is sometimes like an oratory, sometimes a portico with open arcades; but more generally a bedroom. The poverty of Joseph and Mary, and their humble condition in life, are sometimes

[1] So Lord Byron:—

> Ave Maria! blessed be the hour!
> The time, the clime, the spot, where I so oft
> Have felt that moment in its fullest power
> Sink o'er the earth so beautiful and soft,
> While swung the deep bell in the distant tower,
> Or the faint dying day-hymn stole aloft,
> And not a breath crept through the rosy air,
> And yet the forest leaves seem'd stirr'd with prayer.

[2] Protevangelion, ix. 7.

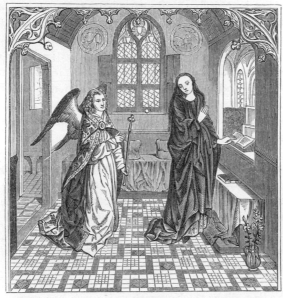

93 J. van Eyck.

attended to, but not always; for, according to one tradition, the house at Nazareth was that which Mary had inherited from her parents, Joachim and Anna, who were people of substance. Hence, the painters had an excuse for making the chamber richly furnished, the portico sustained by marble pillars, or decorated with sculpture. In the German and Flemish pictures, the artist, true to the national characteristic of *naïve* and literal illustration, gives us a German or a Gothic chamber, with a lattice window of small panes of glass, and a couch with pillows, or a comfortable four-post bedstead furnished with draperies, thus imparting to the whole scene an air of the most vivid homely reality. (93)

As for the accessories, the most usual, almost indispensable, is the pot of lilies, the symbolical *Fleur de Marie*, which I have already explained at length. There is also a basket containing needlework and implements of female industry, as scissors, &c., not merely to express Mary's habitual industry, but because it is related that when she returned to her house 'she took the purple linen, and sat down to work it.'

A A

The work-basket is therefore seldom omitted. Sometimes a distaff lies at her feet, as in Raphael's Annunciation. In old German pictures we have often a spinning-wheel. To these emblems of industry is often added a basket, or a dish, containing fruit; and near it a pitcher of water, to express the temperance of the blessed Virgin.

There is grace and meaning in the introduction of birds, always emblems of the spiritual. Titian places a tame partridge at the feet of Mary, which expresses her tenderness; but the introduction of a cat, as in Barroccio's picture, is insufferable.

The archangel Gabriel, 'one of those who stand continually in the presence of God,' having received his mission, descends to earth. In the very earliest representation of the Annunciation as an event,[1] we have this descent of the winged spirit from on high; and I have seen other instances. There is a small and beautiful sketch by Garofalo,[2] in which, from amidst a flood of light and a choir of celestial spirits, such as Milton describes as adoring the 'divine sacrifice' proclaimed for sinful man,[3] the archangel spreads his lucid wings, and seems just about to take his flight to Nazareth. He was accompanied, says the Italian legend, by a train of lower angels, anxious to behold and reverence their Queen; these remained, however, at the door, or 'before the gate,' while Gabriel entered.

The old German masters are fond of representing him as entering by a door in the background; while the serene Virgin, seated in front, seems aware of his presence without seeing him.

In some of the old pictures, he comes in flying from above, or he is upborne by an effulgent cloud, and surrounded by a glory which lights the whole picture—a really *celestial* messenger, as in a fresco by Spinello Aretino. In others, he comes gliding in, 'smooth sliding without step;' sometimes he enters like a heavenly ambassador, and little angels hold up his train. In a picture by Tintoretto, he comes rushing in as upon a whirlwind, followed by a legion of lesser angels; while on the outside of the building, Joseph the carpenter is seen quietly at his work.[4]

[1] Mosaic, S. Maria Maggiore. [2] Alton Towers.
[3] Par. Lost, b. iii. [4] Venice, School of S. Rocco.

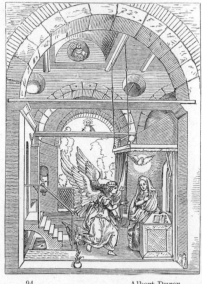

94 Albert Durer.

But, whether walking or flying, Gabriel bears, of course, the conventional angelic form, that of the human creature, winged, beautiful, and radiant with eternal youth, yet with a grave and serious mien. In the later pictures, the drapery given to the angel is offensively scanty; his sandals, and bare arms, and fluttering robe, too much *à l'antique*; he comes in the attitude of a flying Mercury, or a dancer in a ballet. But in the early Italian pictures his dress is arranged with a kind of solemn propriety: it is that of an acolyte, white and full, and falling in large folds over his arms, and in general concealing his feet. In the German pictures, he often wears the priestly robe, richly embroidered, and clasped in front by a jewel. His ambrosial curls fall over this cope in 'hyacinthine flow.' The wings are essential, and never omitted. They are white or many-coloured, eyed like the peacock's train, or bedropped with gold. He usually bears the lily in his hand, but not always. Sometimes it is the sceptre, the ancient attribute of a herald; and this has a scroll around it with the words 'Ave Maria gratia plena!' The sceptre or wand is occasionally surmounted by a cross. (94)

A A 2

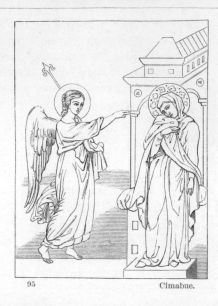

95 Cimabue.

In general, the palm is given to the angel who announces the death of Mary. In one or two instances only, I have seen the palm given to the angel Gabriel, as in a predella by Angelico; for which, however, the painter had the authority of Dante, or Dante some authority earlier still. He says of Gabriel,

> That he bore the *palm*
> Down unto Mary when the Son of God
> Vouchsafed to clothe him in terrestrial weeds.

The olive-bough has a mystical sense wherever adopted: it is the symbol of *peace* on earth. Often the angel bears neither lily, nor sceptre, nor palm, nor olive. His hands are folded on his bosom; or, with one hand stretched forth, and the other pointing upwards, he declares his mission from on high.

In the old Greek pictures, and in the most ancient Italian examples, the angel stands, as in this sketch after Cimabue (95), wherein the Greek model is very exactly followed. According to the Roman Catholic belief, Mary is Queen of heaven and of angels—the superior

being; consequently, there is propriety in making the angel deliver his message kneeling: but even according to the Protestant belief the attitude would not be unbecoming, for the angel, having uttered his salutation, might well prostrate himself as witness of the transcending miracle, and beneath the overshadowing presence of the Holy Spirit.

Now, as to the attitude and occupation of Mary at the moment the angel entered, authorities are not agreed. It is usual to exhibit her as kneeling in prayer, or reading with a large book open on a desk before her. St. Bernard says that she was studying the book of the prophet Isaiah, and as she recited the verse, ‘Behold, a Virgin shall conceive, and bear a son,’ she thought within her heart, in her great humility, ‘How blessed the woman of whom these words are written! Would I might be but her handmaid to serve her, and allowed to kiss her feet!’ —when, in the same instant, the wondrous vision burst upon her, and the holy prophecy was realised in herself.[1]

I think it is a manifest fault to disturb the sublime tenor of the scene by representing Mary as starting up in alarm; for, in the first place, she was accustomed, as we have seen, to the perpetual ministry of angels, who daily and hourly attended on her. It is, indeed, said that Mary was troubled; but it was not the presence, but the ‘saying’ of the angel which troubled her—it was the question ‘how this should be?’ (Luke i. 29.) The attitude, therefore, which some painters have given to her, as if she had started from her seat, not only in terror, but in indignation, is altogether misplaced. A signal instance is the statue of the Virgin by Mocchi in the choir of the cathedral at Orvieto, so grand in itself, and yet so offensive as a devotional figure. Misplaced is also, I think, the sort of timid shrinking surprise which is the expression in some pictures. The moment is much too awful, the expectance much too sublime, for any such human, girlish emotions. If the painter intend to express the moment in which the angel appears and utters the salutation, ‘Hail!’ then Mary may be standing, and her looks directed towards him, as in a fine majestic Annunciation of

[1] Il perfetto Legendario.

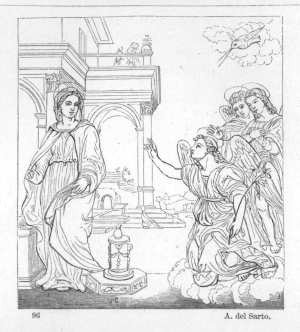

96 A. del Sarto.

Andrea del Sarto. (96) Standing was the antique attitude of prayer;
so that if we suppose her to have been interrupted in her devotions, the
attitude is still appropriate. But if that moment be chosen in which
she expressed her submission to the divine will, 'Behold the handmaid
of the Lord! let it be unto me according to thy word!' then she might
surely kneel with bowed head, and folded hands, and 'downcast eyes
beneath th' almighty Dove.' No attitude could be too humble to
express that response; and Dante has given us, as the most perfect
illustration of the virtue of humility, the sentiment and attitude of Mary
when submitting herself to the divine will.[1]

> The angel (who came down to earth
> With tidings of the peace so many years
> Wept for in vain, that op'd the heavenly gates
> From their long interdict) before us seem'd

[1] Purg. x., Cary's Trans.

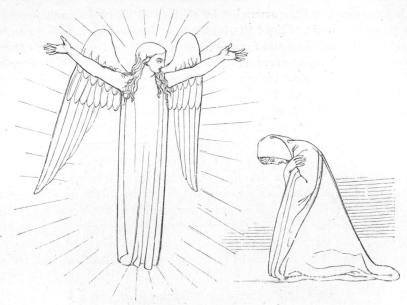

97 Flaxman.

In a sweet act, so sculptur'd to the life,
He look'd no silent image. One had sworn
He had said 'Hail!' for SHE was imag'd there,
By whom the key did open to God's love;
And in her act as sensibly imprest
That word, 'Behold the handmaid of the Lord,'
As figure seal'd on wax.

And very beautifully has Flaxman transferred the sculpture 'divinely wrought upon the rock of marble white' to earthly form. (97)

The presence of the Holy Spirit in the historical Annunciations is to be accounted for by the words of St. Luke, and the visible form of the Dove is conventional and authorised. In many pictures, the celestial Dove enters by the open casement. Sometimes it seems to brood immediately over the head of the Virgin; sometimes it hovers towards her bosom. As for the perpetual introduction of the emblem of the Padre Eterno, seen above the sky, under the usual half-figure of a

kingly ancient man, surrounded by a glory of cherubim, and sending forth upon a beam of light the immaculate Dove, there is nothing to be said but the usual excuse for the mediæval artists, that certainly there was no *conscious* irreverence. The old painters, great as they were in art, lived in ignorant but zealous times—in times when faith was so fixed, so much a part of the life and soul, that it was not easily shocked or shaken; as it was not founded in knowledge or reason, so nothing that startled the reason could impair it. Religion, which now speaks to us through words, then spoke to the people through visible forms universally accepted; and, in the fine arts, we accept such forms according to the feeling which *then* existed in men's minds, and which, in its sincerity, demands our respect, though now we might not, could not, tolerate the repetition. We must also remember that it was not in the ages of ignorance and faith that we find the grossest materialism in art. It was in the learned, half-pagan sixteenth and the polished seventeenth century, that this materialised theology became most offensive. Of all the artists who have sinned in the Annunciation—and they are many —Nicolò Poussin is perhaps the worst. Yet he was a good, a pious man, as well as a learned and accomplished painter. All through the history of the art, the French show themselves as the most signal violators of good taste, and what they have invented a word for— *bienséance*. They are worse than the old Germans; worse than the modern Spaniards—and that is saying much.

In Raphael's Annunciation, Mary is seated in a reclining attitude, leaning against the side of her couch, and holding a book. The angel, whose attitude expresses a graceful *empressement*, kneels at some distance, holding the lily.

Michael Angelo gives us a most majestic Virgin standing on the steps of a prie-dieu, and turning with hands upraised towards the angel, who appears to have entered by the open door; his figure is most clumsy and material, and his attitude unmeaning and ungraceful. It is, I think, the only instance in which Michael Angelo has given wings to an angelic being : for here they could not be dispensed with.

In a beautiful Annunciation by Johan van Eyck,[1] the Virgin kneels at a desk with a book before her. She has long fair hair, and a noble intellectual brow. Gabriel, holding his sceptre, stands in the doorway. The Dove enters by the lattice. A bed is in the background, and in front a pot of lilies. In another Annunciation by Van Eyck, painted on the Ghent altar-piece, we have the mystic, not the historical representation, and a very beautiful effect is produced by clothing both the angel and Mary in robes of pure white.[2]

In an engraving after Rembrandt, the Virgin kneels by a fountain, and the angel kneels on the opposite side. This seems to express the legendary scene.

These few observations on the general arrangement of the theme, whether mystical or historical, will, I hope, assist the observer in discriminating for himself. I must not venture further, for we have a wide range of subjects before us.

[1] Munich Gal., Cabinet iii. 35. [2] Berlin Gal., 520, 521.

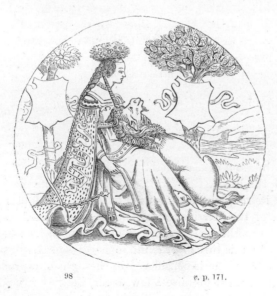

98 v. p. 171.

B B

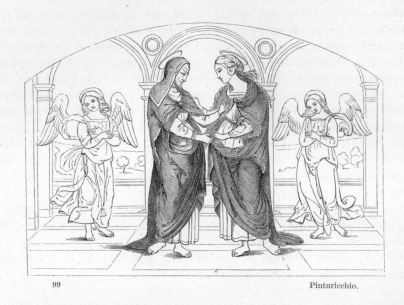

99 Pinturicchio.

The Visitation.

Ital. La Visitazione di Maria. *Fr.* La Visitation de la Vierge.
Ger. Die Heimsuchung Mariä. July 2.

AFTER the Annunciation of the angel, the Scripture goes on to relate
how 'Mary arose and went up into the hill country with haste, to the
house of her cousin Elizabeth, and saluted her.' This meeting of the
two kinswomen is the subject styled in art the 'Visitation,' and some-
times the 'Salutation of Elizabeth.' It is of considerable importance,
in a series of the life of the Virgin, as an event; and also, when taken
separately in its religious significance, as being the first recognition of
the character of the Messiah. 'Whence is this to me,' exclaims Eliza-
beth, 'that the mother of my Lord should come to me?' (Luke i. 43);
and as she spoke this through the influence of the Holy Spirit, and not
through knowledge, she is considered in the light of a prophetess.
 Of Elizabeth I must premise a few words, because in many represen-

tations relating to the life of the Virgin, and particularly in those domestic groups, the Holy Families properly so called, she is a personage of great importance, and we ought to be able, by some preconceived idea of her bearing and character, to test the propriety of that impersonation usually adopted by the artists. We must remember that she was much older than her cousin, a woman 'well stricken in years;' but it is a great mistake to represent her as old, as wrinkled and decrepit, as some painters have done. We are told that she was righteous before the Lord, 'walking in all his commandments blameless:' the manner in which she received the visit of Mary, acknowledging with a glad humility the higher destinies of her young relative, shows her to have been free from all envy and jealousy. Therefore all pictures of Elizabeth should exhibit her as an elderly, but not an aged matron; a dignified, mild, and gracious creature; one selected to high honour by the Searcher of hearts, who, looking down on hers, had beheld it pure from any secret taint of selfishness, even as her conduct had been blameless before man.[1]

Such a woman as we believe Mary to have been must have loved and honoured such a woman as Elizabeth. Wherefore, having heard that Elizabeth had been exalted to a miraculous motherhood, she made haste to visit her, not to ask her advice—for being graced with all good gifts of the Holy Spirit, and herself the mother of Wisdom, she could not need advice—but to sympathise with her cousin and reveal what had happened to herself.

Thus then they met, 'these two mothers of two great princes, of whom one was pronounced the greatest born of woman, and the other was his Lord:' happiest and most exalted of all womankind before or since, 'needs must they have discoursed like seraphim and the most ecstasied order of Intelligences!' Such was the blessed encounter represented in the Visitation.

The number of the figures, the locality, and circumstances, vary greatly. Sometimes we have only the two women, without accessories

[1] For a full account of the legends relating to Elizabeth, the mother of the Baptist, see the fourth series of Sacred and Legendary Art.

B B 2

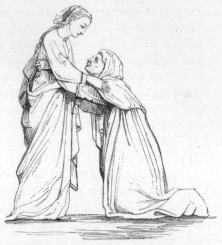

100 The Visitation. (Luca della Robbia.)

of any kind, and nothing interferes with the high solemnity of that mo-
ment in which Elizabeth confesses the mother of her Lord. The better
to express this willing homage, this momentous prophecy, she is often
kneeling. Other figures are frequently introduced, because it could not
be supposed that Mary made the journey from Nazareth to the dwelling
of Zacharias near Jerusalem, a distance of fifty miles, alone. Whether
her husband Joseph accompanied her, is doubtful; and while many
artists have introduced him, others have omitted him altogether. Ac-
cording to the ancient Greek formula laid down for the religious
painters, Mary is accompanied by a servant or a boy, who carries a stick
across his shoulder, and a basket slung to it. The old Italians who
followed the Byzantine models seldom omit this attendant, but in some
instances (as in the magnificent composition of Michael Angelo)[1]
a handmaid bearing a basket on her head is substituted for the boy.
In many instances Joseph, attired as a traveller, appears behind
the Virgin, and Zacharias, in his priestly turban and costume, behind
Elizabeth.

The locality is often an open porch or a garden in front of a house;

[1] In the possession of Mr. Bromley, of Wootten.

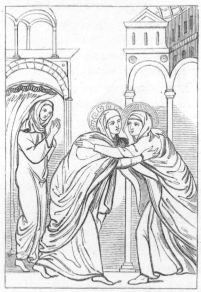

101 The Visitation. (Cimabue.)

and this garden of Zacharias is celebrated in Eastern tradition. It is related that the blessed Virgin, during her residence with her cousin Elizabeth, frequently recreated herself by walking in the garden of Zacharias, whilst she meditated on the strange and lofty destiny to which she was appointed; and further, that happening one day to touch a certain flower, which grew there, with her most blessed hand, from being inodorous before, it became from that moment deliciously fragrant. The garden, therefore, was a fit place for the meeting.

1. The earliest representation of the Visitation to which I can refer is a rude but not ungraceful drawing, in the catacombs at Rome, of two women embracing. It is not of very high antiquity, perhaps the seventh or eighth century, but there can be no doubt about the subject.[1]

2. Cimabue has followed the Greek formula, and his simple group appears to me to have great feeling and simplicity. (101)

[1] Cemetery of Julius : v. Bosio, Roma sotterana.

3. More modern instances, from the date of the revival of art, abound in every form. Almost every painter who has treated subjects from the life of the Virgin has treated the Visitation. In the composition by Raphael [1] there are the two figures only; and I should object to this otherwise perfect picture, the bashful conscious look of the Virgin Mary. The heads are, however, eminently beautiful and dignified. In the far background is seen the baptism of Christ—very happily and significantly introduced, not merely as expressing the name of the votary who dedicated the picture, *Giovan-Battista* Branconio, but also as expressing the relation between the two unborn Children—the Christ and his prophet.

4. The group by Sebastian del Piombo is singularly grand, showing in every part the influence of Michael Angelo, but richly coloured in Sebastian's best manner. The figures are seen only to the knees. In the background, Zacharias is seen hurrying down some steps to receive the Virgin.[2]

5. The group by Pinturicchio (99), with the attendant angels, is remarkable for its poetic grace; and this, by Lucas v. Leyden (102), is equally remarkable for affectionate sentiment.

6. Still more beautiful, and more dramatic and varied, is another composition by Pinturicchio in the Sala Borgia.[3] The Virgin and St. Elizabeth, in the centre, take each other's hands. Behind the Virgin are St. Joseph, a maiden with a basket on her head, and other attendants. Behind St. Elizabeth, we have a view into the interior of her house, through arcades richly sculptured; and within, Zacharias is reading, and the handmaids of Elizabeth are spinning and sewing. This elegant fresco was painted for Alexander VI.

7. There is a fine picture of this subject, by Andrea Sabattini of Salerno, the history of which is rather curious. 'It was painted at the request of the Sanseverini, princes of Salerno, to be presented to a nunnery, in which one of that noble family had taken the veil. Under the form of the blessed Virgin, Andrea represented the last princess of

[1] Madrid Gal.

[2] Louvre, 1224. There is, in the Louvre, another Visitation of singular and characteristic beauty by D. Ghirlandajo.

[3] Vatican, Rome.

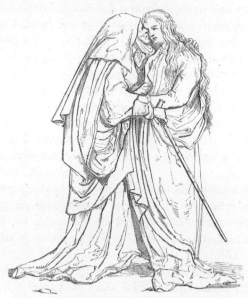

102 The Visitation. (Lucas von Leyden.)

Salerno, who was of the family of Villa Marina; under that of St.
Joseph, the prince her husband; an old servant of the family figures as
St. Elizabeth; and in the features of Zacharias we recognise those of
Bernardo Tasso, the father of Torquato Tasso, and then secretary to
the prince of Salerno. After remaining for many years over the high
altar of the church, it was removed through the scruples of one of the
Neapolitan archbishops, who was scandalised by the impropriety of
placing the portraits of well-known personages in such a situation.'
The picture, once removed from its place, disappeared, and by some
means found its way to the Louvre. Andrea, who was one of the most
distinguished of the scholars of Raphael, died in 1545.[1]

8. The composition by Rubens has all that scenic effect and dramatic
movement which was characteristic of the painter. The meeting takes
place on a flight of steps leading to the house of Zacharias. The Virgin

[1] This picture is thus described in the old catalogues of the Louvre (No. 1207); but is not
to be found in that of Villot.

wears a hat, as one just arrived from a journey; Joseph and Zacharias greet each other; a maiden with a basket on her head follows; and in the foreground a man unloads the ass.

I will mention two other examples, each perfect in its way, in two most opposite styles of treatment.

9. The first is the simple majestic composition of Albertinelli.[1] The two women, standing alone under a richly sculptured arch, and relieved against the bright azure sky, embrace each other. There are no accessories. Mary is attired in dark blue drapery, and Elizabeth wears an ample robe of a saffron or rather amber colour. The mingled grandeur, power, and grace, and depth of expression in these two figures, are quite extraordinary; they look like what they are, and worthy to be mothers of the greatest of kings and the greatest of prophets. Albertinelli has here emulated his friend Bartolomeo—his friend, whom he so loved, that when, after the horrible execution of Savonarola, Bartolomeo, broken-hearted, threw himself into the convent of St. Mark, Albertinelli became almost distracted and desperate. He would certainly, says Vasari, have gone into the same convent, but for the hatred he bore the monks, 'of whom he was always saying the most injurious things.'

Through some hidden influence of intense sympathy, Albertinelli, though in point of character the very antipodes of his friend, often painted so like him, that his pictures—and this noble picture more particularly—might be mistaken for the work of the Frate.

10. We will now turn to a conception altogether different, and equally a masterpiece; it is the small but exquisitely finished composition by Rembrandt.[2] The scene is the garden in front of the house of Zacharias; Elizabeth is descending the steps in haste to receive and embrace with outstretched arms the Virgin Mary, who appears to have just alighted from her journey. The aged Zacharias, supported by a youth, is seen following Elizabeth to welcome their guest. Behind Mary stands a black female attendant, in the act of removing a mantle from her shoulders; in the background a servant, or (as I think) Joseph,

[1] Florence Gal. [2] Grosvenor Gal.

holds the ass on which Mary has journeyed; a peacock with a gem-like train, and a hen with a brood of chickens (the latter the emblem of maternity), are in the foreground. Though the representation thus conceived appears like a scene of every-day life, nothing can be more poetical than the treatment, more intensely true and noble than the expression of the diminutive figures, more masterly and finished than the execution, more magical and lustrous than the effect of the whole. The work of Albertinelli, in its large and solemn beauty and religious significance, is worthy of being placed over an altar, on which we might offer up the work of Rembrandt as men offer incense, gems, and gold.

As the Visitation is not easily mistaken, I have said enough of it here; and we pass to the next subject—the Dream of Joseph.

Although the feast of the Visitation is fixed for the 2nd of July, it was, and is, a received opinion, that Mary began her journey to the hill country but a short time, even a few days, after the Annunciation of the angel. It was the sixth month with Elizabeth, and Mary sojourned with her three months. Hence it is supposed, by many commentators, that Mary must have been present at the birth of John the Baptist. It may seem surprising that the early painters should not have made use of this supposition. I am not aware that there exists among the numerous representations of the birth of St. John, any instance of the Virgin being introduced; it should seem that the lofty ideas entertained of the Mater Dei rendered it impossible to place her in a scene where she would necessarily take a subordinate position: this, I think, sufficiently accounts for her absence.[1] Mary then returned to her own dwelling at Nazareth; and when Joseph (who in these legendary stories is constantly represented as a house-carpenter and builder, and travelling about to exercise his trade in various places) also came back to his home, and beheld his wife, the suspicion entered his mind that she was about

[1] There is, however, in the Liverpool Museum, a very exquisite miniature of the birth of St. John the Baptist, in which the female figure standing near represents, I think, the Virgin Mary. It was cut out of a choral book of the Siena school.

C C

to become a mother, and very naturally his mind was troubled ' with sorrow and insecure apprehensions; but being a just man, that is, according to the Scriptures and other wise writers, a good, a charitable man, he would not openly disgrace her, for he found it more agreeable to justice to treat an offending person with the easiest sentence, than to render her desperate, and without remedy, and provoked by the suffering of the worst of what she could fear. No obligation to justice can force a man to be cruel; pity, and forbearance, and long-suffering, and fair interpretation, and excusing our brother' (and our sister), ' and taking things in the best sense, and passing the gentlest sentence, are as certainly our duty, and owing to every person who *does* offend and *can* repent, as calling men to account can be owing to the law.' [1] Thus says the good Bishop Taylor, praising Joseph, that he was too truly just to call furiously for justice, and that, waiving the killing letter of the law, he was ' minded to dismiss his wife privily;' and in this he emulated the mercy of his divine foster-Son, who did not cruelly condemn the woman whom he knew to be guilty, but dismissed her ' to repent and sin no more.' But while Joseph was pondering thus in his heart, the angel of the Lord, the prince of angels, even Gabriel, appeared to him in a dream, saying, ' Joseph, thou son of David, fear not to take unto thee Mary thy wife!' and he awoke and obeyed that divine voice.

This first vision of the angel is not in works of art easily distinguished from the second vision; but there is a charming fresco by Luini, which can bear no other interpretation. Joseph is seated by the carpenter's bench, and leans his head on his hand, slumbering.[2] An angel stands by him pointing to Mary, who is seen at a window above, busied with needlework.

On waking from this vision, Joseph, says the legend, ' entreated forgiveness of Mary for having wronged her even in thought.' This is a subject quite unknown, I believe, before the fifteenth century, and not commonly met with since, but there are some instances. On one of the carved stalls of the Cathedral of Amiens it is very poetically treated.[3] Mary is seated on a throne under a magnificent canopy;

[1] *v.* Bishop Taylor's Life of Christ. [2] Milan, Brera.
[3] Stalles d'Amiens, p. 205.

Joseph, kneeling before her and presented by two angels, pleads for pardon. She extends one hand to him; in the other is the volume of the Holy Scriptures. There is a similar version of the text in sculpture over one of the doors of Notre-Dame at Paris. There is also a picture by Alessandro Tiarini,[1] and reckoned by Malvasia his finest work, wherein Joseph kneels before the Virgin, who stands with a dignified air, and, while she raises him with one hand, points with the other up to heaven. Behind are seen the angel Gabriel with his finger on his lip, as commanding silence, and two other angels. The figures are life-size, the execution and colour very fine; the whole conception in the grand but mannered style of the Guido school.

[1] Le repentir de Saint Joseph, Louvre, 416.

103

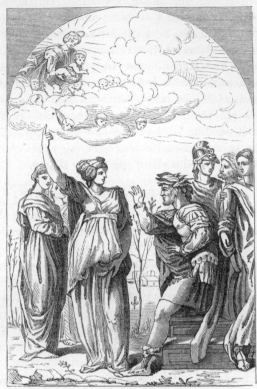

104 The Sibyl's Prophecy. (Baldassare Peruzzi.)

The Nativity.

Ital. Il Presepio. Il Nascimento del Nostro Signore. *Fr.* La Nativité.
Ger. Die Geburt Christi. Dec. 25.

The birth of our Saviour is related with characteristic simplicity and
brevity in the Gospels; but in the early Christian traditions this great
event is preceded and accompanied by several circumstances which
have assumed a certain importance and interest in the artistic repre-
sentations.

According to an ancient legend, the Emperor Augustus Cæsar repaired to the sibyl Tiburtina, to inquire whether he should consent to allow himself to be worshipped with divine honours, which the Senate had decreed to him. The sibyl, after some days of meditation, took the Emperor apart, and showed him an altar; and above the altar, in the opening heavens, and in a glory of light, he beheld a beautiful Virgin holding an Infant in her arms, and at the same time a voice was heard saying, 'This is the altar of the Son of the living God;' whereupon Augustus caused an altar to be erected on the Capitoline Hill, with this inscription, *Ara primogeniti Dei*; and on the same spot, in later times, was built the church called the *Ara-Cœli*, well known, with its flight of one hundred and twenty-four marble steps, to all who have visited Rome.

Of the sibyls generally, in their relation to sacred art, I have already spoken.[1] This particular prophecy of the Tiburtine sibyl to Augustus rests on some very antique traditions, pagan as well as Christian. It is supposed to have suggested the 'Pollio' of Virgil, which suggested the 'Messiah' of Pope. It is mentioned by writers of the third and fourth centuries, and our own divines have not wholly rejected it, for Bishop Taylor mentions the sibyl's prophecy among 'the great and glorious accidents happening about the birth of Jesus.'[2]

A very rude but curious bas-relief, preserved in the church of the Ara-Cœli, is perhaps the oldest representation extant. The Church legend assigns to it a fabulous antiquity; but it must be older than the twelfth century, as it is alluded to by writers of that period. Here the Emperor Augustus kneels before the Madonna and Child, and at his side is the sibyl Tiburtina, pointing upwards.

Since the revival of art, the incident has been frequently treated. It was painted by Cavallini, about 1340, on the vault of the choir of the Ara-Cœli. In the sixteenth and seventeenth centuries, it became a favourite subject. It admitted of those classical forms, and that mingling of the heathen and the Christian in style and costume, which

[1] Introduction. The personal character and history of the Sibyls will be treated in detail in the fourth series of Sacred and Legendary Art.

[2] Life of Jesus Christ, sec. 4.

were calculated to please the churchmen and artists of the time, and the examples are innumerable.

The most celebrated, I believe, is the fresco by Baldassare Peruzzi (104), in which the figure of the sibyl is certainly very majestic, but the rest of the group utterly vulgar and commonplace.[1] Less famous, but on the whole preferable in point of taste, is the group by Garofalo, in the palace of the Quirinal; and there is another by Titian, in which the scene is laid in a fine landscape after his manner. Vasari mentions a cartoon of this subject, painted by Rosso for Francis I., 'among the best things Rosso ever produced,' and introducing the King and Queen of France, their guards, and a concourse of people, as spectators of the scene. In some instances, the locality is a temple, with an altar, before which kneels the Emperor, having laid upon it his sceptre and laurel crown : the sibyl points to the vision seen through a window above. I think it is so represented in a large picture at Hampton Court, by Pietro da Cortona.

The sibylline prophecy is supposed to have occurred a short time before the Nativity, about the same period when the decree went forth 'that all the world should be taxed.' Joseph, therefore, arose and saddled his ass, and set his wife upon it, and went up from Nazareth to Bethlehem. The way was long, and steep, and weary; 'and when Joseph looked back, he saw the face of Mary that it was sorrowful, as of one in pain; but when he looked back again, she smiled. And when they were come to Bethlehem, there was no room for them in the inn, because of the great concourse of people. And Mary said to Joseph, "Take me down, for I suffer." '[2]

The journey to Bethlehem, and the grief and perplexity of Joseph, have been often represented. 1. There exists a very ancient Greek carving, in ivory, wherein Mary is seated on the ass, with an expression of suffering, and Joseph tenderly sustains her; she has one arm round his neck, leaning on him : an angel leads the ass, lighting the way with a torch. It is supposed that this curious relic formed part of the ornaments of the ivory throne of the Exarch of Ravenna, and

[1] Siena, Fonte Giusta. [2] Protevangelion.

that it is at least as old as the sixth century.[1] 2. There is an instance more dramatic in an engraving after a master of the seventeenth century. Mary, seated on the ass, and holding the bridle, raises her eyes to heaven with an expression of resignation; Joseph, cap in hand, humbly expostulates with the master of the inn, who points towards the stable; the innkeeper's wife looks up at the Virgin with a strong expression of pity and sympathy. 3. I remember another print of the same subject, where, in the background, angels are seen preparing the cradle in a cave.

I may as well add that the Virgin, in this character of mysterious, and religious, and most pure maternity, is venerated under the title of *La Madonna del Parto*.[2]

The Nativity of our Saviour, like the Annunciation, has been treated in two ways, as a mystery and as an event, and we must be careful to discriminate between them.

[1] It is engraved in Gori's Thesaurus, and described in Münter's Sinnbilder.

[2] Every one who has visited Naples will remember the church on the Mergellina, dedicated to the *Madonna del Parto*, where lies, beneath his pagan tomb, the poet Sannazzaro. Mr. Hallam, in a beautiful passage of his History of the Literature of Europe, has pointed out the influence of the genius of Tasso on the whole school of Bolognese painters of that time. Not less striking was the influence of Sannazzaro and his famous poem on the Nativity (*De Partu Virginis*), on the contemporary productions of Italian art, and more particularly as regards the subject under consideration: I can trace it through all the schools of art, from Milan to Naples, during the latter half of the sixteenth century. Of Sannazzaro's poem, Mr. Hallam says, that 'it would be difficult to find its equal for purity, elegance, and harmony of versification.' It is not the less true, that even its greatest merits as a Latin poem exercised the most perverse influence on the religious art of that period. It was, indeed, only *one* of the many influences which may be said to have demoralised the artists of the sixteenth century, but it was one of the greatest.

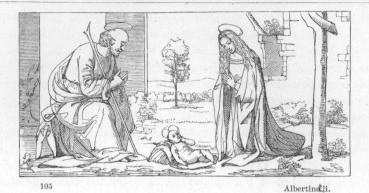

105 Albertinelli.

THE NATIVITY AS A MYSTERY.

In the first sense, the artist has intended simply to express the advent of the Divinity on earth in the form of an infant, and the *motif* is clearly taken from a text in the Office of the Virgin, *Virgo quem genuit adoravit*. In the beautiful words of Jeremy Taylor, 'She blessed him, she worshipped him, and she thanked him that he would be born of her;' as, indeed, many a young mother has done before and since, when she has hung in adoration over the cradle of her first-born child—but *here* the child was to be a descended God; and nothing, as it seems to me, can be more graceful and more profoundly suggestive than the manner in which some of the early Italian artists have expressed this idea. When, in such pictures, the locality is marked by the poor stable, or the rough rocky cave, it becomes 'a temple full of religion, full of glory, where angels are the ministers, the holy Virgin the worshipper, and Christ the Deity.' Very few accessories are admitted, merely such as serve to denote that the subject is 'a Nativity,' properly so called, and not the 'Madre Pia,' as already described.

The divine Infant lies in the centre of the picture, sometimes on a white napkin, sometimes with no other bed than the flowery turf; sometimes his head rests on a wheatsheaf, always here interpreted as 'the bread of life.' He places his finger on his lip, which expresses the *Verbum sum*,[1] 'I am the word,' or 'I am the bread of life,'[2]

[1] Or, *Vere Verbum hoc est abbreviatum.* [2] *Ego sum panis ille vitæ.* John vi. 48.

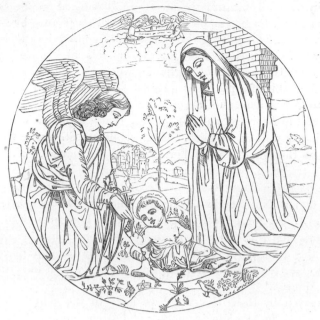

106 Lorenzo di Credi.

and fixes his eyes on the heavens above, where the angels are sing-
ing the *Gloria in excelsis.* In one instance, I remember, an angel holds
up the cross before him (106); in another, he grasps it in his hand;
or it is a nail, or the crown of thorns, anticipative of his earthly destiny.
The Virgin kneels on one side; St. Joseph, when introduced, kneels
on the other; and frequently angels unite with them in the act of
adoration, or sustain the new-born Child. In this poetical version
of the subject, Lorenzo di Credi, Perugino, Francia, and Bellini,
excelled all others.[1] Lorenzo, in particular, became quite renowned
for the manner in which he treated it, and a number of beautiful com-
positions from his hand exist in the Florentine and other galleries.

 There are instances in which attendant saints and votaries are intro-
duced as beholding and adoring this great mystery. 1. For instance, in

[1] There are also most charming examples in sculpture by Luca della Robbia, Donatello,
and other masters of the Florentine school.

D D

a picture by Cima, Tobit and the angel are introduced on one side, and St. Helena and St. Catherine on the other. 2. In a picture by Francia,[1] the Infant, reclining upon a white napkin, is adored by the kneeling Virgin, by St. Augustine, and by two angels also kneeling. The votary, Antonio Galeazzo Bentivoglio, for whom the picture was painted, kneels in the habit of a pilgrim.[2] He had lately returned from a pilgrimage to Jerusalem and Bethlehem, thus poetically expressed in the scene of the Nativity, and the picture was dedicated as an act of thanksgiving as well as of faith. St. Joseph and St. Francis stand on one side; on the other is a shepherd crowned with laurel. Francia, according to tradition, painted his own portrait as St. Francis; and his friend the poet, Girolamo Casio de' Medici, as the shepherd. 3. In a large and famous Nativity by Giulio Romano,[3] which once belonged to our Charles I., St. John the Evangelist, and St. Longinus (who pierced our Saviour's side with his lance), are standing on each side as two witnesses to the divinity of Christ—here strangely enough placed on a par; but we are reminded that Longinus had lately been inaugurated as patron of Mantua.[4]

In a triptych by Hans Hemling [5] we have in the centre the Child, adored, as usual, by the Virgin mother and attending angels, the votary also kneeling: in the compartment on the right, we find the manifestation of the Redeemer to the *west* exhibited in the prophecy of the sibyl to Augustus; on the left, the manifestation of the Redeemer to the *east* is expressed by the journey of the Magi, and the miraculous star—' we have seen his *star in the east.*'

But of all these ideal Nativities, the most striking is one by Sandro Botticelli, which is indeed a comprehensive poem, a kind of hymn on the Nativity, and might be set to music. In the centre is a shed, beneath which the Virgin, kneeling, adores the Child, who has his finger on his lip. Joseph is seen a little behind, as if in meditation. On the right hand, the angel presents three figures (probably the shepherds)

[1] Bologna Gal.

An excellent likeness,' says Vasari. It is engraved as such in Litta's Memorials of the Bentivogli. Girolamo Casio received the laurel crown from the hand of Clement VII. in 1523. A beautiful votive Madonna, dedicated by Girolamo Casio and his son Giacomo, and painted by Beltraffio, is in the Louvre, 71. [3] Louvre, 293.

[4] v. Sacred and Legendary Art, 1st series, 3rd edit. p. 787. [5] Berlin Gal.

crowned with olive; on the left is a similar group. On the roof of the shed, three angels, with olive-branches in their hands, sing the *Gloria in excelsis*. Above these are twelve angels dancing or floating round in a circle, holding olive-branches between them. In the foreground, in the margin of the picture, three figures rising out of the flames of purgatory are received and embraced by angels. With all its quaint fantastic grace and dryness of execution, the whole conception is full of meaning, religious as well as poetical. The introduction of the olive, and the redeemed souls, may express 'peace on earth, good will towards men;' or the olive may likewise refer to that period of universal peace in which the *Prince of Peace* was born into the world.[1]

I must mention one more instance for its extreme beauty. In a picture by Lorenzo di Credi [2] the Infant Christ lies on the ground on a part of the veil of the Virgin, and holds in his hand a bird. In the background, the miraculous star sheds on the earth a perpendicular blaze of light, and further off are the shepherds. On the other side, St. Jerome, introduced, perhaps, because he made his abode at Bethlehem, is seated beside his lion.

[1] This singular picture, formerly in the Ottley collection, was, when I saw it, in the possession of Mr. Fuller Maitland, of Stansted Park. [2] Florence, Pal. Pitti.

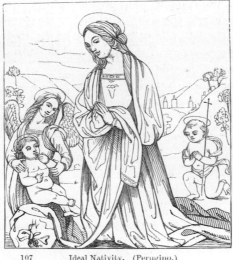

107 Ideal Nativity. (Perugino.)
D D 2

THE NATIVITY AS AN EVENT.

We now come to the Nativity as historically treated, in which time, place, and circumstance, have to be considered as in any other actual event.

The time was the depth of winter, at midnight; the place a poor stable. According to some authorities, this stable was the interior of a cavern, still shown at Bethlehem as the scene of the Nativity; in front of which was a ruined house, once inhabited by Jesse, the father of David, and near the spot where David pastured his sheep : but the house was now a shed partly thatched, and open at that bitter season to all the winds of heaven. Here it was that the Blessed Virgin 'brought forth her first-born Son, wrapped him in swaddling clothes, and laid him in a manger.'

We find in the early Greek representations, and in the early Italian painters who imitated the Byzantine models, that in the arrangement a certain pattern was followed : the locality is a sort of cave—literally a hole in a rock; the Virgin Mother reclines on a couch; near her lies the new-born Infant wrapped in swaddling clothes. In one very ancient example (a miniature of the ninth century in a Greek Menologium), an attendant is washing the Child.

But from the fourteenth century we find this treatment discontinued. It gave just offence. The greatest theologians insisted that the birth of the Infant Christ was as pure and miraculous as his conception : and it was considered little less than heretical to portray Mary reclining on a couch as one exhausted by the pangs of childbirth,[1] or to exhibit assistants as washing the heavenly Infant. 'To her alone,' says St. Bernard, 'did not the punishment of Eve extend.' 'Not in sorrow,' says Bishop Taylor, 'not in pain, but in the posture and guise of worshippers (that is, kneeling), and in the midst of glorious thoughts and speculations, did Mary bring her Son into the world.'

We must seek for the accessories and circumstances usually introduced by the painters in the old legendary traditions then accepted and

[1] Isaiah, lxvi. 7.

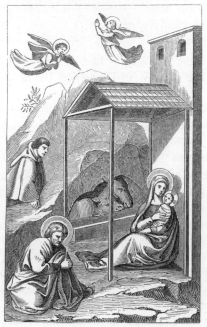

108 Ancient Nativity.

believed.[1] Thus one legend relates that Joseph went to seek a midwife, and met a woman coming down from the mountains, with whom he returned to the stable. But when they entered it was filled with light greater than the sun at noon-day; and as the light decreased and they were able to open their eyes, they beheld Mary sitting there with her Infant at her bosom. And the Hebrew woman being amazed said, 'Can this be true?' and Mary answered, 'It is true; as there is no child like unto my son, so there is no woman like unto his mother.'

These circumstances we find in some of the early representations, more or less modified by the taste of the artist. I have seen, for instance, an old German print, in which the Virgin, 'in the posture and

[1] Protevangelion, xiv.

guise of worshippers,' kneels before her Child as usual; while the
background exhibits a hilly country, and Joseph, with a lantern in his
hand is helping a woman over a stile. Sometimes there are two women,
and then the second is always Mary Salome, who, according to a pas-
sage in the same popular authority, visited the mother in her hour of
travail.

The angelic choristers in the sky, or upon the roof of the stable, sing
the *Gloria in excelsis Deo*; they are never, I believe, omitted, and in
early pictures are always three in number; but in later pictures,
the mystic *three* become a chorus of musicians. Joseph is generally
sitting by, leaning on his staff in profound meditation, or asleep as one
overcome by fatigue; or with a taper or a lantern in his hand, to ex-
press the night-time.

Among the accessories, the ox and the ass are indispensable. The
introduction of these animals rests on an antique tradition mentioned
by St. Jerome, and also on two texts of prophecy: 'The ox knoweth his
owner, and the ass his master's crib;'[1] and Habakkuk, iii. 4., is ren-
dered in the Vulgate, 'He shall lie down between the ox and the ass.'
From the sixth century, which is the supposed date of the earliest ex-
tant, to the sixteenth century, there was never any representation of
the Nativity without these two animals; thus in the old carol so often
quoted—

> 'Agnovit bos et asinus
> Quod Puer erat Dominus!'

In some of the earliest pictures the animals kneel, 'confessing the
Lord.'[2] (109) In some instances they stare into the manger with a most
naïve expression of amazement at what they find there. One of the old
Latin hymns, *De Nativitate Domini,* describes them, in that wintry
night, as warming the new-born Infant with their breath; and they have
always been interpreted as symbols, the ox as emblem of the Jews, the
ass of the Gentiles.

I wonder if it has ever occurred to those who have studied the inner
life and meaning of these old representations—owed to them, perhaps,

[1] Isaiah, i. 3. [2] Isaiah, xliii. 20.

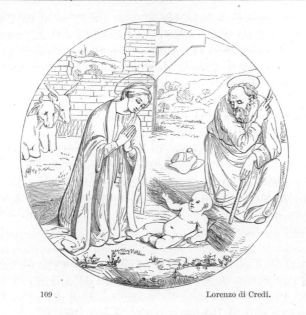

109 . Lorenzo di Credi.

homilies of wisdom, as well as visions of poetry—that the introduction of the ox and the ass, those symbols of animal servitude and inferiority, might be otherwise translated—that their pathetic dumb recognition of the Saviour of the world might be interpreted as extending to them also a participation in his mission of love and mercy—that since to the lower creatures it was not denied to be present at that great manifestation, they are thus brought nearer to the sympathies of our humanity, as we are, thereby, lifted to a nearer communion with the universal spirit of love—but this is 'considering too deeply,' perhaps, for the occasion. Return we to our pictures. Certainly we are not in danger of being led into any profound or fanciful speculations by the ignorant painters of the later schools of art. In their 'Nativities,' the ox and ass are not, indeed, omitted; they must be present by religious and prescriptive usage; but they are to be made picturesque, as if they were in the stable by right, and as if it were only a stable, not a temple hallowed to a diviner significance. The ass, instead of looking devoutly into the cradle, stretches out his lazy length in the foreground; the ox winks

his eyes with a more than bovine stupidity. In some of the old German pictures, while the Hebrew ox is quietly chewing the cud, the Gentile ass 'lifts up his voice' and brays with open mouth, as if in triumph.

One version of this subject, by Agnolo Gaddi, is conceived with much simplicity and originality. The Virgin and Joseph are seen together within a rude and otherwise solitary building. She points expressively to the manger where lies the divine Infant, while Joseph leans on his staff and appears lost in thought.

Correggio has been much admired for representing in his famous Nativity the whole picture as lighted by the glory which proceeds from the divine Infant, as if the idea had been new and orginal.[1] It occurs frequently before and since his time, and is founded on the legendary story quoted above, which describes the cave or stable filled with a dazzling and supernatural light.

It is not often we find the Nativity represented as an historical event without the presence of the shepherds; nor is the supernatural announcement to the shepherds often treated as a separate subject: it generally forms part of the background of the Nativity; but there are some striking examples.

In a print by Rembrandt, he has emulated, in picturesque and poetical treatment, his famous Vision of Jacob, in the Dulwich Gallery. The angel (always supposed to be Gabriel) appears in a burst of radiance through the black wintry midnight, surrounded by a multitude of the heavenly host. The shepherds fall prostrate, as men amazed and 'sore afraid;' the cattle flee different ways in terror.[2] I do not say that this is the most elevated way of expressing the scene; but, as an example of characteristic style, it is perfect.

[1] '*La Notte*,' Dresden Gal. [2] Luke, ii. 9.

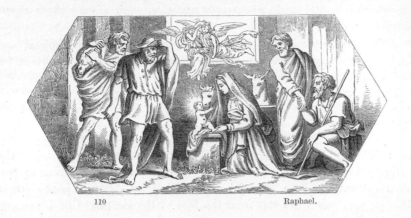

110 Raphael.

The Adoration of the Shepherds.

Ital. L'Adorazione dei Pastori. *Fr.* L'Adoration des Bergers.
Ger. Die Anbetung der Hirten.

THE story thus proceeds:—When the angels were gone away into heaven, the shepherds came with haste, 'and found Mary, and Joseph, and the young Child lying in a manger.'

Being come, they present their pastoral offerings—a lamb, or doves, or fruits (but these, considering the season, are misplaced); they take off their hats with reverence, and worship in rustic fashion. In Raphael's composition, the shepherds, as we might expect from him, look as if they had lived in Arcadia. In some of the later Italian pictures, they pipe and sing. It is the well-known custom in Italy for the shepherds of the Campagna, and of Calabria, to pipe before the Madonna and Child at Christmas time; and these *Piffereri*, with their sheepskin jackets, ragged hats, bagpipes, and tabors, were evidently the models reproduced in some of the finest pictures of the Bolognese school; for instance, in the famous Nativity by Annibal Caracci, where a picturesque figure in the corner is blowing into the bagpipes with might and main. In the Venetian pictures of the Nativity, the shepherds are accompanied by their women, their sheep, and even their dogs. According to an old

E E

legend, Simon and Jude, afterwards apostles, were among these shep-
herds.

When the angels scatter flowers, as in compositions by Raphael and
Ludovico Caracci, we must suppose that they were not gathered on
earth, but in heaven.

The Infant is sometimes asleep :—so Milton sings—

> But see the Virgin blest
> Hath laid her Babe to rest!

In a drawing by Raphael, the Child slumbers, and Joseph raises the
coverlid, to show him to a shepherd. We have the same idea in several
other instances. In a graceful composition by Titian, it is the Virgin
Mother who raises the veil from the face of the sleeping Child.

From the number of figures and accessories, the Nativity thus treated
as an historical subject becomes capable of almost endless variety ; but as
it is one not to be mistaken, and has a universal meaning and interest,
I may now leave it to the fancy and discrimination of the observer.

The Adoration of the Magi.

Ital. L'Adorazione de' Magi. L'Epifania. *Fr.* L'Adoration des Rois Mages.
Ger. Die Anbetung der Weisen aus dem Morgenland. Die heilige drei Königen. Jan. 6.

This, the most extraordinary incident in the early life of our Saviour,
rests on the authority of one evangelist only. It is related by
St. Matthew so briefly, as to present many historical and philosophical
difficulties. I must give some idea of the manner in which these diffi-
culties were elucidated by the early commentators, and of the notions
which prevailed in the middle ages relative to the country of the Three
Kings, before it will be possible to understand or to appreciate the
subject as it has been set before us in every style of art, in every
form, in every material, from the third century to the present time.

In the first place, who were these Magi, or these kings, as they are
sometimes styled ? 'To suppose,' says the antique legend, 'that they
were called Magi because they were addicted to magic, or exercised un-

holy or forbidden arts, would be, heaven save us! a rank heresy.' No! Magi, in the Persian tongue, signifies 'wise men.' They were, in their own country, kings or princes, as it is averred by all the ancient fathers; and we are not to be offended at the assertion, that they were at once princes and *wise* men—'Car à l'usage de ce temps-là les princes et les rois étoient très sages!'[1]

They came from the eastern country, but from what country is not said; whether from the land of the Arabians, or the Chaldeans, or the Persians, or the Parthians.

It is written in the Book of Numbers, that when Balaam, the son of Beor, was called upon to curse the children of Israel, he, by divine inspiration, uttered a blessing instead of a curse. And he took up this parable, and said, 'I shall see him, but not now; I shall behold him, but not nigh: there shall come a star out of Jacob, and a sceptre shall rise out of Israel.' And the people of that country, though they were Gentiles, kept this prophecy as a tradition among them, and waited with faith and hope for its fulfilment. When, therefore, their princes and wise men beheld a star different in its appearance and movement from those which they had been accustomed to study (for they were great astronomers), they at once knew its import, and hastened to follow its guidance. According to an ancient commentary on St. Matthew, this star, on its first appearance, had the form of a radiant

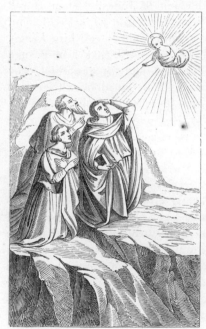

111 The Star (*like a child*) appearing to the Wise Men.

child bearing a sceptre or cross. In a fresco by Taddeo Gaddi, it is

[1] Quoted literally from the legend in the old French version of the *Flos Sanctorum*.

E E 2

thus figured; and this is the only instance I can remember. But to proceed with our story.

When the eastern sages beheld this wondrous and long-expected star, they rejoiced greatly; and they arose, and taking leave of their lands and their vassals, their relations and their friends, set forth on their long and perilous journey across vast deserts and mountains, and broad rivers, the star going before them, and arrived at length at Jerusalem, with a great and splendid train of attendants. Being come there, they asked at once, 'Where is he who is born King of the Jews?' On hearing this question, King Herod was troubled, and all the city with him; and he inquired of the chief priests where Christ should be born. And they said to him, 'in Bethlehem of Judea.' Then Herod privately called the wise men, and desired they would go to Bethlehem, and search for the young child (he was careful not to call him *King*), saying, 'When ye have found him, bring me word, that I may come and worship him also.' So the Magi departed, and the star which they had seen in the east went before them, until it stood over the place where the young child was—he who was born King of kings. They had travelled many a long and weary mile; 'and what had they come for to see?' Instead of a sumptuous palace, a mean and lowly dwelling; in place of a monarch surrounded by his guards and ministers and all the terrors of his state, an infant wrapped in swaddling clothes and laid upon his mother's knee, between the ox and the ass. They had come, perhaps, from some far-distant savage land, or from some nation calling itself civilised, where innocence had never been accounted sacred, where society had as yet taken no heed of the defenceless woman, no care for the helpless child; where the one was enslaved, and the other perverted: and here, under the form of womanhood and childhood, they were called upon to worship the promise of that brighter future, when peace should inherit the earth, and righteousness prevail over deceit, and gentleness with wisdom reign for ever and ever! How must they have been amazed! how must they have wondered in their souls at such a revelation!—yet such was the faith of these wise men and excellent kings, that they at once prostrated themselves, confessing in the glorious Innocent who smiled upon them from his mother's knee, a greater than themselves—the image of a truer divinity than they had

ever yet acknowledged. And having bowed themselves down—first, as was most fit, offering *themselves*—they made offering of their treasure, as it had been written in ancient times, 'The kings of Tarshish and the isles shall bring presents, and the kings of Sheba shall offer gifts.' And what were these gifts? Gold, frankincense, and myrrh; by which symbolical oblation they protested a threefold faith—by gold, that he was king; by incense, that he was God; by myrrh, that he was man, and doomed to death. In return for their gifts, the Saviour bestowed upon them others of more matchless price. For their gold he gave them charity and spiritual riches; for their incense, perfect faith; and for their myrrh, perfect truth and meekness: and the Virgin, his mother, also bestowed on them a precious gift and memorial, namely, one of those linen bands in which she had wrapped the Saviour, for which they thanked her with great humility, and laid it up amongst their treasures. When they had performed their devotions, and made their offerings, being warned in a dream to avoid Herod, they turned back again to their own dominions; and the star which had formerly guided them to the west, now went before them towards the east, and led them safely home. When they were arrived there, they laid down their earthly state; and in emulation of the poverty and humility in which they had found the Lord of all power and might, they distributed their goods and possessions to the poor, and went about in mean attire, preaching to their people the new King of heaven and earth, the CHILD-KING, the Prince of Peace. We are not told what was the success of their mission; neither is it anywhere recorded that from that time forth, every child, as it sat on its mother's knee, was, even for the sake of that Prince of Peace, regarded as sacred—as the heir of a divine nature—as one whose tiny limbs enfolded a spirit which was to expand into the man, the king, the God. Such a result was, perhaps, reserved for other times, when the whole mission of that divine Child should be better understood than it was then, or is *now*. But there is an ancient oriental tradition, that about forty years later, when St. Thomas the apostle travelled into the Indies, he found these Wise Men there, and did administer to them the rite of baptism; and that afterwards, in carrying the light of truth into the far East, they fell among barbarous Gentiles, and were put to death; thus each of them

receiving, in return for the earthly crowns they had cast at the feet of the Saviour, the heavenly crown of martyrdom and of everlasting life.

Their remains, long afterwards discovered, were brought to Constantinople by the Empress Helena; thence in the time of the first Crusade they were transported to Milan, whence they were carried off by the Emperor Barbarossa, and deposited in the cathedral at Cologne, where they remain to this day, laid in a shrine of gold and gems; and have performed divers great and glorious miracles.

Such, in few words, is the Church legend of the Magi of the East, the 'three Kings of Cologne,' as founded on the mysterious Gospel incident. Statesmen and philosophers, not less than ecclesiastics, have, as yet, missed the whole sense and large interpretation of the mythic as well as the scriptural story; but well have the artists availed themselves of its picturesque capabilities! In their hands it has gradually expanded from a mere symbol into a scene of the most dramatic and varied effect and the most gorgeous splendour. As a subject it is one of the most ancient in the whole range of Christian art. Taken in the early religious sense, it signified the calling of the Gentiles; and as such we find it carved in bas-relief on the Christian sarcophagi of the third and fourth centuries, and represented with extreme simplicity. The Virgin Mother is seated on a chair, and holds the Infant upright on her knee. The Wise Men, always three in number, and all alike, approach in attitudes of adoration. In some instances they wear Phrygian caps, and their camels' heads are seen behind them, serving to express the land whence they came, the land of the East, as well as their long journey; as on one of the sarcophagi in the Christian Museum of the Vatican. The star in these antique sculptures is generally omitted; but in one or two instances it stands immediately over the chair of the Virgin. On a sarcophagus near the entrance of the tomb of Galla Placidia, at Ravenna, they are thus represented.

The mosaic in the church of Santa Maria Maggiore at Rome, is somewhat later in date than these sarcophagi (A.D. 440), and the representation is very peculiar and interesting. Here the Child is seated alone on a kind of square pedestal, with his hand raised in benediction; behind the throne stand two figures, supposed to be the Virgin and

Joseph; on each side, two angels. The kings approach, dressed as Roman warriors, with helmets on their heads.

In the mosaic in the church of Sant' Apollinare-Novo, at Ravenna (A. D. 534), the Virgin receives them seated on a throne, attended by the archangels; they approach, wearing crowns on their heads, and bending in attitudes of reverence: all three figures are exactly alike, and rather less in proportion than the divine group.

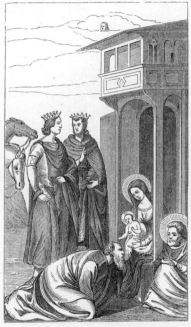

112 Taddeo Gaddi.

Immediately on the revival of art we find the Adoration of the Kings treated in the Byzantine style, with few accessories. Very soon, however, in the early Florentine school, the artists began to avail themselves of that picturesque variety of groups of which the story admitted.

In the legends of the fourteenth century, the kings had become distinct personages, under the names of Caspar (or Jasper), Melchior, and Balthasar: the first being always a very aged man, with a long white beard; the second, a middle-aged man; the third is young, and frequently he is a Moor or negro, to express the King of Ethiopia or Nubia, and also to indicate that when the Gentiles were called to salvation, all the continents and races of the earth, of whatever complexion, were included. The difference of ages is indicated in the Greek formula; but the difference of complexion is a modern innovation, and more frequently found in the German than in the Italian schools. In the old legend of the Three Kings, as inserted in Wright's 'Chester Mysteries,' Jasper, or Caspar, is King of Tarsus, the land of merchants; he makes the offering of gold. Melchior, the King of Arabia and Nubia, offers frankincense; and Balthasar,

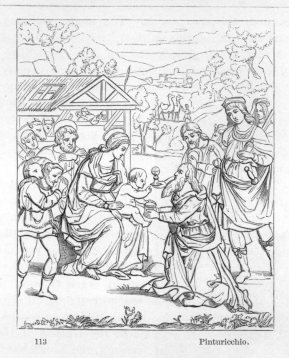

113 Pinturicchio.

King of Saba—'the land of spices and all manner of precious gums'—
offers myrrh.[1]

It is very usual to find, in the Adoration of the Magi, the angelic
announcement to the shepherds introduced into the background; or,
more poetically, the Magi approaching on one side, and the shepherds
on the other. The intention is then to express a double signification;
it is at once the manifestation to the Jews, and the manifestation to the
Gentiles.

The attitude of the Child varies. In the best pictures he raises his
little hand in benediction. The objection that he was then only an
infant of a few days old is futile: for he was from his birth the CHRIST.
It is also in accordance with the beautiful and significant legend which

[1] The names of the Three Kings appear for the first time in a piece of rude sculpture over
the door of Sant' Andrea at Pistoia, to which is assigned the date 1166. (*Vide* D'Agin-
court, *Scultura*, pl. xxvii.)

describes him as dispensing to the old wise men the spiritual blessings of love, meekness, and perfect faith, in return for their gifts and their homage. It appears to me bad taste, verging on profanity, to represent him plunging his little hand into the coffer of gold, or eagerly grasping one of the gold pieces. Neither should he be wrapped up in swaddling clothes, nor in any way a subordinate figure in the group; for it is the Epiphany, the Manifestation of a divine humanity to Jews and Gentiles, which is to be expressed; and there is meaning as well as beauty in those compositions which represent the Virgin as lifting a veil and showing him to the Wise Men.

The kingly character of the adorers, which became in the thirteenth century a point of faith, is expressed by giving them all the paraphernalia and pomp of royalty according to the customs of the time in which the artist lived. They are followed by a vast train of attendants, guards, pages, grooms, falconers with hawks; and, in a picture by Gaudenzio Ferrari, we have the court-dwarf, and, in a picture by Titian, the court-fool, both indispensable appendages of royal state in those times. The Kings themselves wear embroidered robes, crowns, and glittering weapons, and are booted and spurred as if just alighted from a long journey; even on one of the sarcophagi they are seen in spurs.

The early Florentine and Venetian painters profited by the commercial relations of their countries with the Levant, and introduced all kinds of outlandish and oriental accessories to express the far country from which the strangers had arrived; thus we have among the presents, apes, peacocks, pheasants, and parrots. The traditions of the crusades also came in aid, and hence we have the plumed and jewelled turbans, the armlets and the scimitars, and, in the later pictures, even umbrellas and elephants. I remember, in an old Italian print of this subject, a pair of hunting leopards or *chetas*.

It is a question whether Joseph was present—whether he *ought* to have been present: in one of the early legends, it is asserted that he hid himself and would not appear, out of his great humility, and because it should not be supposed that he arrogated any relationship to the divine Child. But this version of the scene is quite inconsistent with the extreme veneration afterwards paid to Joseph; and in later times, that

F F

is, from the fifteenth century, he is seldom omitted. Sometimes he is
seen behind the chair of the Virgin, leaning on his stick, and con-
templating the scene with a quiet admiration. Sometimes he receives
the gifts offered to the Child, acting the part of a treasurer or cham-
berlain. In a picture by Angelico one of the Magi grasps his hand as
if in congratulation. In a composition by Parmigiano one of the Magi
embraces him.

It was not uncommon for pious votaries to have themselves painted
in likeness of one of the adoring Kings. In a picture by Sandro
Botticelli, Cosmo de' Medici is thus introduced; and in a large and
beautifully arranged composition by Leonardo da Vinci, which un-
happily remains as a sketch only, the three Medici of that time, Cosmo,
Lorenzo, and Giuliano, are figured as the three Kings.[1]

A very remarkable altar-piece, by Jean van Eyck, represents the
worship of the Magi. In the centre, Mary and her Child are seated
within a ruined temple; the eldest of the three Kings, kneeling, does
homage by kissing the hand of the Child: it is the portrait of Philip
the Good, Duke of Burgundy. The second, prostrate behind him with
a golden beaker in his hand, is supposed to be one of the great officers
of his household. The third King exhibits the characteristic portrait of
Charles the Bold : there is no expression of humility or devotion either
in his countenance or attitude; he stands upright, with a lofty dis-
dainful air, as if he were yet unresolved whether he would kneel or
not. On the right of the Virgin, a little in the foreground, stands
Joseph in a plain red dress, holding his hat in his hand, and looking
with an air of simple astonishment at his magnificent guests. All the
accessories in this picture, the gold and silver vessels, the dresses of
the three Kings sparkling with jewels and pearls, the velvets, silks,
and costly furs, are painted with the most exquisite finish and delicacy,
and exhibit to us the riches of the court of Burgundy, in which Van
Eyck then resided.[2]

In Raphael's composition, the worshippers wear the classical, not the
oriental costume; but an elephant with a monkey on his back is seen in
the distance, which at once reminds us of the far East.[3]

[1] Both these pictures are in the Florence Gal. [2] Munich Gal., 45.
[3] Rome, Vatican.

Ghirlandajo frequently painted the Adoration of the Magi, and shows in his management of the accessories much taste and symmetry. In one of his compositions, the shed forms a canopy in the centre; two of the Kings kneel in front. The country of the Ethiopian King is not expressed by making him of a black complexion, but by giving him a negro page, who is in the act of removing his master's crown.[1]

A very complete example of artificial and elaborate composition may be found in the drawing by Baldassare Peruzzi in our National Gallery. It contains at least fifty figures; in the centre, a magnificent architectural design; and wonderful studies of perspective to the right and left, in the long lines of receding groups. On the whole, it is a most skilful piece of work; but to my taste much like a theatrical decoration —pompous without being animated.

A beautiful composition by Francia I must not pass over.[2] Here, to the left of the picture, the Virgin is seated on the steps of a ruined temple, against which grows a fig-tree, which, though it be December, is in full leaf. Joseph kneels at her side, and behind her are two Arcadian shepherds, with the ox and the ass. The Virgin, who has a charming air of modesty and sweetness, presents her Child to the adoration of the Wise Men: the first of these kneels with joined hands; the second, also kneeling, is about to present a golden vase; the negro King, standing, has taken off his cap, and holds a censer in his hand; and the divine Infant raises his hand in benediction. Behind the Kings are three figures on foot, one a beautiful youth in an attitude of adoration. Beyond these are five or six figures on horseback, and a long train upon horses and camels is seen approaching in the background. The landscape is very beautiful and cheerful, the whole picture much in the style of Francia's master, Lorenzo Costa. I should at the first glance have supposed it to be his, but the head of the Virgin is unmistakably Francia.

There are instances of this subject idealised into a mystery; for example, in a picture by Palma Vecchio,[3] St. Helena stands behind

[1] Florence, Pitti Pal.
[2] Dresden Gal. Arnold, the well-known printseller at Dresden, has lately published a very beautiful and finished engraving of this fine picture; the more valuable, because engravings after Francia are very rare. [3] Milan, Brera,

the Virgin, in allusion to the legend which connects her with the history of the Kings. In a picture by Garofalo, the star shining above is attended by angels bearing the instruments of the Passion, while St. Bartholomew, holding his skin, stands near the Virgin and Child: it was painted for the abbey of St. Bartholomew, at Ferrara.

Among the German examples, the picture by Albert Durer, in the tribune of the Florence Gallery; and that of Mabuse, in the collection of Lord Carlisle, are perhaps the most perfect of their kind.

In the last-named picture the Virgin, seated, in a plain dark-blue mantle, with the German physiognomy, but large-browed, and with a very serious, sweet expression, holds the Child. The eldest of the Kings, as usual, offers a vase of gold, out of which Christ has taken a piece, which he holds in his hand. The name of the King, JASPER, is inscribed on the vase; a younger King behind holds a cup. The black Ethiopian King, Balthasar, is con-spicuous on the left; he stands, crowned and arrayed in gorgeous drapery, and, as if more fully to mark the equality of the races—at least in spiritual privileges—his train is borne by a white page. An exquisite landscape is seen through the arch behind, and the shepherds are approaching in the middle dis-tance. On the whole, this is one of the most splendid pictures of the early Flemish school I have ever seen; for variety of character, glow of colour, and finished execution, quite unsurpassed.

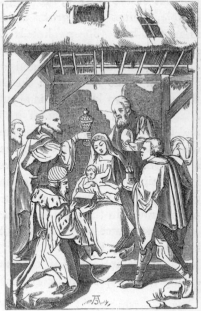

114 Albert Durer.

In a very rich composition by Lucas van Leyden, Herod is seen in the background, standing in the balcony of his palace, and pointing out the scene to his attendants. As an example of the German style, I give a sketch after a drawing by Albert Durer.

As we might easily imagine, the ornamental painters of the Venetian and Flemish schools delighted in this subject, which allowed them full scope for their gorgeous colouring, and all their scenic and dramatic power. Here Paul Veronese revelled unreproved in Asiatic magnificence : here his brocaded robes and jewelled diadems harmonised with his subject; and his grand, old, bearded Venetian senators figured, not unsuitably, as Eastern Kings. Here Rubens lavished his ermine and crimson draperies, his vases, and ewers, and censers of flaming gold; — here poured over his canvas the wealth ' of Ormuz and of Ind.' Of fifteen pictures of this subject, which he painted at different times, the finest undoubtedly is that in the Madrid Gallery. Another, also very fine, is in the collection of the Marquis of Westminster. In both these, the Virgin, contrary to all former precedent, is not seated, but *standing*, as she holds up her Child for worship. Afterwards we find the same position of the Virgin, in pictures by Vandyck, Poussin, and other painters of the seventeenth century. It is quite an innovation on the old religious arrangement; but in the utter absence of all religious feeling, the mere arrangement of the figures, except in an artistic point of view, is of little consequence.

As a scene of oriental pomp, heightened by mysterious shadows and flashing lights, I know nothing equal to the Rembrandt in the Queen's Gallery; the procession of attendants seen emerging from the background through the transparent gloom is quite awful; but in this miraculous picture, the lovely Virgin Mother is metamorphosed into a coarse Dutch *vrow*, and the divine Child looks like a changeling imp.

In chapels dedicated to the Nativity or the Epiphany, we frequently find the journey of the Wise Men painted round the walls. They are seen mounted on horseback, or on camels, with a long train of attendants, here ascending a mountain, there crossing a river; here winding through a defile, there emerging from a forest; while the miraculous star shines above, pointing out the way. Sometimes we have the approach of the Wise Men on one side of the chapel, and their return to their own country on the other. On their homeward journey they are, in some few instances, embarking in a ship : this occurs in a fresco by Lorenzo Costa, and in a bas-relief in the cathedral of Amiens. The allusion is to a curious legend, mentioned by Arnobius the Younger, in his commentary on the Psalms (fifth century). He says, in reference

to the 48th Psalm, that when Herod found that the three Kings had escaped from him 'in ships of Tarsus,' in his wrath he burned all the vessels in the port.

There is a beautiful fresco of the journey of the Magi in the Riccardi Chapel at Florence, painted by Benozzo Gozzoli for the old Cosmo de' Medici.

'The Baptism of the Magi by St. Thomas' is one of the compartments of the Life of the Virgin, painted by Taddeo Gaddi, in the Baroncelli Chapel at Florence, and this is the only instance I can refer to.

Before I quit this subject—one of the most interesting in the whole range of art—I must mention a picture by Giorgione in the Belvedere Gallery, well known as one of the few undoubted productions of that rare and fascinating painter, and often referred to because of its beauty. Its signification has hitherto escaped all writers on art, as far as I am acquainted with them, and has been dismissed as one of his enigmatical allegories. It is called in German, *Die Feldmässer* (the Land Surveyors), and sometimes styled in English the *Geometricians,* or the *Philosophers,* or the *Astrologers.* It represents a wild, rocky landscape, in which are three men. The first, very aged, in an oriental costume, with a long grey beard, stands holding in his hand an astronomical table; the next, a man in the prime of life, seems listening to him; the third, a youth, seated and looking upwards, holds a compass. I have myself no doubt that this beautiful picture represents the 'three wise men of the East,' watching on the Chaldean hills the appearance of the miraculous star, and that the light breaking in the far horizon, called in the German description the rising sun, is intended to express the rising of the star of Jacob.[1] In the sumptuous landscape, and colour, and the picturesque rather than religious treatment, this picture is quite Venetian. The interpretation here suggested I leave to the consideration of the observer; and, without allowing myself to be tempted on to further illustration, will only add, in conclusion, that I do not remember any Spanish picture of this subject remarkable either for beauty or originality.[2]

[1] There is also a print by Giulio Bonasone, which appears to represent the wise men watching for the star. (*Bartsch,* xv. 156.)

[2] In the last edition of the Vienna Catalogue, this picture has received its proper title.

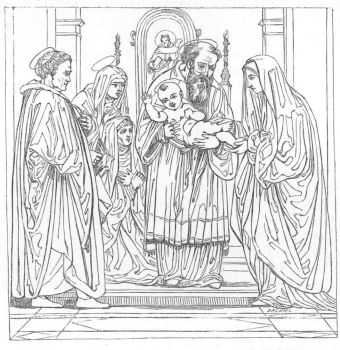

115 Fra Bartolomeo.

The Purification of the Virgin, the Presentation, and the Circumcision of Christ.

Ital. La Purificazione della B. Vergine.
Ger. Die Darbringung im Tempel. Die Beschneidung Christi.

AFTER the birth of her Son, Mary was careful to fulfil all the ceremo-
nies of the Mosaic law. As a first-born son, he was to be redeemed by
the offering of five shekels, or a pair of young pigeons (in memory
of the first-born of Egypt). But previously, being born of the children
of Abraham, the infant Christ was submitted to the sanguinary rite
which sealed the covenant of Abraham, and received the name of JESUS

—'that name before which every knee was to bow, which was to be set above the powers of magic, the mighty rites of sorcerers, the secrets of Memphis, the drugs of Thessaly, the silent and mysterious murmurs of the wise Chaldees, and the spells of Zoroaster; that name which we should engrave on our hearts, and pronounce with our most harmonious accents, and rest our faith on, and place our hopes in, and love with the overflowing of charity, joy, and adoration.'[1]

The circumcision and the naming of Christ have many times been painted to express the first of the sorrows of the Virgin, being the first of the pangs which her Son was to suffer on earth. But the Presentation in the Temple has been selected with better taste for the same purpose; and the prophecy of Simeon, 'Yea, a sword shall pierce through thy own soul also,' becomes the first of the Seven Sorrows. It is an undecided point whether the Adoration of the Magi took place thirteen days, or one year and thirteen days, after the birth of Christ. In a series of subjects artistically arranged, the Epiphany always precedes, in order of time, that scene in the temple which is sometimes styled the Purification, sometimes the Presentation, and sometimes the *Nunc Dimittis*. They are three distinct incidents; but, as far as I can judge, neither the painters themselves, nor those who have named pictures, have been careful to discriminate between them. On a careful examination of various compositions, some of special celebrity, which are styled, in a general way, the Presentation in the Temple, it will appear, I think, that the idea uppermost in the painter's mind has been to represent the prophecy of Simeon.

No doubt, in later times, the whole scene, as a subject of art, was considered in reference chiefly to the Virgin, and the intention was to express the first of her Seven Sorrows. But in ancient art, and especially in Greek art, the character of Simeon assumed a singular significance and importance, which, so long as modern art was influenced by the traditional Byzantine types, modified, in some degree, the arrangement and sentiment of this favourite subject.

It is related that when Ptolemy Philadelphus, about 260 years before Christ, resolved to have the Hebrew Scriptures translated into Greek,

[1] *v.* Bishop Taylor's Life of Christ.

for the purpose of placing them in his far-famed library, he despatched messengers to Eleazar, the High Priest of the Jews, requiring him to send scribes and interpreters learned in the Jewish law to his court at Alexandria. Thereupon Eleazar selected six of the most learned rabbis from each of the twelve tribes of Israel, seventy-two persons in all, and sent them to Egypt, in obedience to the commands of King Ptolemy, and among these was Simeon, a priest, and a man full of learning. And it fell to the lot of Simeon to translate the book of the prophet Isaiah. And when he came to that verse where it is written, 'Behold, a Virgin shall conceive and bear a son,' he began to misdoubt, in his own mind, how this could be possible; and, after long meditation, fearing to give scandal and offence to the Greeks, he rendered the Hebrew word *Virgin* by a Greek word which signifies merely *a young woman*; but when he had written it down, behold an angel effaced it, and substituted the right word. Thereupon he wrote it again and again; and the same thing happened three times; and he remained astonished and confounded. And while he wondered what this should mean, a ray of divine light penetrated his soul; it was revealed to him that the miracle, which, in his human wisdom, he had presumed to doubt, was not only possible, but that he, Simeon, 'should not see death till he had seen the Lord's Christ.' Therefore, he tarried on earth, by the divine will, for nearly three centuries, till that which he had disbelieved had come to pass. He was led by the Spirit to the temple on the very day when Mary came there to present her Son, and to make her offering, and immediately, taking the Child in his arms, he exclaimed, 'Lord, *now* lettest thou thy servant depart in peace, according to thy word.' And of the Virgin Mother, also, he prophesied sad and glorious things.

Anna the Prophetess, who was standing by, also testified to the presence of the theocratic King; but she did not take him in her arms, as did Simeon.[1] Hence, she was early regarded as a type of the synagogue, which prophesied great things of the Messiah, but, nevertheless, did not embrace him when he appeared, as did the Gentiles.

That these curious legends relative to Simeon and Anna, and their symbolical interpretation, were well known to the old painters, there can

[1] Luke ii. 32.

G G

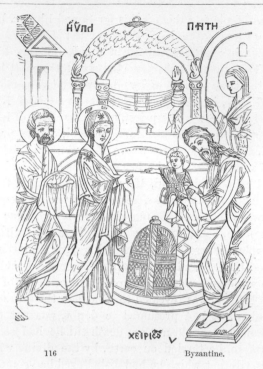

ἅ ỹ πα πΑΤΗ

ΧΕÌΡΙ**ɛ**̄ϲ v

116 Byzantine.

be no doubt; and both were perhaps in the mind of Bishop Taylor
when he wrote his eloquent chapter on the Presentation. 'There be
some,' he says, 'who wear the name of Christ on their heads, to make
a show to the world; and there be some who have it always in their
mouths; and there be some who carry Christ on their shoulders, as if he
were a burthen too heavy to bear; and there be some—woe is me!—
who trample him under their feet: but *he* is the true Christian, who, *like
Simeon*, embraces Christ, and takes him to his heart.'

Now, it seems to me that it is distinctly the acknowledgment of Christ
by Simeon—that is, Christ received by the Gentiles—which is intended
to be placed before us in the very early pictures of the Presentation, or the
Nunc dimittis, as it is always styled in Greek art. The appearance of
an attendant, bearing the two turtledoves, shows it to be also the so-
called Purification of the Virgin. In this antique formal Greek version

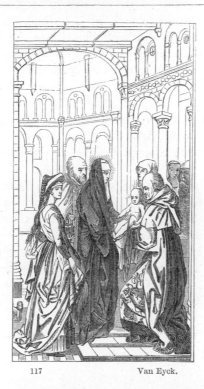

117 Van Eyck.

we have the Presentation exactly according to the pattern described by
Didron. The great gold censer is here; the cupola, at top; Joseph
carrying the two young pigeons, and Anna behind Simeon. (116)

In a celebrated composition by Fra Bartolomeo, of which I give a
sketch (115), there is the same disposition of the personages, but an
additional female figure. This is not Anna, the mother of the Virgin
(as I have heard it said), but probably Mary Salome, who had always
attended on the Virgin ever since the Nativity at Bethlehem.

The subject is treated with exquisite simplicity by Francia; we have
just the same personages as in the rude Greek model, but disposed with
consummate grace. Still, to represent the Child as completely un-
draped has been considered as a solecism. He ought to stretch out his

hands to his mother, and to look as if he understood the portentous words which foretold his destiny. Sometimes the imagination is assisted by the choice of the accessories; thus Fra Bartolomeo has given us, in the background of his group, Moses holding the *broken* table of the old law; and Francia represents in the same manner the sacrifice of Abraham; for thus did Mary bring her Son as an offering. In many pictures Simeon raises his eyes to heaven in gratitude; but those painters who wish to express the presence of the Divinity in the person of Christ, made Simeon looking at the Child, and addressing *him* as 'Lord.'

The sketch on the preceding page (117) is from a beautiful little picture by Van Eyck [1] (or from his school), in which we have the scene in the true Flemish style. A noble Gothic church represents the temple; and, besides the sacred personages and Simeon, there are numerous assistants, among them a woman carrying a basket of doves (Salome, I suppose). She wears a singular head-dress, composed of a narrow bandage of gold stuff twisted round and round her head, till it takes the form of a turban; and the whole figure is particularly graceful.

In the picture by Guido, a young girl offers two turtledoves, and a boy two pigeons.

The Flight into Egypt.

Ital. La Fuga in Egitto.　*Fr*. La Fuite de la Sainte Famille en Egypte.
Ger. Die Flucht nach Aegypten.

THE wrath of Herod against the Magi of the East who had escaped from his power, enhanced by his fears of the divine and kingly Infant, occasioned the massacre of the Innocents, which led to the flight of the Holy Family into Egypt. Of the martyred children, in their character of martyrs, I have already spoken, and of their proper place in a scheme of ecclesiastical decoration. There is surely something very pathetic in that feeling which exalted these infant victims into objects of re-

[1] Boisserée Gal.

ligious veneration, making them the cherished companions in heavenly glory of the Saviour for whose sake they were sacrificed on earth. He had said, 'Suffer little children to come unto me;' and to these were granted the prerogatives of pain, as well as the privileges of innocence. If, in the day of retribution, they sit at the feet of the Redeemer, surely they will appeal against us, then and there—against us who, in these days, through our reckless neglect, slay, body and soul, legions of innocents— poor little unblest creatures, 'martyrs by the pang without the palm '—yet dare to call ourselves Christians.

The Massacre of the Innocents, as an event, belongs properly to the life of Christ: it is not included in a series of the life of the Virgin, perhaps from a feeling that the contrast between the most blessed of women and mothers, and those who wept distracted for their children, was too painful, and did not harmonise with the general subject. In pictures of the Flight into Egypt, I have seen it introduced allusively into the background; and in the architectural decoration of churches dedicated to the Virgin Mother, as Notre Dame de Chartres, it finds a place, but not often a conspicuous place;[1] it is rather indicated than represented. I should pass over the subject altogether, best pleased to be spared the theme, but that there are some circumstances connected with it which require elucidation, because we find them introduced incidentally into pictures of the Flight and the *Riposo*.

Thus, it is related that among the children whom Herod was bent on destroying, was St. John the Baptist; but his mother Elizabeth fled with him to a desert place, and being pursued by the murderers, 'the rock opened by a miracle, and closed upon Elizabeth and her child;' which means, as we may presume, that they took refuge in a cavern, and were concealed within it until the danger was over. Zacharias, refusing to betray his son, was slain 'between the temple and the altar.'[2] Both these legends are to be met with in the Greek pictures, and in the miniatures of the thirteenth and fourteenth centuries.[3]

[1] It is conspicuous and elegantly treated over the door of the Lorenz Kirche at Nuremberg.
[2] Matt. xxii. 35.
[3] They will be found treated at length in the artistic subjects connected with St. John the Baptist.

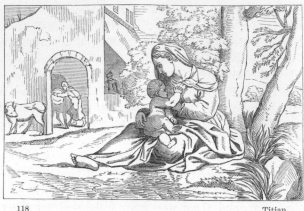

118 Titian.

From the butchery which made so many mothers childless, the divine Infant and his mother were miraculously saved; for an angel spoke to Joseph in a dream, saying, 'Arise, and take the young child and his mother, and flee into Egypt.' This is the second of the four angelic visions which are recorded of Joseph. It is not a frequent subject in early art, but is often met with in pictures of the later schools. Joseph is asleep in his chair, the angel stands before him, and, with a significant gesture, points forward—'arise and flee!'

There is an exquisite little composition by Titian, called a *Riposo*, which may possibly represent the preparation for the Flight. (118) Here Mary is seated under a tree nursing her Infant, while in the background is a sort of rude stable, in which Joseph is seen saddling the ass, while the ox is on the outside.

In a composition by Tiarini, we see Joseph holding the Infant, while Mary, leaning one hand on his shoulder, is about to mount the ass.

In a composition by Poussin, Mary, who has just seated herself on the ass, takes the Child from the arms of Joseph. Two angels lead the ass, a third kneels in homage, and two others are seen above with a curtain to pitch a tent.

I must notice here a tradition that both the ox and the ass who stood over the manger at Bethlehem, accompanied the Holy Family

into Egypt. In Albert Durer's print, the ox and the ass walk side by side. It is also related that the Virgin was accompanied by Salome, and Joseph by three of his sons. This version of the story is generally rejected by the painters; but in the series by Giotto in the Arena at Padua, Salome and the three youths attend on Mary and Joseph; and I remember another instance, a little picture by Lorenzo Monaco, in which Salome, who had vowed to attend on Christ and his mother as long as she lived, is seen following the ass, veiled, and supporting her steps with a staff.

But this is a rare exception. The general treatment confines the group to Joseph, the mother, and the Child. To Joseph was granted, in those hours of distress and danger, the high privilege of providing for the safety of the Holy Infant—a circumstance much enlarged upon in the old legends; and to express this more vividly, he is sometimes represented in early Greek art as carrying the Child in his arms, or on his shoulder, while Mary follows on the ass. He is so figured on the sculptured doors of the cathedral of Beneventum, and in the cathedral of Monreale, both executed by Greek artists.[1] But we are not to suppose that the Holy Family was left defenceless on the long journey. The angels who had charge concerning them were sent to guide them by day, to watch over them by night, to pitch their tent before them, and to refresh them with celestial fruit and flowers. By the introduction of these heavenly ministers the group is beautifully varied.

Joseph, says the Gospel story, 'arose by night;' hence there is both meaning and propriety in those pictures which represent the Flight as a night-scene, illuminated by the moon and stars, though I believe this has been done more to exhibit the painter's mastery over effects of dubious light, than as a matter of biblical accuracy. Sometimes an angel goes before, carrying a torch or lantern, to light them on the way; sometimes it is Joseph who carries the lantern.

In a picture by Nicolo Poussin, Mary walks before, carrying the Infant; Joseph follows, leading the ass; and an angel guides them.

The journey did not, however, comprise one night only. There is, indeed, an antique tradition, that space and time were, on this occasion,

[1] 11th century. Also at Città di Castello; same date.

miraculously shortened to secure a life of so much importance; still, we are allowed to believe that the journey extended over many days and nights; consequently it lay within the choice of the artist to exhibit the scene of the Flight either by night or by day.

In many representations of the Flight into Egypt, we find in the background men sowing or cutting corn. This is in allusion to the following legend:—

When it was discovered that the Holy Family had fled from Bethlehem, Herod sent his officers in pursuit of them. And it happened that when the Holy Family had travelled some distance, they came to a field where a man was sowing wheat. And the Virgin said to the husbandman, 'If any shall ask you whether we have passed this way, ye shall answer, "Such persons passed this way when I was sowing this corn."' For the Holy Virgin was too wise and too good to save her Son by instructing the man to tell a falsehood. But behold, a miracle! For, by the power of the Infant Saviour, in the space of a single night the seed sprang up into stalk, blade, and ear, fit for the sickle. And next morning the officers of Herod came up, and inquired of the husbandman, saying, 'Have you seen an old man with a woman and a Child travelling this way?' And the man, who was reaping his wheat, in great wonder and admiration, replied, 'Yes.' And they asked him again, 'How long is it since?' And he answered, 'When I was sowing this wheat.' Then the officers of Herod turned back and left off pursuing the Holy Family.

A very remarkable example of the introduction of this legend occurs in a celebrated picture by Hans Hemling,[1] known as 'Die sieben Freuden Mariä.' In the background, on the left, is the Flight into Egypt; the men cutting and reaping corn, and the officers of Herod in pursuit of the Holy Family. By those unacquainted with the old legend, the introduction of the corn-field and reapers is supposed to be merely a decorative landscape, without any peculiar significance.

In a very beautiful fresco by Pinturicchio,[2] the Holy Family are taking their departure from Bethlehem. The city, with the massacre

[1] Munich Gal., Cabinet iv. 69. [2] Rome, St. Onofrio.

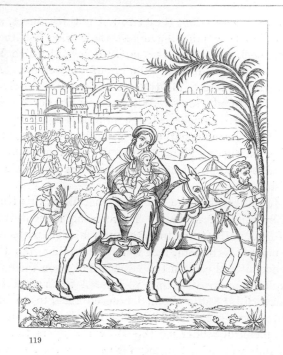

119

of the Innocents, is seen in the background. In the middle distance, the husbandman cutting corn; and nearer, the palm-tree bending down. (119)

It is supposed by commentators that Joseph travelled from Bethlehem across the hilly country of Judea, taking the road to Joppa, and then pursuing the way along the coast. Nothing is said in the Gospel of the events of this long and perilous journey of at least 400 miles, which, in the natural order of things, must have occupied five or six weeks; and the legendary traditions are very few. Such as they are, however, the painters have not failed to take advantage of them.

We are told that on descending from the mountains, they came down upon a beautiful plain enamelled with flowers, watered by murmuring streams, and shaded by fruit-trees. In such a lovely landscape have the painters delighted to place some of the scenes of the Flight into

H H

Egypt. On another occasion, they entered a thick forest, a wilderness of trees, in which they must have lost their way, had they not been guided by an angel. Here we encounter a legend which has hitherto escaped, because, indeed, it defied the art of the painter. As the Holy Family entered this forest, all the trees bowed themselves down in reverence to the Infant God; only the aspen, in her exceeding pride and arrogance, refused to acknowledge him, and stood upright. Then the Infant Christ pronounced a curse against her, as he afterwards cursed the barren fig-tree; and at the sound of his words, the aspen began to tremble through all her leaves, and has not ceased to tremble even to this day.

We know from Josephus the historian, that about this time Palestine was infested by bands of robbers. There is an ancient tradition, that when the Holy Family, travelling through hidden paths and solitary defiles, had passed Jerusalem, and were descending into the plains of Syria, they encountered certain thieves who fell upon them; and one of them would have maltreated and plundered them; but his comrade interfered, and said, 'Suffer them, I beseech thee, to go in peace, and I will give thee forty groats, and likewise my girdle;' which offer being accepted, the merciful robber led the Holy Travellers to his stronghold on the rock, and gave them lodging for the night.[1] And Mary said to him, 'The Lord God will receive thee to his right hand, and grant thee pardon of thy sins!' And it was so: for in after times these two thieves were crucified with Christ, one on the right hand, and one on the left; and the merciful thief went with the Saviour into Paradise.

The scene of this encounter with the robbers, near Ramla, is still pointed out to travellers, and still in evil repute as the haunt of banditti. The crusaders visited the spot as a place of pilgrimage; and the Abbé Orsini considers the first part of the story as authenticated; but the legend concerning the good thief he admits to be doubtful.[2]

As an artistic subject this scene has been seldom treated. I have seen two pictures which represent it. One is a fresco by Giovanni di San Giovanni, which, having been cut from the wall of some suppressed convent, is now in the academy at Florence. The other is a composition by Zuccaro, of which I give a little sketch. (120)

[1] Gospel of Infancy, ch. viii. [2] Vie de la Ste. Vierge.

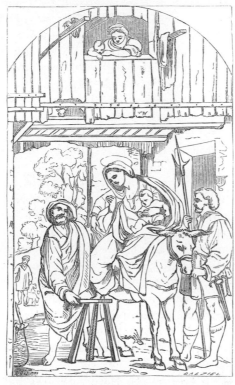

120 The Robber.

One of the most popular legends concerning the Flight into Egypt is that of the palm or date tree, which at the command of Jesus bowed down its branches to shade and refresh his mother; hence, in the scene of the Flight, a palm-tree became a usual accessory. In a picture by Antonello Mellone, the Child stretches out his little hand and lays hold of the branch: sometimes the branch is bent down by angel hands. Sozomenes relates, that when the Holy Family reached the term of their journey, and approached the city of Heliopolis in Egypt, a tree which grew before the gates of the city, and was regarded with great veneration as the seat of a god, bowed down its branches at the approach of the Infant Christ. Likewise it is related (not in legends

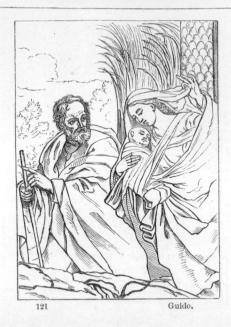

121 Guido.

merely, but by grave religious authorities) that all the idols of the Egyptians fell with their faces to the earth. I have seen pictures of the Flight into Egypt, in which broken idols lie by the wayside.

In the course of the journey the Holy Travellers had to cross rivers and lakes; hence the later painters, to vary the subject, represented them as embarking in a boat, sometimes steered by an angel. The first, as I have reason to believe, who ventured on this innovation, was Annibal Caracci. In this little sketch, after Poussin (122), the Holy Family are about to embark. In a picture by Giordano, an angel, with one knee bent, assists Mary to enter the boat. In a pretty little picture by Teniers, the Holy Family and the ass are seen in a boat crossing a ferry by moonlight; sometimes they are crossing a bridge.

I must notice here a little picture by Adrian Vander Werff, in which the Virgin, carrying her Child, holds by the hand the old decrepid Joseph, who is helping her, or rather is helped by her, to pass a torrent on some stepping-stones. This is quite contrary to the feeling of the

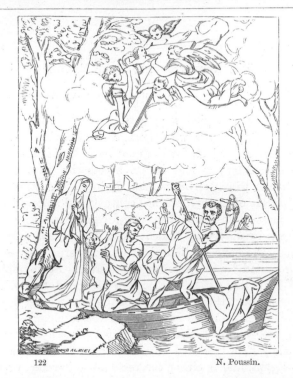

122 N. Poussin.

old authorities, which represent Joseph as the vigilant and capable
guardian of the Mother and her Child; but it appears to have here a
rather particular and touching significance: it was painted by Vander
Werff for his daughter in his old age, and intended to express her filial
duty and his paternal care.

The most beautiful Flight into Egypt I have ever seen, is a com-
position by Gaudenzio Ferarri. The Virgin is seated and sustained on
the ass with a quite peculiar elegance. The Infant, standing on her
knee, seems to point out the way; an angel leads the ass, and Joseph
follows with the staff and wallet. In the background the palm-tree
inclines its branches.[1]

Claude has introduced the Flight of the Holy Family as a landscape
group into nine different pictures.

[1] At Varallo, in the church of the Minorites.

THE REPOSE OF THE HOLY FAMILY.

Ital. Il Riposo. *Fr.* Le Repos de la Sainte Famille. *Ger.* Die Ruhe in Egypten.

THE subject generally styled a 'Riposo' is one of the most graceful and most attractive in the whole range of Christian art. It is not, however, an ancient subject, for I cannot recall an instance earlier than the sixteenth century; it had in its accessories that romantic and pastoral character which recommended it to the Venetians and to the landscape painters of the seventeenth century, and among these we must look for the most successful and beautiful examples.

I must begin by observing that it is a subject not only easily mistaken by those who have studied pictures, but perpetually misconceived and misrepresented by the painters themselves. Some pictures which erroneously bear this title, were never intended to do so. Others intended to represent the scene, are disfigured and perplexed by mistakes arising either from the ignorance or the carelessness of the artist.

We must bear in mind that the Riposo, properly so called, is not merely the Holy Family seated in a landscape; it is an episode of the Flight into Egypt, and is either the rest on the journey, or at the close of the journey; quite different scenes, though all go by the same name. It is not an ideal religious group, but a reality, a possible and actual scene; and it is clear that the painter, if he thought at all, and did not merely set himself to fabricate a pretty composition, was restricted within the limits of the actual and possible, at least according to the histories and traditions of the time. Some of the accessories introduced would stamp the intention at once; as the date-tree, and Joseph gathering dates; the ass feeding in the distance; the wallet and pilgrim's staff laid beside Joseph; the fallen idols; the Virgin scooping water from a fountain; for all these are incidents which properly belong to the Riposo.

It is nowhere recorded, either in Scripture or in the legendary stories, that Mary and Joseph in their flight were accompanied by Elizabeth and the little St. John; therefore, where either of these are

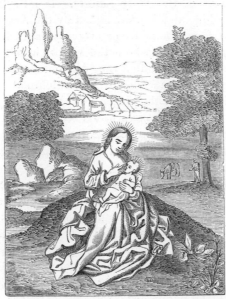

123 Riposo. (Jan Schoreel.)

introduced, the subject is not properly a *Riposo*, whatever the intention of the painter may have been : the personages ought to be restricted to the Virgin, her Infant, and St. Joseph, with attendant angels. An old woman is sometimes introduced, the same who is traditionally supposed to have accompanied them in their flight. If this old woman be manifestly St. Anna or St. Elizabeth, then it is not a *Riposo*, but merely a *Holy Family*.

It is related that the Holy Family finally rested, after their long journey, in the village of Matarea, beyond the city of Hermopolis (or Heliopolis), and took up their residence in a grove of sycamores, a circumstance which gave the sycamore-tree a sort of religious interest in early Christian times. The crusaders imported it into Europe; and poor Mary Stuart may have had this idea, or this feeling, when she brought from France, and planted in her garden, the first sycamores which grew in Scotland.

Near to this village of Matarea, a fountain miraculously sprang up

for the refreshment of the Holy Family. It still exists, as we are informed by travellers, and is still styled by the Arabs, 'the Fountain of Mary.'[1] This fountain is frequently represented, as in the well-known Riposo by Correggio, where the Virgin is dipping a bowl into the gushing stream, hence called the 'Madonna *della Scodella*:'[2] in another by Baroccio,[3] and another by Domenichino.[4]

In this fountain, says another legend, Mary washed the linen of the Child. There are several pictures which represent the Virgin washing linen in a fountain; for example, one by Lucio Massari, where, in a charming landscape, the little Christ takes the linen out of a basket, and Joseph hangs it on a line to dry.[5]

The ministry of the angels is here not only allowable, but beautifully appropriate; and never has it been more felicitously and more gracefully expressed than in a little composition by Lucas Cranach, where the Virgin and her Child repose under a tree, while the angels dance in a circle round them. The cause of the Flight—the Massacre of the Innocents—is figuratively expressed by two winged boys, who, seated on a bough of the tree, are seen robbing a nest, and wringing the necks of the nestlings, while the parent-birds scream and flutter over their heads: in point of taste, this significant allegory had been better omitted; it spoils the harmony of composition. There is another similar group, quite as graceful, by David Hopfer. Vandyck seems to have had both in his memory when he designed the very beautiful Riposo so often copied and engraved:[6] (124) here the Virgin is seated under a tree, in an open landscape, and holds her divine Child; Joseph, behind, seems asleep; in front of the Virgin, eight lovely angels dance in a round, while others, seated in the sky, make heavenly music.

In another singular and charming Riposo by Lucas Cranach, the Virgin and Child are seated under a tree; to the left of the group is a fountain, where a number of little angels appear to be washing linen; to the right, Joseph approaches leading the ass, and in the act of reverently removing his cap.

There is a Riposo by Albert Durer which I cannot pass over. It is

[1] The site of this fountain is about four miles N.E. of Cairo. [2] Parma.
[3] Grosvenor Gal. [4] Louvre, 491. [5] Florence Gal.
[6] Coll. of Lord Ashburton.

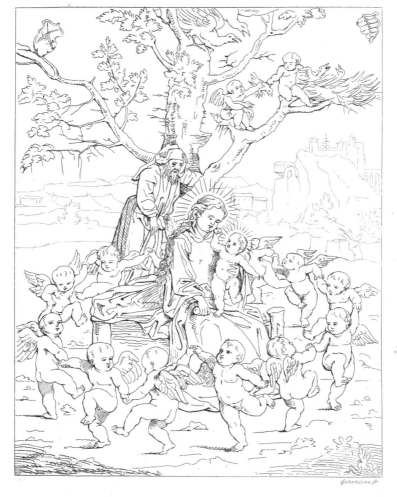

Gerardine ft.

Riposo, with dancing Angels.

touched with all that homely domestic feeling, and at the same time all that fertility of fancy, which are so characteristic of that extraordinary man. We are told that when Joseph took up his residence at Matarea in Egypt, he provided for his wife and Child by exercising his trade as a carpenter. In this composition he appears in the foreground dressed as an artisan with an apron on, and with an axe in his hand is shaping a plank of wood. Mary sits on one side spinning with her distaff, and watching her Infant slumbering in its cradle. Around this domestic group we have a crowd of ministering angels; some of these little winged spirits are assisting Joseph, sweeping up the chips and gathering them into baskets; others are merely 'sporting at their own sweet will.' Several more dignified-looking angels, having the air of guardian spirits, stand or kneel round the cradle, bending over it with folded hands.[1]

In a Riposo by Titian, the Infant lies on a pillow on the ground, and the Virgin is kneeling before him, while Joseph leans on his pilgrim's staff, to which is suspended a wallet. In another, two angels, kneeling, offer fruits in a basket; in the distance, a little angel waters the ass at a stream.[2]

The angels, according to the legend, not only ministered to the Holy Family, but pitched a tent nightly, in which they were sheltered. Poussin, in an exquisite picture, has represented the Virgin and Child reposing under a curtain suspended from the branches of a tree and partly sustained by angels, while others, kneeling, offer fruit.[3]

Poussin is the only painter who has attempted to express the locality. In one of his pictures the Holy Family reposes on the steps of an Egyptian temple; a sphinx and a pyramid are visible in the background. In another Riposo by the same master, an Ethiopian boy presents fruits to the Infant Christ. Joseph is frequently asleep, which is hardly consonant with the spirit of the older legends. It is, however, a beautiful idea to make the Child and Joseph both reposing, while the Virgin Mother, with eyes upraised to heaven, wakes and watches, as in a picture by Mola;[4] but a yet more beautiful idea to represent the Virgin and Joseph sunk in sleep, while the divine Infant lying in his

[1] In the famous set of woodcuts of the Life of the Virgin Mary.
[2] All these are engraved. [3] Grosvenor Gal. [4] Louvre, 269.

I I

mother's arms wakes and watches for both, with his little hands joined in prayer, and his eyes fixed on the hovering angels or the opening skies above.

In a Riposo by Rembrandt, the Holy Family rest by night, and are illuminated only by a lantern suspended on the bough of a tree, the whole group having much the air of a gipsy encampment. But one of Rembrandt's imitators has in his own way improved on this fancy: the Virgin sleeps on a bank with the Child on her bosom; Joseph, who looks extremely like an old tinker, is doubling his fist at the ass, which has opened its mouth to bray.

Before quitting the subject of the Riposo, I must mention a very pretty and poetical legend, which I have met with in one picture only; a description of it may, however, lead to the recognition of others.

There is in the collection of Lord Shrewsbury, at Alton Towers, a Riposo attributed to Giorgione, remarkable equally for the beauty and the singularity of the treatment. The Holy Family are seated in the midst of a wild but rich landscape, quite in the Venetian style; Joseph is asleep; the two children are playing with a lamb. The Virgin, seated, holds a book, and turns round, with an expression of surprise and alarm, to a female figure who stands on the right. This woman has a dark physiognomy, ample flowing drapery of red and white, a white turban twisted round her head, and stretches out her hand with the air of a sibyl. The explanation of this striking group I found in an old ballad-legend. Every one who has studied the moral as well as the technical character of the various schools of art, must have remarked how often the Venetians (and Giorgione more especially) painted groups from the popular fictions and ballads of the time; and it has often been regretted that many of these pictures are become unintelligible to us from our having lost the key to them, in losing all trace of the fugitive poems or tales which suggested them.

The religious ballad I allude to must have been popular in the sixteenth century; it exists in the Provençal dialect, in German, and in Italian; and, like the wild ballad of St. John Chrysostom, it probably

came in some form or other from the East. The theme is, in all these versions, substantially the same. The Virgin, on her arrival in Egypt, is encountered by a gipsy (Zingara or Zingarella), who crosses the Child's palm after the gipsy manner, and foretells all the wonderful and terrible things which, as the Redeemer of mankind, he was destined to perform and endure on earth.

An Italian version which lies before me is entitled, *Canzonetta nuova, sopra la Madonna, quando si partò in Egitto col Bambino Gesù e San Giuseppe,* 'A new Ballad of our Lady, when she fled into Egypt with the Child Jesus and St. Joseph.'

It begins with a conversation between the Virgin, who has just arrived from her long journey, and the gipsy-woman, who thus salutes her :—

ZINGARELLA.

Dio ti salvi, bella Signora,
E ti dia buona ventura.
Ben venuto, vecchiarello,
Con questo bambino bello !

GIPSY.

God save thee, fair Lady, and give thee good luck ! Welcome, good old man, with this thy fair Child !

MADONNA.

Ben trovata, sorella mia,
La sua grazia Dio ti dia.
Ti perdoni i tuoi peccati
L' infinità sua bontade.

MARY.

Well met, sister mine ! God give thee grace, and of his infinite mercy forgive thee thy sins !

ZINGARELLA.

Siete stanchi e meschini,
Credo, poveri pellegrini
Che cercate d' alloggiare.
Vuoi, Signora, scavalcare ?

GIPSY.

Ye are tired and drooping, poor pilgrims, as I think, seeking a night's lodging. Lady, wilt thou choose to alight ?

MADONNA.

Voi che siete, sorella mia,
Tutta piena di cortesia,
Dio vi renda la carità
Per l' infinità sua bontà.
Noi veniam da Nazaretto,
Siamo senza alcun ricetto,
Arrivati all' strania
Stanchi e lassi dalla via !

MARY.

O sister mine ! full of courtesy, God of his infinite goodness reward thee for thy charity. We are come from Nazareth, and we are without a place to lay our heads, arrived in a strange land, all tired and weary with the way !

The Zingarella then offers them a resting-place, and straw and fodder

I I 2

for the ass, which being accepted, she asks leave to tell their fortune, but begins by recounting, in about thirty stanzas, all the past history of the Virgin pilgrim; she then asks to see the Child—

Ora tu, Signora mia,	And now, O Lady mine, that art full of
Che sei piena di cortesia,	courtesy, grant me to look upon thy Son, the
Mostramelo per favore	Redeemer!
Lo tuo Figlio Redentore!	

The Virgin takes him from the arms of Joseph—

Datemi, o caro sposo,	Give me, dear husband, my lovely boy,
Lo mio Figlio grazioso!	that this poor gipsy, who is a prophetess,
Quando il vide sta meschina	may look upon him.
Zingarella, che indovina!	

The gipsy responds with becoming admiration and humility, praises the beauty of the Child, and then proceeds to examine his palm; which having done, she breaks forth into a prophecy of all the awful future, tells how he would be baptised, and tempted, scourged, and finally hung upon a cross—

> Questo Figlio accarezzato
> Tu lo vedrai ammazzato
> Sopra d' una dura croce,
> Figlio bello! Figlio dolce!

but consoles the disconsolate Mother, doomed to honour for the sake of us sinners —

> Sei arrivata a tanti onori
> Per noi altri Peccatori!

and ends by begging an alms —

> Non ti vo' più infastidire,
> Bella Signora; so ch' hai a fare.
> Dona la limosinella
> A sta povera Zingarella.

But not alms of gold or of silver, but the gift of true repentance and eternal life.

> Vo' una vera contrizione
> Per la tua intercezione,
> Accio st' alma dopo morte
> Tragga alle celesti porte!

And so the story ends.

There can be no doubt, I think, that we have here the original theme of Giorgione's picture, and perhaps of others.

In the Provençal ballad, there are three gipsies, men, not women, introduced, who tell the fortune of the Virgin and Joseph, as well as that of the Child, and end by begging alms 'to wet their thirsty throats.' Of this version there is a very spirited and characteristic translation by Mr. Kenyon, under the title of 'a Gipsy Carol.' [1]

The Return from Egypt.

ACCORDING to some authorities, the Holy Family sojourned in Egypt during a period of seven years, but others assert that they returned to Judea at the end of two years.

In general the painters have expressed the Return from Egypt by exhibiting Jesus as no longer an infant sustained in his mother's arms, but as a boy walking at her side. In a picture by Francesco Vanni, he is a boy about two or three years old, and carries a little basket full of carpenter's tools. The occasion of the Flight and Return is indicated by three or four of the martyred Innocents, who are lying on the ground. In a picture by Domenico Feti, two of the Innocents are lying dead on the roadside. In a very graceful, animated picture by Rubens, Mary and Joseph lead the young Christ between them, and the Virgin wears a large straw hat.

[1] A Day at Tivoli, with other Verses, by John Kenyon, p. 149.

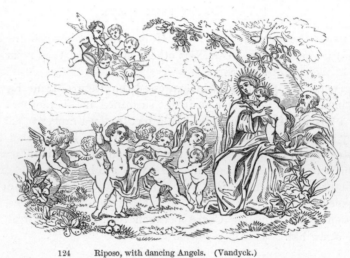

124 Riposo, with dancing Angels. (Vandyck.)

Historical Subjects.

PART III.

The Life of the Virgin Mary from the Sojourn in Egypt to the Crucifixion of our Lord.

1. THE HOLY FAMILY.

2. THE VIRGIN SEEKS HER SON.

3. THE DEATH OF JOSEPH.

4. THE MARRIAGE AT CANA.

5. 'LO SPASIMO.'

6. THE CRUCIFIXION.

7. THE DESCENT FROM THE CROSS.

8. THE ENTOMBMENT.

The Holy Family.

When the Holy Family, under divine protection, had returned safely from their sojourn in Egypt, they were about to repair to Bethlehem; but Joseph hearing that Archelaus 'did reign in Judea in the room of his father Herod, he was afraid to go thither; and being warned of God in a dream, he turned aside into Galilee,' and came to the city of Nazareth, which was the native place and home of the Virgin Mary. Here Joseph dwelt, following in peace his trade of a carpenter, and bringing up his reputed Son to the same craft: and here Mary nurtured her divine Child; 'and he grew and waxed strong in spirit, and the grace of God was upon him.' No other event is recorded until Jesus had reached his twelfth year.

This, then, is the proper place to introduce some notice of those representations of the domestic life of the Virgin and the infancy of the Saviour, which, in all their endless variety, pass under the general title of The Holy Family—the beautiful title of a beautiful subject, addressed in the loveliest and most familiar form at once to the piety and the affections of the beholder.

These groups, so numerous, and of such perpetual recurrence, that they alone form a large proportion of the contents of picture galleries and the ornaments of churches, are, after all, a modern innovation in sacred art. What may be called the *domestic* treatment of the history of the Virgin cannot be traced further back than the midlde of the fifteenth century. It is, indeed, common to class all those pictures as Holy Families which include any of the relatives of Christ grouped with the Mother and her Child; but I must here recapitulate, and insist upon the distinction to be drawn between the *domestic* and the *devotional* treatment of the subject; a distinction I have been careful to keep in view throughout the whole range of sacred art, and which, in this

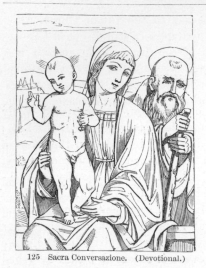 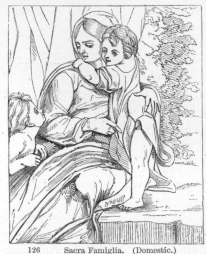

125 Sacra Conversazione. (Devotional.) 126 Sacra Famiglia. (Domestic.)

particular subject, depends on a difference in sentiment and intention, more easily felt than set down in words.

It is, I must repeat, a *devotional* group where the sacred personages are placed in direct relation to the worshippers, and where their supernatural character is paramount to every other. It is a *domestic* or an *historical* group, a Holy Family properly so called, when the personages are placed in direct relation to each other by some link of action or sentiment, which expresses the family connection between them, or by some action which has a dramatic rather than a religious significance. The Italians draw this distinction in the title ' *Sacra Conversazione* ' given to the first-named subject, and that of ' *Sacra Famiglia* ' given to the last. For instance, if the Virgin, watching her sleeping Child, puts her finger on her lip to silence the little St. John, there is here no relation between the spectator and the persons represented, except that of unbidden sympathy: it is a family group, a domestic scene. But if St. John, looking out of the picture, points to the Infant, ' Behold the Lamb of God! ' then the whole representation changes its significance; St. John assumes the character of precursor, and we, the spectators, are directly addressed and called upon to acknowledge the ' Son of God, the Saviour of mankind.'

If St. Joseph, kneeling, presents flowers to the Infant Christ, while Mary looks on tenderly (as in a group by Raphael), it is an act of homage which expresses the mutual relation of the three personages; it is a Holy Family: whereas, in the picture by Murillo, in our National Gallery, where Joseph and Mary present the young Redeemer to the homage of the spectator, while the form of the PADRE ETERNO, and the Holy Spirit, with attendant angels, are floating above, we have a devotional group, a '*Sacra Conversazione*:'—it is, in fact, a material representation of the Trinity; and the introduction of Joseph into such immediate propinquity with the personages acknowledged as divine is one of the characteristics of the later schools of theological art. It could not possibly have occurred before the end of the sixteenth or the beginning of the seventeenth century.

The introduction of persons who could not have been contemporary, as St. Francis or St. Catherine, renders the group ideal and devotional. On the other hand, as I have already observed, the introduction of attendant angels does not place the subject out of the domain of the actual; for the painters literally rendered what in the Scripture text is distinctly set down and literally interpreted, 'He shall give his angels charge concerning thee.' Wherever lived and moved the Infant Godhead, angels were always *supposed* to be present; therefore it lay within the province of an art addressed especially to our senses, to place them bodily before us, and to give to these heavenly attendants a visible shape and bearing worthy of their blessed ministry.

The devotional groups, of which I have already treated most fully, even while placed by the accessories quite beyond the range of actual life, have been too often vulgarised and formalised by a trivial or merely conventional treatment.[1] In these really domestic scenes, where the painter sought unreproved his models in simple nature, and trusted for his effect to what was holiest and most immutable in our common humanity, he must have been a bungler indeed if he did not succeed in touching some responsive chord of sympathy in the bosom of the observer. This is, perhaps, the secret of the universal, and, in general, deserved, popularity of these Holy Families.

[1] See the 'Mater Amabilis' and the 'Pastoral Madonnas,' pp. 114, 128.

TWO FIGURES.

The simplest form of the family group is confined to two figures, and expresses merely the relation between the Mother and the Child. The *motif* is precisely the same as in the formal, goddess-like, enthroned Madonnas of the antique time; but here quite otherwise worked out, and appealing to other sympathies. In the first instance, the intention was to assert the contested pretensions of the human mother to divine honours; here it was rather to assert the humanity of her divine Son; and we have before us, in the simplest form, the first and holiest of all the social relations.

The primal instinct, as the first duty, of the mother, is the nourishment of the life she has given. A very common subject, therefore, is Mary in the act of feeding her Child from her bosom. I have already observed that, when first adopted, this was a theological theme; an answer, *in form*, to the challenge of the Nestorians, 'Shall we call him *God* who hath sucked his mother's breast?' Then, and for at least 500 years afterwards, the simple maternal action involved a religious dogma, and was the visible exponent of a controverted article of faith. All such controversy had long ceased, and certainly there was no thought of insisting on a point of theology in the minds of those secular painters of the sixteenth and seventeenth centuries, who have set forth the representation with such an affectionate and delicate grace; nor yet in the minds of those who converted the lovely group into a moral lesson. For example, we find in the works of Jeremy Taylor (one of the lights of our Protestant Church) a long homily 'Of nursing children, in imitation of the blessed Virgin Mother;' and prints and pictures of the Virgin thus occupied often bear significant titles and inscriptions of the same import; such as 'Le premier devoir d'une mère,' &c.

I do not find this *motif* in any known picture by Raphael; but in one of his designs, engraved by Marc Antonio, it is represented with characteristic grace and delicacy.

Goethe describes with delight a picture by Correggio, in which the attention of the Child seems divided between the bosom of his Mother and some fruit offered by an angel. He calls this subject 'The Weaning of the Infant Christ.' Correggio, if not the very first, is certainly

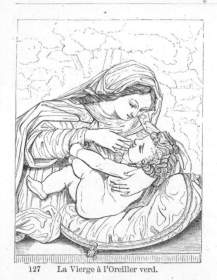

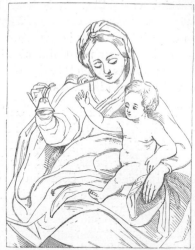

127 La Vierge à l'Oreiller verd. 128 La Madonna della Campanella.

among the first of the Italians who treated this *motif* in the simple domestic style. Others of the Lombard school followed him; and I know not a more exquisite example than the maternal group by Solario, now in the Louvre, styled *La Vierge à l'Oreiller verd*, from the colour of the pillow on which the child is lying. The subject is frequent in the contemporary German and Flemish schools of the sixteenth century. In the next century, there are charming examples by the Bologna painters, and the *Naturalisti*, Spanish, Italian, and Flemish. I would particularly point to one by Agostino Caracci,[1] and to another by Vandyck (that engraved by Bartolozzi), as examples of elegance; while in the numerous specimens by Rubens we have merely his own wife and son, painted with all that coarse vigorous life, and homely affectionate expression, which his own strong domestic feelings could lend them.

We have in other pictures the relation between the Mother and Child expressed and varied in a thousand ways; as where she contemplates him fondly—kisses him, pressing his cheeks to hers; or they sport with a rose, or an apple, or a bird; or he presents it to his mother; these originally mystical emblems being converted into playthings. In this sketch (128) she is amusing him by tinkling a bell:—the bell, which has

[1] Parma.

a religious significance, is here a plaything. One or more attendant angels may vary the group, without taking it out of the sphere of reality. In a quaint but charming picture in the Wallerstein Collection, an angel is sporting with the Child at his mother's feet—is literally his play-fellow; and in a picture by Cambiaso, Mary, assisted by an angel, is teaching her Child to walk.

To represent, in the great enthroned Madonnas, the Infant Saviour of the world asleep, has always appeared to me a solecism : whereas in the domestic subject, the Infant slumbering on his mother's knee, or cradled in her arms, or on her bosom, or rocked by angels, is a most charming subject. Sometimes angels are seen preparing his bed, or looking on while he sleeps, with folded hands and overshadowing wings. Sometimes Mary hangs over his pillow, 'pondering in her heart' the wondrous destinies of her Child. A poetess of our own time has given us an interpretation worthy of the most beautiful of these representa-tions, in the address of the Virgin Mary to the Child Jesus —'Sleep, sleep, mine Holy One!'

> And art thou come for saving, baby-browed
> And speechless Being? art thou come for saving?
> The palm that grows beside our door is bowed
> By treadings of the low wind from the south,
> A restless shadow through the chamber waving.
> Upon its bough a bird sings in the sun.
> But thou, with that close slumber on thy mouth,
> Dost seem of wind and sun already weary.
> Art come for saving, O my weary One?
>
> Perchance this sleep that shutteth out the dreary
> Earth-sounds and motions, opens on thy soul
> High dreams on fire with God ;
> High songs that make the pathways where they roll
> More bright than stars do theirs ; and visions new
> Of thine eternal nature's old abode.
> Suffer this mother's kiss,
> Best thing that earthly is,
> To glide the music and the glory through,
> Nor narrow in thy dream the broad upliftings
> Of any seraph wing.
> Thus, noiseless, thus!—Sleep, sleep, my dreaming One.[1]

[1] Poems by Elizabeth Barrett Browning, vol. ii. p. 174.

Such high imaginings might be suggested by the group of Michael Angelo—his famous 'Silenzio:' but very different certainly are the thoughts and associations conveyed by some of the very lovely, but at the same time familiar and commonplace, groups of peasant mothers and sleeping babies—the countless productions of the later schools—even while the simplicity and truth of the natural sentiment go straight to the heart.

I remember reading a little Italian hymn composed for a choir of nuns, and addressed to the sleeping Christ, in which he is prayed to awake; or if he will not, they threaten to pull him by his golden curls until they rouse him to listen!

I have seen a graceful print which represents Jesus as a child standing at his mother's knee, while she feeds him from a plate or cup held by an angel; underneath is the text, *Butter and honey shall he eat, that he may know to refuse the evil and choose the good.* And in a print of the same period, the mother suspends her needlework to contemplate the Child, who, standing at her side, looks down compassionately on two little birds, which flutter their wings and open their beaks expectingly; underneath is the text, 'Are not two sparrows sold for a farthing?'

Mary employed in needlework, while her cradled Infant slumbers at her side, is a beautiful subject. Rossini, in his *Storia della Pittura*, publishes a group, representing the Virgin mending or making a little coat, while Jesus, seated at her feet without his coat, is playing with a bird; two angels are hovering above. It appears to me that there is here some uncertainty as regards both the subject and the master. In the time of Giottino, to whom Rossini attributes the picture, the domestic treatment of the Madonna and Child was unknown. If it be really by him, I should suppose it to represent Hannah and her son Samuel.

All these, and other varieties of action and sentiment connecting the Mother and her Child, are frequently accompanied by accessory figures, forming, in their combination, what is properly a Holy Family. The personages introduced, singly or together, are the young St. John, Joseph, Anna, Joachim, Elizabeth, and Zacharias.

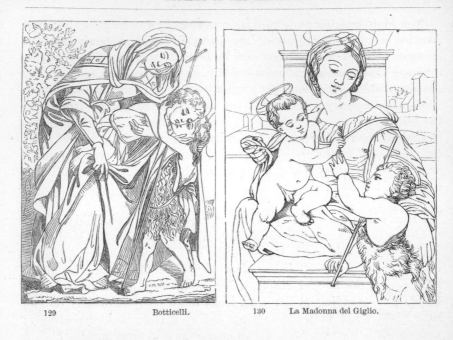

129 Botticelli. 130 La Madonna del Giglio.

THREE FIGURES.

The group of three figures most commonly met with is that of the
Mother and Child, with St. John. One of the earliest examples of the
domestic treatment of this group is a quaint picture by Botticelli (129),
in which Mary, bending down, holds forth the Child to be caressed by
St. John—very dry in colour, and faulty in drawing, but beautiful for
the sentiment.[1] Perhaps the most perfect example which could be cited
from the whole range of art, is Raphael's ' Madonna del Cardellino ; '[2]
another is his ' Belle Jardinière ; '[3] another, in which the figures are
half-length, is his ' Madonna del Giglio.'[4] As I have already observed,
where the Infant Christ takes the cross from St. John, or presents it to
him, or where St. John points to him as the Redeemer, or is represented,
not as a child, but as a youth or a man, the composition assumes a de-
votional significance.

[1] Florence, Pitti Pal. [2] Florence Gal. [3] Louvre, 375. [4] Lord Garvagh's Coll.

The subject of the Sleeping Christ is beautifully varied by the introduction of St. John; as where Mary lifts the veil and shows her Child to the little St. John, kneeling with folded hands: Raphael's well-known 'Vierge à la Diadème' is an instance replete with grace and expression.[1] Sometimes Mary, putting her finger to her lip, exhorts St. John to silence, as in a famous and oft-repeated subject by Annibal Caracci, of which there is a lovely example at Windsor. Such a group is called in Italian, *il Silenzio,* and in French *le Sommeil de Jésus.*

Another group of three figures consists of the Mother, the Child, and St. Joseph as foster-father. This group, so commonly met with in the later schools of art, dates from the end of the fifteenth century. Gerson, an ecclesiastic distinguished at the Council of Constance for his learning and eloquence, had written a poem of three thousand lines in praise of St. Joseph, setting him up as the Christian example of every virtue; and this poem, after the invention of printing, was published and widely disseminated. Sixtus IV. instituted a festival in honour of the 'Husband of the Virgin,' which, as a novelty and harmonising with the tone of popular feeling, was everywhere acceptable. As a natural consequence, the churches and chapels were filled with pictures, which represented the Mother and her Child, with Joseph standing or seated by, in an attitude of religious contemplation or affectionate sympathy; sometimes leaning on his stick, or with his tools lying beside him; and always in the old pictures habited in his appropriate colours, the saffron-coloured robe over the grey or green tunic.

In the Madonna and Child, as a strictly devotional subject, the introduction of Joseph rather complicates the idea; but in the domestic Holy Family his presence is natural and necessary. It is seldom that he is associated with the action, where there is one; but of this also there are some beautiful examples.

1. In a well-known composition by Raphael,[2] the mother withdraws the covering from the Child, who seems to have that moment awaked,

[1] Louvre, 376. It is also styled *la Vierge au Linge.* [2] Grosvenor Gal.

and, stretching out his little arms, smiles in her face: Joseph looks on tenderly and thoughtfully. (131)

2. In another group by Raphael,[1] the Infant is seated on the mother's knee, and sustained by part of her veil; Joseph, kneeling, offers flowers to his divine foster-Son, who eagerly stretches out his little hand to take them.

In many pictures, Joseph is seen presenting cherries; as in the celebrated *Vierge aux Cerises* of Annibal Caracci.[2] The allusion is to a quaint old legend, often introduced in the religious ballads and dra-

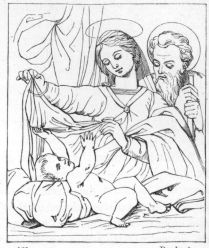

131　　　　　　　　　　Raphael.

matic mysteries of the time. It is related, that before the birth of our Saviour, the Virgin Mary wished to taste of certain cherries which hung upon a tree high above her head; she requested Joseph to procure them for her, and he reaching to pluck them, the branch bowed down to his hand.

3. There is a lovely pastoral composition by Titian, in which Mary is seated under some trees, with Joseph leaning on his staff, and the Infant Christ standing between them; the little St. John approaches with his lap full of cherries; and in the background a woman is seen gathering cherries. This picture is called a Riposo; but the presence of St. John, and the cherry tree instead of the date tree, point out a different signification. Angels presenting cherries on a plate is also a frequent circumstance, derived from the same legend.

4. In a charming picture by Garofalo, Joseph is caressing the Child, while Mary—a rather full figure, calm, matronly, and dignified, as is usual with Garofalo—sits by, holding a book in her hand, from which she has just raised her eyes.[3]

5. In a family group by Murillo, Joseph, standing, holds the Infant

[1] Bridgewater Gal.　　　　　[2] Louvre.　　　　　[3] Windsor Gal.

pressed to his bosom; while Mary, seated near a cradle, holds out her arms to take it from him: a carpenter's bench is seen behind.

6. A celebrated picture by Rembrandt, known as *le Ménage du Menuisier*, exhibits a rustic interior; the Virgin is seated with the volume of the Scriptures open on her knees—she turns, and, lifting the coverlid of the cradle, contemplates the Infant asleep: in the background Joseph is seen at his work; while angels hover above, keeping watch over the Holy Family. Exquisite for the homely natural sentiment, and the depth of the colour and chiaroscuro.[1]

7. Many who read these pages will remember the pretty little picture, by Annibal Caracci, known as 'le Raboteur.'[2] It represents Joseph planing a board, while Jesus, a lovely boy about six or seven years old, stands by, watching the progress of his work. Mary is seated on one side, plying her needle. The great fault of this picture is the subordinate and utterly commonplace character given to the Virgin Mother: otherwise, it is a very suggestive and dramatic subject, and one which might be usefully engraved in a cheap form for distribution.

Sometimes, in a Holy Family of three figures, the third figure is neither St. John nor St. Joseph, but St. Anna. Now, according to some early authorities, both Joachim and Anna died, either before the marriage of Mary and Joseph, or at least before the return from Egypt. Such, however, was the popularity of these family groups, and the desire to give them all possible variety, that the ancient version of the story was overruled by the prevailing taste, and St. Anna became an important personage. One of the earliest groups in which the mother of the Virgin is introduced as a third personage, is a celebrated, but to my taste not a pleasing, composition, by Lionardo da Vinci, in which St. Anna is seated on a sort of chair, and the Virgin on her knees bends down towards the Infant Christ, who is sporting with a lamb.[3]

[1] Petersburg. [2] In the Coll. of the Earl of Suffolk, at Charlton. [3] Louvre, 481.

FOUR FIGURES.

In a Holy Family of four figures, we have frequently the Virgin, the Child, and the infant St. John, with St. Joseph standing by. Raphael's Madonna del Passeggio is an example. In a picture by Palma Vecchio, St. John presents a lamb, while St. Joseph kneels before the Infant Christ, who, seated on his mother's knee, extends his arms to his foster-father. Nicolò Poussin was fond of this group, and has repeated it at least ten times with variations.

But the most frequent group of four figures consists of the Virgin and Child, with St. John and his mother St. Elizabeth—the two mothers and the two sons. Sometimes the children are sporting together, or embracing each other, while Mary and Elizabeth look on with a contemplative tenderness, or seem to converse on the future destinies of their sons. A very favourite and appropriate action is that of St. Elizabeth presenting St. John, and teaching him to kneel and fold his hands, as acknowledging in his little cousin the Infant Saviour. We have then, in beautiful contrast, the aged coifed head of Elizabeth, with its matronly and earnest expression; the youthful bloom and soft virginal dignity of Mary; and the different character of the boys, the fair complexion and delicate proportions of the Infant Christ, and the more robust and brown-complexioned John. A great painter will be careful to express these distinctions, not by the exterior character only, but will so combine the personages, that the action represented shall display the superior dignity of Christ and his mother.

FIVE OR SIX FIGURES.

The addition of Joseph, as a fifth figure, completes the domestic group. The introduction of the aged Zacharias renders, however, yet more full and complete, the circle of human life and human affection. We have then infancy, youth, maturity, and age,—difference of sex and various degrees of relationship, combined into one harmonious whole; and in the midst, the divinity of innocence, the Child-God, the

brightness of a spiritual power, connecting our softest earthly affections with our highest heavenward aspirations.[1]

A Holy Family of more than six figures (the angels not included) is very unusual. But there are examples of groups combining all those personages mentioned in the Gospels as being related to Christ, though the nature and the degree of this supposed relationship has embarrassed critics and commentators, and is not yet settled.

According to an ancient tradition, Anna, the mother of the Virgin Mary, was three times married, Joachim being her third husband: the two others were Cleophas and Salomé. By Cleophas she had a daughter, also called Mary, who was the wife of Alpheus, and the mother of Thaddeus, James Minor, and Joseph Justus. By Salomé, she had a daughter, also Mary, married to Zebedee, and the mother of James Major and John the Evangelist. This idea that St. Anna was successively the wife of three husbands, and the mother of three daughters, all of the name of Mary, has been rejected by later authorities; but in the beginning of the sixteenth century it was accepted, and to that period may be referred the pictures, Italian and German, representing a peculiar version of the Holy Family more properly styled 'the Family of the Virgin Mary.'

A picture by Lorenzo di Pavia, painted about 1513, exhibits a very complete example of this family group. Mary is seated in the centre, holding in her lap the Infant Christ; near her is St. Joseph. Behind the Virgin stand St. Anna, and three men, with their names inscribed, Joachim, Cleophas, and Salomé. On the right of the Virgin are Mary the daughter of Cleophas, Alpheus her husband, and her children Thaddeus, James Minor, and Joseph Justus. On the left of the Virgin are Mary the daughter of Salomé, her husband Zebedee, and her children James Major and John the Evangelist.[2]

A yet more beautiful example is a picture by Perugino in the Musée

[1] The inscription under a Holy Family in which the children are caressing each other is sometimes *Deliciæ meæ esse cum filiis hominum* (Prov. viii. 31: 'My delights were with the sons of men).'

[2] This picture I saw in the Louvre some years ago, but it is not in the New Catalogue by M. Villot.

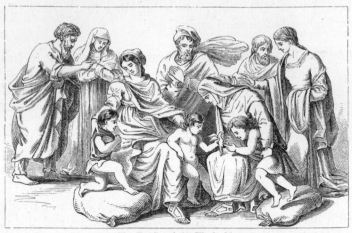

132 The Family of the Virgin Mary.

at Marseilles, which I have already cited and described: [1] here also the relatives of Christ, destined to be afterwards his apostles and the ministers of his word, are grouped around him in his infancy. In the centre Mary is seated and holding the Child; St. Anna stands behind, resting her hands affectionately on the shoulders of the Virgin. In front, at the feet of the Virgin, are two boys, Joseph and Thaddeus; and near them Mary, the daughter of Cleophas, holds the hands of her third son, James Minor. To the right is Mary Salomé, holding in her arms her son John the Evangelist, and at her feet is her other son, James Major. Joseph, Zebedee, and other members of the family, stand around. The same subject I have seen in illuminated MSS., and in German prints. It is worth remarking that all these appeared about the same time, between 1505 and 1520, and that the subject afterwards disappeared; from which I infer that it was not authorised by the Church; perhaps because the exact degree of relationship between these young apostles and the Holy Family was not clearly made out, either by Scripture or tradition.

In this little sketch, (132) which is from a composition by Parmigiano, Christ is standing at his mother's knee; Elizabeth presents St. John the

[1] Sacred and Legendary Art, 3rd edit. p. 253.

Baptist; the other little St. John kneels on a cushion. Behind the Virgin are St. Joachim and St. Anna; and behind Elizabeth, Zebedee and Mary Salomé, the parents of St. John the Evangelist. In the centre, Joseph looks on with folded hands.

A catalogue *raisonnée* of the Holy Families painted by distinguished artists including from two to six figures would fill volumes: I shall content myself with directing attention to some few examples remarkable either for their celebrity, their especial beauty, or for some peculiarity, whether commendable or not, in the significance or the treatment.

The strictly domestic conception may be said to have begun with Raphael and Correggio; and they afford the most perfect examples of the tender and the graceful in sentiment and action, the softest parental feeling, the loveliest forms of childhood. Of the purely natural and familiar treatment, which came into fashion in the seventeenth century, the pictures of Guido, Rubens, and Murillo afford the most perfect specimens.

1. Raphael.[1] Mary, a noble queenly creature, is seated, and bends towards her Child, who is springing from his cradle to meet her embrace; Elizabeth presents St. John; and Joseph, leaning on his hand, contemplates the group: two beautiful angels scatter flowers from above. This is the celebrated picture once supposed to have been executed expressly for Francis I.; but later researches prove it to have been painted for Lorenzo de' Medici, Duke of Urbino.[2]

2. Correggio. Mary holds the Child upon her knee, looking down

[1] Louvre, 377.

[2] It appears from the correspondence relative to this picture and the 'St. Michael,' that both pictures were painted by order of this Lorenzo de' Medici, the same who is figured in Michael Angelo's *Pensiero*, and that they were intended as presents to Francis I. (See Dr. Gaye's *Carteggio*, ii. 146, and also the new Catalogue of the Louvre by F. Villot.) I have mentioned this Holy Family not as the finest of Raphael's Madonnas, but because there is something peculiarly animated and dramatic in the *motif*, considering the time at which it was painted. It was my intention to have given here a complete list of Raphael's Holy Families; but this has been so well done in the last English edition of Kugler's Handbook, that it has become superfluous as a repetition. The series of minute and exquisite drawings by Mr. George Scharf, appended to Kugler's Catalogue, renders it easy to recognise all the groups described in this and the preceding pages.

upon him fondly. Styled, from the introduction of the workbasket, *La Vierge au Panier*. A finished example of that soft, yet joyful, maternal feeling for which Correggio was remarkable.[1]

3. Pinturicchio. In a landscape, Mary and Joseph are seated together; near them are some loaves and a small cask of wine. More in front the two children, Jesus and St. John, are walking arm in arm; Jesus holds a book, and John a pitcher, as if they were going to a well.[2]

4. Andrea del Sarto. The Virgin is seated on the ground, and holds the Child; the young St. John is in the arms of St. Elizabeth, and Joseph is seen behind.[3] This picture, another by the same painter in the National Gallery, a third in the collection of Lord Lansdowne, and in general all the Holy Families of Andrea, may be cited as examples of fine execution and mistaken or defective character. No sentiment, no action, connects the personages either with each other, or with the spectator.

5. Michael Angelo. The composition, in the Florence Gallery, styled a Holy Family, appears to me a signal example of all that should be avoided. It is, as a conception, neither religious nor domestic; in execution and character exaggerated and offensive, and in colour hard and dry.

Another, a bas-relief, in which the Child is shrinking from a bird held up by St. John, is very grand in the forms: the mistake in sentiment, as regards the bird, I have pointed out in the Introduction.[4] A third, in which the Child leans pensively on a book lying open on his mother's knee, while she looks out on the spectator, is more properly a *Mater Amabilis.*

There is an extraordinary fresco still preserved in the Casa Buonarotti at Florence, where it was painted on the wall by Michael Angelo, and styled a Holy Family, though the exact meaning of the subject has been often disputed. It appears to me, however, very clear, and one never before or since attempted by any other artist.[5] Mary is seated in the centre; her Child is reclining on the ground between her knees; and the little St. John, holding his cross, looks on him steadfastly. A man coming forward, seems to ask of Mary, 'Whose son is this?' She

[1] National Gal. 23. [2] Siena Acad. [3] Louvre, 439. [4] Royal Academy.
[5] This fresco is engraved in the *Etruria Pittrice.*

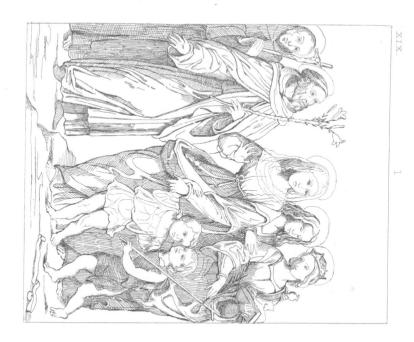

1

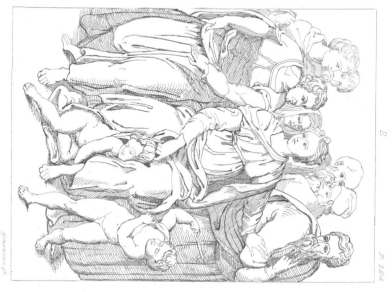

2

Domestic Holy Families.

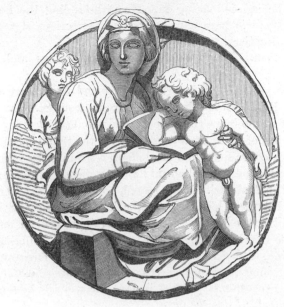

133

most expressively puts aside Joseph with her hand, and looks up, as if answering, 'Not the son of an earthly, but of a heavenly Father!' There are five other figures standing behind, and the whole group is most significant.

6. Albert Durer. The Holy Family seated under a tree; the Infant is about to spring from the knee of his mother into the outstretched arms of St. Anna; Joseph is seen behind with his hat in his hand; and to the left sits the aged Joachim contemplating the group.

7. Mary appears to have just risen from her chair, the Child bends from her arms, and a young and very little angel, standing on tip-toe, holds up to him a flower—other flowers in his lap:—a beautiful old German print.

8. Giulio Romano. (*La Madonna del Bacino.*)[1] The Child stands in a basin, and the young St. John pours water upon him from a vase, while Mary washes him. St. Elizabeth stands by, holding a napkin;

[1] Dresden Gal.

M M

St. Joseph, behind, is looking on. Notwithstanding the homeliness of the action, there is here a religious and mysterious significance, prefiguring the Baptism.

9. N. Poussin. Mary, assisted by angels, washes and dresses her Child.[1]

10. V. Salimbeni.—An Interior. Mary and Joseph are occupied by the Child. Elizabeth is spinning. More in front St. John is carrying two puppies in the lappet of his coat, and the dog is leaping up to him.[2] This is one out of many instances in which the painter, anxious to vary the oft-repeated subject, and no longer restrained by refined taste or religious veneration, has fallen into a most offensive impropriety.

11. Ippolito Andreasi. Mary, seated, holds the Infant Christ between her knees; Elizabeth leans over the back of her chair; Joseph leans on his staff behind the Virgin; the little St. John and an angel present grapes, while four other angels are gathering and bringing them. A branch of vine, loaded with grapes, is lying in the foreground. Christ looks like a young Bacchus; and there is something mannered and fantastic in the execution.[3] With this domestic scene is blended a strictly religious symbol, '*I am the vine.*'

12. Murillo. Mary is in the act of swaddling her Child (Luke ii. 7), while two angels, standing near him, solace the divine Infant with heavenly music.[4]

13. Rubens. Mary, seated on the ground, holds the Child, with a charming maternal expression, a little from her, gazing on him with rapturous earnestness, while he looks up with responsive tenderness in her face. His right hand rests on a cross presented by St. John, who is presented by St. Elizabeth. Wonderful for the intensely natural and domestic expression, and the beauty of the execution.[5]

14. D. Hopfer. Within the porch of a building, Mary is seated on one side, reading intently. St. Anna, on the other side, holds out her arms to the Child, who is sitting on the ground between them: an angel looks in at the open door behind.[6]

15. Rembrandt. (*Le Ménage du Menuisier.*) A rustic interior.

[1] Gal. of Mr. Hope.
[2] Florence, Pitti Pal.
[3] Louvre, 38.
[4] Madrid Gal.
[5] Florence, Pitti Pal.
[6] Bartsch, viii. 483.

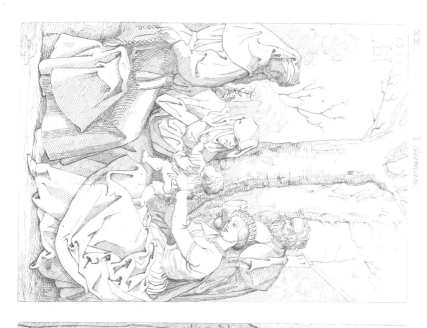

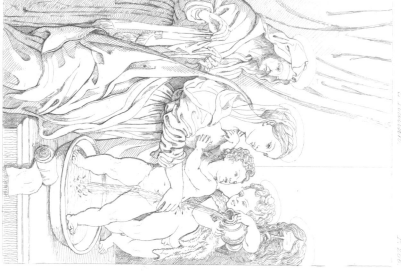

Mary, seated in the centre, is suckling her Child. St. Anna, a fat Flemish grandame, has been reading the volume of the Scriptures, and bends forward in order to remove the covering and look in the Infant's face. A cradle is near. Joseph is seen at work in the background.[1]

16. Le Brun. (*The Benedicite.*) Mary, the Child, and Joseph, are seated at a frugal repast. Joseph is in the act of reverently saying grace, which gives to the picture the title by which it is known.[2]

It is distinctly related, that Joseph brought up his foster-Son as a carpenter, and that Jesus exercised the craft of his reputed father. In the Church pictures, we do not often meet with this touching and familiar aspect of the life of our Saviour. But in the small decorative pictures painted for the rich ecclesiastics, and for private oratories, and in the cheap prints which were prepared for distribution among the people, and became especially popular during the religious reaction of the seventeenth century, we find this homely version of the subject perpetually, and often most pleasingly, exhibited. The greatest and wisest Being who ever trod the earth was thus represented, in the eyes of the poor artificer, as ennobling and sanctifying labour and toil; and the quiet domestic duties and affections were here elevated and hallowed by religious associations, and adorned by all the graces of Art. Even where the artistic treatment was not first-rate, was not such as the painters—priests and poets as well as painters—of the fourteenth and fifteenth centuries would have lent to such themes—still, if the sentiment and significance were but intelligible to those especially addressed, the purpose was accomplished, and the effect must have been good.

I have before me an example in a set of twelve prints, executed in the Netherlands, exhibiting a sort of history of the childhood of Christ, and his training under the eye of his mother. It is entitled *Jesu Christi Dei Domini Salvatoris nostri Infantia,* 'The Infancy of our Lord God and Saviour Jesus Christ;' and the title-page is surrounded by a border composed of musical instruments, spinning-wheels, distaffs, and other

[1] Louvre.

[2] Louvre, Ecole Française, 57. There is a celebrated engraving by Edelinck.

implements of female industry, intermixed with all kinds of mason's and carpenter's tools. To each print is appended a descriptive Latin verse; Latin being chosen, I suppose, because the publication was intended for distribution in different countries, and especially foreign missions, and to be explained by the priests to the people.

1. The figure of Christ is seen in a glory surrounded by cherubim, &c.

2. The Virgin is seated on the hill of Sion. The Infant in her lap, with outspread arms, looks up to a choir of angels, and is singing with them.

3. Jesus, slumbering in his cradle, is rocked by two angels, while Mary sits by, engaged in needlework.[1]

4. The interior of a carpenter's shop. Joseph is plying his work, while Joachim stands near him. The Virgin is measuring linen, and St. Anna looks on. Two angels are at play with the Infant Christ, who is blowing soap-bubbles.

5. While Mary is preparing the family meal, and watching a pot which is boiling on the fire, Joseph is seen behind chopping wood: more in front, Jesus is sweeping together the chips, and two angels are gathering them up.

6. Mary is reeling off a skein of thread; Joseph is squaring a plank; Jesus is picking up the chips, assisted by two angels.

7. Mary is seated at her spinning-wheel; Joseph, assisted by Jesus, is sawing through a large beam; two angels looking on.

8. Mary is spinning with a distaff; behind, Joseph is sawing a beam, on which Jesus is standing above; and two angels are lifting a plank.

9. Joseph is seen building up the framework of a house, assisted by

[1] The Latin stanza beneath is remarkable for its elegance, and because it has been translated by Coleridge, who mentions that he found the print and the verse under it in a little inn in Germany.

Dormi, Jesu, mater ridet,	Sleep, sweet babe! my cares beguiling,
Quæ tam dulcem somnum videt,	Mother sits beside thee smiling;
Dormi, Jesu, blandule!	Sleep, my darling, tenderly!
Si non dormis mater plorat,	If thou sleep not, mother mourneth,
Inter fila cantans orat,	Singing as her wheel she turneth:
Blande, veni, somnule!	'Come, soft slumber, balmily!'

an angel; Jesus is boring a hole with a large gimlet; an angel helps him; Mary is winding thread.

10. Joseph is busy roofing in the house; Jesus, assisted by the angels, is carrying a beam of wood up a ladder; below, in front, Mary is carding wool or flax.

11. Joseph is building a boat, assisted by Jesus, who has a hammer and chisel in his hand: two angels help him. The Virgin is knitting a stocking; and the new-built house is seen in the background.

12. Joseph is erecting a fence round a garden; Jesus, assisted by the angels, is fastening the palings together; while Mary is weaving garlands of roses.

Justin Martyr mentions, as a tradition of his time, that Jesus assisted his foster-father in making yokes and ploughs. In Holland, where these prints were published, the substitution of the boat-building seems very natural. St. Bonaventura, the great Franciscan theologian, and a high authority in all that relates to the life and character of Mary, not only describes her as a pattern of female industry, but alludes particularly to the legend of the distaff, and mentions a tradition, that, when in Egypt, the Holy Family was so reduced by poverty, that Mary begged from door to door the fine flax which she afterwards spun into a garment for her Child.

As if to render the circle of maternal duties, and thereby the maternal example, more complete, there are prints of Mary leading her Son to school. I have seen one in which he carries his hornbook in his hand. Such representations, though popular, were condemned by the highest church authorities as nothing less than heretical. The Abbé Méry counts among the artistic errors 'which endanger the faith of good Christians,' those pictures which represent Mary or Joseph instructing the Infant Christ; as if all learning, all science, divine and human, were not his by intuition, and without any earthly teaching.[1] A beautiful Holy Family, by Schidone, is entitled, 'The Infant Christ learning to read;'[2] and we frequently meet with pictures in which the mother holds a book, while the divine Child, with a serious intent expression,

[1] v. Théologie des Peintres. [2] Bridgewater Gal.

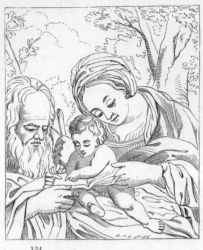

134

turns over the leaves, or points to the letters : but I imagine that these, and similar groups, represent Jesus instructing Mary and Joseph, as he is recorded to have done. There is also a very pretty legend, in which he is represented as exciting the astonishment of the schoolmaster Zaccheus by his premature wisdom. On these, and other details respecting the infancy of our Saviour, I shall have to say much more when treating of the History of Christ.

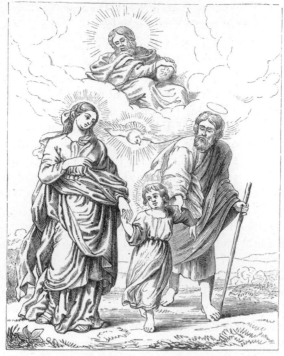

135 Mary and Joseph conduct Jesus home. (Rubens.)

THE DISPUTE IN THE TEMPLE.

Ital. La Disputa nel Tempio. *Fr.* Jésus au milieu des Docteurs.

THE subject which we call the Dispute in the Temple, or 'Christ among the Doctors,' is a scene of great importance in the life of the Redeemer (Luke ii. 41, 52). His appearance in the midst of the doctors, at twelve years old, when he sat 'hearing them and asking them questions, and all who heard him were astonished at his understanding and his answers,' has been interpreted as the first manifestation of his high character as teacher of men, as one come to throw a new light on the prophecies,—

> For trailing clouds of glory had he come
> From heaven, which was his home ;

and also as instructing us that those who are to become teachers of men ought, when young, to listen to the voice of age and experience; and that those who have grown old may learn lessons of wisdom from childish innocence. Such is the historical and scriptural representation. But in the life of the Virgin, the whole scene changes its signification. It is no longer the wisdom of the Son, it is the sorrow of the Mother which is the principal theme. In their journey home from Jerusalem, Jesus has disappeared; he who was the light of her eyes, whose precious existence had been so often threatened, has left her care, and gone she knows not whither. 'No fancy can imagine the doubts, the apprehensions, the possibilities of mischief, the tremblings of heart, which the holy Virgin Mother feels thronging in her bosom. For three days she seeks him in doubt and anguish.'[1] At length he is found seated in the temple in the midst of the learned doctors, 'hearing them, and asking them questions.' And she said unto him, 'Son, why hast thou thus dealt with us? behold, I and thy father have sought thee sorrowing.' And he said unto them, 'How is it that ye sought me? wist ye not that I must be about my Father's business?'

Now there are two ways of representing this scene. In all the earlier pictures, it is chiefly with reference to the Virgin Mother; it is one of the sorrowful mysteries of the Rosary. The Child Jesus sits in the temple, teaching with hand uplifted; the doctors round him turn over the leaves of their great books, searching the law and the prophets. Some look up at the young inspired Teacher—he who was above the law, yet came to obey the law and fulfil the prophecies—with amazement. Conspicuous in front, stand Mary and Joseph, and she is in act to address to him the tender reproach, 'I and thy father have sought thee sorrowing.' In the early examples she is a principal figure, but in later pictures she is seen entering in the background; and where the scene relates only to the life of Christ, the figures of Joseph and Mary are omitted altogether, and the Child teacher becomes the central, or at least the chief, personage in the group.

[1] Jeremy Taylor's Life of Christ.

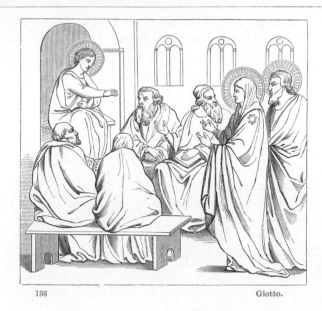

136 Giotto.

In a picture by Giovanni da Udine, the subject is taken out of the region of the actual, and treated altogether as a mystery. In the centre sits the young Redeemer, his hand raised, and surrounded by several of the Jewish doctors; while in front stand the four fathers of the Church, who flourished in the interval between the fourth and sixth centuries after Christ; and these, holding their books, point to Jesus, or look to him, as to the source of their wisdom—a beautiful and poetical version of the true significance of the story, which the critics of the last century would call a chronological mistake.[1]

But those representations which come under our especial consideration at present, are such as represent the moment in which Mary appears before her Son. The earliest instance of this treatment is a group by Giotto. (136) Dante cites the deportment of the Virgin on this occasion, and her mild reproach, ' *con atto dolce di madre,*' as a signal lesson of gentleness and forbearance.[2] It is as if he had transferred the picture of Giotto into his vision; for it is as a picture, not an action, that it is

[1] Venice, Academy. [2] Purgatorio, c. xv.

introduced. Another, by Simon Memmi, in the Roscoe Collection at Liverpool, is conceived in a similar spirit. In a picture by Garofalo, Mary does not reproach her Son, but stands listening to him with her hands folded on her bosom. In a large and fine composition by Pinturicchio, the doctors throw down their books before him, while the Virgin and Joseph are entering on one side. The subject is conspicuous in Albert Durer's Life of the Virgin, where Jesus is seated on high, as one having authority, teaching from a chair like that of a professor in a university, and surrounded by the old bearded doctors; and Mary stands before her Son in an attitude of expostulation.

After the restoration of Jesus to his parents, they conducted him home; 'but his mother kept all these sayings in her heart.' The return to Nazareth, Jesus walking humbly between Joseph and Mary, was painted by Rubens for the Jesuit College at Antwerp, as a lesson to youth. Underneath is the text, 'And he was subject unto them.'[1]

THE DEATH OF JOSEPH.

Ital. La Morte di San Giuseppe. *Fr.* La Mort de St. Joseph. *Ger.* Josef's Tod.

BETWEEN the journey to Jerusalem and the public appearance of Jesus, chronologers place the death of Joseph, but the exact date is not ascertained; some place it in the eighteenth year of the life of our Saviour, and others in his twenty-seventh year, when, as they assert, Joseph was one hundred and eleven years old.

I have already observed, that the enthusiasm for the character of Joseph, and his popularity as a saint and patron of power, date from the fifteenth century; and late in the sixteenth century I find, for the first time, the death of Joseph treated as a separate subject. It appears that the supposed anniversary of his death (July 20) had long been regarded in the East as a solemn festival, and that it was the custom to read publicly, on this occasion, some homily relating to his life and death. The very curious Arabian work, entitled 'The History of Joseph the

[1] It has been called by mistake 'The Return from Egypt.'

Carpenter,' is supposed to be one of these ancient homilies, and, in its original form, as old as the fourth century.[1] Here the death of Joseph is described with great detail, and with many solemn and pathetic circumstances; and the whole history is put into the mouth of Jesus, who is supposed to recite it to his disciples: he describes the pious end of Joseph; he speaks of himself as being present, and acknowledged by the dying man as 'Redeemer and Messiah,' and he proceeds to record the grief of Mary:—

'And my mother, the Virgin, arose, and she came nigh to me and said, "O my beloved Son, now must the good old man die!" and I answered and said unto her, "O my most dear mother, needs must all created beings die; and death will have his rights, even over thee, beloved mother; but death to him and to thee is no death, only the passage to eternal life; and this body I have derived from thee shall also undergo death."'

And they sat, the Son and the mother, beside Joseph; and Jesus held his hand, and watched the last breath of life trembling on his lips; and Mary touched his feet, and they were cold; and the daughters and the sons of Joseph wept and sobbed around in their grief; and then Jesus adds tenderly, 'I, and my mother Mary, we wept with them.'

Then follows a truly oriental scene, of the evil angels rising up with Death, and rejoicing in his power over the saint, while Jesus rebukes them; and at his prayer God sends down Michael, prince of the angelic host, and Gabriel, the herald of light, to take possession of the departing spirit, enfold it in a robe of brightness thereby to preserve it from the 'dark angels,' and carry it up into heaven.

This legend of the death of Joseph was, in many forms, popular in the sixteenth century; hence arose the custom of invoking him as intercessor to obtain a blessed and peaceful end, so that he became, in some sort, the patron saint of deathbeds; and it is at this time we find the first representations of the death of Joseph, afterwards a popular subject in the churches and convents of the Augustine canons and Carmelite

[1] The Arabic MS. in the library at Paris is of the year 1299, and the Coptic version as old as 1367. Extracts from these were become current in the legends of the West, about the fifteenth century.—See the Neu Testamentlichen Apokryphon, edited in German by Dr. K. F. Borberg.

friars, who had chosen him for their patron saint; and also in family chapels consecrated to the memory or the repose of the dead.

The finest example I have seen is by Carlo Maratti, in the Vienna Gallery. St. Joseph is on a couch; Christ is seated near him; and the Virgin stands by with folded hands, in a sad, contemplative attitude.

I am not aware that the Virgin has ever been introduced into any representation of the temptation or the baptism of our Saviour. These subjects, so important and so picturesque, are reserved till we enter upon the History of Christ.

The Marriage at Cana in Galilee.

Ital. Le Nozze di Cana. *Fr.* Les Noces de Cana. *Ger.* Die Hochzeit zu Cana.

AFTER his temptation and baptism, the first manifestation of the divine mission and miraculous power of Jesus was at the wedding feast at Cana in Galilee; and those who had devoted themselves to the especial glorification of the Virgin Mother did not forget that it was at her request this first miracle was accomplished :—that out of her tender and sympathetic commiseration for the apparent want, arose her appeal to him— not, indeed, as requiring anything from him, but looking to him with habitual dependence on his goodness and power. She simply said, 'They have no wine!' He replied, 'Woman, what have I to do with thee? mine hour is not yet come.' The term *woman*, thus used, sounds harsh to us; but in the original is a term of respect. Nor did Jesus intend any denial to the mother, whom he regarded with dutiful and pious reverence :—it was merely an intimation that he was not yet entered into the period of miraculous power. He anticipated it, however, for her sake, and because of her request. Such is the view taken of this beautiful and dramatic incident by the early theologians; and in the same spirit it has been interpreted by the painters.

The Marriage at Cana appears very seldom in the ancient representations taken from the Gospel. All the monkish institutions then prevalent discredited marriage; and it is clear that this distinct consecration

of the rite by the presence of the Saviour and his mother did not find favour with the early patrons of art.

There is an old Greek tradition, that the Marriage at Cana was that of John the Evangelist. In the thirteenth century, when the passionate enthusiasm for Mary Magdalene was at its height, it was a popular article of belief that the Marriage which Jesus graced with his presence was that of John the Evangelist and Mary Magdalene; and that immediately after the wedding feast, St. John and Mary, devoting themselves to an austere and chaste religious life, followed Christ, and ministered to him.

As a scene in the life of Christ, the Marriage at Cana is of course introduced incidentally; but even here, such were the monastic principles and prejudices, that I find it difficult to point out any very early example. In the 'Manual of Greek Art,' published by Didron, the rules for the representation are thus laid down:—'A table; around it Scribes and Pharisees; one holds up a cup of wine, and seems astonished. In the midst the bride and bridegroom are seated together. The bridegroom is to have " grey hair and a round beard " (*cheveux gris et barbe arrondie*); both are to be crowned with flowers; behind them, a servitor. Christ, the Virgin, and Joseph are to be on one side, and on the other are six jars; the attendants are in the act of filling them with water from leathern buckets.'

The introduction of Joseph is quite peculiar to Greek art; and the more curious, that in the list of Greek subjects there is not one from his life, or in which he is a conspicuous figure. On the other hand, the astonished 'ruler of the feast' (the *Architriclino*), so dramatic, and so necessary to the comprehension of the scene, is scarcely ever omitted. The apostles whom we may imagine to be present, are Peter, Andrew, James, and John.

As a separate subject, the Marriage at Cana first became popular in the Venetian school, and thence extended to the Lombard and German schools of the same period, that is, about the beginning of the sixteenth century.

The most beautiful representation I have ever seen is a fresco, by Luini, in the Church of San Maurizio, at Milan. It belongs to a convent

of nuns; and I imagine, from its introduction there, that it had a mystic signification, and referred to a divine *Spozalizio*. In this sense, the treatment is perfect. There are just the number of figures necessary to tell the story, and no more. It is the bride who is here the conspicuous figure, seated in the centre, arrayed in spotless white, and represented as a nun about to make her profession; for this is evidently the intended signification. The bridegroom is at her side, and near to the spectator. Christ and the Virgin are seated together, and appear to be conversing. A man presents a cup of wine. Including guests and attendants, there are only twelve figures. The only fault of this exquisite and graceful composition is the introduction of a cat and dog in front: we feel that they ought to have been omitted, as giving occasion for irreverent witticisms.[1]

In contrast with this picture, and as a gorgeous specimen of the Venetian style of treatment, we may turn to the 'Marriage at Cana' in the Louvre, originally painted to cover one side of the refectory of the convent of *San Giorgio Maggiore* at Venice, whence it was carried off by the French in 1796. This immense picture is about thirty-six feet in length, and about twenty feet in height, and contains more than a hundred figures above life-size. In the centre Christ is seated, and beside him the Virgin Mother. Both heads are merely commonplace, and probably portraits, like those of the other personages at the extremity of the table. On the left are seated the bride and bridegroom. In the foreground a company of musicians are performing a concert; behind the table is a balustrade, where are seen numerous servants occupied in cutting up the viands and serving dishes, with attendants and spectators. The chief action to be represented, the astonishing miracle performed by him at whose command 'the fountain blushed into wine,' is here quite a secondary matter; and the value of the picture lies in its magnitude and variety as a composition, and the portraits of the historical characters and remarkable personages introduced— Francis I., his queen Eleanora of Austria, Charles V., and others. In the group of musicians in front we recognise Titian and Tintoretto, old Bassano, and Paolo himself.

[1] This beautiful fresco, which is seldom seen, being behind the altar, was in a very ruined condition when I saw it last in 1855.

The Marriage at Cana, as a refectory subject, had been unknown till this time: it became popular, and Paolo afterwards repeated it several times. The most beautiful of all, to my feeling, is that in the Dresden Gallery, where the 'ruler of the feast,' holding up the glass of wine with admiration, seems to exclaim, 'Thou hast kept the good wine until now.' In another, which is at Milan, the Virgin turns round to the attendant, and desires him to obey her Son—'Whatsoever he saith unto you, do it!'

As the Marriage at Cana belongs, as a subject, rather to the history of Christ than to that of the Virgin his mother, I shall not enter into it further here, but proceed.

After the marriage at Cana in Galilee, which may be regarded as the commencement of the miraculous mission of our Lord, we do not hear anything of his mother, the Virgin, till the time approached when he was to close his ministry by his death. She is not once referred to by name in the Gospels until the scene of the Crucifixion. We are indeed given to understand, that in the journeys of our Saviour, and particularly when he went up from Nazareth to Jerusalem, the women followed and ministered to him;[1] and those who have written the life of the Virgin for the edification of the people, and those who have translated it into the various forms of art, have taken it for granted that SHE, his mother, could not have been absent or indifferent where others attended with affection and zeal: but I do not remember any scene in which she is an actor, or even a conspicuous figure.

Among the carvings on the stalls at Amiens, there is one which represents the passage (Matt. xii. 46) wherein our Saviour, preaching in Judea, is told that his mother and his brethren stand without. 'But he answering, said to him that told him, "Who is my mother, and who are my brethren?" And he stretched forth his hand toward his disciples, and said, "Behold my mother and my brethren!"' The composition exhibits on one side Jesus standing and teaching his disciples; while on the other, through an open door, we perceive the Virgin and two or

[1] Matt. xxvii. 55; Luke viii. 2.

three others. This representation is very rare. The date of these stalls is the sixteenth century; and such a group in a series of the life of the Virgin could not, I think, have occurred in the fifteenth. It would have been quite inconsistent with all the religious tendencies of that time, to exhibit Christ as preaching *within*, while his 'divine and most glorious' Mother was standing *without*.

The theologians of the middle ages insist on the close and mystical relation which they assure us existed between Christ and his mother: however far separated, there was constant communion between them; and wherever he might be—in whatever acts of love, or mercy, or benign wisdom occupied for the good of man—*there* was also his mother, present with him in the spirit. I think we can trace the impress of this mysticism in some of the productions of the fourteenth and fifteenth centuries. For example, among the frescoes by Angelico da Fiesole in the cloisters of St. Mark, at Florence, there is one of the Transfiguration, where the Saviour stands glorified with arms outspread—a simple and sublime conception—and on each side half-figures of Moses and Elias: lower down appear the Virgin and St. Dominick. There is also in the same series a fresco of the Last Supper as the Eucharist, in which the Virgin is kneeling, glorified, on one side of the picture, and appears as a partaker of the rite. Such a version of either subject must be regarded as wholly mystical and exceptional, and I am not acquainted with any other instance.

LO SPASIMO.

'O what avails me now that honour high,
To have conceived of God, and that salute,
"Hail, highly favoured among women blest!"
While I to sorrows am no less advanced,
And fears as eminent, above the lot
Of other women by the birth I bore.'

—— 'this is my favoured lot,
My exaltation to afflictions high.'
MILTON.

IN the Passion of our Lord, taken in connection with the life of the Virgin Mother, there are three scenes in which she is associated with the action as an important, if not a principal, personage.

We are told in the Gospel of St. John (chap. xvii.), that Christ took a solemn farewell of his disciples : it is therefore supposed that he did not go up to his death without taking leave of his Mother—without preparing her for that grievous agony by all the comfort that his tender and celestial pity and superior nature could bestow. This parting of Christ and his Mother before the Crucifixion is a modern subject. I am not acquainted with any example previous to the beginning of the sixteenth century. The earliest I have met with is by Albert Dürer, in the series of the life of the Virgin, but there are probably examples more ancient, or at least contemporary. In Albert Dürer's composition, Mary is sinking to the earth, as if overcome with affliction, and is sustained in the arms of two women; she looks up with folded hands and streaming eyes to her Son who stands before her; he, with one hand extended, looks down upon her compassionately, and seems to give her his last benediction. I remember another instance, by Paul Veronese, full of that natural affectionate sentiment which belonged to the Venetian school.[1] In a very beautiful picture by Carotto of Verona, Jesus *kneels* before his Mother, and receives her benediction before he departs : this must be regarded as an impropriety, a mistake in point of sentiment, considering the peculiar relation between the two personages ; but it is a striking instance of the popular notions of the time respecting the high dignity of the Virgin Mother. I have not seen it repeated.[2]

It appears from the Gospel histories, that the women who had attended upon Christ during his ministry failed not in their truth and their love to the last. In the various circumstances of the Passion of our Lord, where the Virgin Mother figures as an important personage, certain of these women are represented as always near her, and sustain-

[1] Florence Gal.

[2] Verona, San Bernardino. It is worth remarking, with regard to this picture, that the Intendant of the Convent rebuked the artist, declaring that he had made the Saviour show *too little* reverence for his Mother, seeing that he knelt to her on one knee only. See the anecdote in *Vasari*, vol. i. p. 651. Fl. Edit. 1838.

ing her with a tender and respectful sympathy. Three are mentioned
by name—Mary Magdalene; Mary, the wife of Cleophas; and Mary,
the mother of James and John. Martha, the sister of Mary Magda-
lene, is also included, as I infer from her name, which in several instances
is inscribed in the nimbus encircling her head. I have in another place
given the story of Martha, and the legends which in the fourteenth
century converted her into a very important character in sacred art.[1]
These women, therefore, form, with the Virgin, the group of *five* female
figures which are generally included in the scriptural scenes from the
Life of Christ.

Of course, these incidents, and more especially the ' Procession to
Calvary,' and the ' Crucifixion,' belonged to another series of subjects,
which I shall have to treat hereafter in the History of our Lord; but
they are also included in a series of the Rosary, as two of the mystical
Sorrows; and under this point of view I must draw attention to the
peculiar treatment of the Virgin in some remarkable examples, which
will serve as a guide to others.

The Procession to Calvary (*Il Portamento del Croce*) followed a path
leading from the gate of Jerusalem to Mount Calvary, which has been
kept in remembrance and sanctified as the *Via Dolorosa*; and there is
a certain spot near the summit of the hill, where, according to a very
ancient tradition, the Virgin Mother, and the women her companions,
placed themselves to witness the sorrowful procession; where the
Mother, beholding her divine Son dragged along, all bleeding from the
scourge, and sinking under his cross, in her extreme agony sank, faint-
ing, to the earth. This incident gave rise to one of the mournful fes-
tivals of the Passion Week, under the title, in French, of *Notre Dame
du Spasme* or *du Pâmoison*; in Italian *La Madonna dello Spasimo*, or
Il Pianto di Maria; and this is the title given to some of those repre-
sentations in which the affliction of Mary is a prominent part of the
tragic interest of the scene. She is sometimes sinking to the earth,
sustained by the women or by St. John; sometimes she stands with
clasped hands, mute and motionless with excess of anguish; sometimes

[1] First Series of Sacred and Legendary Art, 3rd edit.

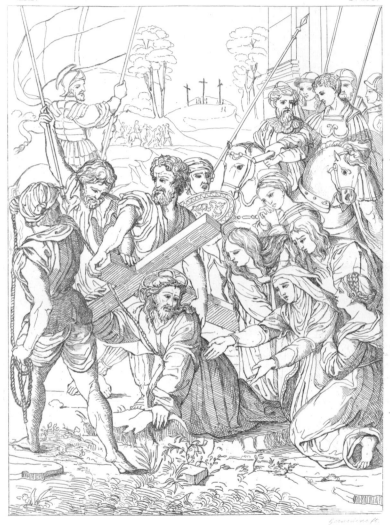

Lo Spasimo.

she stretches out her arms to her Son, as Jesus, sinking under the weight of his cross, turns his benign eyes upon her, and the others who follow him: ' Daughters of Jerusalem, weep not for me ! '

This is the moment chosen by Raphael in that sublime composition celebrated under the title ' *Lo Spasimo di Sicilia* ; '[1] so called because it was originally painted for the high altar of the church of the Sicilian Olivetans at Palermo, dedicated to the *Madonna della Spasimo.* It was thence removed, by order of Philip IV. of Spain, early in the seventeenth century, and is now placed in the gallery at Madrid. Here the group of the five women forms an important part of the picture, occupying the foreground on the right. The expression in the face of the Mother, stretching forth her arms to her Son with a look of appealing agony, has always been cited as one of the great examples of Raphael's tragic power. It is well known that in this composition the attitude of Christ was suggested by the contemporary engraving of Martin Schoen ; but the prominence given to the group of women, the dramatic propriety and pathetic grace in the action of each, and the consummate skill shown in the arrangement of the whole, belong only to Raphael.[2] In Martin Schoen's vivid composition, the Virgin, and the women her companions, are seen far off in the background, crouching in the ' hollow way ' between two cliffs, from which spot, according to the old tradition, they beheld the sad procession. We have quite a contrary arrangement in an early composition by Lucas van Leyden. The procession to Calvary is seen moving along in the far distance, while the foreground is occupied by two figures only, Mary in a trance of anguish sustained by the weeping St. John.

[1] Madrid Gal.

[2] The veneration at all times entertained for this picture was probably enhanced by a remarkable fact in its history. Raphael painted it towards the close of the year 1517, and when finished, it was embarked at the port of Ostia, to be consigned to Palermo. A storm came on, the vessel foundered at sea, and all was lost except the case containing this picture, which was floated by the currents into the Bay of Genoa ; and, on being landed, the wondrous masterpiece of art was taken out unhurt. The Genoese at first refused to give it up, insisting that it had been preserved and floated to their shores by the miraculous interposition of the blessed Virgin herself ; and it required a positive mandate from the pope before they would restore it to the Olivetan fathers.—See *Passavant's Rafael,* i. 292.

In a very fine 'Portamento del Croce,' by Gaudenzio Ferrari, one of the soldiers or executioners, in repulsing the sorrowful mother, lifts up a stick as if to strike her—a gratuitous act of ferocity, which shocks at once the taste and the feelings, and, without adding anything to the pathos of the situation, detracts from the religious dignity of the theme. It is like the soldier kicking our Saviour, which I remember to have seen in a version of the subject, by a much later painter, Daniele Crespi.

Murillo represents Christ as fainting under the weight of the cross, while the Virgin sits on the ground by the wayside, gazing on him with fixed eyes and folded hands, and a look of unutterable anguish.[1]

The Ecce Homo, by Correggio, in our National Gallery, is treated in a very peculiar manner with reference to the Virgin, and is, in fact, another version of *Lo Spasimo*, the fourth of her ineffable sorrows. Here Christ, as exhibited to the people by Pilate, is placed in the distance, and is in all respects the least important part of the picture, of which we have the real subject in the far more prominent figure of the Virgin in the foreground. At sight of the agony and degradation of her Son, she closes her eyes, and is on the point of swooning. The pathos of expression in the half-unconscious face and helpless, almost lifeless hands, which seem to seek support, is particularly fine.

The Crucifixion.

'Verum stabas, optima Mater, juxta crucem Filii tui, non solum corpore, sed mentis constantia.'

This great subject belongs more particularly to the Life of Christ. It is, I observe, always omitted in a series of the Life of the Virgin, unless

[1] This picture, remarkable for the intense expression, was in the collection of Lord Orford, and sold in June, 1856.

it be the Rosary, in which the 'Vigil of the Virgin by the Cross' is the fifth and greatest of the Seven Sorrows.

We cannot fail to remark, that whether the Crucifixion be treated as a mystery or as an event, Mary is always an important figure.

In the former case she stands alone on the right of the cross, and St. John on the left.[1] She looks up with an expression of mingled grief and faith, or bows her head upon her clasped hands in resignation. In such a position she is the idealised Mater Dolorosa, the Daughter of Jerusalem, the personified Church mourning for the great Sacrifice; and this view of the subject I have already discussed at length.

On the other hand, when the Crucifixion is treated as a great historical event, as a living scene acted before our eyes, then the position and sentiment given to the Virgin are altogether different, but equally fixed by the traditions of art. That she was present, and near at hand, we must presume from the Gospel of St. John, who was an eye-witness; and most of the theological writers infer that on this occasion her constancy and sublime faith were even greater than her grief, and that her heroic fortitude elevated her equally above the weeping women and the timorous disciples. This is not, however, the view which the modern painters have taken, and even the most ancient examples exhibit the maternal grief for a while overcoming the constancy. She is standing indeed, but in a fainting attitude, as if about to sink to the earth, and is sustained in the arms of the two Maries, assisted, sometimes, but not generally, by St. John; Mary Magdalene is usually embracing the foot of the cross. With very little variation this is the usual treatment down to the beginning of the sixteenth century. I do not know who was the first artist who placed the Mother prostrate on the ground; but it must be regarded as a fault, and as detracting from the high religious dignity of the scene. In all the greatest examples, from Cimabue, Giotto, and Pietro Cavallini, down to Angelico, Masaccio, and Andrea

[1] It has been a question with the learned whether the Virgin Mary, with St. John, ought not to stand on the left of the cross, in allusion to Psalm cxlii. (always interpreted as prophetic of the Passion of Christ) ver. 4.: '*I looked on my right hand, and beheld, but there was none who would know me.*'

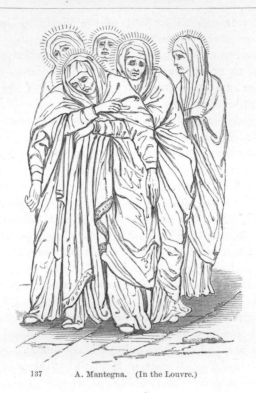

137 A. Mantegna. (In the Louvre.)

Mantegna, and their contemporaries, Mary is uniformly standing. This
group (137), from a famous picture by Andrea Mantegna, will give an
idea of the general mode of treatment.

In a Crucifixion by Martin Schoen, the Virgin, partly held up in
the arms of St. John, embraces with fervour the foot of the cross: a
very rare and exceptional treatment, for this is the proper place of Mary
Magdalene. In Albert Dürer's composition, she is just in the act of
sinking to the ground in a very natural attitude, as if her limbs had
given way under her. In Tintoretto's celebrated Crucifixion, we have
an example of the Virgin placed on the ground, which if not one of the
earliest, is one of the most striking of the more modern conceptions.
Here the group at the foot of the cross is wonderfully dramatic and

expressive, but certainly the reverse of dignified. Mary lies fainting
on the earth; one arm is sustained by St. John, the other is round the
neck of a woman who leans against the bosom of the Virgin, with eyes
closed, as if lost in grief. Mary Magdalene and another look up to the
crucified Saviour, and more in front a woman kneels wrapped up in a
cloak, and hides her face.[1]

Zani has noticed the impropriety here, and in other instances, of
exhibiting the '*Grandissima Donna*' as prostrate, and in a state of
insensibility; a style of treatment which, in more ancient times, would
have been inadmissible. The idea embodied by the artist should be
that which Bishop Taylor has *painted* in words:—'By the cross stood
the holy Virgin Mother, upon whom old Simeon's prophecy was now
verified; for now she felt a sword passing through her very soul. She
stood without clamour and womanish noises; sad, silent, and with a
modest grief, deep as the waters of the abyss, but smooth as the face of
a pool; full of love, and patience, and sorrow, and hope!' To suppose
that this noble creature lost all power over her emotions, lost her con-
sciousness of the 'high affliction' she was called to suffer, is quite un-
worthy of the grand ideal of womanly perfection here placed before
us. It is clear, however, that in the later representations, the intense
expression of maternal anguish in the hymn of the Stabat Mater gave
the key to the prevailing sentiment. And as it is sometimes easier to
faint than to endure; so it was easier for certain artists to express the
pallor and prostration of insensibility, than the sublime faith and for-
titude which in that extremest hour of trial conquered even a mother's
unutterable woe.

That most affecting moment, in which the dying Saviour recommends
his Mother to the care of the best beloved of his disciples, I have never
seen worthily treated. There are, however, some few Crucifixions in
which I presume the idea to have been indicated; as where the Virgin
stands leaning on St. John, with his sustaining arm reverently round
her, and both looking up to the Saviour, whose dying face is turned
towards them. There is an instance by Albert Dürer;[2] but the
examples are so few as to be exceptional.

[1] Venice, S. Rocco. [2] The woodcut in the 'Large Passion.'

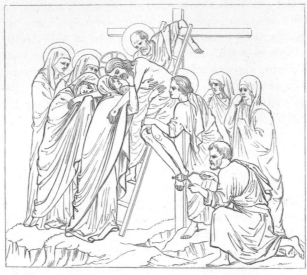

138 Descent from the Cross. A.D. 1308. (Duccio di Siena.)

THE DESCENT FROM THE CROSS, and the DEPOSITION, are two
separate themes. In the first, according to the antique formula, the
Virgin should stand; for here, as in the Crucifixion, she must be asso-
ciated with the principal action, and not, by the excess of her grief,
disabled from taking her part in it. In the old legend it is said, that
when Joseph of Arimathea and Nicodemus wrenched out the nails which
fastened the hands of our Lord to the cross, St. John took them away
secretly, that his mother might not see them—'*affin que la Vierge
Marie ne les veit pas, crainte que le cœur ne lui amolist.*' And then,
while Nicodemus drew forth the nails which fastened his feet, Joseph
of Arimathea sustained the body, so that the head and arms of the dead
Saviour hung over his shoulder. And the afflicted Mother, seeing this,
arose on her feet, and she took the bleeding hands of her Son, as they
hung down, and clasped them in her own, and kissed him tenderly.
And then, indeed, she sank to the earth, because of the great anguish
she suffered, lamenting her Son, whom the cruel Jews had murdered.[1]

[1] '——— tant qu'il n'y a cœur si dur, ni entendement d'homme qui n'y deust penser.
"Lasse, mon confort! m'amour et ma joye, que les Juifz ont faict mourir à grand tort et sans

XXII.

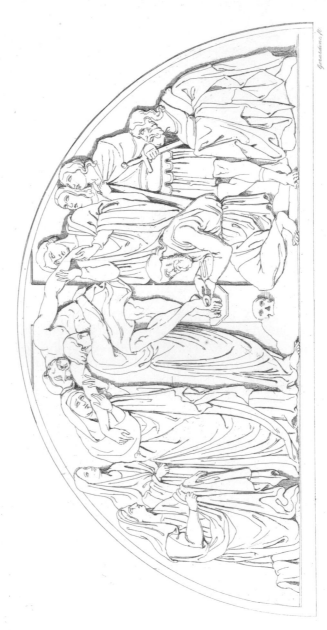

The Descent from the Cross.

Grauians fc

The first action described in this legend (the afflicted Mother embracing the arm of her Son) is precisely that which was adopted by the Greek masters, and by the early Italians who followed them, Nicolo Pisano, Cimabue, Giotto, Puccio Capanna, Duccio di Siena, and others from the thirteenth to the fifteenth century. But in later pictures, the Virgin in the extremity of her grief has sunk to the ground. In an altar-piece by Cigoli, she is seated on the earth, looking out of the picture, as if appealing, 'Was ever sorrow like unto my sorrow?' while the crown of thorns lies before her. This is very beautiful; but even more touching is the group in the famous 'Descent from the Cross,' the masterpiece of Daniel di Volterra: [1] here the fainting form of the Virgin, extended on the earth, and the dying anguish in her face, have never been exceeded, and are, in fact, the chief merit of the picture. In the famous Descent at Antwerp, the masterpiece of Rubens, Mary stands, and supports the arm of her Son as he is let down from the cross. This is in accordance with the ancient version; but her face and figure are the least effective part of this fine picture.

In a beautiful small composition, a print, attributed to Albert Dürer, there are only three figures. Joseph of Arimathea stands on a ladder, and detaches from the cross the dead form of the Saviour, who is received into the arms of his Mother. This is a form of the *Mater Dolorosa* which is very uncommon, and must be regarded as exceptional and ideal, unless we are to consider it as a study and an incomplete group.

THE DEPOSITION is properly that moment which succeeds the DESCENT from the Cross; when the dead form of Christ is deposed or laid upon the ground, resting on the lap of his Mother, and lamented by St. John, the Magdalene, and others. The ideal and devotional form of this

cause pour ce qu'il leur monstrait leurs faultes et enseignoit leur saulvement! O felons et mauvais Juifz, ne m'epargnez pas! puisque vous crucifiez mon enfant crucifiez moy—moy qui suis sa dolente mere, et me tuez d'aucune mort affin que je meure avec luy!"' v. *The old French Legend*, ' *Vie de Notre-Dame la glorieuse Vierge Marie.*'

[1] Rome, Trinità di Monte.

subject, styled a Pietà, may be intended to represent one of those festivals of the Passion Week which commemorate the participation of the holy Virgin Mother in the sufferings of her Son.[1] I have already spoken at length of this form of the Mater Dolorosa; the historical version of the same subject is what we have now to consider, but only so far as regards the figure of the Virgin.

In a Deposition thus dramatically treated, there are always from four to six or eight figures. The principal group consists of the dead Saviour and his Mother. She generally holds him embraced, or bends over him contemplating his dead face, or lays her cheek to his with an expression of unutterable grief and love : in the antique conception she is generally fainting; the insensibility, the sinking of the whole frame through grief, which in the Crucifixion is misplaced, both in regard to the religious feeling and the old tradition, is here quite proper.[2] Thus she appears in the genuine Greek and Greco-Italian productions of the thirteenth and fourteenth centuries, as well as in the two finest examples that could be cited in more modern times.

1. In an exquisite composition by Raphael, usually styled a Pietà, but properly a Deposition, there are six figures : the extended form of Christ; the Virgin swooning in the arms of Mary Salome and Mary Cleophas; Mary Magdalene sustains the feet of Christ, while her sister Martha raises the veil of the Virgin, as if to give her air; St. John stands by with clasped hands; and Joseph of Arimathea looks on the sorrowing group with mingled grief and pity.[3]

2. Another, an admirable and celebrated composition by Annibal Caracci, known as the Four Maries, omits Martha and St. John. The attention of Mary Magdalene is fixed on the dead Saviour; the other two Maries are occupied by the fainting Mother.[4] On comparing this

[1] 'C'est ce que l'on a jugé à propos d'appeller *La Compassion* de la Vierge, autrement *Notre Dame de Pitié.*'—Vide *Baillet*, 'Les Fêtes Mobiles.'

[2] The reason given is curious:—'*Perchè quando Gesù pareva tormentato essendo vivo, il dolore si partiva frà la santissima madre e lui; ma quando poi egli era morto, tutto il dolore rimaneva per la sconsolata madre.*'

[3] This wonderful drawing (there is no *finished* picture) was in the collection of Count Fries, and then belonged to Sir T. Lawrence. There is a good engraving by Agricola.

[4] Castle Howard.

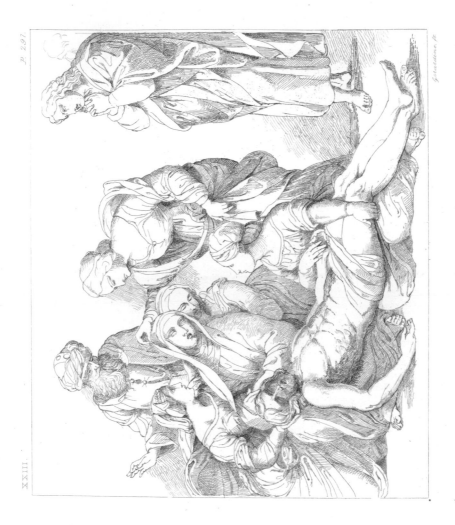

Gebastone fc

The Deposition.

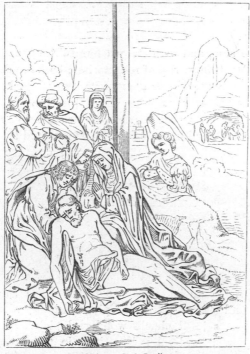

139 Deposition. (B. de Bruÿn.)

with Raphael's conception, we find more of common nature, quite as much pathos, but in the forms less of that pure poetic grace, which softens at once, and heightens the tragic effect.

Besides Joseph of Arimathea, we have sometimes Nicodemus; as in the very fine Deposition by Perugino, and in one, not less fine, by Albert Dürer. In a Deposition by Ambrogio Lorenzetti, Lazarus, whom Jesus raised from the dead, stands near his sister Martha.

In a picture by Vandyck, the Mother closes the eyes of the dead Redeemer: in a picture by Rubens, she removes a thorn from his wounded brow:—both natural and dramatic incidents very characteristic of these dramatic painters.

There are some fine examples of this subject in the old German school. In spite of ungraceful forms, quaint modern costumes, and

worse absurdities, we often find *motifs*, unknown in the Italian school, most profoundly felt, though not always happily expressed. I remember several instances in which the Madonna does not sustain her Son; but kneeling on one side, and with clasped hands, she gazes on him with a look, partly of devotion, partly of resignation; both the devotion and the resignation predominating over the maternal grief. I have been asked, 'why no painter has ever yet represented the Great Mother as raising her hands in thankfulness that her Son *had* drunk the cup—*had* finished the work appointed for him on earth?' This would have been worthy of the religious significance of the moment; and I recommend the theme to the consideration of artists.[1]

THE ENTOMBMENT follows, and when treated as a strictly historical scene, the Virgin Mother is always introduced, though here as a less conspicuous figure, and one less important to the action. Either she swoons, which is the ancient Greek conception; or she follows, with streaming eyes and clasped hands, the pious disciples who bear the dead form of her Son, as in Raphael's wonderful picture in the Borghese Palace, and Titian's, hardly less beautiful, in the Louvre, where the compassionate Magdalene sustains her veiled and weeping figure;—or she stands by, looking on disconsolate, while the beloved Son is laid in the tomb.

All these fine and important themes belong properly to a series of the History of Christ. In a series of the Life of the Virgin, the incidents of the Passion of our Lord are generally omitted; whereas, in the cycle of subjects styled the ROSARY, the Bearing of the Cross, the Crucifixion, and the Deposition, are included in the fourth and fifth of the 'Sorrowful Mysteries.' I shall have much more to say on these subjects

[1] In the most modern Deposition I have seen (one of infinite beauty, and new in arrangement, by Paul Delaroche), the Virgin, kneeling at some distance, and a little above, contemplates her dead Son. The expression and attitude are those of intense anguish, and *only* anguish. It is the bereaved Mother; it is a craving desolation, which is in the highest degree human and tragic; but it is not the truly religious conception.

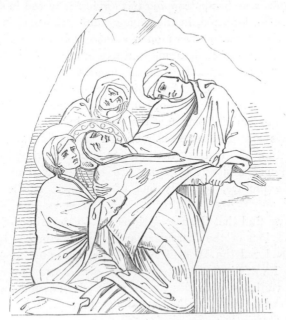

140 The Virgin in the Entombment. (Ancient Greek conception.)

when treating of the artistic representations from the History of Christ.
I will only add here, that their frequency as *separate* subjects, and the
pre-eminence given to the figure of the Virgin as the Mother of Pity,
are very suggestive and affecting when we come to consider their
intention as well as their significance. For, in the first place, they
were in most instances the votive offerings of those who had lost the
being most dear to them, and thus appealed to the divine compassion
of her who had felt that sword ' pierce through her own heart also.' In
this sense they were often suspended as memorials in the chapels dedi-
cated to the dead, of which I will cite one very beautiful and touching
example. There is a votive Deposition by Giottino, in which the
general conception is that which belonged to the school, and very like
Giotto's Deposition in the Arena at Padua. The dead Christ is extended
on a white shroud, and embraced by the Virgin; at his feet kneels the
Magdalene, with clasped hands and flowing hair; Mary Salome kisses
one of his hands, and Martha (as I suppose) the other; the third Mary,

with long hair, and head drooping with grief, is seated in front to the right. In the background, in the centre, stands St. John, bending over the group in profound sorrow; on his left hand Joseph of Arimathea stands with the vase of 'spices and ointments,' and the nails; near him Nicodemus. On the right of St. John kneels a beautiful young girl, in the rich Florentine costume, who, with a sorrowful earnestness and with her hands crossed over her bosom, contemplates the dead Saviour. St. Romeo (or San Remigio) patron of the church in which the picture was dedicated, lays his hand paternally on her head; beside her kneels a Benedictine nun, who in the same manner is presented by St. Benedict. These two females, sisters perhaps, are the bereaved mourners who dedicated the picture, certainly one of the finest of the Giottesque school.[1]

Secondly, we find that the associations left in the minds of the people by the expeditions of the Crusaders and the pilgrimages to the Holy Sepulchre, rendered the Deposition and the Entombment particularly popular and impressive as subjects of art, even down to a late period. 'Ce que la vaillante épée des ayeux avait glorieusement defendu, le ciseaux des enfans aimait à le réproduire, leur piété à l'honorer.' I think we may trace these associations in many examples, particularly in a Deposition by Raphael (141), of which there is a fine old engraving. Here, in the centre, stands a circular building, such as the church at Jerusalem was always described; in front of which are seen the fainting Virgin and the mournful women; a grand and solemn group, but poetically rather than historically treated.

In conclusion, I must notice one more form of the Mater Dolorosa, one of the dramatic conceptions of the later schools of art: as far as I know, there exist no early examples.

In a picture by Guercino,[2] the Virgin and St. Peter lament the

[1] It is now in the gallery of the Uffizii, at Florence. In the Florentine edition of Vasari the name of the church in which this picture was originally placed is called San *Romeo*, who is St. Remi (or Remigio), Bishop of Reims. The painter, Giottino, the greatest and the most interesting, personally, of the Giottesque artists, was, as Vasari says, 'of a melancholy temperament, and a lover of solitude;' 'more desirous of glory than of gain;' 'contented with little, and thinking more of serving and gratifying others than of himself;' 'taking small care for himself, and perpetually engrossed by the works he had undertaken.' He died of consumption, in 1356, at the age of thirty-two. [2] Louvre.

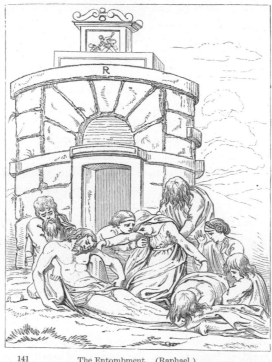

141 The Entombment. (Raphael.)

death of the Saviour. The Mother, with her clasped hands resting on
her knees, appears lost in resigned sorrow : she mourns her Son. Peter,
weeping, as with a troubled grief, seems to mourn at once his Lord and
Master, and his own weak denial. This picture has the energetic feel-
ing and utter want of poetic elevation which generally characterised
Guercino.

There is a similar group by Ludovico Caracci in the Duomo at
Bologna.

In a picture by Tiarini, the *Madre Addolorata* is seated, holding in
her hand the crown of thorns ; Mary Magdalene kneels before her, and
St. John stands by—both expressing the utmost veneration and sym-
pathy. These and similar groups are especially to be found in the later
Bologna school. In all the instances known to me, they have been

painted for the Dominicans, and evidently intended to illustrate the
sorrows of the Rosary.

In one of the services of the Passion Week, and in particular reference
to the maternal anguish of the Virgin, it was usual to read, as the
Epistle, a selection from the first chapter of the Lamentations of Jere-
miah, eloquent in the language of desolation and grief. The painters
seemed to have filled their imagination with the images there presented;
and frequently in the ideal *Pietà* the daughter of Jerusalem 'sits soli-
tary, with none to comfort her.' It is the contrary in the dramatic
version : the devotion of the women, the solicitude of the affectionate
Magdalene, and the filial reverence of St. John, whom the scriptural
history associates with the Virgin in a manner so affecting, are never
forgotten.

In obedience to the last command of his dying Master, John the
Evangelist—

> ' He, into whose keeping, from the cross,
> The mighty charge was given—'
> DANTE

conducted to his own dwelling the Mother to whom he was henceforth
to be as a Son. This beautiful subject, 'John conducting the Virgin
to his home,' was quite unknown, as far as I am aware, in the earlier
schools of art, and appears first in the seventeenth century. An eminent
instance is a fine solemn group by Zurbaran.[1] Christ was laid in the
sepulchre by night, and here, in the grey dawn, John and the veiled
Virgin are seen as returning from the entombment, and walking mourn-
fully side by side.

We find the peculiar relation between the Mother of Christ and St.
John, as her adopted son, expressed in a very tender and ideal manner,
on one of the wings of an altar-piece, attributed to Taddeo Gaddi.[2]
Mary and St. John stand in front; he holds one of her hands clasped in
both his own, with a most reverent and affectionate expression. Christ,
standing between them, lays one hand on the shoulder of each: the
sentiment of this group is altogether very unusual, and very remarkable.

[1] Munich. [2] Berlin Gal., No. 1081.

Historical Subjects.

PART IV.

The Life of the Virgin Mary from the Resurrection of our Lord to the Assumption.

1. THE APPARITION OF CHRIST TO HIS MOTHER.
2. THE ASCENSION.
3. THE DESCENT OF THE HOLY GHOST.
4. THE DEATH OF THE VIRGIN.
5. THE ASSUMPTION AND CORONATION.

THE APPARITION OF CHRIST TO HIS MOTHER.

THE enthusiastic and increasing veneration for the Madonna, the large place she filled in the religious teaching of the ecclesiastics and the religious sentiments of the people, are no where more apparent, nor more strikingly exhibited, than in the manner in which she was associated with the scenes which followed the Passion;—the manner in which some incidents were suggested, and treated with a peculiar reference to her, and to her maternal feelings. It is no where said that the Virgin Mother was one of the Maries who visited the tomb on the morning of the resurrection, and no where is she so represented. But out of the human sympathy with that bereaved and longing heart, arose the beautiful legend of the interview between Christ and his Mother after he had risen from the dead.

There existed a very ancient tradition (it is mentioned by St. Ambrose in the fourth century, as being then generally accepted by Christians), that Christ, after his return from Hades, visited his Mother even before he appeared to Mary Magdalene in the garden. It is not indeed so written in the Gospel; but what of that? The reasoning which led to the conclusion was very simple. He whose last earthly thought was for his Mother would not leave her without that consolation it was in his power to give; and what, as a son, it was his duty to do (for the *humanity* of Christ is never forgotten by those who most intensely believed in his *divinity*), that, of course, he did do.

The story is thus related:—Mary, when all was 'finished,' retired to her chamber, and remained alone with her grief—not wailing, not repining, not hopeless, but waiting for the fulfilment of the promise. Open before her lay the volume of the prophecies; and she prayed earnestly, and she said, 'Thou didst promise, O my most dear Son! that thou wouldst rise again on the third day. Before yesterday was

the day of darkness and bitterness, and, behold, this is the third day.
Return then to me thy Mother; O my Son, tarry not, but come!' And
while thus she prayed, lo! a bright company of angels, who entered
waving their palms and radiant with joy; and they surrounded her,
kneeling and singing the triumphant Easter hymn, *Regina Cœli lætare,
Alleluia!* [1] And then came Christ partly clothed in a white garment,
having in his left hand the standard with the cross, as one just returned
from the nether world, and victorious over the powers of sin and death.
And with him came the patriarchs and prophets, whose long-imprisoned
spirits he had released from Hades.[2] All these knelt before the Virgin,
and saluted her, and blessed her, and thanked her, because through her
had come their deliverance. But, for all this, the Mother was not com-
forted till she had heard the voice of her Son. Then he, raising his
hand in benediction, spoke, and said, 'I salute thee, O my Mother!'
and she, weeping tears of joy, responded, 'Is it thou indeed, my most
dear Son?' and she fell upon his neck, and he embraced her tenderly,
and showed her the wounds he had received for sinful men. Then he
bid her be comforted and weep no more, for the pain of death had
passed away, and the gates of hell had not prevailed against him. And
she thanked him meekly on her knees, for that he had been pleased to
bring redemption to man, and to make her the humble instrument of his
great mercy. And they sat and talked together, until he took leave of
her to return to the garden, and to show himself to Mary Magdalene,
who, next to his glorious Mother, had most need of consolation.[3]

[1] ' Regina Cœli lætare, Alleluia !
 Quia quem meruisti portare, Alleluia !
 Resurrexit sicut dixit, Alleluia !
 Ora pro nobis Deum, Alleluia ! '

[2] The legend of the 'Descent into Hades' (or Limbo), often treated in art, will be given
at length in the History of our Lord.

[3] I have given the legend from various sources; but there is something quite untranslatable
and perfectly beautiful in the naïveté of the old Italian version. After describing the celestial
music of the angels, the rejoicing of the liberated patriarchs, and the appearance of Christ,
allegro, e bello e tutto lucido, it thus proceeds : ' *Quando ella lo vidde, gli ando incontro ella
ancora con le braccia aperte, e quasi tramortita per l'allegrezza. Il benedetto Gesù l'abbraccio
teneressimamente, ed ella gli disse ; " Ahi, figliuolo mio cordialissimo, sei tu veramente il mio Gesù,
ò pur m' inganna l' affetto !" " Io sono il tuo figliuolo, madre mia dolcissima," disse il Signore:
" cessino hormai le tue lagrime, non fare ch' io ti veda più di mala voglia. Già son finiti li tuoi*

XXIV.

2

1

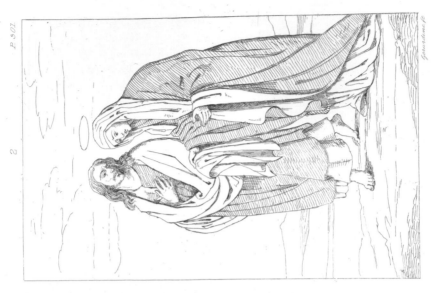

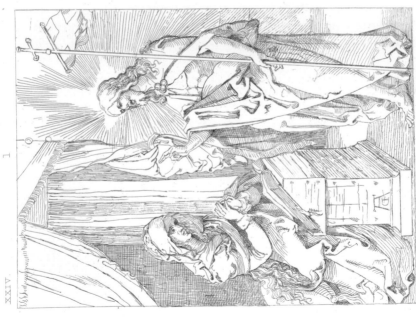

Saunders sc.

The Virgin, Mary and St John.

Christ appears to the Virgin.

The pathetic sentiment, and all the supernatural and mystical accompaniments of this beautiful myth of the early ages, have been very inadequately rendered by the artists. It is always treated as a plain matter-of-fact scene. The Virgin kneels; the Saviour, bearing his standard, stands before her; and where the delivered patriarchs are introduced, they are generally either Adam and Eve, the authors of the fall, or Abraham and David, the progenitors of Christ and the Virgin. The patriarchs are omitted in the earliest instance I can refer to, one of the carved panels of the stalls in the Cathedral of Amiens; also in the composition by Albert Dürer, not included in his life of the Virgin, but forming one of the series of the Passion. Guido has represented the scene in a very fine picture, wherein an angel bears the standard of victory, and behind our Saviour are Adam and Eve.[1]

Another example, by Guercino,[2] is cited by Goethe as an instance of that excellence in the expression of the natural and domestic affections which characterised the painter. Mary kneels before her Son, looking up in his face with unutterable affection; he regards her with a calm, sad look, ' as if within his noble soul there still remained the recollection of his sufferings and hers, outliving the pang of death, the descent into the grave, and which the resurrection had not yet dispelled.' This, however, is not the sentiment, at once affectionate and joyously triumphant, of the old legend. I was pleased with a little picture in the Lichtenstein Gallery at Vienna, where the risen Saviour, standing before his Mother, points to the page of the book before her, as if he said, ' See you not that thus it is written?' (Luke xxiv. 46.) Behind Jesus is St. John the Evangelist bearing the cup and the cross, as the cup of sorrow and the cross of pain, not the mere emblems. There is another example, by one of the Caracci, in the Fitzwilliam Collection at Cambridge.

A picture by Albano of this subject, in which Christ comes flying or floating on the air, like an incorporeal being, surrounded by little

e li miei travagli e dolori insieme!' Erano rimase alcune lagrime ne gli occhi della Vergine e per la grande allegrezza non poteva proferire parola alcuna ma quando al fine potè parlare, lo ringrazio per parte di tutto il genere humano, per la redenzione, operata e fatta, per tutto generalmente.'—v. Il Perfetto Legendario.

[1] Dresden Gal. [2] Cathedral, Cento.

fluttering cherubim, very much like Cupids, is an example of all that is most false and objectionable in feeling and treatment.[1]

The popularity of this scene in the Bologna school of art arose, I think, from its being adopted as one of the subjects from the Rosary, the first of 'the five Glorious Mysteries;' therefore especially affected by the Dominicans, the great patrons of the Caracci at that time.

THE ASCENSION, though one of the 'Glorious Mysteries,' was also accounted as the seventh and last of the sorrows of the Virgin, for she was then left alone on earth. All the old legends represent her as present on this occasion, and saying as she followed with uplifted eyes the soaring figure of Christ, 'My Son, remember me when thou comest to thy kingdom! Leave me not long after thee, my Son!' In Giotto's

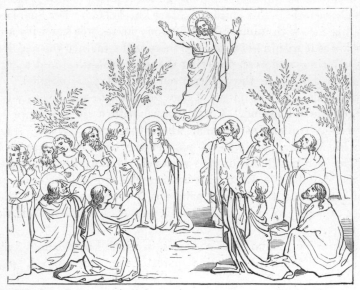

142 The Ascension of Christ in presence of the Virgin and the Apostles. (Giotto.)

composition in the chapel of the Arena, at Padua, she is by far the most

[1] Florence, Pitti Pal.

prominent figure. In almost all the late pictures of the Ascension, she is introduced with the other Maries, kneeling on one side, or placed in the centre among the apostles.

THE DESCENT OF THE HOLY GHOST is a strictly scriptural subject. I have heard it said that the introduction of Mary is not authorised by the scripture narrative. I must observe, however, that, without any wringing of the text for an especial purpose, the passage might be so interpreted. In the first chapter of the Acts (ver. 14), after enu-

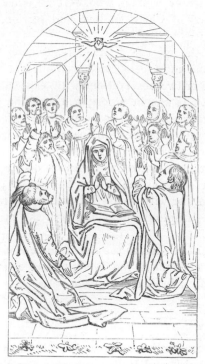

143 Descent of the Holy Ghost. (H. Hemmelinck.)

merating the apostles by name, it is added, 'These all continued with one accord in prayer and supplication, with the women and Mary the

mother of Jesus, and with his brethren.' And in the commencement of the second chapter the narrative thus proceeds : ' And when the day of Pentecost was fully come, they were *all* with one accord in one place.' The word *all* is, in the Concordance, referred to the previous text (ver. 14), as including Mary and the women : thus they who were constant in their love were not refused a participation in the gifts of the Spirit. Mary, in her character of the divine Mother of Wisdom, or even Wisdom herself,[1] did not, perhaps, need any accession of intellectual light; but we must remember that the Holy Spirit was the Comforter as well as the Giver of Wisdom; therefore, equally needed by those, whether men or women, who were all equally called upon to carry out the ministry of Christ in love and service, in doing and in suffering.

In the account of the apostles I have already described at length the various treatment and most celebrated examples of this subject, and shall only make one or two observations with especial reference to the figure of the Virgin. It was in accordance with the feelings and convictions prevalent in the fifteenth century, that if Mary were admitted to be present, she would take the principal place, as Queen and Mother of the Apostles (*Regina et Mater Apostolorum*). She is, therefore, usually placed either in front, or in the centre on a raised seat or dais; and often holding a book (as the *Mater Sapientiæ*); and she receives the divine affusion either with veiled lids and meek rejoicing; or with uplifted eyes, as one inspired, she pours forth the hymn, *Veni, Sancte Spiritus.*

I agree with the critics that, as the Spirit descended in form of cloven tongues of fire, the emblem of the Dove, almost always introduced, is here superfluous, and, indeed, out of place.

I must mention here another subject altogether apocryphal, and confined to the late Spanish and Italian schools : The Virgin receives the sacramental wafer from the hand of St. John the Evangelist. This is

[1] The sublime eulogium of Wisdom (Prov. viii. 22), is, in the Roman Catholic Church, applied to the Virgin Mary. See *ante* p. 51.

frequently misunderstood, and styled the Communion of Mary Magdalene. But the long hair and uncovered head of the Magdalene, and the episcopal robe of St. Maximin, are in general distinguishable from the veiled matronly head of the Virgin Mother, and the deacon's vest of St. John. There is also a legend that Mary received baptism from St. Peter; but this is a subject I have never met with in art, ancient or modern. It may possibly exist.

I am not acquainted with any representations taken from the sojourn on earth of the Blessed Virgin from this time to the period of her death, the date of which is uncertain. It is, however, generally supposed to have taken place in the forty-eighth year of our era, and about eleven years after the Crucifixion, therefore in her sixtieth year. There is no distinct record, either historical or legendary, as to the manner in which she passed these years. There are, indeed, floating traditions alluded to by the early theological writers, that when the first persecution broke out at Jerusalem, Mary accompanied St. John the Evangelist to Ephesus, and was attended thither by the faithful and affectionate Mary Magdalene. Also that she dwelt for some time on Mount Carmel, in an oratory erected there by the prophet Elijah, and hence became the patroness of the Carmelites, under the title of Our Lady of Mount Carmel (*La Madonna del Carmine*, or *del Carmelo*). If there exist any creations of the artists founded on these obscure traditions, which is indeed most probable, particularly in the edifices of the Carmelites in Spain, I have not met with them.

It is related that before the apostles separated to obey the command of their divine Master, and preach the gospel to all the nations of the earth, they took a solemn leave of the Virgin Mary, and received her blessing. This subject has been represented, though not by any distinguished artist. I remember such a picture, apparently of the sixteenth century, in the Church of S. Maria-in-Capitolio at Cologne, and another, by Bissoni, in the San Giustina at Padua.[1]

[1] Sacred and Legendary Art, 3rd edit. p. 183.

R R

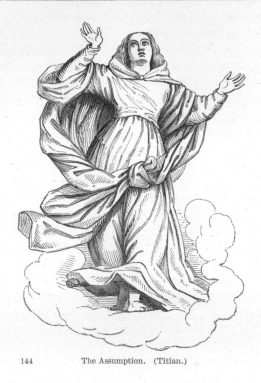

144 The Assumption. (Titian.)

The Death and Assumption of the Virgin.

Lat. Dormitio, Pausatio, Transitus, Assumptio, B. Virginis. *Ital.* Il Transito di Maria. Il
Sonno della Beata Vergine. L'Assunzione. *Fr.* La Mort de la Vierge. L'Assomption.
Ger. Das Absterben der Maria. Mariä Himmelfahrt. August 13, 15.

We approach the closing scenes.

Of all the representations consecrated to the glory of the Virgin,
none have been more popular, more multiplied through every form of
art, and more admirably treated, than her death and apotheosis. The
latter in particular, under the title of 'the Assumption' became the
visible expression of a dogma of faith then universally received—
namely, the exaltation and deification of the Virgin in the body as well

as in the spirit. As such it meets us at every turn in the edifices dedi-
cated to her; in painting over the altar, in sculpture over the portal, or
gleaming upon us in light from the shining many-coloured windows.
Sometimes the two subjects are combined, and the death-scene (*Il
transito di Maria*) figured below, is, in fact, only the *transition* to the
blessedness and exaltation figured above. But whether separate ·or
combined, the two scenes, in themselves most beautiful and touching—
the extremes of the mournful and the majestic—the dramatic and the
ideal—offered to the mediæval artists such a breadth of space for the
exhibition of feeling and fancy as no other subject afforded. Conse-
quently, among the examples handed down to us, are to be found some
of the most curious and important relics of the early schools, while
others rank among the grandest productions of the best ages of art.

For the proper understanding of these, it is necessary to give the old
apocryphal legend at some length; for, although the very curious and
extravagant details of this legend were not authorised by the Church as
matters of fact or faith, it is clear that the artists were permitted thence
to derive their materials and their imagery. In what manner they
availed themselves of this permission, and how far the wildly poetical
circumstances with which the old tradition was gradually invested, were
allowed to enter into the forms of art, we shall afterwards consider.

The Legend of the Death and Assumption of the most Glorious Virgin Mary.

Mary dwelt in the house of John upon Mount Sion, looking for the fulfilment of the
promise of deliverance; and she spent her days in visiting those places which had been
hallowed by the baptism, the sufferings, the burial and resurrection of her divine Son, but
more particularly the tomb wherein he was laid. And she did not this as seeking the living
among the dead, but for consolation and for remembrance.

And on a certain day, the heart of the Virgin, being filled with an inexpressible longing to
behold her Son, melted away within her, and she wept abundantly. And, lo! an angel
appeared before her clothed in light as with a garment. And he saluted her, and said,
'Hail, O Mary! blessed by him who hath given salvation to Israel! I bring thee here a
branch of palm gathered in Paradise; command that it be carried before thy bier in the day
of thy death; for in three days thy soul shall leave thy body, and thou shalt enter into
Paradise, where thy Son awaits thy coming.' Mary, answering, said, 'If I have found
grace in thy eyes, tell me first what is thy name; and grant that the apostles my brethren
may be reunited to me before I die, that in their presence I may give up my soul to God.
Also, I pray thee, that my soul, when delivered from my body, may not be affrighted by any

spirit of darkness, nor any evil angel be allowed to have any power over me.' And the angel said, 'Why dost thou ask my name? My name is the Great and the Wonderful. And now doubt not that all the apostles shall be reunited to thee this day; for he who in former times transported the prophet Habakkuk from Judea to Jerusalem by the hair of his head, can as easily bring hither the apostles. And fear thou not the evil spirit, for hast thou not bruised his head and destroyed his kingdom?' And having said these words, the angel departed into heaven.; and the palm branch which he had left behind him shed light from every leaf, and sparkled as the stars of the morning. Then Mary lighted the lamps and prepared her bed, and waited until the hour was come. And in the same instant John, who was preaching at Ephesus, and Peter, who was preaching at Antioch, and all the other apostles, who were dispersed in different parts of the world, were suddenly caught up as by a miraculous power, and found themselves before the door of the habitation of Mary. When Mary saw them all assembled round her, she blessed and thanked the Lord, and she placed in the hands of St. John the shining palm, and desired that he should bear it before her at the time of her burial. Then Mary, kneeling down, made her prayer to the Lord her Son, and the others prayed with her; then she laid herself down in her bed and composed herself for death. And John wept bitterly. And about the third hour of the night, as Peter stood at the head of the bed and John at the foot, and the other apostles around, a mighty sound filled the house, and a delicious perfume filled the chamber. And Jesus himself appeared accompanied by an innumerable company of angels, patriarchs, and prophets: all these surrounded the bed of the Virgin, singing hymns of joy. And Jesus said to his mother, 'Arise, my beloved, mine elect! come with me from Lebanon, my espoused! receive the crown that is destined for thee!' And Mary, answering, said, 'My heart is ready; for it was written of me that I should do thy will!' Then all the angels and blessed spirits who accompanied Jesus began to sing and rejoice. And the soul of Mary left her body, and was received into the arms of her Son; and together they ascended into heaven.[1] And the apostles looked up, saying, 'O most prudent Virgin, remember us when thou comest to glory!' and the angels who received her into heaven, sang these words, 'Who is this that cometh up from the wilderness leaning upon her Beloved? she is fairer than all the daughters of Jerusalem.'

But the body of Mary remained upon the earth; and three among the virgins prepared to wash and clothe it in a shroud; but such a glory of light surrounded her form, that though they touched it they could not see it, and no human eye beheld those chaste and sacred limbs unclothed. Then the apostles took her up reverently and placed her upon a bier, and John, carrying the celestial palm, went before. Peter sang the 114th Psalm, '*In exitu Israel de Egypto, domus Jacob de populo barbaro,*' and the angels followed after, also singing. The wicked Jews, hearing these melodious voices, ran together; and the high-priest, being seized with fury, laid his hands upon the bier intending to overturn it on the earth; but both his arms were suddenly dried up, so that he could not move them. and he was overcome with fear; and he prayed to St. Peter for help, and Peter said, 'Have faith in Jesus Christ, and

[1] In the later French legend, it is the angel Michael who takes charge of the departing soul. '*Ecce Dominus venit cum multitudine angelorum*; et Jésus Christ vint en grande compaignie d'anges; entre lesquels estoit Sainct Michel, et quand la Vierge Marie le veit elle dit, "Benoist soit Jésus Christ car il ne m'a pas oubliée." Quand elle eut ce dit elle rendit l'esprit, lequel Sainct Michel print.'

his Mother, and thou shalt be healed;' and it was so. Then they went on and laid the Virgin in a tomb in the Valley of Jehoshaphat.[1]

And on the third day, Jesus said to the angels, 'What honour shall I confer on her who was my mother on earth, and brought me forth?' And they answered, 'Lord, suffer not that body which was thy temple and thy dwelling to see corruption; but place her beside thee on thy throne in heaven.' And Jesus consented; and the Archangel Michael brought unto the Lord the glorious soul of our Lady. And the Lord said, 'Rise up, my dove, my undefiled, for thou shalt not remain in the darkness of the grave, nor shalt thou see corruption;' and immediately the soul of Mary rejoined her body, and she arose up glorious from the tomb, and ascended into heaven surrounded and welcomed by troops of angels, blowing their silver trumpets, touching their golden lutes, singing, and rejoicing as they sang, 'Who is she that riseth as the morning, fair as the moon, clear as the sun, and terrible as an army with banners?' (Cant. vi. 10.)

But one among the apostles was absent; and when he arrived soon after, he would not believe in the resurrection of the Virgin; and this apostle was the same Thomas, who had formerly been slow to believe in the resurrection of the Lord; and he desired that the tomb should be opened before him; and when it was opened it was found to be full of lilies and roses. Then Thomas, looking up to heaven, beheld the Virgin bodily, in a glory of light, slowly mounting towards heaven; and she, for the assurance of his faith, flung down to him her girdle, the same which is to this day preserved in the cathedral of Prato. And there were present at the death of the Virgin Mary, besides the twelve apostles, Dionysius the Areopagite, Timotheus, and Hierotheus; and of the women, Mary Salome, Mary Cleophas,[2] and a faithful handmaid whose name was Savia.

This legend of the Death and Assumption of the Virgin has afforded to the artists seven distinct scenes.

1. The Angel, bearing the palm, announces to Mary her approaching Death. The announcing angel is usually supposed to be Gabriel, but it is properly Michael, the 'angel of death.' 2. She takes leave of the Apostles. 3. Her Death. 4. She is borne to the Sepulchre. 5. Her Entombment. 6. Her Assumption, where she rises triumphant and glorious, 'like unto the morning' ('*quasi aurora consurgens*'). 7. Her Coronation in heaven, where she takes her place beside her Son.

In early art, particularly in the Gothic sculpture, two or more of these subjects are generally grouped together. Sometimes we have the death-scene and the entombment on a line below, and, above these, the coronation or the assumption, as over the portal of Notre-Dame at Paris,

[1] Or Gethsemane. I must observe here, that in the genuine oriental legend, it is Michael the Archangel who hews off the hands of the audacious Jew, which were afterwards, at the intercession of St. Peter, reunited to his body.

[2] According to the French legend, Mary Magdalene and her sister Martha were also present.

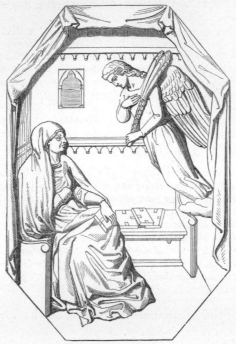

145 The Angel announces to the Virgin her approaching Death. (Sculpture. Orcagna.)

and in many other instances; or we have first her death, above this, her assumption, and, above all, her coronation; as over the portal at Amiens and elsewhere.

I shall now take these subjects in their order.

THE ANGEL ANNOUNCING TO MARY HER APPROACHING DEATH has been rarely treated. In general, Mary is seated or standing, and the angel kneels before her, bearing the starry palm brought from Paradise. In the frescoes at Orvieto, and in the bas-relief of Orcagna [1] (145) the angel

[1] On the beautiful shrine in Or-San-Michele, at Florence.

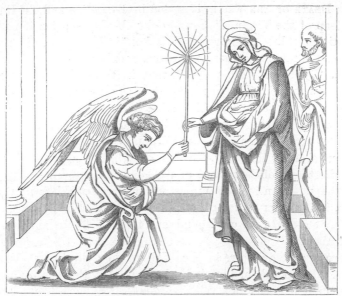

146 The Angel Michael announces to the Virgin her approaching Death.

comes flying downwards with the palm. In the next sketch (146), which
is from a predella by Fra Filippo Lippi, the angel kneels, reverently
presenting a taper, which the Virgin receives with majestic grace;
St. Peter stands behind. It was the custom to place a taper in the
hand of a dying person; and as the palm is also given sometimes to the
angel of the incarnation, while the taper can have but one meaning, the
significance of the scene is here fixed beyond the possibility of mistake,
though there is a departure from the literal details of the old legend.
There is in the Munich Gallery, a curious German example of this sub-
ject by Hans Schauffelein.[1]

[1] See also the woodcut of the archangel bearing the starry palm. First Series of Sacred
and Legendary Art, 3rd edit. p. 124.

THE DEATH OF THE VIRGIN is styled in Byzantine and old Italian art the Sleep of the Virgin, *Il Sonno della Madonna*; for it was an old superstition, subsequently rejected as heretical, that she did not really die after the manner of common mortals, only fell asleep till her resurrection. Therefore, perhaps, it is, that in the early pictures we have before us, not so much a scene or action, as a sort of mysterious rite; it is not the Virgin dead or dying in her bed; she only slumbers in preparation for her entombment; while in the later pictures, we have a death-bed scene with all the usual dramatic and pathetic accessories.

In one sense or the other, the theme has been constantly treated, from the earliest ages of the revival of art down to the seventeenth century.

In the most ancient examples which are derived from the Greek school, it is always represented with a mystical and solemn simplicity, adhering closely to the old legend, and to the formula laid down in the Greek Manual.

There is such a picture in the Wallerstein Collection at Kensington Palace. The couch or bier is in the centre of the picture, and Mary lies upon it wrapped in a veil and mantle with closed eyes and hands crossed over her bosom. The twelve apostles stand round in attitudes of grief; angels attend bearing tapers. Behind the extended form of the Virgin is the figure of Christ; a glorious red seraph with expanded wings hovers above his head. He holds in his arms the soul of the Virgin in likeness of a new-born child. On each side stand St. Dionysius the Areopagite, and St. Timothy, Bishop of Ephesus, in episcopal robes. In front, the archangel Michael bends forward to strike off the hands of the high priest Adonijah, who had attempted to profane the bier. (This last circumstance is rarely expressed, except in the Byzantine pictures; for in the Italian legend, the hands of the intruder wither and adhere to the bed or shrine). In the picture just described, all is at once simple, and formal, and solemn, and supernatural; it is a very perfect example in its way of the genuine Byzantine treatment. There is a similar picture in the Christian Museum of the Vatican.

Another (the date about the first half of the fourteenth century, as I think), is curious from the introduction of the women.[1] The Virgin

[1] At present in the collection of Mr. Bromley, of Wootten.

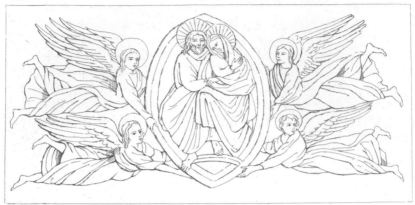

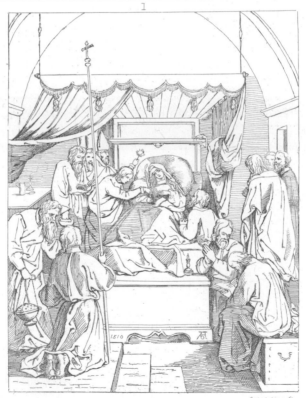

Geraldine fc.

The Death and Assumption of the Virgin.

lies on an embroidered sheet held reverently by angels; at the feet and at the head other angels bear tapers; Christ receives the departing soul, which stretches out its arms; St. John kneels in front, and St. Peter reads the service; the other apostles are behind him, and there are three women. The execution of this curious picture is extremely rude, but the heads very fine. Cimabue painted the Death of the Virgin at Assisi. There is a beautiful example by Giotto, where two lovely angels stand at the head and two at the feet, sustaining the pall on which she lies; another most exquisite by Angelico in the Florence Gallery; another most beautiful and pathetic by Taddeo Bartoli in the Palazzo Publico at Siena.

The custom of representing Christ as standing by the couch or tomb of his mother, in the act of receiving her soul, continued down to the fifteenth century, at least with slight deviations from the original conception. The later treatment is quite different. The solemn mysterious sleep, the transition from one life to another, became a familiar death-bed scene with the usual moving accompaniments. But even while avoiding the supernatural incidents, the Italians gave to the representation much ideal elegance; for instance, in the beautiful fresco by Ghirlandajo.[1]

In the old German school we have that homely matter-of-fact feeling and dramatic expression, and defiance of all chronological propriety, which belonged to the time and school. The composition by Albert Dürer, in his series of the Life of the Virgin, has great beauty and simplicity of expression, and in the arrangement a degree of grandeur and repose which has caused it to be often copied and reproduced as a picture, though the original form is merely that of a woodcut.[2] In the centre is a bedstead with a canopy, on which Mary lies fronting the spectator, her eyes half closed. On the left of the bed stands St. Peter, habited as a bishop; he places a taper in her dying hand; another apostle holds the asperge with which to sprinkle her with holy water; another reads the service. In the foreground is a priest bearing a cross,

[1] Florence, S. Maria-Novella.
[2] There is one such copy in the Sutherland Gallery; and another in the Munich Gallery, Cabinet viii. 161.

and another with incense; and on the right, the other apostles in
attitudes of devotion and grief.

Another picture by Albert Dürer, once in the Fries Gallery at
Vienna, unites, in a most remarkable manner, all the legendary and
supernatural incidents with the most intense and homely reality. It
appears to have been painted for the Emperor Maximilian, as a tribute
to the memory of his first wife, the interesting Maria of Burgundy.
The disposition of the bed is the same as in the woodcut, the foot
towards the spectator. The face of the dying Virgin is that of the
young duchess. On the right, her son, afterwards Philip of Spain and
father of Charles V., stands as the young St. John, and presents the
taper; the other apostles are seen around, most of them praying;
St. Peter, habited as bishop, reads from an open book (this is the
portrait of George à Zlatkonia, bishop of Vienna, the friend and
counsellor of Maximilian); behind him, as one of the apostles,
Maximilian himself, with head bowed down as in sorrow. Three eccle-
siastics are seen entering by an open door, bearing the cross, the
censer, and the holy water. Over the bed is seen the figure of Christ;
in his arms, the soul of the Virgin, in likeness of an infant with clasped
hands; and above all, in an opening glory and like a vision, her recep-
tion and coronation in heaven. Upon a scroll over her head, are the
words, ' *Surge, propera, amica mea; veni de Libano, veni coronaberis.*'
(Cant. iv. 8.) Three among the hovering angels bear scrolls, on one
of which is inscribed the text from the Canticles, ' *Quæ est ista quæ
progreditur quasi aurora consurgens, pulchra ut luna, electa ut sol,
terribilis ut castrorum acies ordinata?* ' (Cant. vi. 10); on another,
' *Quæ est ista quæ ascendit de deserto deliciis affluens super dilectum
suum?* ' (Cant. viii. 5); and on the third, ' *Quæ est ista quæ ascendit
super dilectum suum ut virgula fumi?* ' (Cant. iii. 6.) This picture
bears the date 1518. If it be true, as is, indeed, most apparent, that it
was painted by order of Maximilian nearly forty years after the loss of
the young wife he so tenderly loved, and only one year before his own
death, there is something very touching in it as a memorial. The in-
genious and tender compliment implied by making Mary of Burgundy
the real object of those mystic texts consecrated to the glory of the
MATER DEI, verges, perhaps, on the profane; but it was not so in-

tended; it was merely that combination of the pious, and the poetical, and the sentimental, which was one of the characteristics of the time, in literature, as well as in art.[1]

The picture by Jan Schoreel, one of the great ornaments of the Boisserée Gallery,[2] is remarkable for its intense reality and splendour of colour. The heads are full of character; that of the Virgin in particular, who seems, with half-closed eyes, in act to breathe away her soul in rapture. The altar near the bed, having on it figures of Moses and Aaron, is, however, a serious fault and incongruity in this fine painting.

I must observe that Mary is not always dead or dying; she is sometimes preparing for death, in the act of prayer at the foot of her couch, with the apostles standing round, as in a very fine picture by Martin Schaffner, where she kneels with a lovely expression, sustained in the arms of St. John, while St. Peter holds the gospel open before her.[3] Sometimes she is sitting up in her bed, and reading from the Book of the Scripture, which is always held by St. Peter.

In a picture by Cola della Matrice, the Death of the Virgin is treated at once in a mystical and dramatic style. Enveloped in a dark blue mantle spangled with golden stars, she lies extended on a couch; St. Peter, in a splendid scarlet cope as bishop, reads the service; St. John, holding the palm, weeps bitterly. In front, and kneeling before the couch or bier, appear the three great Dominican saints as witnesses of the religious mystery; in the centre, St. Dominick; on the left, St. Catherine of Siena; and on the right, St. Thomas Aquinas. In a compartment above is the Assumption.[4]

Among the later Italian examples, where the old legendary accessories are generally omitted, there are some of peculiar elegance. One by Ludovico Caracci, another by Domenichino, and a third by Carlo Maratti, are treated, if not with much of poetry or religious sentiment, yet with great dignity and pathos.

[1] Heller's Albrecht Dürer, p. 261.
[2] Munich (70.) The admirable lithograph by Strixner is well known.
[3] Munich Gal. [4] Rome, Capitol.

I must mention one more, because of its history and celebrity: Caravaggio, of whom it was said that he always painted like a ruffian, because he *was* a ruffian, was also a genius in his way, and for a few months he became the fashion at Rome, and was even patronised by some of the higher ecclesiastics. He painted for the church of *la Scala in Trastevere* a picture of the Death of the Virgin, wonderful for the intense natural expression, and in the same degree grotesque from its impropriety. Mary, instead of being decently veiled, lies extended with long scattered hair; the strongly-marked features and large proportions of the figure are those of a woman of the Trastevere.[1] The apostles stand around; one or two of them—I must use the word—blubber aloud: Peter thrusts his fists into his eyes to keep back the tears; a woman seated in front cries and sobs; nothing can be more real, nor more utterly vulgar. The ecclesiastics for whom the picture was executed were so scandalised, that they refused to hang it up in their church. It was purchased by the Duke of Mantua, and, with the rest of the Mantuan Gallery, came afterwards into the possession of our unfortunate Charles I. On the dispersion of his pictures, it found its way into the Louvre, where it now is. It has been often engraved.

THE APOSTLES CARRY THE BODY OF THE VIRGIN TO THE TOMB. This is a very uncommon subject. There is a most beautiful example by Taddeo Bartoli,[2] full of profound religious feeling. There is a small engraving by Bonasone, in a series of the Life of the Virgin, apparently after Parmigiano, in which the apostles bear her on their shoulders over rocky ground, and appear to be descending into the Valley of Jehoshaphat: underneath are these lines:—

> Portan gli uomini santi in su le spalle
> Al Sepolcro il corpo di Maria
> Di Josaphat nelle famosa valle.

[1] The face has a swollen look, and it was said that his model had been a common woman whose features were swelled by intoxication. (Louvre, 32.)

[2] Siena, Pal. Publico.

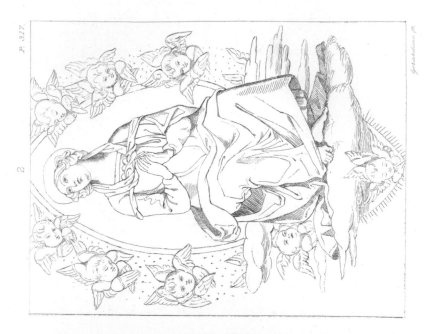

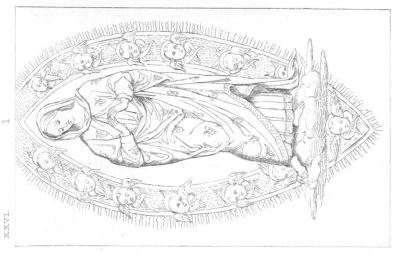

The Assumption.

There is another picture of this subject by Ludovico Caracci, at Parma.

THE ENTOMBMENT. In the early pictures, there is little distinction between this subject and the Death of the Virgin. If the figure of Christ stand over the recumbent form, holding in his arms the emancipated soul, then it is the *Transito*—the death or sleep; but when a sarcophagus is in the centre of the picture, and the body lies extended above it on a sort of sheet or pall held by angels or apostles, it may be determined that it is the Entombment of the Virgin after her death. In a small and very beautiful picture by Angelico, we have distinctly this representation.[1] She lies, like one asleep, on a white pall, held reverently by the mourners. They prepare to lay her in a marble sarcophagus. St. John, bearing the starry palm, appears to address a man in a doctor's cap and gown, evidently intended for Dionysius the Areopagite. Above, in the sky, the soul of the Virgin, surrounded by most graceful angels, is received into heaven. This group is distinguished from the group below, by being painted in a dreamy blueish tint, like solidified light, or like a vision.

THE ASSUMPTION. The old painters distinguish between the Assumption of the soul and the Assumption of the body of the Virgin. In the first instance, at the moment the soul is separated from her body, Christ receives it into his keeping, standing in person either beside her death-bed or above it. But in the Assumption properly so called, we have the moment wherein the soul of the Virgin is reunited to her body, which, at the command of Christ, rises up from the tomb. Of all the themes of sacred art, there is not one more complete and beautiful than this, in what it represents, and in what it suggests. Earth and its sorrows, death and the grave, are left below; and the pure spirit of the

[1] This picture, now in the possession of W. Fuller Maitland, Esq., was exhibited in the British Institution in the summer of 1852. It is engraved in the Etruria Pittrice.

Mother, again clothed in its unspotted tabernacle, surrounded by angelic harmonies, and sustained by wings of cherubim and seraphim, soars upwards to meet her Son, and to be reunited to him for ever.

We must consider this fine subject under two aspects.

The first is purely ideal and devotional; it is simply the expression of a dogma of faith, '*Assumpta est Maria Virgo in Cœlum.*' The figure of the Virgin is seen within an almond-shaped aureole (the mandorla), not unfrequently crowned as well as veiled, her hands joined, her white robe falling round her feet (for in all the early pictures the dress of the Virgin is white, often spangled with stars) and thus she seems to cleave the air upwards, while adoring angels surround the glory of light within which she is enshrined. Such are the figures which are placed in sculpture over the portals of the churches dedicated to her, as at Florence.[1] She is not always standing and upright, but seated on a throne, placed within an aureole of light, and borne by angels, as over the door of the Campo Santo at Pisa. I am not sure that such figures are properly styled the Assumption; they rather exhibit in an ideal form the glorification of the Virgin, another version of the same idea expressed in the *Incoronata.* She is here *Maria Virgo Assumpta,* or, in Italian, *L'Assunta*; she has taken upon her the glory of immortality, though not yet crowned.

But when the Assumption is presented to us as the final scene of her life, and expresses, as it were, a progressive action—when she has left the empty tomb, and the wondering, weeping apostles on the earth below, and rises 'like the morning' ('*quasi aurora surgens*') from the night of the grave,—then we have the Assumption of the Virgin in its dramatic and historical form, the final act and consummation of her visible and earthly life. As the Church had never settled in what manner she was translated into heaven, only pronouncing it heresy to doubt the fact itself, the field was in great measure left open to the artists. The tomb below, the figure of the Virgin floating in mid-air, and the opening heavens above, such is the general conception fixed by the traditions of art; but to give some idea of the manner in which this has been varied. I shall describe a few examples.

[1] The 'Santa Maria del Fiore,'—the Duomo.

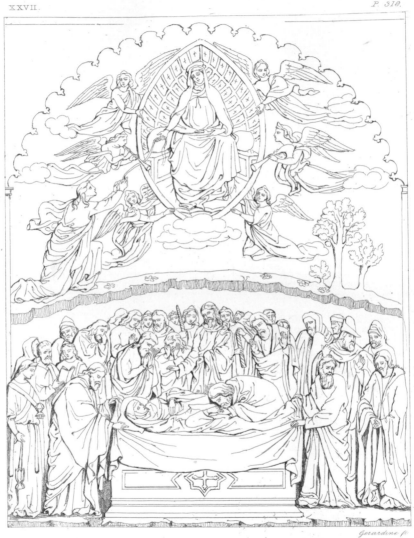

Death and Assumption of the Virgin.
(Sculpture.)

1. Giunta Pisano, 1230.[1] Christ and the Virgin ascend together in a seated attitude upborne by clouds and surrounded by angels; his arm is round her. The empty tomb, with the apostles and others, below. The idea is here taken from the Canticles (ch. viii.), 'Who is this that ariseth from the wilderness leaning upon her beloved?'

2. Andrea Orcagna, 1359.[2] The Virgin Mary is seated on a rich throne within the *Mandorla,* which is borne upwards by four angels, while two are playing on musical instruments. Immediately below the Virgin, on the right, is the figure of St. Thomas, with hands outstretched, receiving the mystic girdle; below is the entombment; Mary lies extended on a pall above a sarcophagus. In the centre stands Christ, holding in his arms the emancipated soul; he is attended by eight angels. St. John is at the head of the Virgin, and near him an angel swings a censer; St. James bends and kisses her hand; St. Peter reads as usual; and the other apostles stand round, with Dionysius, Timothy, and Hierotheus, distinguished from the apostles by wearing turbans and caps. The whole most beautifully treated.

I have been minutely exact in describing the details of this composition, because it will be useful as a key to many others of the early Tuscan school, both in sculpture and painting; for example, the fine bas-relief by Nanni over the south door of the Duomo at Florence, represents St. Thomas in the same manner kneeling outside the aureole and receiving the girdle; but the entombment below is omitted. These sculptures were executed at the time when the enthusiasm for the *Sacratissima Cintola della Madonna* prevailed throughout the length and breadth of Tuscany, and Prato had become a place of pilgrimage.

This story of the Girdle was one of the legends imported from the East. It had certainly a Greek origin[3]; and, according to the Greek formula, St. Thomas is to be figured apart in the clouds, on the right of the Virgin, and in the act of receiving the girdle. Such is the approved arrangement till the end of the fourteenth century; afterwards we find St. Thomas placed below among the other apostles.

[1] Assisi, S. Francesco. [2] Bas-relief, Or-San-Michele, Florence.
[3] It may be found in the Greek Menologium, iii. p. 225.

THE LEGEND OF THE HOLY GIRDLE.

An account of the Assumption would be imperfect without some notice of the western legend, which relates the subsequent history of the Girdle, and its arrival in Italy, as represented in the frescoes of Agnolo Gaddi at Prato.[1]

The chapel *della Sacratissima Cintola* was erected from the designs of Giovanni Pisano about 1320. This ' most sacred ' relic had long been deposited under the high altar of the principal chapel, and held in great veneration; but in the year 1312, a native of Prato, whose name was Musciatino, conceived the idea of carrying it off, and selling it in Florence. The attempt was discovered; the unhappy thief suffered a cruel death; and the people of Prato resolved to provide for the future custody of the precious relic a new and inviolable shrine.

The chapel is in the form of a parallelogram, three sides of which are painted, the other being separated from the choir by a bronze gate of most exquisite workmanship, designed by Ghiberti, or, as others say, by Brunelleschi, and executed partly by Simone Donatello.

On the wall, to the left as we enter, is a series of subjects from the Life of the Virgin, beginning, as usual, with the Rejection of Joachim from the temple, and ending with the Nativity of our Saviour.

The end of the chapel is filled up by the Assumption of the Virgin, the tomb being seen below, surrounded by the apostles; and above it the Virgin, as she floats into heaven, is in the act of loosening her girdle, which St. Thomas, devoutly kneeling, stretches out his arms to receive. Above this, a circular window exhibits, in stained glass, the Coronation of the Virgin, surrounded by a glory of angels.

On the third wall to the right we have the subsequent History of the Girdle, in six compartments.

St. Thomas, on the eve of his departure to fulfil his mission as apostle in the far East, entrusts the precious girdle to the care of one of his

[1] *Notizie istoriche intorno alla sacratissima Cintola di Maria Vergine, che si conserva nella Città di Prato, dal Dottore Giuseppe Bianchini di Prato*, 1795.

disciples, who receives it from his hands in an ecstasy of amazement and devotion.

The deposit remains, for a thousand years, shrouded from the eyes of the profane; and the next scene shows us the manner in which it reached the city of Prato. A certain Michael, of the Dogomari family in Prato, joined, with a party of his young townsmen, the crusade in 1096. But, instead of returning to his native country after the war was over, this same Michael took up the trade of a merchant, travelling from land to land in pursuit of gain, until he came to the city of Jerusalem, and lodged in the house of a Greek priest, to whom the custody of the sacred relic had descended from a long line of ancestry; and this priest, according to the custom of the oriental church, was married, and had ' one fair daughter, and no more, the which he loved passing well,' so well, that he had entrusted to her care the venerable girdle. Now it chanced that Michael, lodging in the same house, became enamoured of the maiden, and not being able to obtain the consent of her father to their marriage, he had recourse to the mother, who, moved by the tears and entreaties of the daughter, not only permitted their union, but bestowed on her the girdle as a dowry, and assisted the young lovers in their flight.

In accordance with this story, we have, in the third compartment, the Marriage of Michael with the Eastern Maiden, and then the Voyage from the Holy Land to the Shores of Tuscany. On the deck of the vessel, and at the foot of the mast, is placed the casket containing the relic, to which the mariners attribute their prosperous voyage to the shores of Italy. Then Michael is seen disembarking at Pisa, and, with his casket reverently carried in his hands, he re-enters the paternal mansion in the city of Prato.

Then we have a scene of wonder. Michael is extended on his bed in profound sleep. An angel at his head, and another at his feet, are about to lift him up; for, says the story, Michael was so jealous of his treasure, that not only he kindled a lamp every night in its honour, but, fearing he should be robbed of it, he placed it under his bed, which action, though suggested by his profound sense of its value, offended his guardian angels, who every night lifted him from his bed and placed him on the bare earth, which nightly infliction this pious man endured rather

than risk the loss of his invaluable relic. But after some years Michael
fell sick and died.

In the last compartment we have the scene of his death. The bishop
Uberto kneels at his side, and receives from him the sacred girdle, with
a solemn injunction to preserve it in the cathedral church of the city,
and to present it from time to time for the veneration of the people,
which injunction Uberto most piously fulfilled; and we see him carrying
it, attended by priests bearing torches, in solemn procession to the
chapel, in which it has ever since remained.

Agnolo Gaddi was but a second-rate artist, even for his time, yet
these frescoes, in spite of the feebleness and general inaccuracy of the
drawing, are attractive from a certain *naïve* grace; and the romantic
and curious details of the legend have lent them so much of interest, that,
as Lord Lindsay says, ' when standing on the spot one really feels in-
disposed for criticism.' [1]

The exact date of the frescoes executed by Agnolo Gaddi is not
known, but, according to Vasari, he was called to Prato *after* 1348.
An inscription in the chapel refers them to the year 1390, a date too
late to be relied on. The story of Michele di Prato I have never seen
elsewhere; but just as the vicinity of Cologne, the shrine of the ' Three
Kings,' had rendered the Adoration of the Magi one of the popular
themes in early German and Flemish art; so the vicinity of Prato ren-
dered the legend of St. Thomas a favourite theme of the Florentine
school, and introduced it wherever the influence of that school had ex-
tended. The fine fresco by Mainardi, in the Baroncelli Chapel, is an
instance; and I must cite one yet finer, that by Ghirlandajo in the choir
of S. Maria-Novella ; in this last-mentioned example, the Virgin stands
erect in star-bespangled drapery and closely veiled.

[1] M. Rio is more poetical. ' Comme j'entendais raconter cette légende pour la première
fois, il me semblait que le tableau réfléchissait une partie de la poësie qu'elle renferme. Cet
amour d'outre mer mêlé aux aventures chevaleresques d'une croisade, cette relique précieuse
donnée pour dot à une pauvre fille, la dévotion des deux époux pour ce gage révéré de leur
bonheur, leur départ clandestin, leur navigation prospère avec des dauphins qui leur font
cortége à la surface des eaux, leur arrivée à Prato et les miracles répétés qui, joints à une
maladie mortelle, arrachèrent enfin de la bouche du moribond une déclaration publique à la
suite de laquelle la ceinture sacrée fut déposée dans la cathédrale, tout ce mélange de passion
romanesque et de piété naïve, avait effacé pour moi les imperfections techniques qui auraient
pu frapper une observateur de sang-froid.'

We now proceed to other examples of the treatment of the Assumption.

3. Taddeo Bartoli, 1413. He has represented the moment in which the soul is reunited to the body. Clothed in a starry robe she appears in the very act and attitude of one rising up from a reclining position, which is most beautifully expressed, as if she were partly lifted up upon the expanded many-coloured wings of a cluster of angels, and partly drawn up, as it were, by the attractive power of Christ, who, floating above her, takes her clasped hands in both his. The intense, yet tender ecstacy in *her* face, the mild spiritual benignity in *his*, are quite indescribable, and fix the picture in the heart and the memory as one of the finest religious conceptions extant.[1]

I imagine this action of Christ taking her hands in both his, must be founded on some ancient Greek model, for I have seen the same *motif* in other pictures, German and Italian; but in none so tenderly or so happily expressed.

The following example is from the early German school.

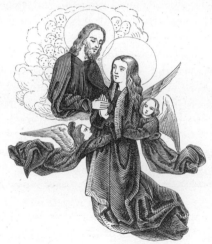

147 Assumption. (I. v. Mekenen. Munich.)

4. Domenico di Bartolo, 1430. A large altar-piece. Mary seated

[1] Siena, Palazzo Publico.

T T 2

on a throne, within a glory of encircling cherubim of a glowing red, and about thirty more angels, some adoring, others playing on musical instruments, is borne upwards. Her hands are joined in prayer, her head veiled and crowned, and she wears a white robe, embroidered with golden flowers. Above, in the opening heaven, is the figure of Christ, young and beardless (*à l'antique*), with outstretched arms, surrounded by the spirits of the blessed. Below, of a diminutive size, as if seen from a distant height, is the tomb surrounded by the apostles, St. Thomas holding the girdle. This is one of the most remarkable and important pictures of the Siena school, out of Siena, with which I am acquainted.[1]

5. Ghirlandajo, 1475. The Virgin stands in star-spangled drapery, with a long white veil, and hands joined, as she floats upwards. She is sustained by four seraphim.[2]

6. Raphael, 1516. The Virgin is seated within the horns of a crescent moon, her hands joined. On each side an angel stands bearing a flaming torch; the empty tomb and the eleven apostles below. This composition is engraved after Raphael by an anonymous master (*Le Maître au dé*). It is majestic and graceful, but peculiar for the time. The two angels, or rather genii, bearing torches on each side, impart to the whole something of the air of a heathen apotheosis.

7. Albert Durer. The apostles kneel or stand round the empty tomb; while Mary, soaring upwards, is received into heaven by her Son; an angel on each side.

8. Gaudenzio Ferrari, 1525. Mary, in a white robe spangled with stars, rises upwards as if cleaving the air in an erect position, with her hands extended, but not raised, and a beautiful expression of mild rapture, as if uttering the words attributed to her, 'My heart is ready;' many angels, some of whom bear tapers, around her. One angel presents the end of the girdle to St. Thomas; the other apostles and the empty tomb lower down.[3]

9. Correggio. Cupola of the Duomo at Parma, 1530. This is, perhaps, one of the earliest instances of the Assumption applied as a grand piece of scenic decoration; at all events we have nothing in this luxuriant composition of the solemn simplicity of the older conception. In

[1] Berlin Gal., 1122. [2] Florence, S. Maria-Novella.
[3] Vercelli, S. Christoforo.

the highest part of the Cupola, where the strongest light falls, Christ, a violently foreshortened figure, precipitates himself downwards to meet the ascending Madonna, who, reclining amid clouds, and surrounded by an innumerable company of angels, extends her arms towards him. One glow of heavenly rapture is diffused over all; but the scene is vast, confused, almost tumultuous. Below, all round the dome, as if standing on a balcony, appear the apostles.

10. Titian, 1540 (about.) In the Assumption at Venice, a picture of world-wide celebrity, and, in its way, of unequalled beauty, we have another signal departure from all the old traditions. The noble figure of the Virgin (144) in a flood of golden light is borne, or rather impelled, upwards with such rapidity, that her veil and drapery are disturbed by the motion. Her feet are uncovered, a circumstance inadmissible in ancient art; and her drapery, instead of being white, is of the usual blue and crimson, her appropriate colours in life. Her attitude, with outspread arms—her face, not indeed a young or lovely face, but something far better, sublime and powerful in the expression of rapture—the divinely beautiful and childish, yet devout, unearthly little angels around her—the grand apostles below—and the splendour of colour over all—render this picture an enchantment at once to the senses and the imagination; to me the effect was like music.

11. Palma Vecchio, 1535.[1] The Virgin looks down, not upwards, as is usual, and is in the act of taking off her girdle to bestow it on St. Thomas, who, with ten other apostles, stands below. (148)

12. Annibal Caracci, 1600.[2] The Virgin amid a crowd of youthful angels, and sustained by clouds, is placed *across* the picture with extended arms. Below is the tomb (of sculptured marble) and eleven apostles, one of whom, with an astonished air, lifts from the sepulchre a handful of roses. There is another picture wonderfully fine in the same style by Agostino Caracci. This fashion of varying the attitude of the Virgin was carried in the later schools to every excess of affectation. In a picture by Lanfranco, she cleaves the air like a swimmer, which is detestable.

13. Rubens painted at least twelve Assumptions with characteristic *verve* and movement. Some of these, if not very solemn or poetical, convey very happily the idea of a renovated life. The largest and most

[1] Venice Acad. [2] Bologna Gal.

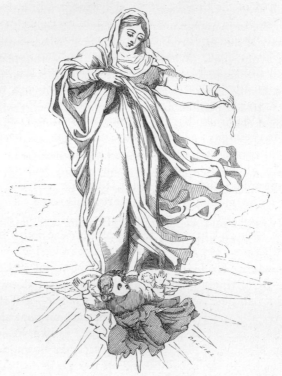

148 La Madonna della Cintola. (The Virgin presents her Girdle to St. Thomas.)

splendid as a scenic composition is in the Musée at Brussels. More
beautiful, and, indeed, quite unusually poetical for Rubens, is the
small Assumption in the Queen's Gallery, a finished sketch for the
larger picture. The majestic Virgin, arrayed in white and blue drapery,
rises with outstretched arms, surrounded by a choir of angels; below,
the apostles and the women either follow with upward gaze the soaring
ecstatic figure, or look with surprise at the flowers which spring within
the empty tomb.

In another Assumption by Rubens, one of the women exhibits the
miraculous flowers in her apron, or in a cloth, I forget which; but the
whole conception, like too many of his religious subjects, borders on the
vulgar and familiar.

14. Guido, as it is well known, excelled in this fine subject—I mean, according to the taste and manner of his time and school. His ascending Madonnas have a sort of aërial elegance, which is very attractive; but they are too nymph-like. We must be careful to distinguish in his pictures (and all similar pictures painted after 1615) between the Assumption and the Immaculate Conception; it is a difference in sentiment which I have already pointed out. The small finished sketch by Guido in our National Gallery is an Assumption and Coronation together; the Madonna is received into heaven as *Regina Angelorum*. The fine large Assumption in the Munich Gallery may be regarded as the best example of Guido's manner of treating this theme. His picture in the Bridgewater Gallery, often styled an Assumption, is an Immaculate Conception.

The same observations would apply to Poussin, with, however, more of majesty. His Virgins are usually seated or reclining, and in general we have a fine landscape beneath.

The Assumption, like the Annunciation, the Nativity, and other historical themes, may, through ideal accessories, assume a purely devotional form. It ceases then to be a fact or an event, and becomes a vision or a mystery, adored by votaries, to which attendant saints bear witness. Of this style of treatment there are many beautiful examples.

1. Early Florentine, about 1450.[1] The Virgin, seated, elegantly draped in white, and with pale-blue ornaments in her hair, rises within a glory sustained by six angels; below is the tomb full of flowers, and in front, kneeling, St. Francis and St. Jerome.

2. Ambrogio Borgognone, 1500.[2] She stands, floating upwards in a fine attitude: two angels crown her; others sustain her; others sound their trumpets. Below are the apostles and empty tomb; at each side, St. Ambrose and St. Augustine; behind them, St. Cosimo and St. Damian; the introduction of these saintly apothecaries stamps the picture as an ex-voto—perhaps against the plague. It is very fine, expressive, and curious.

3. F. Granacci, 1530.[3] The Virgin, ascending in glory, presents her

[1] Coll. of Fuller Maitland, Esq. [2] Milan, Brera,
[3] In the Casa Ruccellai. (?) Engraved in the *Etruria Pittrice*.

girdle to St. Thomas, who kneels; on each side, standing as witnesses, St. John the Baptist, as patron of Florence, St. Laurence, as patron of Lorenzo de' Medici, and the two apostles, St. Bartholomew and St. James.

4. Andrea del Sarto, 1520.[1] She is seated amid vapoury clouds, arrayed in white; on each side adoring angels; below, the tomb with the apostles, a fine solemn group; and in front, St. Nicholas, and that interesting penitent saint, St. Margaret of Cortona.[2] The head of the Virgin is the likeness of Andrea's infamous wife; otherwise this is a magnificent picture.

THE CORONATION of the Virgin follows the Assumption. In some instances, this final consummation of her glorious destiny supersedes, or rather includes, her ascension into heaven.

As I have already observed,[3] it is necessary to distinguish this scenic Coronation from the mystical INCORONATA, properly so called, which is the triumph of the allegorical church, and altogether an allegorical and devotional theme; whereas, the scenic Coronation is the last event in a series of the Life of the Virgin. Here we have before us, not merely the court of heaven, its argent fields peopled with celestial spirits, and the sublime personification of the glorified Church exhibited as a vision, and quite apart from all real, all human associations; but we have rather the triumph of the human mother;—the lowly woman lifted into immortality. The earth and its sepulchre, the bearded apostles beneath, show us that, like her Son, she has ascended into glory by the dim portal of the grave, and entered into felicity by the path of pain. Her Son, next to whom she has taken her seat, has himself wiped the tears from her eyes, and set the resplendent crown upon her head; the Father blesses her; the Holy Spirit bears witness; cherubim and seraphim welcome her, and salute her as their queen. So Dante—

'At their joy
And carol smiles the Lovely One of heaven,
That joy is in the eyes of all the blest.'

[1] Florence, Pitti Pal. [2] Legends of the Monastic Orders. [3] v. antè, p. 14.

Thus, then, we must distinguish :—

1. The Coronation of the Virgin is a strictly devotional subject where she is attended, not merely by angels and patriarchs, but by canonised saints and martyrs, by fathers and doctors of the Church, heads of religious orders in monkish dresses, patrons and votaries.

2. It is a dramatic and historical subject when it is the last scene in a series of the life of the Virgin ; when the deathbed, or the tomb, or the wondering apostles, and weeping women, are figured on the earth below.

Of the former treatment, I have spoken at length. It is that most commonly met with in early pictures and altar-pieces.

With regard to the historical treatment, it is more rare as a separate subject, but there are some celebrated examples both in church decoration and in pictures.

1. In the apsis of the Duomo at Spoleto, we have, below, the death of the Virgin in the usual manner, that is, the Byzantine conception treated in the Italian style, with Christ receiving her soul, and over it the Coronation. The Virgin kneels in a white robe, spangled with golden flowers; and Christ, who is here represented rather as the Father than the Son, crowns her as Queen of heaven.

2. The composition by Albert Durer, which concludes his fine series of woodcuts, the 'Life of the Virgin,' is very grand and singular. On the earth is the empty tomb ; near it the bier ; around stand the twelve apostles, all looking up amazed. There is no allusion to the girdle, which, indeed, is seldom found in northern art. Above, the Virgin floating in the air, with the rainbow under her feet, is crowned by the Father and the Son, while over her head hovers the holy Dove.

3. In the Vatican is the Coronation attributed to Raphael. That he designed the cartoon, and began the altar-piece, for the nuns of Monte-Luce, near Perugia, seems beyond all doubt ; but it is equally certain that the picture as we see it was painted almost entirely by his pupils Giulio Romano and Gian Francesco Penni. Here we have the tomb below, filled with flowers ; and around it the twelve apostles ; John and his brother James, in front, looking up ; behind John, St. Peter ; more in the background, St. Thomas holds the girdle. Above is the throne set in heaven, whereon the Virgin, mild and beautiful, sits beside

her divine Son, and with joined hands, and veiled head, and eyes meekly
cast down, bends to receive the golden coronet he is about to place on
her brow. The Dove is omitted, but eight seraphim, with rainbow-
tinted wings, hover above her head. On the right, a most graceful
angel strikes the tambourine; on the left, another, equally graceful,
sounds the viol; and, amidst a flood of light, hosts of celestial and re-
joicing spirits fill up the background.

Thus, in highest heaven, yet not out of sight of earth, in beatitude
past utterance, in blessed fruition of all that faith creates and love
desires, amid angel hymns and starry glories, ends the pictured life of
Mary, MOTHER OF OUR LORD.

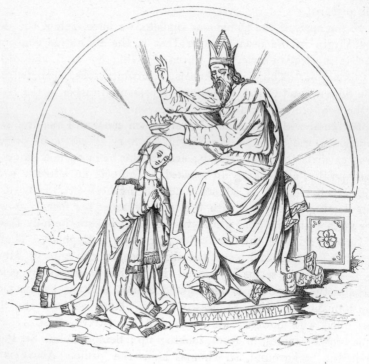

149 The Coronation of the Virgin. (At Spoleto. F. Filippo Lippi.)

INDEXES.

———◆———

I. NAMES OF ARTISTS (EMBRACING PAINTERS, SCULPTORS, AND ENGRAVERS).

II. GALLERIES, CHURCHES, MUSEUMS, AND OTHER DEPOSITORIES OF ART.

III. GENERAL INDEX.

I.

INDEX TO NAMES OF ARTISTS

(EMBRACING PAINTERS, SCULPTORS, AND ENGRAVERS.)

ALB

Albano, 301
Albertinelli, 192, 200
Allori, Cristofano, 121
Alunno, Nicolo, 34
Andreasi, Ippolito, 266
Angelico da Fiesole, 17, 38, 39, 94, 160, 174, 180, 280, 286, 313, 317
Angelo, Michael, 28, 38, 82, 184, 188, 190, 264
Areto, Spinelli, 178

Baldovinetti, 142
Baroccio, 72, 178, 240
Bartoli, Taddeo, 173, 220, 316, 323
Bartolo, Domenico di, 323
Bartolomeo, Domenico di, 169
Bartolomeo, Fra, 33, 88, 118, 173, 174, 192, 227, 228
Bartolozzi, 253
Bassano, 298
Bellini, 109, 117, 118, 201
Betiaffio, 202
Benozzo Gozzoli, 173, 222
Benvenuto di Siena, 95
Bianchi, Pietro, 50
Bissoni, 305
Bonasone, 317
Bonifazio, 79
Bordone, Paris, 130
Borgognone, Ambrogio, 90, 327
Botticelli, 22, 112, 202, 218, 256
Brunelleschi, 320
Bruÿn, B. de, 292

COT

Cambiaso, 254
Cano, Alonzo, 50
Canova, 95
Caracci, the, 23, 36, 120, 301 : — Agostino, 253, 325 ; Annibal, 23, 209, 236, 257, 259, 290, 325 ; Ludovico, 210, 295, 315, 317
Caravaggio, 95, 316
Carducho, V., 94
Carlo Dolce, 120, 169
Carotto of Verona, 281
Carpaccio, Vittore, 146, 150, 153
Carraglio, 80
Cavallini, 197, 286
Cavazzolo, Paolo, 94
Cerezo, Mateo de, 95
Cesi, 140
Champagne, Philippe de, 38
Ciampini, 6, 62
Cignani, Carlo, 120
Cigolo, 289
Cima, 202
Cimabue, 26, 64, 66, 76, 180, 181, 189, 190, 286, 289, 313
Claude, 237
Cola della Matrice, 315
Correggio, 23, 88, 94, 100, 126, 200, 252, 263, 284, 324
Cortona, Pietro da, 198
Cosimo, Pierio, 10
Costa, Lorenzo, 101, 219, 221
Cotignola, Francesco da, 173
Cotignola, Girolamo da, 53, 162

CRA

Cranach, Luis, 240
Credi, Lorenzo di, 22, 125, 201, 203, 206
Crespi, Daniele, 284
Crivelli, Carlo, 71, 74, 85

Daniel di Volterra, 289
Domenichino, 240, 315
Donatello, 17, 320
Dosso Dossi, 47
Duccio di Siena, 289
Durer, Albert, 121, 143, 145, 148, 153, 154,
 180, 220, 231, 240, 265, 274, 281, 286, 287,
 289, 291, 301, 313, 329

Eastlake, Sir Charles, 109, 131

Feti, Domenico, 245
Finiguerra, Maso, 25
Flaxman, 183, 184
Florigerio, 93
Francesca, Piero della, 81
Francia, 39, 53, 79, 80, 88, 110, 127, 173, 201,
 219, 227
Francia, Francesco, 101
Francia, Giacomo, 132

Gaddi, Gaddo, 17
Gaddi, Taddeo, 77, 141, 143, 145, 147, 152, 160,
 211, 215, 222, 296
Gaddo, Agnolo, 154, 208, 320, 322
Garofalo, 72, 88, 178, 198, 220, 258, 273
Gaudenzio Ferrari, 217, 284, 324
Ghiberti, 320
Ghirlandajo, 22, 142, 143, 145, 146, 148, 149,
 152, 153, 160, 161, 168, 219, 313, 322
Giordano, 236
Giorgione, 222, 242
Giottino, 255, 293
Giotto, 17, 67, 76, 92, 160, 273, 286, 289, 293,
 302, 313
Giovanni, Giovanni di San, 234
Granacci, 70, 327
Greucino, 295, 301
Guido, 12, 22, 40, 47, 50, 52, 64, 100, 123,
 127, 154, 171, 194, 228, 263, 301, 327
Guidotti, Saulo, 100

ORC

Hemling, Hans, 19, 89, 105, 202, 304
Hernandez, 50
Herrera, 49
Holbein, 102, 129
Hopfer, David, 240, 266

Lanfranco, 34, 325
Lasinio, 148
Laurati, Piero, 17
Le Brun, 50, 267
Lionardo, 101
Lippi, Fra Filippo, 30, 311, 330
Lippi, Filippo, 24
Lippi, Filippino, 124
Lorenzetti, Ambrogio, 291
Lucas van Leyden, 190, 220, 283
Luini, 117, 143, 154, 155, 162, 194, 277

Mabuse, 220
Maiano, Benedetto, 174
Mainardi, 142, 322
Mantegna, Andrea, 97, 117, 121, 286
Maratti, Carlo, 88, 124, 275
Marc Antonio, 39, 352
Masaccio, 286
Massari, Lucio, 240
Matteo di Giovanni, 99
Mekenen, I. v., 323
Meldula, Andrea, 86
Mellone, Antonello, 235
Memmi, Simone, 172, 273
Mocchi, 181
Mola, 241
Monaco, Lorenzo, 231
Montanez, 50
Moretto, 32, 87
Morone, 94
Murillo, 34, 36, 43, 46, 49, 50, 52, 95, 120,
 151, 251, 258, 263, 266, 284

Nanni, 319
Negroponte, Fra Antonio da, 74

Orcagna, Andrea, 28, 152, 319

PAC

Pacheco, 46, 49, 50
Palma, 127, 129, 130
Paolo, 278
Parmigiano, 132, 218, 262, 316
Paul Veronese, 81, 221, 281
Pavia, Lorenzo di, 261
Pellegrino, 94
Penni, Gian Francesco, 329
Perugino, 86, 110, 161, 201, 210, 261, 291
Peruzzi, Baldassare, 197, 198, 219
Pinturicchio, 22, 186, 195, 216, 233, 264, 273
Piombo, Sebastian del, 190
Pisano, Giovanni, 320
Pisano, Giunta, 319
Pisano, Nicolò, 66, 289
Pordenone, 95
Poussin, Niccolò, 120, 162, 184, 221, 230, 232, 236, 241, 260, 265, 327
Puccio, Capanna, 67, 289
Puligo, D., 93

Raphael, 9, 24, 26, 35, 38, 76, 84, 93, 102, 103, 105, 110, 116, 117, 123, 124, 128, 160, 161, 178, 184, 190, 209, 210, 218, 252, 256, 257, 258, 263, 264, 283, 290, 291, 292, 294, 324, 329
Rembrandt, 185, 192, 208, 221, 242, 259, 266, 292
Robbia, Luca della, 174, 188
Roche, Paul de la, 293
Roelas, 49
Romano, Giulio, 84, 202, 265, 329
Rosso, 198
Rubens, 24, 29, 151, 162, 174, 191, 221, 245, 253, 263, 266, 271, 274, 289, 291, 326

Sabbatini, Andrea, 190, 191
Salimbeni, V., 266
Salvator Rosa, 96
Sanzio, Giovanni, 171
Sarto, Andrea del, 73, 123, 148, 149, 169, 181, 182, 264, 328
Sasso Ferrato, 120

ZUR

Scharf, George, 17, 263
Schauffelein, Hans, 311
Schidone, 269
Schoen, Martin, 27, 68, 173, 283, 286
Schoreel, Jan, 315
Seidler, Mademoiselle Louise, 33
Sesto, Cesare de, 113
Signorelli, 131
Solario, 253
Spagnoletto, 50
Squarcione, 117, 118
Steinle, 129
Strixner, 315

Tafi, Andrea, 64
Tavarone, Lazaro, 49
Teniers, 236
Tiarini, Alessandro, 195, 230, 295
Tintoretto, 178, 278, 286
Titian, 99, 107, 112, 123, 129, 130, 132, 153, 154, 178, 198, 210, 217, 230, 241, 258, 278, 292, 306, 325
Tobar, Alonzo Miguel de, 33
Turrita, Jacopo della, 16

Udine, Giovanni da, 273

Vandyck, 37, 120, 221, 240, 253, 291
Van Eyck (the Brothers), 8; — John, 68, 105, 107, 177, 185, 218, 228
Vanni, Francesco, 245
Vecchio, Palma, 219, 260, 325
Velasquez, 23, 49
Venusti, Marcello, 39
Vinci, Lionardo da, 80, 84, 122, 123, 218, 259
Vivarini, 20, 81, 87

Werff, Adrian Vander, 236

Zuccaro, 234
Zurbaran, 296

II.

INDEX TO GALLERIES, CHURCHES, MUSEUMS, AND OTHER DEPOSITORIES OF ART.

———o∘⦂⦙⦂∘o———

AIX

Aix, 106
Alton Towers, 178, 242
Amiens, 155, 171, 195, 221, 279, 301
Antwerp, 108, 151, 289
Arena at Padua, 160, 162, 293, 302
Ashburton, Lord, collection of, 240
Assisi, 319

Baroncelli Chapel, 322
Berlin, 8, 30, 47, 77, 173, 185, 202, 296
Biagio, San, 48
Blenheim Gallery, 245
Boisserée Gallery, 23, 185, 228, 315
Bologna:—Gallery, 22, 40, 41, 100, 162, 173, 221, 350; Churches, 101, 295; Palace, 86
Borgo San Sepolcro, 31
Borghese Gallery, 88, 190, 293
Breslau, 170
Bridgewater Gallery, 117, 120, 258, 269, 327
British Institution, 317
British Museum, 171
Bromley, Mr., his collection at Wootten, 52, 53, 86, 312
Bruges, 89
Brussels, 24, 29, 326

Caen Musée, 161
Campo Santo, 7
Carlisle, Lord, collection of, 220
Capua, Cathedral, 62
Catacombs, 189

HOP

Cento Cathedral, 301
Charles, Archduke, collection of, 154
Colonna Palace, Rome, 34
Cologne, 172, 305

Dresden, 47, 90, 94, 99, 102, 129, 208, 219, 265, 278, 301
Dulwich Gallery, 95, 208

Ellesmere, Lord, collection of, 48, 154
Esterhazy Gallery, 49, 94

Ferrara, 220, 284
Florence:—Gallery, 10, 22, 25, 65, 72, 88, 91, 94, 111, 121, 126, 141, 192, 218, 220, 234, 240, 256, 264, 281, 294, 313; Churches, 17, 65, 77, 142, 148, 152, 154, 161, 168, 169, 172, 222, 280, 294, 311, 318, 319; Palaces, 169, 203, 219, 256, 264, 301, 328
Frankfort Museum, 87
Frari at Venice, 74, 107
Frere, Mr., collection of, 49
Fries Gallery, 314

Garvagh, Lord, collection of, 256
Ghent, 185
Grahl, M., collection of, 90
Grosvenor Gallery, 192, 221, 257

Hampton Court Gallery, 50, 198
Halford, Mr., collection of, 52
Hope, Mr., collection of, 266

KEN

Kensington Palace, 19, 24, 116, 312

Lansdowne Collection, 50, 264
Leuchtenberg Gallery, 109
Lichtenstein Gallery, 301
Liverpool, 273
Lucca, 33

Madrid, 23, 33, 49, 84, 190, 221, 283
Maitland, Mr., collection of, 203, 317, 327
Mantua, 316
Marseilles, 262
Milan:—Brera, 87, 101, 110, 143, 144, 154,
 161, 162, 171, 194, 219, 327; Churches,
 277, 278
Monreale, near Palermo, 6
Munich Gallery, 109, 126, 138, 296, 311, 323,
 327
Murano, 6

Naples, 199
National Gallery, 39, 79, 80, 84, 110, 219, 251,
 264, 284, 327

Orvieto, 67, 181, 310
Overston, Lord, collection of, 50

Padua, 160, 162, 293, 302, 305
Palermo, 283
Paris:—Louvre, 17, 22, 50, 80, 89, 107, 112,
 123, 130, 190, 192, 195, 202, 240, 241, 253,
 256, 257, 258, 261, 263, 266, 267, 278, 292,
 361; Bibliothèque Imp., 25; Church of
 Notre Dame, 309
Parma, 88, 253, 317
Perugia, 116, 161
Pesaro, 53
Petersburg, 48, 123, 259
Prato, 320

Quandt, Herr v., collection of, 31, 32

WOO

Queen's Gallery, 39, 221, 326
Quirinal Palace, 47, 198

Ravenna, 6, 76, 214, 215
Rinucci Chapel, 77
Rogers, Mr., collection of, 22, 68
Rome:—Vatican, 9, 22, 24, 25, 38, 99, 104,
 151, 190, 214, 218, 312, 329; Churches, 5,
 6, 8, 15, 16, 24, 34, 47, 50, 62, 63, 173, 189,
 197, 198, 214, 222, 233, 289
Roscoe, Mr., collection of, 273
Rouen, 105
Rucellai Chapel, 65, 76, 142

Schleissheim Gallery, 27
Seville, 50
Siena:—Churches, 316, 323; Palazzo Publico,
 98, 99, 264, 313
Solly, Mr., collection of, 52, 53
Spoleto, 329
Strasburg, 27
Suffolk, Earl of, collection of, 122, 259
Sutherland Gallery, 94, 313

Torcello, 6
Trastevere, La Scala in, 316
Treves Cathedral, 22

Venice:—Churches, 6, 30, 74, 78, 92, 107,
 286, 325; Academy, 20, 79, 81, 87, 93, 95,
 109, 153, 325
Vercelli, 284, 324
Verona, 281
Vienna Galleries, 49, 68, 94, 95, 112, 113, 120,
 123, 131, 154, 222, 275, 301, 314

Wallerstein Collection, 19, 24, 84, 116, 254,
 312
Ward, Lord, collection of, 85
Windsor Castle, 112, 257, 258
Woodburn, Mr., collection of, 108

III.

GENERAL INDEX.

————oo｡｡oo————

ADA

Adam and Eve in pictures of the Virgin, 47, 68, 106

Adoration of the Magi, 210–222

Adoration of the Shepherds, 209, 210

Agabus, a suitor of the Virgin, 60

Agincourt, M. d', references to his works on Painting and Sculpture, 17, 67, 147, 151, 216

Alexander VI., Pope, 108, 190

Alexandria, 59

Ambrose, St., his relation of the apparition of Christ to his Mother, 299

Angels, their appearance in pictures of the Madonna, 76, 84

Anna, St., mother of the Virgin, her life and history. See *Saints*.

Annunciation, the, 165. Regarded as a mystery, 167. As an event, 175.

Apelles, sarcasm of, 71

Apostles and Four Evangelists. See *Saints*.

Apparition of Christ to his Mother, 299

Aquinas, Thomas, his opposition to the festival of the Immaculate Conception, 44

Arbia, battle of, 98

Arians, their persecution of the Nestorians, 59

Arius, 58, 62

Arnobius the Younger, his commentary on the forty-eighth psalm, 221

'Arte de la Pintura' of Pacheco, reference to, 46

Ascension of Christ, viewed in its relation to the life of the Virgin, 302

Assumption of the Virgin, 317. Its ideal and devotional aspect, 318. Its dramatic and

CAL

historical aspect, 318. The legend of the Girdle, 319

Augustines, saints of the, their appearance in pictures of the Virgin, 93

Augustus Cæsar and the Sibyl Tiburtina, 196, 197

Baillet, references to his work, 43, 290

Balaam, allusion to the prophecy of, 211

Bartsch, reference to, 266

Belle Jardinière, Raphael's picture of, 256

Bembo, Cardinal, likeness of, 154

Benedictines, paintings of the Virgin for the, 85, 93

Bentivoglio, votive picture of the family of, in Francia's Nativity, 202

Bernard, St., 35, 138, 181, 204

Bernardines of Monte Oliveto, 22

Bernardino, San, 47

Bonaventura, San, his character of the Virgin, 269

Borgias, their opposition to the festival of the Immaculate Conception, 52, 53

Bosio's 'Roma Sotterana,' reference to, 189

Branconio, *Giovan-Battista*, 190

Browning, Elizabeth Barrett, lines of, on the Virgin and sleeping Christ, quoted, 254

Byzantine Art, Lord Lindsay's description of, 8

Cæsar Augustus and the Sibyl Tiburtina, legend of, 198

Calvary, procession to, 282

CAR

Carmel, Mount, Our Lady of, 95
Carmelites, their privilege of styling themselves the 'Family of the Blessed Virgin,' 95
Cartoons of Raphael, 24, 58
Cary's 'Dante,' quotations from, 180, 182, 273, 296, 328
Catherine, St., marriage of, 88. See *Saints.*
Celestine II., Pope, 68
Charles I., his collection of pictures, 108, 202, 316
Charles V., portrait of, 278
Charles the Bold, portrait of, 218
Cicognara's 'Storia della Scultura,' reference to, 66
Cintola. See *Girdle.*
Circumcision of Christ, 223
Clement VII. bestows the laurel crown on Girolamo Casio, 202
Coleridge, 268
Colonna, Cardinal, kneeling figure of, 16
Conception, Immaculate, rise and origin of the doctrine, 43. How treated by artists, 45–53
Confraternità dell' Annunziata, 174
Constantine the Great, 58
Conti, Sigismund, his votive picture, 103
Coronation of the Virgin as the type of the Church triumphant, 13
Coronation of the Virgin, 328. How to be distinguished from the mystical Incoronata, 328
Crucifixion, the, viewed as historically illustrating the life of the Virgin, 284

Dagomari Family, story of the, 321
Dalmatica, figure of the Virgin on the, 7
Dante, quotations from, 180, 182, 273, 296, 328
David, King, in pictures of the Virgin, 78, 174
Day of Judgment, the Virgin as the 'Virgin of Mercy,' 26
Death of the Virgin, 306–316. The Announcement by the angel, 311
Death of Joseph, legend of, 274
Dennistoun, Mr., his 'Dukes of Urbino,' 53
Deposition of the body of Christ, 289

GER

Descent from the Cross, 288
Didron's 'Manual of Greek Art,' quoted, 27, 145, 154, 277
'Disputa' dell' Sacramento, Raphael's fresco, 9
Dispute in the Temple, pictures of, 271
Distaff, legend of the, 268
Doctors or Fathers of the Church, their appearance in pictures of the Virgin, 87
Dominicans, paintings for the order of, 95, 101, 296, 302
Dream of Joseph, 193–195
Duns Scotus, his fame as champion of the Virgin, 44. His portrait by Spagnoletto, 50

Entombment of Christ, 292
Entombment of the Virgin, 316, 317
Ephesus, General Council of, 60
Este, Beatrice d', portrait of, 102
Este, Isabella d', reference to, 97
'Etruria Pittrice,' referred to, 264
Evode, St., patriarch of Antioch, 155
Exarch of Ravenna, relic of his ivory throne, 198

Feltri, Bernardino da, notice of, 91
Flight into Egypt, 228. Traditions concerning, 232–237
'Flos Sanctorum,' extract from, 210
Forman, Helena, wife of Rubens, 151
Fornone, battle of, 97
Franceschi, Andrea de', Titian's friend, 153
Francis I., Rosso's Nativity painted for, 198. Portrait of, 278
Francisca, daughter of Murillo, 50
Franciscans, their theory of the Immaculate Conception, 146. Pictures of the Virgin for, 34, 85, 93, 94, 99, 104

Gabriel the Archangel, in the Annunciation, 178 *et seq.*
Gaston de Foix, his portrait by Cotignola, 53
Gaye's 'Carteggio,' referred to, 263
Germanus, St., his account of the Greek tradition of the Virgin, 155

GER

Gerson, his poem on St. Joseph, 257
Giovanni II., tyrant of Bologna, 101
Girdle, legend of the, 320
Goethe, reference to, 301
Gonzaga, his victory and votive picture, 97
Gori's 'Thesaurus,' referred to, 199
'Gospel of Infancy,' 234
Gregory the Great, 60

Hallam's 'Literature of Europe,' 199
Holy Family. See *Virgin Mary, scenes in the Life of*. The title descriptive of the *domestic* life of the Virgin, 239. *Domestic* and *devotional* treatment of the subject, 250. Examples, 250, 251. Two figures—the Mother and Child, 252. Three figures and examples, 256. Four figures and examples, 260. Five and six figures, 260. Pictures illustrating early childhood of Christ, 263
Holy Ghost, descent of, treatment by artists, and its relation to the life of the Virgin, 303
Honorius III., Pope, 95

Iconoclasts, allusion to the, 61
Immaculate Conception. See *Conception*.
Incoronata, l', 13, 26
Innocents, massacre of the, 228
Isaiah, in a picture of the Virgin, 175
Isis and Horus, 58

James, king of Aragon, 80
Jeremiah the prophet, in pictures of the Virgin, 62, 175
Jerome, St., 206
Jesuits, 24
Joachim and Anna, legend of, 137. Signification and derivation of the name *Anna*, 138. Veneration of Anna derived from the East, 138. Pictures illustrative of the legend, 141, 146
Job the patriarch, in pictures of the Virgin, 78
John IV. and Theodorus, Popes, 5, 6
Joseph, legend of, 274. See *Saints*.
Joseph and the Virgin Mary, marriage of, 156–162

MAD

Josephus, extract from, 152
Judith, maid of Anna, 144, 145
Julius, cemetery of, 189
Justin Martyr, tradition related by him, 211

Kenyon, Mr., his translation of the Gipsy legend of the Madonna, 245
Kugler's 'Handbook,' references to, 10, 17, 24, 25, 63, 161, 263

Lanzi, 32, 53
'Last Judgment,' mosaic in the cathedral of Torcello, 27. Michael Angelo's picture of, 28. Rubens' picture of, 29
Laval, Jeanne de, portrait of, 106
Lindsay, Lord, his work on 'Christian Art' referred to, 8, 322
Litanies of the Virgin, 51
Litta's 'History of the Italian Families,' referred to, 101, 202
Lorenzo the Magnificent, 92
Lucrezia, wife of A. del Sarto, 149
Luke, St., notices of, 12, 115, 116, 169
Ludovico il Moro, 101

Madonna. See *Virgin and Child*.
Madonnas by Raphael:—
— del Baldachino, 93
— delle Candelabre, 110
— del Cardellino, 256
— della Famiglia Alva, 123
— di Foligno, 104
— del Giglio, 256
— del Passegio, 260
— dell' Pesce, 84
— della Seggiola, 110
— di San Sisto, 104, 129; and *Introduction*, xliv.
Madonnas by Correggio:—
— di San Giorgio, 100
— di San Sebastiano, 99
Madonna Conestabile, 117
— de la Diadème, 125
— della Famiglia Bentivoglio (Costa), 100
— di San Francesco (Sarto), 72

MAD

Madonna del Gran Duca, 117
— di S. Margherita (Parmigiano), 132
— of the Meyer Family, 102
— di Misericordia (F. F. Lippi), 30
— di Misericordia (Francesca), 31
— di Misericordia (Fra Bartolomeo), 33
— del Parto, 199
— del Rosario, 95
— di Silenzio (M. Angelo), 255
— Tempi, 117
— in Trono and in Gloria, 75
— della Vittoria, 96
— del Voto, of Siena, 98
Madonnas, half-length, enthroned, 108
— votive, public and private, 96
Madre di Dolore, 37
Madre Pia, 68, 125
Magi, journey of the, 202. Legend, 210–214.
 How represented in works of art, 214–222
Malvasia, reference to, 195
Marriage at Cana, 276
Marriage of the Virgin, 156, 162
Martyrs, their appearance in pictures of the
 Virgin, 82
Mary Stuart, first planter of sycamores in
 Scotland, 239
Matarea, the resting-place of the Holy Family,
 239
Mater Amabilis, 114, 118
Mater Dolorosa, 12, 35–41
Maximilian, Emperor, 314
Medici Family, patron saints of, 92. Portraits
 of, in Pictures of the Madonna, 112, 202, 218,
 263
Mendicant Orders, pictures of the Virgin for,
 41, 94
Menologion, the Greek, references to, 204, 320
Mercy, Order of, 34, 96
Méry, Abbé, quoted, 171. On artistic errors
 endangering the Christian faith, 269
'Messiah' of Pope, origin of, 197
Meyer Family, 102
Milnes, Monckton, quoted, 124
Milton, quoted, 178, 210, 280
Monastic Orders, pictures of the Virgin for
 the, 10, 22, 30, 34, 41, 53, 64, 65, 85, 92–96,

PIU

99, 101, 104, 105, 131, 146, 168, 283, 296,
 302
Moses and Aaron, in pictures of the Virgin,
 72, 174
Munter's 'Sinnbilder,' 62, 199
Murray's 'Handbooks,' references to, 33, 53

Nativity of the Blessed Virgin, 146–149
Nativity of Christ, 197–210. As a mystery,
 199–203. Historically treated, 204–210
Neander's 'Church History,' referred to, 58
Nestorius, patriarch of Constantinople, 59. His
 schism the cause of the *religious* importance
 attached to the worship of the Virgin and
 Child, 59, 60. History of the dispute, 59,
 60
Nicholas IV., Pope, 7, 16

'Office of the Blessed Virgin,' references to
 the, 26, 51, 53, 150
Olivetans, pictures painted for the, 283
Otley's 'History of Engraving,' references to,
 25, 203

Pacheco, his rules for artists, 46
'Paradise Lost,' referred to and quoted, 178,
 210, 280
Paschal I., Pope, 62
Passavant's 'Raphael,' referred to, 10, 25,
 283
Pastora, la Divina, 33
Patron Saints :—of Mantua, 97, 202 ; of the
 Medici Family, 92 ; of Milan, 102 ; of
 Modena, 99 ; of Philip the Good, 20 ; of
 Provence, 106 ; of Siena, 89, 92 ; of Venice,
 78, 81, 90, 107, 130, 131, 278
Paul V. and the Immaculate Conception, 45
Pesaro Family, chapel of the, 107, 108
Philip the Good, picture of the 'Coronation'
 painted for, 19. Portrait of, 218
Pietà, the, of M. Angelo, 38 ; of Raphael, 38 ;
 of Francia, 39 ; of Angelico, 39 ; of Guido,
 40
Piffereri of the Campagna, 209
Pius IX., his ordinance on the Immaculate
 Conception, 45

PLA

Plague and pestilence, pictures commemorative of, 98
'Pollio' of Virgil, suggested by the prophecy of the Sibyl Tiburtina, 197
Predestination of Mary, pictures of the, 51
Presentation of the Virgin, legend of the, 150
Presentation of Christ, 223
Prophets, their appearance in pictures of the Virgin, 78
'Protevangelion,' quoted, 151, 159, 176, 198, 205
Ptolemy Philadelphus and the Septuagint, historical notice of, 224
Purification of the Virgin, 223

Raboteur, le, A. Caracci's picture of, 259
Raphael leading Tobias, 84
Raphael and Tobit, 131
René, Duke of Anjou, 106, 173
Return from Egypt, 245
Ridolfi, reference to, 153
Rio, M., quoted, 322
Riposo (Repose) of the Holy Family, 238. The legend, 242
Rosario, Madonna del, 95
Rosary, references to, 282, 284, 292, 296, 302
Rossini's 'Storia della Pittura,' reference to, 255

Saints, list of, that appear in pictures of the Madonna :—
Adrian, 20
Agatha, 62, 105
Agnes, 19, 88, 105, 133
Ambrose, 47, 87, 98, 102, 327
Andrew, 20, 80, 97
Anna, Mother of the Virgin, 80, 131, 137, 146, 149, 155, 160, 177, 259, 261, 262, 265, et seq.
Anselm, 47
Antonino, 10, 92
Antony of Padua, 16, 22, 82, 93, 94, 106, 107
Apollonia, 87, 105
Aquinas, Thomas, 19, 315

SAI

Saints—continued.
Augustine, 19, 21, 22, 47, 87, 93, 102, 202, 327
Barbara, 22, 89, 90, 100, 105, 110, 129
Bartholomew, 328
Benedict, 19, 93, 133, 294
Bernard, 22, 47, 93
Bernardino, 92
Bernardo, Cardinale, 22
Bonaventura, 22, 94
Bruno, 93
Catherines, the two, 10, 19, 22, 53, 82, 87, 90, 92, 95, 99, 105, 106, 109, 127, 132, 202, 315
Cecilia, 19, 77, 105
Charlemagne, 19
Charles Borromeo, 41
Christina, 22
Christopher, 90
Clara, 19, 80, 94
Cosimo, 327
Cosmo, 26, 92, 99, 100
Cyprian, 47
Cyril, 47
Damian, 26, 92, 99, 327
Dionysius the Areopagite, 312, 317, 319
Domnio, 6
Dominick, 17, 22, 33, 41, 94, 95, 100, 110, 127, 133, 280, 315
Dorothea, 105, 130, 131
Elizabeth, 82, 97, 127, 133, 140, 186–192, 260, 263, 264, et seq.
Elizabeth of Hungary, 91, 94
Eleazar of Toulouse, 94
Florian, 100
Francis, 16, 17, 22, 41, 80, 91, 94, 95, 99, 100, 104, 107, 127, 133, 172, 202, 327
Gabriel, 83, 84
Geminiano, 99, 101
George, 20, 82, 90, 92, 99, 100, 107, 109, 112, 127
Gregory, 21, 87, 102
Helena, 202
Hierotheus, 319
Hilarius, 47
Ignatius, 100

SAI

Saints—*continued.*

Ildefonso, 43, 48

Ives of Bretagne, 94

James, 93, 328, 329

Jerome, 21, 25, 53, 82, 87, 88, 95, 102, 104, 109, 112, 131, 140, 159, 173, 203, 327

Joachim, father of the Virgin, 80, 81, 140 –146, 149–155, 177, 259, 261, 263, 265

John the Baptist, 4, 6, 8, 16, 25, 70, 79, 82, 86, 89, 91–94, 97, 101, 104, 109, 113, 122–126, 129 *et seq.*, 173 *et seq.*, 262, 263, 328

John the Evangelist, 6, 16, 21, 22, 37, 40, 78, 86, 89, 106, 110, 202, 261, 262, 263, 282, 285–287, 289, 290, 293, 295, 296, 313, 314, 315, 317, 329

John Damascene, 48

John Gualberto, 22

Joseph, husband of the Virgin, 80, 81, 113, 127, 130, 140, 146, 158–162, 176, 178, 188, *et seq.*

Julian of Rimini, 22

Justina, 82, 92

Laurence, 92, 110, 112, 146, 328

Leonard, 91

Longinus, 97, 202

Louis of France, 94

Louis of Toulouse, 22, 94, 146

Lucia, 90, 105

Luke, 12, 21, 78, 169

Margaret, 10, 132, 173, 327

Mark, 21, 78, 92, 139

Martha, 109

Martin, 91

Mary Magdalene, 19, 40

Matthew, 21, 78

Maurice, 20, 92, 97, 106

Michael, 70, 83, 84, 87, 97

Monica, 93

Nicholas, 19, 22, 91, 92, 99, 106, 328

Omobuono, 91

Origen, 47

Paul, 5, 7, 16, 24, 62, 84, 85, 93, 133, 173

Peter, 4, 5, 7, 10, 16, 24, 62, 80, 84, 85, 93,

SYC

Saints—*continued.*

99, 107, 109, 139, 140, 294, 311, 315, 319, 329

Peter Martyr, 19, 22, 95, 101, 174

Petronius, 41, 100, 132

Philip, 20

Philip Benozzi, 10

Proculus, 41, 100

Ranieri, 7

Remi, 294

Reparata, 25

Roch, 80, 91, 99, 100

Romualdo, 93

Scholastica, 93

Sebastian, 20, 80, 99, 100

Stephen, 24, 62

Theresa, 158

Thomas, 80, 319, 329

Timothy, 312, 319

Ursula, 131, 146

Venantius, 6

Xavier, Francis, 100

Zacharias, 113, 188–192, 261

Zenobio, 92

Sannazzaro, 199

Sanseverini, family of, 191

Savonarola, death of, 192

Scuola or Brotherhood of Charity, 30

Servi, Serviti, pictures for the, 11, 53, 146, 168

Sforza Family, historical portraits of, 53, 101

Shepherds, adoration of the, 209, 210

Sibyls, their relation to sacred art, 197. See *Introduction.*

Sibyl Tiburtina and Augustus, 197

Simeon, legend of, 224

Sixtus IV., Pinturicchio's Coronation for, 22. His decree for celebrating the festival of the Immaculate Conception, 44. Institutes a festival in honour of St. Joseph, 257

Sorbonne, the, 45

Spasimo, Lo, 280

Spozalizio. See *Marriage of the Virgin.*

'Stalles d'Amiens,' referred to, 170, 194

Stirling's 'Artists of Spain,' referred to and quoted, 45, 50, 95, and *note*

Sycamore tree, 239

TAS

Tasso, Bernardo, his portrait, 191
Taylor, Jeremy, quoted, 194, 197, 200, 204, 226, 252, 272, 287
Theodosius II., Emperor, his persecution of Nestorius, 60
Tiepolo, Ginevra, her portrait, 53
Theseus and Hippolyta, 72
Thieves, the Two, legend of the, 234
Three Kings. See *Magi.*
Tieck, 170
Tobias, 84, 131
Torrecremata, Cardinal, 173

Vallombrosian Monks, pictures for the, 22, 66
Vasari, quoted, 53, 66, 148, 192, 198, 202, 281, 294, 322
Vierge au Lapin, of Titian, 130
Vierge aux Cerises, of Annibal Caracci, 258
Villegas' ' Flos Sanctorum,' 45
Virgin without the Child, early worship of, 3. Accompanied by Greek and Egyptian types, 4. Characters under which she is early exhibited, 4. The Virgin, separate from her Son, rarely met with in modern art, 10
Virgin with the Child — her maternal character, 57–134. Images and pictures introduced in the reign of Constantine, 58. Egyptian influences, 58. Votive Madonnas, public and family, 96, 97. Half-length figures of the, 108. As the Mater Amabilis, 114. As the Madre Pia, 125. Pastoral Madonnas, 127.. Concluding remarks suggested by a review of the subject, 133, 134
Virgin Mary, life of, illustrated by historical legends, 135–162. See *Joachim and Anna.*
Virgin Mary, scenes in the life of ; from the annunciation to the return from Egypt, 163–

WRI

245. The annunciation, 165–185. The visitation, 186–193. Dream of Joseph, 193–195. The nativity, 197–208. Adoration of the shepherds, 209, 210. Adoration of the Magi, 210–222. Purification of the Virgin, presentation and circumcision of Christ, 223–228. The flight into Egypt, 228–236. The Repose of the Holy Family, 238–245. Poetical legend of the Riposo, 242–245. The return from Egypt, 245
Virgin Mary, historical scenes in the life of, from the sojourn in Egypt to the crucifixion, 247–296. The Holy Family, 249–270. The dispute in the Temple, 271–274. The death of Joseph, 274, 275. The marriage at Cana in Galilee, 276–279. Ministry of Christ, 279, 280. Lo Spasimo, 280–282. The procession to Calvary, 282–284. The crucifixion, 284–287. The descent from the Cross, 288, 289. The deposition, 290–292. The entombment, 292–296
Virgin Mary, the life of, from the resurrection of our Lord to the assumption, 297–328. The apparition of Christ to his Mother, 299–302. The ascension, 302, 303. The descent of the Holy Ghost, 303–305. The death of the Virgin, 306–316. Her body carried by the Apostles to the tomb, 316, 317. Her entombment, 317. Her assumption, 317. Her coronation, 328–330
Virgo Sapientissima, 9
Visitation, the, 186–193

Wilkie, Sir David, his estimate of the ' Misericordia di Lucca,' 33
Wright's ' Chester Mysteries,' reference to, 215

LONDON

PRINTED BY SPOTTISWOODE AND CO.

NEW-STREET SQUARE